THE
MISSING
REEL

Also by Christopher Rawlence
About Time

THE
MISSING
REEL

The Untold Story of the Lost Inventor of Moving Pictures

Christopher Rawlence

ATHENEUM
New York • 1990

Maxwell Macmillan International
New York Oxford Singapore Sydney

Originally published in Great Britain in 1990 by William Collins Sons & Co. Ltd

PICTURE ACKNOWLEDGMENTS

The photographs in this book are reproduced by kind permission
of the following:

Theodore Chevignard Plate IX; *Scientific American* Plate XIII; US Dept
of the Interior, National Park Service, Edison National Historic Site
Plates III, IV, VI.

The remaining photographs come from the Huettel and Graves families
in Memphis, Tennessee.

Atheneum
Macmillan Publishing Company
866 Third Avenue, New York, NY 10022

Collier Macmillan Canada, Inc.
1200 Eglinton Avenue East, Suite 200
Don Mills, Ontario M3C 3N1

Library of Congress Cataloging-in-Publication Data

Rawlence, Christopher.
 The missing reel : the untold story of the lost inventor of moving
pictures / Christopher Rawlence.
 p. cm.
 "Originally published in Great Britain in 1990 by William Collins
Sons & Co. Ltd."—T.p. verso.
 Includes bibliographical references (p.) and index.
 ISBN 0-689-12068-0
 1. Le Prince, Louis Aimé Augustin, 1842–1890. 2. Inventors—Great
Britain—Biography. 3. Cinematography—History. I. Title.
 TR849.L4R39 1990
 778.5'3'092—dc20
 [B] 90-1032
 CIP

Macmillan books are available at special discounts for bulk purchases for
sales promotions, premiums, fund-raising, or educational use.
For details, contact:

Special Sales Director
Macmillan Publishing Company
866 Third Avenue
New York, NY 10022

10 9 8 7 6 5 4 3 2 1

Printed in the United States of America

For Jo and Emily

What is it that the modern soul does, in truth, dread infinitely, and contemplate with entire despair? What *is* hell? With hesitation, with astonishment, I pronounce it to be the terror of 'Not succeeding'. THOMAS CARLYLE

Everyone steals in industry and commerce. I've stolen a lot myself. The thing is to know how to steal. THOMAS EDISON

CONTENTS

Part Four

Part Five

Part Six

LIST OF ILLUSTRATIONS

Between pages 114 and 115

ACKNOWLEDGEMENTS

I am especially grateful to: William Le Prince Huettel, for trusting me to tell the right story; Julia Le Prince Graves, for her direct line to Lizzie; Alice Le Prince Huettel, for her memories; Chick Le Prince Huettel, for his probing and doubting; Lester Le Prince Graves, for his enthusiasm; Janet Huettel, Barbara Graves, Kathy Huettel and all the Le Prince and Graves great-great-grandchildren, for their generosity. Also, Theodore Chevignard and François Auzel, for their help from the French end.

Many thanks also to: Steve Trafford, for hours of joint speculation; Peter Sainsbury, for making the early running; Jeremy Isaacs, for coaxing it off the back burner; Sophie Balhetchet and Glen Wilhide, for helping it into life; Walter Donaghue, for encouraging me to tell it my way; Alan Fountain and Rod Stoneman, for enabling the film version to happen; Alex Ehrmann, for making that call; Imogen Parker, for trusting my act and for her sustained creative support; Henry Dunow, for believing in my energy; Mike Fishwick, for grasping it before it was written; Alex Howell, for her acute eye.

Thank you: Peter Kelly and Leeds Industrial Museum; Leeds Reference Library; Leeds City Archive; the Science Museum, London; Muriel Atkinson and Audrey Caton.

I am grateful for the openness of: the Federal Archive, Bayonne, New Jersey; the New York Public Library; the New York Historical Society; the Film Department of the Museum of Modern Art, New York; the Jumel Mansion; the Library of Congress, Washington DC; the US Patent Office; the Edison National Historic Site, West Orange, New Jersey.

And thank you, Betty Rawlence, for your painter's eye; Anthony Rawlence, for bequeathing your love of engines; and Marsha Rowe, who sustained me through all the ups and downs and helped bring this story back to life, always believing in it.

Part One

LONG-DISTANCE INFORMATION

He left Dijon for Paris on Tuesday 16th September, 1890. He missed the morning train. After an early lunch Albert accompanied him in a cab to the station. They arrived early to be on the safe side. Albert waited to see him off on the 2.42 p.m.

They chatted warmly to each other on the platform. They had managed to discuss the will over lunch. To Le Prince's relief it had all seemed very straightforward. Albert assured him that he would receive his share of the inheritance within months. Neither he nor Le Prince noticed the man in the brown coat watching them from the opposite platform.

At 2.39 p.m. the train drew into the station. As the locomotive clanked past, the two brothers were momentarily enveloped in steam.

They embraced each other warmly. Le Prince climbed on to the train. He was carrying a single black valise. When he reached his compartment he leant out of the window to exchange a few last precious words. Albert wished him luck with the machines. A shrill whistle sounded. Le Prince promised to send Lizzie and the children Albert's love. The train began to move. Albert waved back as his brother receded.

Le Prince took his seat. He was alone in the compartment. There was work to be done. He opened the black valise on his knees and took out several papers. The next morning he was due to discuss important matters with his patent agents. His stereoscopic viewing device was still not patented, and he was anxious that the British patent specifications on his single-lens moving-picture camera were not yet detailed enough. This left both machines dangerously exposed to piracy.

As he toyed with a rewording the compartment door opened. A man wanted to know if he could take a seat. He wore a brown coat. Le Prince smiled assent.*

I first came across Augustin Le Prince in the spring of 1976 when I was planning to buy a house with a group of friends in the Chapeltown area of north Leeds. A large terraced house, it had been solidly built a century before in the purplish red brick that was local to the area. It stood on an

avenue which had once housed proud shopkeepers and self-made entrepreneurs who could afford a servant or two.

Times had changed. The area was now in decline, part of the city's red light district. Many of the neighbouring houses were owned by the city council and were in dire need of repair. Gutters hung loose. Broken windows swung open. Damp crept up the walls. In winter the area was a desert of old prams, tyres caught in trees, the dumped rubbish bags of local restaurants ripped open by roaming packs of dogs. In summer it was like a wood. As the houses disintegrated, nature reclaimed the huge gardens and derelict spaces. Sycamores and poplars soared unpruned. Elder and bindweed choked the open space. To the visitor it looked beautiful. The local inhabitants knew better. They lived in the shadow of the Yorkshire Ripper who had made Chapeltown one of his killing grounds. Several bodies had been found in the immediate vicinity. He had not yet been caught, which was the main reason why Tom, the present owner of the house, wanted to sell it.

Another reason was that the city council had plans to demolish it, along with a number of others on the street. Tom had somehow forgotten to tell us this. When confronted with the fact he mumbled something vague about its not being definite, that they'd have to get the owner's permission, and besides, it wouldn't happen for a good ten years. Then he said rather more clearly, 'Anyway they can't knock it down because the inventor of the movies once lived here.'

We were sitting in Tom's kitchen, surrounded by the bell boxes, stained-glass and cast-iron central heating of this beautiful old Victorian house. I said, 'Ha ha, a likely story!'

He repeated himself, a little irritated by my cynicism, then added, 'They should put a blue plaque on the house, then it'd be protected as a place of historic interest.'

The next thing I knew he was beckoning me to the front door. Pointing down the full length of the hall, through an open door to the dining room beyond, he said, 'I think he needed the unbroken distance for his film shows.' It was about sixty feet from where I stood to a bay window that overlooked the back garden. 'That's why he had the house built like this,' he continued, 'so that he could place his projector here by the door and the screen in the bay through there.'

I did not dare contradict him, but it was clearly all nonsense because the projector beam would have hit the door jamb.

'It was the distance he needed to focus his lenses. All the other houses have obstructions,' said Tom, reading my doubts. I felt embarrassed by his insistence. The whole yarn was so skimpy. So I mumbled that I wanted to take a look at the garden and sauntered away. But he

intercepted me by thrusting the land deeds of the house under my nose. 'If you still don't believe me, look at this.' He pointed to a neat copperplate signature at the bottom of the old document. I read the name L. A. A. Le Prince.

I wasn't convinced by Tom's story, still less by his claims that it would prevent the council knocking the house down. But we bought it anyway and moved in. Life went on. I forgot all about Le Prince and became immersed in reclaiming the garden. For three years I spent long summer evenings double digging the soil, extracting vast dandelion roots, old beer bottles, broken clay pipes and shards of blue and white pottery from a long-gone epoch, testing the pH and charting my slow reduction of the grimy precipitate of Leeds' industrial heyday until I was happy to eat the lettuce, beans and radishes I planted there. I even had the slugs under control. Then the threat of demolition became a reality.

We sat round the kitchen table in silence, wondering what to do. I was devastated. All that work on the garden. Then I remembered Le Prince. 'If I made a film about him,' I suggested, half joking, 'then we'd get all the publicity we needed and save the house.'

Next day I decided to follow my hunch. Down at the city reference library I found the relevant card index and fingered my way through the LEs. I made a strike early – four Le Prince cards, all of them referring to articles or booklets written in the 1920s by E. K. Scott, an electrical engineer.

I filled in the forms and sat down to wait. Next to me a man with an old coat and a sniff was reading all the newspapers at once. My books were not long in coming. I opened the largest one first. It was a carbon copy of a manuscript, about thirty pages long. Ignoring the snorts to my right I started reading.

I first became aware of the work of Augustin Le Prince in 1888 and 1889 when I had to see him about a focussing lamp to attach to a projector for moving pictures. He had a workshop at 160 Woodhouse Lane, Leeds, where he was assisted by his son Adolphe, J. W. Longley, a clever mechanic who I had met previously, and Frederick Mason, who made the woodwork for the machines and patterns.

They were all very enthusiastic about the possibilities of moving pictures and naturally I became interested by having to see about the lamp. By leaving Leeds at the end of 1889 the matter passed out of my head until about ten years later when I saw a demonstration of moving pictures of short plays in the Edison Laboratories at Orange, New Jersey, and recognised that the dreams of Le Prince

and other pioneers were coming true and a wonderful industry was being built up.

In 1919 there was a correspondence in the *New York Tribune* regarding the invention of Kinematography and Le Prince's name was mentioned, and through this I was able to meet Mrs Le Prince and learnt that owing to her husband's death in 1890 she had not benefited by his pioneering work. She seemed anxious that credit should be given for his work in early Kinematography, and as the son Adolphe and the mechanic, J. W. Longley, are also dead and few living who actually saw his apparatus, I have felt it a sort of duty to put the following on record.

I read on. According to Scott, a Frenchman called Louis Aimé Augustin Le Prince had invented a single-lens moving-picture camera and projector in Leeds in the late 1880s. By 1890 he was ready to embark for New York where his family had been busily preparing a venue for the world's first public showing of moving pictures. Then came the twist. Before setting sail Le Prince made a brief trip to France to clear up some family business with his brother, Albert, who lived in Dijon. On 16th September, 1890, he was seen on to the Paris train at Dijon station by Albert. His plan was to meet up with friends in Paris and return with them to Leeds to collect his apparatus before continuing via Liverpool to New York. But Le Prince never arrived in Paris. He was never seen again. Detectives from three countries were employed to search for him, but no trace was ever found.

Scott's conclusion gave the story all the ingredients of a thriller: 'The entire disappearance of Le Prince's luggage and business papers helped in suggesting foul play and his widow always thought that he had been removed through the agency of persons who wished to get control of the moving picture situation.'

I was hooked. Here I was, living in a house where a pioneering inventor of the movie camera had once lived. He had mysteriously vanished from a train in France. Kidnapping and perhaps murder were suspected in a disappearance that had never been solved. It was the perfect enigma. And an irresistible challenge.

Which is how I became a detective. It was now 1980. I had very little to go on. All that was known about Le Prince seemed to be contained in Scott's slim booklets. Ill-equipped, I set out to explore trails which had long since gone cold. Instead of digging the garden, I now spent my days rooting in libraries and archives. Little by little a picture of the man I was searching for began to form from the shards of his life that I unearthed.

Two years went by. I worked hard at two drafts of a film script about Le Prince with Steve, my collaborator. But there were still gaping holes

in the story. Month after month we would pace Le Prince's old haunts, the ridges and gunnels of north Leeds, the cobbled yards and warehouses of the city centre, worrying away at the unanswered questions. Exactly what had he achieved in Leeds? How and why did he vanish at the apparent moment of his success? When no documentary evidence was forthcoming we filled in the empty spaces with our imagination, fantasizing about a world of industrial espionage and bodies thrown from trains.

Our knowledge of Le Prince himself was largely drawn from the testimony of one of his assistants, Frederick Mason, quoted by Scott. 'In many ways an extraordinary man, in addition to his inventive genius which was undoubtedly great. He stood six foot three or four inches in his stockings, well built in proportion, slow moving, most gentle and considerate. And though an inventor, of an extremely placid disposition which nothing could ruffle.'

Or again: 'He was very secretive and would tell us very little of his plans at first. He never gave me a whole plan to execute but brought his work in segments, to be done by me alone.'

And that was more or less it. In fact, my research threw up a great deal more about the Leeds environment in which Le Prince worked than about the man himself. I developed a good idea of the cultural circles he moved in. I found out about his father-in-law's brass foundry and that this engineering background provided Le Prince with inspiration and assistance in his experiments. Yet Le Prince himself eluded me.

For better or worse this first film script never became a film. I anaesthetized my obsession with the man, relegated him to a bottom drawer and busied myself with other things. Then in 1986 the possibility of making the film came up again. So I set out on the trail once more, but this time more thoroughly.

The Science Museum in London has two moving-picture cameras which are alleged to have been built by Le Prince. They were donated by his daughter, Marie Le Prince, in the 1930s. My earlier detective work had already led me to the files held on them, but they seemed to yield nothing new. It was a colleague's inspiration to return to the Science Museum and ask if, in some dusty corner, there weren't some files which I had overlooked. Her hunch was right. There were.

The new find consisted of the correspondence that had led to the donation of the cameras. The most recent document was a telegram from Memphis, Tennessee, dated 1953. It was from Le Prince's son Joseph, asking the museum's keeper of photography to show the cameras to his nephew, William Le Prince Huettel, who was on a visit to London.

For many years I had hoped that there might be surviving material on
Le Prince somewhere in the United States, a residue of communication
with his wife and children in New York. I had even gone as far as locat-
ing every Le Prince in the phone books of virtually every city of the
Union, to each of whom I had sent a duplicate letter with a list of ques-
tions. No one had replied.

But with the new Memphis lead, there now seemed an outside chance
of making a contact. So my colleague called Information in Memphis to
find out if there was a William Huettel still living in the city. There was.
She was given a number and dialled it.*

Billy Huettel answered through the crackle in a broad Southern
drawl. 'Why yes, as a matter of fact we do have material on my great-
grandfather. My brother and I have been trying to draw up our family
tree. Only last month we were searching through some old trunks in my
mother's attic to try and get the lineage right and we stumbled on an
unpublished book by Le Prince's widow, Lizzie. It's called *The Life Story
of Augustin Le Prince, Inventor of Moving Pictures*. There's 160 typed
pages of it. It looks unfinished.'

I didn't waste time. It was the kind of break historians dream of. I
caught the first plane out.

It was a hiccuping landing. The wheels were six feet off the tarmac when
the captain spotted a stray 727 taxiing across the runway. He must have
pushed the engine thrust levers forward very hard, because we started
climbing again with a roar and a shudder. I thought for one moment
that I'd never solve the mystery.

Billy had said he'd be holding a photograph of Le Prince against his
chest. I spotted him easily. We approached each other like spies and
shook hands. His brother Chick was there with him. The jokes started
almost immediately. Billy wanted to know if I would write a scene for
him and Jacqueline Bisset. I demurred. Chick preferred Debra Winger.

We cruised away from the airport in a large station wagon along the
banks of the Mississippi. Enormous slow-motion eddies confounded
the brown flow of the great river. Nothing was simple. Billy told a story.

'I had a phone call last week from a man who spoke in a thick French
accent. He told me that his great-grandfather had been a peasant farmer
in France. His land had been alongside the Dijon to Paris railroad track.
Apparently, one day late in 1890 he found the dead body of a gentleman
hidden near the bottom of the railway embankment. He didn't dare tell
the police in case they suspected him of murder. Instead, he buried the
body and told no one but his wife.'

I laughed nervously. Chick guffawed. The strange thing was that

apart from the outrageous coincidence of such a call coming nearly one hundred years after the event, it seemed quite a likely solution. Billy continued, 'The guy on the phone gave me the Memphis number of friends where he was staying. I called him back later. The line was dead.'

Next morning I met the whole family at a Southern-style breakfast where I was the guest of honour. We sat round a huge table eating ham and grits off pewter plates. Billy introduced me as Sir Christopher, toasting me with orange juice in cut glass. 'God Save the Queen,' he proclaimed in a mock English accent. Then he leant over and whispered in my ear, 'The call was a hoax, by the way. One of my friends.' Chick was watching for my reaction. He fell apart when he saw my face drop.

Among those at the table were Le Prince's grandchildren, Billy's mother and aunt, Alice Le Prince Huettel and Julie Le Prince Graves. Both women were in their eighties, born twenty years after his disappearance, but they remembered his widow, Grandmother Lizzie, very clearly. As girls they had spent their vacations with her at the summer home on Fire Island. When later they'd become students at Columbia University they'd lived with her and her daughter, Aunty Marie, in an apartment in Washington Heights. It was Julie who had kept Lizzie's unfinished memoirs, passed on to her by her father, Le Prince's son Joseph, when he died.

After breakfast I walked the few hundred yards to Julie's home where she lived with her son and his wife. She let me into the living room through the mosquito door. It was large, made dark by the stained-wood panelling that covered the walls. She sat down at a table in the centre of the room and took Lizzie's memoirs from an old leather suitcase. I spent the whole morning immersed in those badly typed pages. It was a mesmerizing read.

'Looking backward on the rapid adoption of my husband's invention of moving pictures,' the memoirs began, 'and forward to its increasing utility as an educational factor and financial interest, I feel it is due to his memory and to the sacrifice and loss his family sustained, to put on record a true and attested account of the first moving picture machines.'

I spent nearly a week in Memphis on this first visit. The memoirs turned out to be only part of the seam I had struck. As the days went by new treasures kept emerging. Julie's suitcase contained many photographs of Le Prince and his family. On the walls of her home were a number of paintings, some by Lizzie, others by Le Prince himself.

What came through so strongly in all this material was Lizzie Le Prince's determination to tell the world the truth about her husband's achievement. Yet the tragedy of his disappearance was compounded by the tragedy that she never quite succeeded in getting the world to listen

to her. At the bottom of Julie's leather suitcase I found a photograph of Lizzie taken in 1926. She was sitting in a wheelchair on a Memphis veranda, dying slowly of cancer. Her sad expression showed a pained acceptance of defeat. Her condition, which had rendered her speech-less, seemed a cruel embodiment of the thirty-six years she had spent struggling to tell her story. [Plate I]

Behind the family wit and their thrill at my interest in Le Prince, I felt the reach of Lizzie's bereavement. Julie and Alice had experienced Lizzie's grief at first hand. Le Prince's absence seemed even to touch Chick and Billy, who as boys had known three of the Le Prince children. It was as if all the pent-up feeling of the past tragedy had transmitted itself down the years through the emotional fabric of the family, diluted but never quite dissolved.

Lizzie's living shadow combined with the detailed knowledge of her that I was drawing from the memoirs to make her a very real presence for me. The encounter gave me mixed feelings. I felt like an intruder, trespassing in the intimacy of her notes, letters and family photographs, demanding a relationship which she was powerless to reject. But these twinges of guilt paled beside the exhilaration I felt as an historian, that special thrill when the unearthing of new material confers unexpected emotional substance on characters who had previously been little more than distillations of fantasy and scant detail.

Yet, even as Le Prince began to stir within the lines of Lizzie's text and the dust of her *memorabilia*, I had doubts. In my rush to embrace him I wondered whom I would meet. I felt weighed down with the emotional baggage of years of searching. I feared that in all this time the Le Prince I sought had become blurred with the absent figures of my own inner landscape. Perhaps the soft-focus image of the missing inventor which I had carried so close to my heart had more in common with me and my own absent father than the Frenchman with mutton-chop side whiskers who stared at me so solemnly across the century. So I hesitated, and then approached him more slowly.

One photograph of Le Prince struck me particularly. [Plate II] It was taken in a garden in Leeds a few months before his disappearance. He was standing in front of a rhododendron hedge in a work-crumpled suit. He was as tall as I'd been led to believe. A cigarette burned between his fingers. He seemed tense, tired, almost broken. Yet behind his stern fatigue I thought I glimpsed kindness and compassion. I circled him warily, marking out where I ended and he began. It was a reunion of strangers.

This was the last photograph taken of Le Prince. I found myself pic-turing what this final image of the man she still loved might have meant

to Lizzie. It seemed saturated with grief. But it was a grief laced with a strong dose of anger.

Lizzie's anger was directed against those she believed had murdered her husband, stolen his invention, and given credence to a false history of the origins of the cinema. Her statement that Le Prince was 'removed through the agency of persons who wished to get control of the moving picture situation' turned out to be directed against none other than Thomas A. Edison. Although she never alleged his complicity directly, her version of events unmistakably linked Le Prince's disappearance in 1890 with Edison's subsequent claims to have invented the motion-picture camera.

To question the achievements of Edison in the early years of this century was little short of blasphemy. To compound this disrespect with the inference that he was involved in murder verged on madness. Yet this was the clear tenor of Lizzie's writing.

The tacit presence of Edison as the villain of the piece was as strong in the memoirs as the tangible absence of Le Prince. Lizzie had confronted me with a new character. I felt as if she were challenging me from the grave to explore her veiled allegations, making it impossible for me to embark on telling the Le Prince story without embarking on an Edison story as well. So my search became a double whodunit. Who invented the movies? Who killed Le Prince?

The history of the invention of the movies is a jungle of contending versions of who was the true inventor. As with most inventions, the true history – if such a concept is possible – is one of many men struggling to realize the same dream of moving pictures on both sides of the Atlantic between 1880 and 1900. Here is a new version. It interweaves Lizzie's story with mine. It braids the strands of her unfinished memoirs with the many other threads of testimony and fresh evidence I have dug up through the years in Leeds, London and New York. It treads a few new pathways through the history of moving pictures. Many others exist. The strong desire is to assert one version of the truth: Le Prince was *the* inventor of the movie camera. The challenge is to resist collapsing complex realities into a single pathway of historical certainty.

But as for who killed Le Prince . . .

LEEDS, 1930

He left Dijon for Paris on Tuesday 16th September, 1890. He missed the morning train. After an early lunch Albert accompanied him in a cab to the station. They arrived early to be on the safe side. Albert waited to see him off on the 2.42 p.m.

They chatted warmly to each other on the platform. They had managed to discuss the will over lunch. To Le Prince's relief it had all seemed very straightforward. Albert assured him that he would receive his share of the inheritance within months.

At 2.39 p.m. the train drew into the station. As the locomotive clanked past, the two men were momentarily enveloped in steam.

They embraced each other warmly. A shrill whistle sounded. Le Prince climbed aboard. He was carrying a single black valise. As the train pulled out of the station he leant out of the carriage window and waved. He was travelling first class. Albert waved back as his brother receded.

Le Prince took his seat. He was alone in the compartment. There was work to be done. He opened the black valise on his knees and took out several papers. A few months earlier the secretary of the Paris Opéra had witnessed the working of one of his projectors for the purposes of authorizing his French patent. At the time, mention had been made of Le Prince taking moving pictures of an operatic production. Naturally, he was keen to secure this arrangement.*

As he started writing he noticed a slight numbness in the fingers of his right hand. It was an unusual sensation. He shook his hand vigorously, trying to bring it back to life.

I was looking for Number 160. I wanted to stand in the space in which Le Prince had carried out the final and apparently successful trials of his projector. I could think of no better way of sharpening my picture of his last months than by surrounding myself with the bricks and mortar of his workshop.

It was a bleak part of town. The stained geometry of sixties office blocks dominated the skyline. I wandered through vandalized shopping centres. Graffiti shouted from the walls – MUFC DIE TONIGHT; KILL THE RIPPER.

I walked on up Woodhouse Lane, crossing over the ring road. A drab roar of traffic welled up, anchoring my fantasies in the present. I shut it all out, and kept my eyes on the vast Yorkshire flagstones of the pavement. They had weathered the years well. A century of sulphurous rain had eroded shallow depressions in their surfaces which now held small puddles of water. I splashed through them, made footprints on the dry bits, and thought of Le Prince walking the same slabs. A hole in the tarmac caught my eye, worn away by the combined action of tyres and frost. Several cobblestones glistened through, their fabric intact. The past pressed in insistently. The Leeds that I sought lay just beneath the skin of this desolate place. I drifted away, wishing I could have slipped back into Le Prince's laboratory through some tear in the fabric of time.

I passed a shell of soot-blackened masonry. The little that remained of nineteenth-century Leeds was being swallowed by the sprawl of university development. Across the road, cramped terraces were being collapsed into their basements by the steel ball of the demolition men. Above, a fireplace gazed at empty space. It was surrounded by grimy pink wallpaper. A paler rectangle suggested where a picture had once hung. The ripped floral wallpaper sagged in damp tatters where the corners of the room had once been. I looked away from its intimacy. It seemed such a callous exposure.

Number 160 wasn't there any more. In its place stood the television studios of BBC North, built in 1964. The BBC coat of arms hung above the door. The motto read: 'Nation Shall Speak Unto Nation'.

The janitor intercepted me. I told him I was searching for the workshop of an inventor called Le Prince. He pointed to a plaque set halfway up the wall.

LOUIS AIMÉ AUGUSTIN LE PRINCE HAD A WORKSHOP ON THIS SITE, WHERE HE MADE A ONE LENS CAMERA AND WITH IT PHOTOGRAPHED ANIMATED PICTURES. SOME WERE TAKEN AT LEEDS BRIDGE IN 1888. ALSO HE MADE A PROJECTING MACHINE AND THUS INITIATED THE ART OF KINEMATOGRAPHY. HE WAS ASSISTED BY HIS SON AND BY JOSEPH WHITLEY; JAMES WILLIAM LONGLEY AND FREDERICK MASON OF LEEDS.

The supporting evidence was on the opposite wall. Sixteen blown-up square images of a view down on to Leeds Bridge were arranged in four columns of four. In each consecutive frame, a horse and cart nudged further past a lamp post. A man was leaning over the parapet of the bridge, smoking a pipe. It looked like what 1888 ought to have looked like. The clothes had the right feel, give or take a year. I was looking at

what were alleged to be blow-ups from the world's first strip of moving-picture film.

I stood in the foyer for a while and tried to rebuild the walls of Le Prince's workshop around me. It was a hopeless endeavour. Eager production assistants clutching vital cans of film kept intersecting my reverie. 'Seen enough, sir?' the janitor hinted. I gave up and headed for the reference library.

The microfilm reading room was full of people winding little plastic handles, in search of their origins. Leeds censuses rushed by on the dim screens to each side of me. Occasionally some distant aunt was located and someone pencilled in another branch of a growing family tree. Outside, the town-hall clock loomed large through dirty windows, tolling the halves and the hours. I wound my handle, wrestling with eyestrain and a stiff neck.

I was reading the *Leeds Mercury*, looking for a report on the unveiling of the plaque. Headlines flashed by as I coasted up through the last months of 1930. I passed Martial Law in Cuba, Revolt in Spain, and Much Progress on Slum Clearance. When I reached December my hand slowed. The first week drifted past. Unemployment was a problem. Sinks were best cleaned with Vim. I entered the second week more slowly, scanning column after column. Then suddenly, on the twelfth, there it was: LEEDS HONOURS VANISHED INVENTOR. Beneath it was a photograph of a group of dignitaries sitting behind a long trestle table set up on a platform.* One man wore a chain of office over his heavy winter coat. They were listening to a woman of about sixty who was speaking into a primitive microphone placed on the table in front of her. The caption named her as Miss Marie Le Prince. A large box-like camera stood on a hefty wooden tripod in front of her. I recognized it as Le Prince's. Set into the wall behind her was the same plaque I had seen at the BBC studios.

It was a gusty day. A Union Jack hung against the plaque. It was grubbier than it should have been. The official town-hall flag had gone missing. Only a last-minute offer of a flag from the pub across the road had prevented an embarrassment. Mr E. K. Scott, whose slim volume on Le Prince I stumbled on fifty years later, had supervised all the arrangements. For the past few days workmen had been scrambling up and down ladders, setting the plaque into the brickwork of what was now a small car-repair shop. With much sawing and banging, a wooden platform had been built. Now everything was ready. None too soon, because a crowd had started forming and the VIPs were expected. The French ambassador was sending a representative. Members of the

Society of Motion Picture Engineers were coming all the way from California. There was to be a contingent from the Royal Photographic Society. The Lord Mayor of Leeds had agreed to unveil the plaque. Frederick Mason, Le Prince's only surviving assistant, had promised to give his recollections. And to crown the proceedings, the inventor's daughter, Marie, had brought her father's cameras from New York. Leeds was in for a big day.

Opposite the platform two newsreel crews were competing for the best vantage point. The Gaumont-Pathé men had decided that the event warranted sound in spite of the practical difficulties. This had meant laying yards of thick cable which disappeared into a van that was parked round the corner, where a clutch of harassed sound recordists in Bakelite earphones contended with unpredictable technology and the wind as it scuffed at the microphone.

Marie Le Prince was sitting on the platform surrounded by people in top hats and furs. The Lord Mayor was standing close by her, halfway through his speech. Her turn was next. She had waited forty years for this day. Her one wish was that her mother could have lived long enough to have been there. Most of her adult life had been lived in the shadow of her father's disappearance and her mother's bitter struggle to tell the world the truth. For decades she had shouldered the burden of Lizzie's grief and anger at a cynical and uninterested world. Now the moment had come to set the record straight.

'I doubt whether many people realize,' the Lord Mayor was saying, 'what Le Prince did for the world in creating an enormous amount of employment. We have only to think of Hollywood and other centres where they make films to bring this fact home.' Marie was puzzled by these remarks. Moving pictures had not brought much prosperity to Leeds. From the little she'd seen of the place since arriving the day before, it was no longer the thriving industrial city she'd known as a girl. It felt worn out. The streets showed signs of the Depression.

Was she being too harsh on him? Why shouldn't he be permitted to make a little political capital out of the event? He was a Liberal, after all, and that was where her sympathies lay. The Lord Mayor continued, pointing at the flag-draped plaque. 'I hope that this tablet will be an inspiration to the young people of this city. Because the fact is . . .' He stopped abruptly.

One of the newsreel men making sweeping gestures from the back? Had something gone wrong? The man spoke up. 'I'm sorry, ladies and gents, but we can't see the plaque. If all the speakers could move up to the far end of the platform, then we'll get all of you into the picture with the plaque.' A brief hiatus followed. The speakers regrouped. The

microphone was moved and cameras were realigned. Another signal was given.

'The fact is,' said the Lord Mayor, picking up from where he'd left off, 'we can never know what urchin in the street will turn out to be some great benefactor or pioneer for civilization.' With these unfitting words he pulled the cord, the flag fell, and the audience applauded. Then it was Marie's turn.

'I come,' she began, 'as a witness from America that my father . . .' She stopped. It was the moving-picture man again. What was it now?

She craned forward to make out what he was saying. 'Will you point out your father's camera?' he shouted against the wind. 'And will you please hold up the celluloid so that we can see it?' He retreated behind the camera, which started to whirr.

'Shoot, Jack!' came a voice from the van round the corner.

Marie began again. Her American accent was tinged with the inflexions of her Yorkshire childhood. 'I come as a witness from America that my father *did* make moving pictures in New York and Paris, and perfected them here in Leeds. This is his single-lens camera. And this is his film.' She tapped her father's camera. A four-foot-long tail of celluloid,* four inches wide, hung loose from a large spool on the table. She picked it up as instructed. 'My father included sound in his early experiments. He used one of the first Edison phonographs to provide music. I often heard him say that films would one day talk and have colour.' The wind gusted. A framed photograph of Le Prince which was propped up on the table in front of her blew over. Everyone held on to their hats.

'He also said that the film would change politics. And governments.' She smiled at the Lord Mayor. 'And he often spoke of the tremendous influence film must have in stimulating feeling between nations.'

An elderly man was sitting close to her, nodding occasional agreement. He had a small goatee beard and wore a straw hat. It was Frederick Mason, Le Prince's only surviving assistant. His presence lent weight to Marie's memories and spurred her on. 'I remember my father, when I was a very small child, always talking about this idea,' she continued. 'And when he went to New York he found some facilities for his work. My mother taught at a deaf-and-dumb school and he had a little room there fitted up for his experiments.

'One day, when I was about fourteen, I was sent over to call him for tea. It was a dark winter night.† As I was walking across to the school buildings I saw a ray of light coming from beneath the door. When I pushed the door open I saw some figures who appeared to be moving about on a whitewashed wall. I did not know what they were. My father asked me what I wanted and, before I knew what had happened, he had

shut the door on me. I obviously wasn't meant to be there, but I suppose that I was the first child ever to have seen a moving-picture film.'

Mason had heard that story before. It was typical of Mr Le Prince's secrecy. Sitting there listening to Marie brought it all back. The day when the tall gentleman with a French accent had walked into his father's timber yard, just a stone's throw from where he was sitting, looking for someone to carry out some very accurate woodwork for him. Mason had been nineteen at the time, still serving his apprenticeship. The job fell to him. It was 1887 and for the next two years he had worked exclusively for Mr Le Prince. Now, nearly half a century later, the result was standing on a heavy wooden tripod right in front of him. He'd recognized the single-lens camera as soon as they'd lifted it from the trunk which Miss Le Prince had brought with her from New York. The woodwork, the immaculate dovetail joints, the red glow of the Honduras mahogany cabinet which he'd brought out by careful French polishing – it was all his handiwork. He would vouch for it. Even the trunk was original. He remembered Mr Le Prince ordering it from Trinder the portmanteau-maker before his ill-fated journey to France.*

Marie's voice trickled into his thoughts. The audience sat, captivated. The newsreel camera was still whirring. 'My mother once said he felt he was watched during his experiments in Leeds.' She was pointing to the open doors of the garage where Le Prince had conducted his experiments all those years earlier. An enamel Firestone advertisement was nailed to the wall. A coiled air-line dangled from a hook. 'I understand that this workshop was entered and parts were taken away after his disappearance.'

It could have been yesterday. Mason recalled the high hopes and the tragedy. The worst thing had been never knowing quite what had happened. It had been bad enough for him. Quite a shock. But much worse for the family. If there'd just been a body, or a scandalous incident, or even a suicide note, then they could have grieved or been outraged and been done with the pain in one go. But the dreadful unfinished nature of the business, the futile years of searching and fighting for justice, seemed so cruel. Mind you, he had his opinions. When the newspapers talked to him, which they would later that day, he'd tell them what he thought. Why would a man kill himself when he had everything to gain from the invention? It couldn't have been an accident either, because his luggage never turned up. And certainly not a scandal. The man was too decent for that, and from everything he'd heard his married life was ideal. No. Clear as daylight, it was foul play. Someone got hold of his secrets, and killed him.

Mason looked up. The audience was applauding. Marie was beaming

at the camera. It seemed to him that a painfully long closing chapter was over at last. Leeds had honoured Le Prince.

His reflections were cut short by a nudge. Scott had stood up and was trying to persuade him to do the same. Now Scott had started to sing and was gesturing at everyone to join him. They soon cottoned on and a chorus of 'For She's A Jolly Good Fellow' rose above the Leeds streets. How embarrassing. But it was just the thing for the newsreel men.

LEEDS, 1889

A white sheet was hanging up at one end of the large workshop room. At the other end stood the machine, which, if it hadn't been for the lens, might have been mistaken for an automatic ticket machine. Three men were hunched over it. One was Jim Longley, Le Prince's mechanic, making last-minute adjustments to the mechanism. He was chatting to young Scott who was fitting the carbon rods of the arc lamp under the false impression that the machine was a sophisticated magic lantern. Longley soon put him right. The third man, Walter Gee, was checking the connections of a thick cable which snaked across the room to the projector. Like Scott, he worked for the electrical engineering firm which had supplied the arc lamp and generating equipment. The dynamo was installed in a timber yard, a few doors down the road. In the last few days Gee had supervised the laying of the cable over the intervening rooftops.*

In the background, noticeably quieter than the rest, Le Prince paced the room, chain-smoking cigarettes. His silence was part of his calm nature, unusual in an inventor. But the thick mutton-chop whiskers that camouflaged his face couldn't disguise the fact that he was also exhausted and tense. The morning had been thundery and humid, putting everyone on edge. The storm broke at midday but did little to relieve Le Prince's anxiety. In a few hours they would be putting the single-lens projector through its final tests. The build-up to this moment had been long and difficult, full of mechanical setbacks. What had made matters worse was that the strain had affected his health, laying him up with flu just when the machine required most of his time.

He was checking the shutters on the windows. They had two purposes: to keep light out, and to prevent people looking in. Le Prince was very security-conscious. For some time now he had had the feeling that the workshop was being watched. He had even had extra bolts fitted to guard against break-ins.

His sensitivity about being spied on had become something of a joke among his assistants. But his precautions were wise. He had not yet applied for a patent on the machine that was about to be tested, which left him vulnerable to industrial espionage. This was no oversight. The

British Patent Office published patent specifications. Premature appli-
cations risked the public exposure of half-formed technical ideas to
unscrupulous men who, familiar with the loopholes of patent law, were
only too eager to steal and exploit others' work.

Le Prince's precautions against the theft of his ideas meant that he
had confided his evolving invention only to those he trusted. As the
long summer evening surrendered to darkness on that night in July
1889, three men stayed behind in the workshop to witness the grand
switching-on. They were Le Prince himself; Walter Gee, the electrician;
and Jim Longley, the mechanic, who was indispensable to the work,
although he had recently rattled Le Prince by thoughtlessly jabbering to
his friends about what he was doing. No one else was present. Scott had
gone home. Young Fred Mason was tending the dynamo in the timber
yard down the road.

Mason would have loved to have been in on the showing. It was dark
and he was waiting for the signal from Mr Le Prince. He checked the
tension of the drive belts and tried to cheer himself up. Although still an
apprentice, he had been assisting Mr Le Prince for two years now, build-
ing the wooden cabinets for his cameras and mounting literally hun-
dreds of glass slides in identical wooden frames. He hadn't known what
he had been making at first. But then Mr Le Prince had come to trust
him and put him in the picture. Moving pictures. After that revelation,
Le Prince's secrecy made sense. From chats with Longley and his father
it became clear that Le Prince stood to make a fortune from his inven-
tion. And he, Mason, was part of the team.*

Feeling better, he put a shovelful of coke into the small firebox of the
boiler, and tapped the gauge. The pressure was rising fast, causing the
safety valve to release a burst of steam. A bell rang. It was Mr Le Prince
calling down from the workshop. He was ready.

Le Prince's worries about spies were well founded. When he had arrived
back in Leeds from New York two years earlier he had already been
working on his moving-picture idea for two years. His return had been
prompted by an inexplicable delay in the granting of a patent on his first
machine by the US Patent Office.† For several months he had waited as
the patent examiner rejected clause after clause of his application,
claiming that the idea had been anticipated by other inventors years
before. At first Le Prince had thought that such a radical idea was simply
not being grasped. But as more and more correspondence shuttled back
and forth, querying one part of the claim, rejecting another, he had
become suspicious. Deliberate obstruction was a common occurrence
in these circles. Every inventor knew of cases where the Patent Office

had been bribed to divulge secrets or where patent lawyers had been in the pay of other inventors to pass on information. Le Prince was not naïve in these matters. Years earlier, as a partner in his father-in-law's brass foundry in Leeds, the business of patents and invention had been his daily concern. He was familiar with the small print of contracts which laid down the conditions for the manufacture of patented inventions under licence. He knew from experience that patent law existed to regulate the ruthless cut and thrust that surrounded profitable and innovative ideas. He was well aware of the grey areas in this legal labyrinth which left the inventor vulnerable to those who wanted to manipulate or bypass the law.

It was his father-in-law, Joseph Whitley, who had finally persuaded Le Prince not to wait any longer for his US patent to come through. Whitley had made him an offer which he found hard to refuse – the use of the craftsmen and tools of his Leeds foundry for the development of his moving-picture machines. Whitley Partners had been producing valves, pipes and governors for the Leeds steam locomotive industry for nearly forty years. Le Prince himself had supervised the valve department when he first came to Leeds from France in 1869. He had become immersed in a technology of brass moving parts, surrounded by a know-how which, fifteen years later, would prove to be well suited to solving the problems of motion-picture technology.*

Whitley's offer had come with a warning not to talk too much about the new invention.† Le Prince needed little persuasion. He had been glad of the chance to get away from New York's prying eyes and develop his moving-picture idea in the relative secrecy of Leeds.

Le Prince left New York for Leeds in April 1887. His eldest son Adolphe joined him a few weeks later as his assistant. Lizzie had stayed behind in New York with their other four children. It had been a difficult separation. His comings and goings made her miserable. To make up for his absence, they had agreed that she would join him in Leeds for the summer. It was just as well. Initially Le Prince had assumed that his work on the moving-picture machines would take only a few months to complete, a year at most. At first it had seemed that way. Development of the cameras, though complex, had gone relatively smoothly. But the projector had been quite a different matter. Imperceptibly the promised one year had become two, and Lizzie had joined Le Prince and Adolphe at her father's home in Leeds for a second summer in 1888. When the time came for her to return to New York in early September, Le Prince was still absorbed by the work, with no immediate end in sight.

Throughout the first half of 1889 Le Prince wrestled with the

challenge of projection. His main problem was the absence of a suitable film. He knew exactly the properties of the material he was searching for, yet it eluded him. It had to have the transparency of glass magic-lantern slides, enabling a clear image to be projected over some distance. It had to withstand the considerable heat of the concentrated beams of the arc lamp. It had to be light enough to be stopped and started many times a second without shaking the apparatus to bits. And it had to be flexible enough to be rolled into reels. He had been on the lookout for such a material for three years, and had kept in constant touch with the major photographic suppliers in Europe and America.* So far no one had helped. Neither Swan & Fry nor Blair in England. Not even the Lumières Brothers' famed establishment in Lyons.

The reproduction of a photographic illusion of movement requires the moving-picture camera to take sequential photographs of the subject in motion at a rate of at least sixteen exposures per second. When the images are reproduced at or above this rate, the human visual cortex is unable to distinguish them individually. They become synthesized into an image of continuous motion through a phenomenon of human sight known as 'the persistence of vision'.†

The persistence of vision was known about long before Le Prince's time. From 1820 onwards, Roget, Plateau, Wheatstone and Faraday, among others, had observed what they thought to be the persistence of the retinal impression of an image beyond the initial light stimulus. They supposed that, when the human retina received changing images above a certain frequency, the incoming image was received before its predecessor had faded. The result was a blending of one image into another. A number of experiments accompanied these observations, resulting in popular optical toys like the thaumatrope and phenakistascope.

Latterly it has been suggested that 'persistence' and 'retention' of image have nothing to do with the phenomenon. What actually happens is that the retina is unable to distinguish between rapid fluctuations in brightness. In other words, if the pictures come fast enough we literally lose sight of the gaps between them, fusing the sequence into one.

It is one thing to understand, more or less, the optical principles behind moving pictures, but quite another to realize them photographically. First, photography itself had to be invented. This happened in the late 1830s. Next, three fundamental technical breakthroughs were required.

The first of these concerned the light-sensitive emulsion with which

films were coated. To capture a sharp image of an object in motion requires an exposure of at least 1/100 of a second. Thirty years after the advent of photography there was still no film material that could approach this speed. The early chemistry of this process – Wet Collodion – demanded exposure times of several seconds and sometimes minutes. People who had their portraits taken often had to have their heads supported by headclamps to prevent their tiniest movements from blurring the image.

The advent of the gelatine bromide process in 1871 changed all this. An English doctor called Maddox discovered that by mixing a solution of gelatine with cadmium bromide and silver nitrate, an emulsion of silver bromide was formed, suspended in the gelatine. The resulting 'film', when coated on glass plates or paper, was many more times sensitive to light than the Wet Collodion process it now displaced. By the late 1870s the gelatine dryplate, as it was called, made exposures of 1/1000 of a second a reality, revolutionizing the possibilities of still photography.

The invention of moving pictures required mechanical as well as chemical breakthroughs. The film had not only to be fast enough to record a sharp image of the subject in motion, but at rest at the moment of exposure and viewing. It was not a new problem. Earlier optical toys, like the phenakistascope and the zootrope, worked by viewing sequential images placed on the surfaces of continuously rotating drums or discs through slits. But the continuous movement of drum or disc led to blurring of the animated image. The French inventor, Reynaud, solved this in 1877, with his praxinoscope, introducing a prismatically mirrored revolving drum which enabled each sequential image to be perceived as a static reflection. The development of the moving-picture camera and projector a few years later called for a far more complex solution. Specifically, this involved the invention of a mechanical means for advancing and arresting the film *intermittently* across the focal plane of the lens, where it was exposed or projected at least sixteen times a second. For obvious reasons, this device became known as the intermittent mechanism.

Lastly, and this was the greatest hurdle of all, moving pictures required the development of a suitable film base – the material upon which the photosensitive emulsion was coated.

In 1885 the American film and camera manufacturer George Eastman went halfway towards solving this problem when he introduced his paper-roll film. It consisted of a paper base coated with a layer of soluble gelatine. On this was coated a layer of collodion followed by a layer of light-sensitive gelatine emulsion. After processing, the soluble gelatine layer was softened by soaking it in water, enabling the negative

image-bearing layer to be stripped from its paper base and mounted on glass or thicker gelatine backing sheets for printing.

The advent of Eastman's paper-stripping film enabled Le Prince to develop his first moving-picture cameras. Its availability in long rolls made it admirably suited to his first film-feed mechanisms, although it did tend to tear.

But Le Prince found Eastman's paper film unsuitable for projection, which requires a transparent film base. Attempts to wax-paper positive strips to give them the necessary translucency invariably failed. The results were not transparent enough and tended to catch fire in the concentrated rays of the projector lamp. To complicate matters, for the human visual cortex to register the projected image, the film has to be at rest before the lens for longer in the projector than in the camera. This not only exposes the film to even greater heat from the lamp, but also means that it must be advanced faster between images, to make up for lost time. Paper film could not withstand this kind of stress.

Unable to use paper for projection, and in the absence of what we now know as celluloid, Le Prince experimented with all kinds of other materials to back the thin gelatine positives that were the end result of the film-stripping process. It was a painstaking search.

Glass was ideally transparent, fine for still photography but too fragile. Its brittleness also meant that it could not be rolled. And it was too heavy. Even assuming a way could be found of advancing sequential glass images past a lens many times a second, the sheer inertia of glass required a projector that was robust enough to withstand the jarring of its incessant stops and starts.

Le Prince also tried mounting his gelatine positives on mica and horn, but neither of them could be rolled and neither proved sufficiently transparent. Thicker sheets of gelatine as a base for the thinner image-bearing gelatine strips seemed to offer a solution. But although gelatine could be rolled (not too tightly), the heat of the projector lamp caused it to buckle and blister, throwing the image out of focus.

In spite of the drawbacks, Le Prince opted for glass backing to the gelatine positives he ran in his single-lens projector on that night in Leeds, July 1889. It was a temporary decision. The harsh parameters of this weighty film base had dictated a projector design about which he had severe reservations.

The apparatus consisted of a continuous spiral belt wound round a vertical drum.* Hundreds of individually mounted glass positives were slotted into guides in the belt in the same sequence in which they had been exposed in the camera. By turning a crank, the belt moved towards the top of the drum. As the belt left the top of the drum, the positives fell

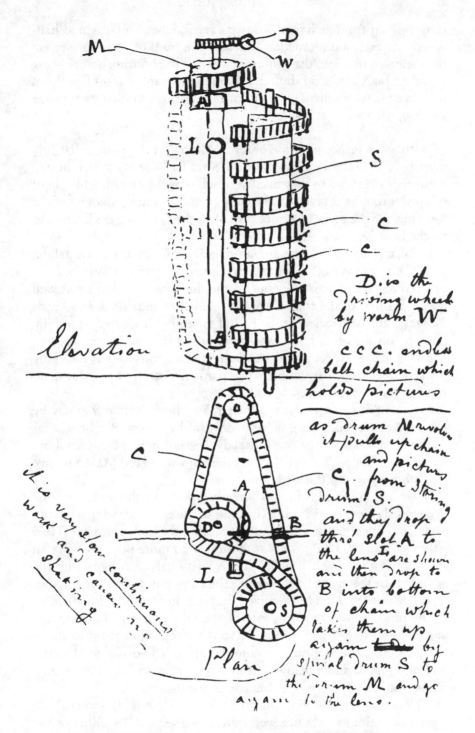

Drawing by Le Prince, sent to Lizzie, of the single lens projector

consecutively from their guides down a vertical metal tube, where, half-way down, each was momentarily arrested in front of a lens, projected, then released to rejoin the continuous belt at the bottom, before going round again. A revolving shutter, geared to the crank, cut off light from the screen between the movement of each positive, so that each image was projected while at rest.

As soon as Le Prince gave the order to Mason on the phone that July evening in 1889 the arc lamp came on. Scott had already tested the gap between the carbons so they needed no adjustment. Dazzling blue light escaped through the cracks in the lamp housing, casting shadows of the three men on the walls. Le Prince turned off the flickering gas lamps and reached for the crank.

It was a noisy affair. The arc lamp, gearing mechanism and falling glass positives gave off a spluttering clatter. Walter Gee watched the proceedings transfixed, oblivious to the din which could just as well have been that of the traffic that was somehow moving across Leeds Bridge on the white sheet at the end of the room. It was magic to him. Longley, on the other hand, was more proud than surprised. He had known what to expect and it was a great relief to him that the thing worked, since the construction of this particular machine was due in no small part to his resourcefulness.*

Even Le Prince came out of himself. For the first time that day he relaxed and started talking more openly to the others. But he was far from satisfied. The image was unsteady. It was dim and flickered more than he had hoped. To rectify it he called down to Fred Mason to give him more power for the arc lamp.

Down the road, Mason was already operating the steam engine dangerously close to its limits. The balls of the governor were whizzing round and opening the safety valve, relieving the boiler pressure. He'd either have to tell Le Prince that there was no more power, or risk an explosion by putting a weight on the safety valve, so bypassing the governor. In the event Le Prince got the extra power and the brighter image he wanted. Fred Mason lived. But it didn't get rid of the flicker.

The problem was the slow rate of the projector. Jim Longley had ingeniously fitted it with a counter so that they could tell how many images were projected each minute. Le Prince's knowledge of optics told him that at a rate below sixteen frames a second each individual frame would be perceived, giving rise to the flicker.

A glance at the counter confirmed his suspicions. It showed 426 frames per minute – about seven frames per second – well below the critical rate. Turning the crank faster made matters worse. The glass

positives simply jammed. The projector was already at its limits.

What seemed like a successful trial to the witnesses showed Le Prince only too clearly what he was up against. He lit a cigarette. He knew there could be no satisfactory solution to moving-picture projection until the right film material was located. There was worse. This mythical material would almost certainly necessitate a new projector design. It was time to go back to the drawing-board. Lizzie wouldn't like it at all. It meant delaying his return to New York yet again.

WEST ORANGE, 1889

In June 1889 a package was delivered to the Edison Laboratories at West Orange, New Jersey.* The label read: ONE DOZEN CARBUTTS FLEXIBLE NEGATIVE FILMS, A PERFECT SUBSTITUTE FOR GLASS. The package contained a number of sheets of thickish celluloid coated with a photographic emulsion. They were manufactured by John Carbutt, a well-known photographic materials supplier.

The delivery was not for Edison himself, but for a young Scottish assistant called William Dickson. For the past few months, when his demanding employer allowed him time away from his Promethean plan to extract low-grade iron ore from the New Jersey highlands, Dickson had been experimenting with moving pictures.

Although Edison himself had prompted Dickson's initiative, he was not particularly interested in the idea at this time. Moving pictures were just one of many evolving ideas that made up the broad front of work at West Orange, the most important of which for Edison was his great iron ore separation project.

But even iron ore took second place in the great inventor's mind that summer. For once in his life, he had put the hard graft of inventing to one side. Utterly exhausted by a string of turbulent events in his vast electrical empire, he had been persuaded by his wife, Mina, to take a vacation in Europe.

It was to be no ordinary trip. At the pinnacle of his career, the man the world understood to have invented the phonograph, the incandescent lamp, numerous improvements to the telegraph and the telephone, the man who was contemplating moving pictures, whose unique research and development laboratories and factories had attracted eager and talented assistants from all over America and Europe, whose extra-ordinary example in harnessing invention to commercial manufacture was laying the foundations for industrial America, Thomas A. Edison, the great tinkerer, the living embodiment of the Great American Dream, had been invited to the Exposition Universelle in Paris, where the centenary of the French Revolution was being celebrated in a vast homage to science and progress. [Plate III]

Dominating the countless pavilions which bristled with electrical and

mechanical inventions was the Edison Company's own exhibit. For several months a team of his men had been erecting a complete central lighting station to demonstrate what electricity could do for the dim gas-lit streets of the city. It covered one acre of the exhibition grounds. A tall tower festooned with 20,000 light bulbs rose above it, signalling the genius of the man who had allegedly invented them. Edison's other inventions were also showcased. Crowds flocked to see 'his' telegraph and 'his' telephone. Fifteen thousand people queued up daily to hear his phonograph, which was second only to the Eiffel Tower in its popularity.

Although exhausted, Edison was far from downhearted. As trunks were packed and itineraries arranged in preparation for the grand tour, he could reflect on a great victory. A grand consolidation of the sprawling Edison electrical empire had been achieved. The giant new set-up was called the Edison General Electric Company. His name was enshrined in the title. Indelibly secured, so it seemed, for posterity.

Edison rarely pursued his inventions unless he was convinced of their commercial viability. A decade earlier he had evolved his first carbon filament incandescent lamp. Within a few years this led to a comprehensive system of electricity distribution for New York. The potential of electric lighting and power generation had seemed enormous to him from the outset, but even a man of his considerable means had not been in the position to finance the massive investment which the manufacture of generators, motors, incandescent lamps, switching, cables and so on would require.

The Edison Electric Light Company was formed in 1878 by a syndicate of influential financiers who had risen with the fortunes of the railroads and telegraphy. The directors included Vanderbilt, J. P. Morgan's partner Fabbri, and Tracy Edson and James Banker of Western Union. Behind the scenes stood Morgan himself, America's most powerful banker.

These men had been impressed by Edison's electrical vision and were prepared to invest in it. In exchange they would control a holding company – Edison Electric Light – which would own all Edison's patents in the field and profit from their licensing worldwide.

Three subsidiary manufacturing companies developed under the wing of this parent holding company. The Edison Lamp Company produced incandescent lamps; the Edison Machine Works produced the generating equipment; and the Bergmann Company specialized in electrical appliances. Edison himself held substantial shares in all of these companies, but they were dependent for capital investment on the financiers who controlled the parent holding company.

And this was the problem. Bankers are naturally conservative. Invest-
ment in railroads and telegraphy – the communications infrastructure
of a rapidly growing continent – had seemed a safe proposition to these
men. It had made them all multi-millionaires. But the unpredictable
future of the electricity industry had suggested more caution. Weren't
gas and steam perfectly adequate? 'Pioneering don't pay,' said the steel
giant, Andrew Carnegie, meaning, 'Let others take the risk.' Fellow capi-
talists mostly agreed, with the result that the various Edison electrical
companies were critically undercapitalized during their vital periods of
growth through the early 1880s, and they could not meet demand.

Increasingly sharp competition from rival companies had com-
pounded these problems. In 1883 George Westinghouse had realized
that alternating-current engineering offered decisive advantages over
Edison's more limited direct-current system and had purchased the
American patent rights. Alternating current (AC) provided a vastly
more flexible system of power distribution, a fact that Edison took forty
years to acknowledge. In the meantime he sanctioned a series of ploys
designed to discredit AC. Throughout 1887, the stray cats and dogs of
West Orange were periodically roasted alive on metal plates wired up to
AC in demonstrations of its hazards to the press. This grisly propaganda
reached its climax in 1888 during the controversy over the use of AC for
the electric chair. A former Edison employee demonstrated the effec-
tiveness of the grisly new device by executing numerous dogs at public
gatherings in New York. 'To Westinghouse' was even proposed as a verb
to describe the new form of execution. In this 'war of the currents'
Edison used every opportunity to point out the low scruples of men
who planned to wire people's homes with this death-dealing current.

The first decade of Edison's commercial exploitation of electricity
also witnessed a string of lawsuits as he prosecuted and defended his
numerous patents in the electrical field. Many men had contested
Edison's claim to have been the first to invent the incandescent lamp.
The cost of defending these suits, chiefly against his main rivals
Westinghouse and Thomson-Houston, had been and continued to be
crippling.

In short, the incandescent lamp had brought Edison little but trouble.
By 1889, when the world perceived Edison as the Wizard of Menlo Park,
he himself felt that what was most precious to him – the process of
invention itself – was being denied him by financial anxiety, the
constant demands of his manufacturing companies, and the stresses
of consuming litigation.

It was therefore an immense relief to him when in the summer of
1889 a plan for the rationalization of the Edison companies came to

fruition. Masterminded by the financier Henry Villard, the manufacturing companies were amalgamated with the holding company, Edison Electric Light, to form the giant Edison General Electric Company. Overnight Edison realized nearly two million dollars. Morgan made even more. Edison was unperturbed. He had been relieved of a great burden, his name still dominated the new company, and for the first time in his life it provided him with sufficient capital to invest in his own inventions.

Edison sailed from New York with his family aboard the steamer *La Bourgogne* on 3rd August, 1889. Dickson was left behind at West Orange, to tinker away with the moving-picture idea when time permitted.

Inventions are rarely the brainchild of one man. When Edison started toying with the idea of moving pictures in 1887 he was tuning in to a field of interest in Europe and America which was already emitting a distinct hum. Many men were beginning to grapple with the problem.

The dream of making moving pictures was centuries old. Since the birth of photography in the late 1830s the reality had seemed within reach. Increasingly, inventors had speculated on and experimented with animated photography. The technical solutions had eluded them, but with the advent of the gelatine dryplate in the late 1870s, the pace of interest quickened.

The greatest impetus to the dream had come from two men whose primary interest was not moving pictures at all, but rapid-sequence still photography for the analysis of human and animal movement. Edison's interest, like that of others including Le Prince, had been stimulated by the much-publicized success that the English photographer Eadweard Muybridge had been having with his photographs of animals in motion. Spurred on by the acclaim, Muybridge had found a way of animating these images. Since 1881 he had been captivating audiences from Liverpool to San Francisco with his brief sequences of birds in flight and galloping horses. Although Muybridge's techniques were far from those that would eventually be required of successful cinematography, his shows were spectacular, and suggested what was possible, given an effective technology.

Muybridge's success encouraged a French physiologist, Jules Etienne Marey, to seek a photographic solution to the analysis of bird and animal motion with which he had been struggling throughout the 1870s. In 1882, he produced the photographic gun, taking twelve exposures per second on a glass plate which turned like the chamber of a revolver.

The excitement generated by Muybridge and Marey spurred others

to experiment with rapid-sequence photography. Scopes of all kinds spawned throughout Europe. The photographic journals chattered. Otto Anschutz, in Berlin, improved on Muybridge's zoopraxiscope with his electrotachyscope, a stroboscopic method of projecting his short animated picture sequences by the use of a spark. In Paris, Emile Reynaud evolved his projecting praxinoscope, which projected animated sequences of drawings. These were painted on gelatine picture bands and advanced by means of perforations along their edges.

Edison was finally stirred to half-hearted action when he attended an illustrated lecture given by Muybridge to the New England Society in West Orange in February 1888. A few days later the two men met to discuss the possibilities of synchronizing the Edison phonograph with Muybridge's zoopraxiscope to create talking moving pictures. The proposal was a pipe dream, but this first-hand encounter with the famous photographer helped persuade Edison that it was time once again to beat the well-trodden path to the Patent Office.*

By 1888 the forty-one-year-old Thomas A. Edison had had plenty of experience of the patent game. He had learnt the hard way. Most of the many inventions he had claimed had spawned their own saga of lawsuits, many of which were still grinding through the legal process. Edison hated patent litigation. He nonetheless employed a small army of lawyers to press his claims with legendary ruthlessness. The bullying tactics of the Edison legal machine were notorious.

Patent law is an etymological labyrinth. It is full of grey Latin terms with unexpected meanings. Words like anticipation, aggregation and interference turn out to have the slippery power of different chess pieces in a game that has more to do with subterfuge than with justice.

A wise early move in the US patent game is the issue of caveat. The caveat is a way of giving legal notice of your intentions before a full patent is taken out, to inhibit others from making patent applications on the same invention. Should push come to shove, the caveat serves to say 'I thought of it first'.

Edison's technique was to write caveats on every and any invention that came into his mind, claiming ideas as his irrespective of their true source. His caveats were intended to cover all eventualities. At one level, they were a kind of diary of his thinking about an invention at any given time. But if an evolving idea showed enough promise to warrant commercial exploitation (whether or not it was original to him), he lost no time in submitting a formal patent application with full specifications. The rest was up to the lawyers.

Edison was a master of hyperbole. His first moving-picture caveat to the US Patent Office, filed in October 1888, began with the customary

burst of hot air. 'I am experimenting,' he wrote, 'upon an instrument which does for the Eye what the phonograph does for the Ear, which is the recording and reproduction of things in motion . . . The invention consists in photographing continuously a series of pictures occurring at intervals . . . and photographing this series of pictures in a continuous spiral on a cylinder or plate in the same manner as sound is recorded on a phonograph.'

As was often the case at West Orange, the first practical work on moving pictures fell to an assistant. Edison knew next to nothing about photography, but William Dickson had taken some excellent photographs of the Edison family. To be sure, the young Scot was indispensable to the ore-milling project, but he had a little spare time, and seemed just the man to squeeze in some work on the embryonic moving-picture idea. Dickson began work sporadically early in 1889. His starting point was the Edison phonograph.

Edison's phonograph recorded sound by etching signals into a groove which ran in a continuous spiral around a wax cylinder. It was reproduced when the process was reversed, with the addition of a small horn as an amplifier.

The first Edison-Dickson moving-picture apparatus was based on phonograph technology. In place of stored sound signals in a groove, there was to be a spiral of numerous tiny sequential photographs, one-sixteenth of an inch square. As a camera, the device was intended to work by stopping and starting the cylinder forty times a second, sequentially exposing the appropriate tiny area of its light-sensitive surface to the image for a fraction of a second.

Dickson's first film material was Eastman paper film, which he rolled round the cylinder. When it came to viewing the results, the place of the camera lens was taken by a microscope, through which the spectator viewed the animated sequence of stills, now processed as positives in the same spiral arrangement on the cylinder.

It was an interesting idea, but wildly impractical. Stopping and starting the cylinder forty times a second posed insuperable problems. Registration of such small images was impossible. Torn between this project and his other more pressing responsibilities in the Edison Company, Dickson worked on spasmodically at the idea, but he did not get very far.

Meanwhile the unique qualities of the consignment of Carbutt's celluloid which had arrived at West Orange in June 1889 seem to have escaped Dickson's notice. He attempted rolling it round the cylinder in place of the Eastman paper, but it was too stiff. No matter. Since Dickson's priority was to make the apparatus work as a camera with a

peephole viewing device, he had no immediate need of a transparent film base for projection. Paper film would do.

So the very substance which Le Prince was so urgently seeking in Europe, and which would prove decisive in the birth of moving pictures, was put to one side to gather dust in some New Jersey store room.

Edison was aware of his reputation in France, but quite unprepared for the apotheosis that greeted him when *La Bourgogne* docked at Le Havre. An official government delegation was waiting to welcome him. Reporters competed for interviews and crowds cheered him on his way to the train.

This was just the start. When Edison reached Paris, much larger crowds besieged the entrance to his hotel. He was the toast of banquet after banquet thrown in his honour. King Humbert of Italy named him a Grand Officer of the Crown of Italy and weighed him down with prestigious decorations. President Carnot of France received him at the Elysée Palace and decorated him with the red sash of the *Légion d'honneur*. The press called him 'the man who tamed lightning'. The Opera House orchestra struck up with 'The Star-Spangled Banner'.

Adulation, unabated, for ten days. Soon he was heartily sick of it. His ego, though large, did not thrive on public massage. Steering clear of more unwelcome acclaim he elected to spend diverting afternoons with Buffalo Bill, who was giving chase to the famed Deadwood Stage with his Howling Redskins.

Edison also enjoyed meeting other scientists. One of these was Louis Pasteur, already famous for his vaccination discoveries. Another was Jules Etienne Marey.

Edison's meeting with Marey occurred at yet another of the dreaded banquets, thrown this time to commemorate the fiftieth anniversary of the invention of photography by Louis Daguerre. Europe's most eminent photographers had been invited, including Marey. Over the meal Edison got chatting with the famous physiologist and made an arrangement to visit him the next day.*

When Edison visited Marey at his home in Paris early in September 1889 he was intrigued by the Frenchman's improvement on his photographic gun of seven years earlier. Marey had no qualms about revealing his discoveries to others. Sharing, not secrecy, was his code. For several months he had been presenting papers on his photographic developments to the French Academy of Sciences and his achievements were public knowledge.

As soon as Edison saw Marey's new camera for himself, he realized that the phonograph-based approach which Dickson was worrying

away at back home was wrong. Marey's camera employed a narrow band of film stored in a roll, rather than a sheet of film rolled round a cylinder. Furthermore, Marey's film band was advanced intermittently past the camera lens, where it was held momentarily by an electro-magnetically operated clamp and exposed by a revolving shutter.

Marey's revelations showed Edison all too clearly that European photographers had made significant progress in the moving-picture field. The work of such men as Anschutz and Reynaud was also being widely publicized at this time. And unlike Marey, whose concern to analyse movement in sequential stills had so far not led him to repro-duce moving pictures, Reynaud's praxinoscope was a sophisticated, although non-photographic, projection device.

Edison left Paris for Germany in mid-September. The triumphal tour continued. In Berlin he met Hermann von Helmholtz whose first law of thermodynamics was to become a building block of modern physics. But Edison did not speak German and had little time for mathematics and theory. He was on surer ground with Werner von Siemens with whom he could compare, in English, the practical merits of their respec-tive forays into electric traction for trains. He was also received by the Kaiser and met Friedrich Krupp in Essen.

Towards the end of the month, Edison travelled on to London where he was the guest of the heads of the fledgling electrical industry. In between inspecting the Edison central generating station at Holborn Viaduct and a tense encounter with a Mr Ferranti who was introducing alternating current to London, Edison rested. Those interminable French banquets had played havoc with his gut.

Two hundred miles to the north, in Leeds, Le Prince was poised to make the breakthrough he had worked towards for so long.

SUCCESSES

On a sunny Sunday in September 1889, four thousand men gathered in an open space near Leeds city centre. Hundreds of red and green banners held on long poles stood out above a sea of faces. Images of heroic labourers, hands clasped over slogans – WORK-ERS UNITE, ONE FOR ALL, ALL FOR ONE, THE COURSE OF LABOUR IS THE HOPE OF THE WORLD – shimmered in the breeze.*

They were being addressed by a young Irishman, Tom Maguire. 'It's worse than Hades,' he was shouting. 'They expect a man to shovel four tons of coal in a twelve-hour shift. You work a full day for five shillings in a temperature of 130 degrees. For what? For the glory of Leeds?' His lip curled. 'For civilized, Christianized Leeds?' The crowd roared its approval. 'I say that the condition of the gasworkers of Leeds is a shame on the people of this city. It should not be allowed. It will not be allowed any longer. We have a message for the Leeds Corporation Gas Commit-tee.' The cheering died. Maguire paused, allowing the crowd's expec-tancy to build. He was a photographer, poet and agitator. He had been at the centre of events for a year now, giving shape to the unfolding struggle.

The trouble wasn't limited to the gasworks. The whole labouring population of the city was in ferment. First the building workers had struck, demanding 5½d an hour. Then out came the tramway workers, followed by dyers, plasterers, axle workers, tailoresses, slipperworkers and teamsters. They were turbulent months. The whole city was in the grip of trade-union fever as the bottled-up grievances of a working-class generation exploded into protest. Maguire had risen on the crest of their unrest, the voice of their discontent.

Now he let them have it. 'Brothers, we have a message for the Gas Committee: Gentlemen, you, in conjunction with your colleagues on the council, have acted with the spirit of the times most commendably and quite voluntarily. You have provided the people with public plea-sure grounds, public libraries, art galleries and reading rooms.' A few peals of laughter faded to silence. All held their breath for the punch line. 'We now request you to provide us with the opportunities to know and appreciate these things!' Now they roared their agreement. Maguire

could barely penetrate the din. 'We the gas stokers, wheelers, purifiers and general labourers, demand shorter hours! Higher pay! Better working conditions! Or else the gaslights of the city will go out!'

At that moment, barely a mile away, a gentleman of the very class that Maguire was lambasting for denying the Leeds working class the time to educate themselves was chatting with a bearded old man about the power of animated photography to transform the nature of education and leisure.

Le Prince was taking his Sunday constitutional with his father-in-law, Joseph Whitley. They were ambling alongside the lake in Roundhay Park, a stone's throw from Whitley's home. In less troubled times the park would have been packed with workers and their families, out boating for the day, taking tea, roller skating or fishing. But today it was virtually empty.

'They're all down in town, listening to some agitator,' Whitley said disapprovingly. 'The city council's given them this park, and now they don't want to use it. They prefer rioting instead.'

'It all comes down to communicating,' Le Prince said, distantly. 'If people would just listen to each other.'

'Now with one of your machines, Augustin, we could make them see sense,' Whitley said with a grin. 'Or better still, three or four hundred . . .'

The summer of 1889 had been as frustrating for Le Prince as it had been exhilarating for the workers of Leeds. The single-lens projector had proved unsuccessful. The thing worked after a fashion, but not well enough and he was reluctant to go public with what he regarded as imperfect apparatus. This had meant changing plans. He cancelled an arrangement to show it at the Spanish Exhibition organized by his brother-in-law, John Whitley, at Earl's Court. He put off a visit to Scarborough, where he was to have taken moving pictures of boats, waves and donkeys on the sands. He shelved plans to show the results at the Great Exhibition in Paris.*

His son Adolphe, who had assisted Le Prince for two years with the experiments, was exasperated by his father's postponements. Impatient for some kind of public showing, he tried to persuade him to exhibit the single-lens machine locally at the Leeds Mechanics' Institute, or at least to a select group of friends. But there was no question of showing it to anyone until the image was steadier and the flicker was eliminated. Most depressing was that these problems could not be surmounted by tinkering. The projector needed a radical rethink. And any new design relied on the availability of the new film material which, in spite of Le Prince's constant searching, continued to elude him.

The break came in early autumn, when Edison was returning from London to New York. For some months photographic journals on both sides of the Atlantic had been discussing the potential of celluloid film base as a flexible substitute for gelatine or glass. Le Prince could scarcely have missed the implications. Celluloid could be wound. It was tough and transparent. There was even talk of its becoming available in thirty-foot lengths. In July, a large Carbutt shipment had reached a London dealer from America. It just remained to locate it.

One day in September 1889 Le Prince arrived with a package at his Leeds workshop in high spirits. He waited until after dark before opening it. Watched by the young Fred Mason, he withdrew several sheets of the substance that was to make moving pictures a commercial reality. Each sheet was one foot square and coated with gelatine emulsion. By the red light of the photographer's lamp, Le Prince gave Mason instructions to cut the sheets into several four-inch-wide strips and splice them together into a long roll. At last it seemed to Le Prince that the final hurdle had been surmounted. The new material would dictate the mechanical solutions.*

With the coming of celluloid Le Prince felt confident enough to plan the public exhibition of his machines in America. Adolphe, now seventeen and fully conversant with his father's work, was sent back to New York with instructions to help Lizzie find a suitable venue. Le Prince was to follow a few months later with the perfected projector.

Edison sailed home from Europe on 29th September, 1889. He was laden with booty from the triumphant tour. Crated up in the hold was a statue of a winged nude called the Genius of Electricity. She held a working lightbulb above her head. This glorious piece of kitsch seemed just the thing for the library at West Orange.

There were more invidious spoils. When his troubled digestion allowed, he took time to sketch his memories of Marey's new camera. The Frenchman's use of bands of film, propelled intermittently, struck him in particular.

Edison arrived back in New York on 6th October, a national hero. A brass band aboard a launch greeted him when his ship entered New York harbour. He was returning to the best possible news. For three years the lawyers of what was now the Edison General Electric Company had been locked in litigation with those who contested Edison's patent rights on the incandescent lamp. His opponents claimed, rightly, that he was not its first inventor. Often, during the protracted proceedings, Edison had seemed on the verge of losing, but two days before his ship docked, a Pittsburgh judge ruled that he was responsible for the

breakthrough that had made electric lighting a commercial reality. Close-run patent battles were often decided in favour of those who achieved commercial success. The Pittsburgh verdict established Thomas Alva Edison as the undisputed inventor of the incandescent lamp, a judgement worth far more to Edison than the millions of dollars it would bring him in royalties. For Edison, real power lay not so much in owning corporations and commanding huge bankrolls as in the prestige that accrued to his name.

As soon as he got back to his laboratory at West Orange he went to the photographic room to check on Dickson's progress with the moving-picture idea. Dickson gave him a demonstration of the phonograph-inspired cylinder apparatus. The results were disappointing. Edison was clearly dissatisfied.* What he had seen in Europe had transformed casual interest in moving pictures into flickering enthusiasm. He now communicated to Dickson what he had learnt from Marey and others. The cylinder approach, with its spiral of microscopic images, was clearly a dead end. Edison had become convinced that the key to a successful motion-picture camera now lay in developing a machine that would advance rolls of film intermittently past a single lens.

By early November Edison filed his fourth motion-picture caveat. It incorporated much that he had taken from Marey and a little from Anschutz. It was a pirated move in the right direction. He now described a 'sensitive film in the form of a long band passing from one reel to another'.

Yet the details of his proposal remained technically impractical. He indicated perforations on each side of the film band, but the film-transport mechanism was unworkable. His suggestion that ten frames per second was an adequate speed for the persistence of vision betrayed an igorance of optical principles. He proposed a film band with a width of less than a quarter of an inch – far too narrow to withstand the stresses of intermittent motion. He was to achieve projection by means of a spark – Anschutz's idea – timed to flash when each frame was at rest before the lens. And so the wild proposals went on.

It is significant that Edison omitted to state the nature of the film material in his November 1889 caveat. Carbutt's sheets of sensitized celluloid lay unused. In August the Eastman Company began producing thinner and more flexible celluloid than Carbutt's in fifty-foot lengths which were designed to be rolled, and Dickson ordered some in November. But he used them for astronomical experiments which were part of his other photographic work for Edison. The West Orange conception of moving pictures apparently still had no use for the new material.

* * *

Leeds had a treat late in November: Eadweard Muybridge with his spectacular illustrated lecture on animal locomotion. For Muybridge it was yet another one-night stand in a gruelling tour of Europe. For the people of Leeds it was the first chance to see animated pictures.*

He was there at the invitation of the Literary and Philosophical Society, of which Le Prince had been a leading light in the 1870s when he first lived in Leeds. Muybridge's work was not new to Le Prince. It had been his inspiration in the early 1880s when Muybridge gave similar illustrated lectures in New York. The Leeds venue was the Mechanics' Institute where Adolphe had tried unsuccessfully to persuade Le Prince to show his own moving pictures some months earlier.

The audience loved the show. The fiery Muybridge paced the stage, all white beard, hair and eyebrows. He began with his series stills of the horse in motion, signalling each slide with a clicker as he took the audience through the walk, amble, trot, canter and gallop, demonstrating the truth of his own observations compared with the erroneous assumptions of artists through history. Then came oxen, wild bulls, deer and lastly, man himself.

The grand finale was moving pictures. Muybridge lit up his zoopraxiscope and a white cockatoo appeared on the screen. When its wing moved in the upstroke, each plume could be seen turning to present its edge to the direction of motion. And in the downstroke, the plumes turned back, presenting their flat surfaces to the air, so driving the bird forward. The audience gasped. Murmurs of astonishment peaked in sustained applause and cries of 'Encore!'

How would Le Prince have reacted to this virtuoso display right on his doorstep? He would certainly have been impressed by the lack of flicker in Muybridge's animated sequences. But he would surely not have been threatened. His own work represented a quantum leap forward by comparison. Muybridge's celebrated achievement remained rooted in the technology of still photography. While his famous animated sequences pushed the boundaries of still photography towards movement, his concern was the analysis of motion. Le Prince, on the other hand, wanted to reproduce motion. From the outset, this led him towards different technical solutions. The paradigm of image-making had shifted.

The Jumel Mansion is in Washington Heights at the northern end of Harlem, Manhattan. The safest way to see it, said the guide, was by chauffeured car. I put my cash and credit cards in my underpants, took the A-Train to 168th Street, and walked. On the sidewalk, men haggled

over secondhand carburettors. A rat sidled off with a half-eaten hamburger. It seemed safe enough. Just the usual New York horror.

At 161st Street I turned left down a terraced street of immaculately restored timber-frame houses. There were no cars. Apart from the occasional NO WAITING sign, it might have been nineteenth-century New York. At the end of the terrace, a larger white-timbered house showed between the trees.

I entered through the iron gates, left the roar of traffic behind, crunched up the gravel drive towards a Greek revival portico. A pair of cannons guarded the mansion, which was surrounded by trees. I skirted the house before going in. Through the windows I caught glimpses of a sumptuous past.

When Lizzie Le Prince rented the Jumel Mansion as a venue for Le Prince's début of moving pictures late in 1889 she took over a historic building in desperate need of repair. George Washington had made it his headquarters when the British fired Manhattan during the Revolutionary War. It had subsequently belonged to Eliza Jumel whose ghost was said to walk the back staircase. Others claimed it was the ghost of a Hessian soldier. There was also a secret passage which provided an escape route from the cellars, all very thrilling for the younger Le Prince children who joined Marie, Adolphe and Lizzie in the marathon task of restoration.

It was an exciting undertaking: a new home that heralded the end of Le Prince's absence. The family would be reunited. No more waiting. No more inadequate answers to the endless refrain, 'When's Father coming back?'

Lizzie supervised the work with vigour. She and Le Prince had run their own interior-decoration business in New York some years before. She had an eye for these things. First, a new roof was added. Pathways and driveway were relaid. The exterior was repainted in white. The columned portico was brought back to its former splendour. The secret passage was bricked up.

Next, she brought her experience to bear upon the interior. She oversaw the hanging of ornate wallpapers and chose the correct period dados, mouldings and borders. The woodwork was stripped down and repainted. The boys revived the Florida pine floors by rushing flagstones wrapped in beeswax-soaked blankets over them from one end of the house to the other. The girls brought their friends in to dance the floorboards up to a polish.*

Lizzie took particular care with the council chamber. This elegant oblong room was her reason for choosing the Jumel Mansion. It was large enough to seat fifty people in comfort when a screen was placed at

one end. George Washington had once sat in it with his officers, planning how to defeat the British. Now, more than a century later, Lizzie saw it as the perfect setting for the unveiling of her husband's secret. Within a few months, if all went as planned, an audience of scientists, impresarios, photographers and reporters would gather there to witness modern magic as Le Prince launched his business ambitions in America.

Lizzie Le Prince was not possessed of the same calm as her husband. Although she had long since understood the nature of his aims – he frequently sent her little sketches of the work in progress – she did not have a full technical grasp of his work. When, late in 1889, she began to notice reports of other men experimenting with moving pictures, she became alarmed. Towards Christmas a description of Anschutz's tachyscope appeared in the *Scientific American*. In mounting panic she read of 'pictures succeeding each other so rapidly that the retinal image of one picture is retained until the next is superimposed upon it, thereby giving to the observer the sense of a continuous image in constant motion'.* Wasn't this her Gus's invention? Had someone beaten him to it? Was his long absence in Leeds going to prove a fruitless sacrifice?

Le Prince wrote back, reassuring her: 'The paper you sent me is interesting. It is one of *many* who [sic] are trying *my* problem – but it is only a *small* part of what I am trying – it does not affect me. It is all of the old Gyroscope – and has neither background nor any number of figures moving in a street.'† As with Muybridge, he perceived no threat to his work. Anschutz's machine could not reproduce the motion of figures across a steady background, which Le Prince regarded as his fundamental aim. Anschutz's work, like Muybridge's, remained an inspiring outgrowth of still photography, stuck in a technological cul-de-sac.

Lizzie had other reasons for worrying. Several months had gone by since Adolphe had returned to New York, but Le Prince's homecoming seemed no nearer. Her hopes that he would be back for Christmas were dashed when he wrote announcing another delay. 'And now, all you dear ones, I am sorry I cannot come and see you merry and lively on this coming Christmas, but it's not to be. I am bound to my chain for a while longer, but I shall think of you and want you to be as happy as you can and to surround your dear Mama with your love and cheerfulness, and not fret over me and my loneliness. I shall be with you in mind. We will make up for lost time in January.'‡

It was a difficult Christmas for the family in New York. Hard-pressed finances were compounded by illness. In Leeds, Le Prince had had flu. His mechanic too had been ill and lost a child to bronchitis. The New Year brought predictable news. 'I still have a little more to do at the

machine, but I expect it will be the last and do away with all the noise . . .
I have no other news as I do not feel much like visiting even if I had time.
I have only one aim and that is to get right through.'*

Winter drew to a close. Still no Le Prince. In March he wrote saying
that the projector would be completed within ten to fourteen days. The
delay was put down to modifications. 'Every alteration in one part
always brings so many in others,' he wrote. 'This is absolutely my last
trial and I trust it will answer perfectly.'†

A few weeks later Lizzie received the same explanation. 'A few more
days and I will be through with the machine, but there are so many
pieces to adjust. It takes an infinity of time.'

Far too long, Lizzie reflected. Le Prince had now been away for three
years. The Jumel Mansion was ready. The children were buzzing in anti-
cipation of their father's long-awaited return. What was keeping him?
Should she, perhaps, join him? Was he in need of her presence in the last
months of his long ordeal? She weighed up the pros and cons. Her funds
were running low and the trans-Atlantic fare was expensive. The inter-
minable waiting had started to undermine her health, and she won-
dered whether she was up to an Atlantic crossing. Then came a letter
which put her mind at rest. It seemed that he was coming at last.

Leeds, April 18, 1890. I have not had news for more than a week and
hope nothing but occupation has prevented you [from writing] and
that I shall soon have your much-prized letters. I am just reaching
the end of the tedious work I was describing in my last, and there-
fore getting near the trial, the final, and I trust the successful one.
What a relief it will be – I shall scarcely believe it is over after all this
anxious tugging, waiting, and trying again . . .

DISAPPEARANCE I

The last 'Hip hip hooray!' died in the wind. Leeds had honoured Le Prince. Almost at once the newsreel crews started packing up. Mason, Scott and Marie made their way through the frantic winding of cables towards the waiting cars that would take them to a commemorative luncheon at the Queen's Hotel.

Scott was pleased. The success of the day was largely due to his efforts. Years of fund-raising, organizing and campaigning had gone into the event. A special committee had been set up. He had written articles about Le Prince for the Royal Photographic Society and the Society of Motion Picture Engineers in America. He had penned letters to the newspapers contesting the exclusive claims of other men to have invented moving pictures.

The whole business had created quite a stir, adding to the clamour that had recently begun to surround the vexed issue of who was the 'true inventor' of moving pictures. Not only had Mr E. K. Scott had to confront the firmly entrenched orthodoxy that gave Edison the credit – a myth crystallized during thirty years of relentless repetition by the Wizard's publicity machine. He had also had to contend with the indignation of the French who gave the credit to the Lumières Brothers; as well as the dismissiveness of a Mr Will Day who insisted that William Friese-Greene was the inventor of commercial cinematography, as he put it. The chauvinism of it all had infuriated him. The Americans resented any tarnishing of the Edison myth. The French were reluctant to concede that anything had been achieved in England. While the English were being childishly stubborn about giving any credit to a Frenchman.*

Scott hated the phrase 'true inventor'. In his view, there was rarely a true inventor of anything. The steam engine was a good example. James Watt hadn't invented it. Newcomen and Cawley had built engines with pistons much earlier. Nor was George Stephenson responsible for the first locomotives. There was Trevithick in Cornwall, and, for that matter, Hero of Alexandria who was said to have made a steam turbine two thousand years earlier to operate the gates of a temple. No, the fact was that inventions were usually collective enterprises, a mysteriously

synchronous application of many hands and minds to a problem in different places at the same time.

The attribution of invention, Scott believed, was also complicated by the aggregation of technical innovations and improvements that usually constituted a single invention. The many facets of moving-picture technology were a classic example. Intermittent mechanisms, celluloid, arc lamps, loops, perforated film and revolving shutters were all essential parts of the whole and no one man invented all of them. It was a federation of different technical breakthroughs. In the commercially motivated fight to claim the sole invention of moving pictures, this simple fact of life had been ignored.

Not that individuals should go without credit. That was the point, indeed, the main reason for Scott's interest in Le Prince. It was high time that the man's contribution was acknowledged. In his opinion, Le Prince was the first to make a successful single-lens moving-picture camera. And he was the first to exhibit moving pictures on a screen, which he did in Leeds in 1889. Le Prince had also proposed moving film through his camera by the use of sprocket wheels which would engage in perforations in the film. He'd advocated the use of colour and stressed the importance of flexible film. In fact, Fred Mason, who at that moment was sitting right next to him in the car, had stated categorically that Le Prince had used celluloid films before his ill-fated journey to France in September 1890. These were all highly significant steps in the evolution of moving pictures and Scott was keen that they should be recognized as such.*

The car turned down Park Row. 'There it is!' Marie shook Scott from his reflections with a cry of delight. The old Philosophical Hall was still standing. Scott looked at the old building and heard how, as a girl, Marie had attended the sophisticated conversaziones of the Leeds Literary and Philosophical Society in which her parents had played such an active part, those elaborate tea parties, where the progressives of Leeds' middle class had mingled to reflect on the benign face of their industrial culture. She remembered ambling among the adults, absorbed by the various exhibits. There were cabinets of labelled fossils, phonographs, telephones, etchings of Kirkstall Abbey, demonstrations of new methods of casting, new techniques of photography, exhibitions of watercolours and her father's enamel portraiture. Then someone would strike up on the piano, some Schumann perhaps, and the chatter would fade to a hush. She recalled the thrill of an ideal, an ambience in which art was united with science for the improvement of the world. Her father's moving-picture idea had been born of this benevolent vision of capitalism.

How things had changed, Scott replied. How that ideal had been shattered. Only that morning he had read in the paper of a moving picture called *All Quiet on the Western Front* which had been banned by the German censor. Depressing that a pacifist film should be banned. The showing of the film had created disturbances in Berlin. 'Nazi' members of a political organization run by one Herr Hitler had invaded the cinema where it was being shown and thrown stinkbombs into the audience. Le Prince would have been so disillusioned.

Marie agreed vehemently. Her father's outlook had been fuelled by his pacifism. Like *All Quiet on the Western Front*, he had envisaged moving pictures of vast battles, conceived as instruments of peace. He believed that the experience of horror on screen would be a deterrent to the real violence of conflict. At least, that was what her mother had told her, and she believed it.

Scott pointed out of the window. They were passing a moving-picture house. An afternoon queue was forming outside. The hoarding read *Romance of the Sheik*. Marie said rather primly, 'He wouldn't have made that kind of film.'

Mason grunted, 'I don't go to the flickers myself. I prefer a good book of poems by the fireside.'

I wound on to the end of December. The screen went black. The celluloid microfilm flapped clear of its spool: 1930 was over. It was time to leave Scott, Mason and Marie to their luncheon at the Queen's. I was beginning to smell the leather of the car. I reached for the *Yorkshire Factory Times* microfilm, threaded up, and plunged back into the barely decipherable newsprint of 1890.

I encountered a turbulent summer. Le Prince's struggle to perfect his projector shadowed the snowballing unrest of the working class of Leeds. The troubles of 1889 had continued unabated through the winter into the spring and summer of 1890.

In April the Corporation Gas Committee refused to pay double time to the gasworkers for Good Friday working and declared that it no longer recognized their union. The result was a May Day as never before. Six thousand people marched through the city. At the head of the procession a band played the 'Marseillaise', followed by one thousand Jewish tailors, nine hundred slippermakers, eight hundred gasworkers and so on. In early June the Gas Committee posted new rules. The work that had been done by the gasworkers in twelve hours was now to be accomplished in eight. It was like a red rag to a bull. The gasworkers struck to a man. The Gas Committee responded with a lockout. They would starve the men back.

As the days went by the Leeds gas supply started to dwindle. By mid-June the Gas Committee began to panic. Seven hundred blacklegs were brought in by train from London and Manchester and escorted to the gasworks by police and soldiers. Then the bricks started flying. For days Leeds was the scene of major rioting as the people rallied to the gasworkers' cause.

On the night of 1st July, 1890, the streets of Leeds were in complete darkness. The gas had finally run out. The next day the Gas Committee caved in on all the workers' demands.

This fade to black coincided with Le Prince's last days in Leeds. The labour unrest in the city peaked with his final experiments. It's a pity that he was unable to film these events. In his patent applications he proposed the filming of meetings, processions and races. One of his aims was to reproduce the movement of a great battle. Now, in the last days of his life, this chance passed him by. Perhaps the Leeds gas riots would have been too spontaneously violent a subject for a man of his nature. More likely, he was simply too busy with preparations for his return to New York.

It had been agreed between Lizzie and Le Prince that her father, Joseph Whitley, would accompany him to New York for an extended stay with the family. Mrs Whitley had died two years earlier leaving Whitley to fend for himself. In recent months the old man's health had begun to fail. Now that Le Prince was finally leaving Leeds, it made perfect sense that Whitley should travel with him.

A month before the planned departure, in August 1890, Le Prince travelled to France with his friends Mr and Mrs Wilson, for a brief farewell holiday together. Richard Wilson was a prominent banker in Leeds and, like Le Prince, a Freemason in the Leeds Fidelity Lodge.* The two men had been close for some years. Wilson was also Le Prince's bank manager.

Le Prince had an extensive knowledge of art and was the perfect guide to a tour of the great Gothic cathedrals of northern France. By early September the party had reached Bourges. Le Prince was apparently in high spirits. He told the Wilsons that he had at last been successful with his experiments.

The friends parted at Bourges on Friday, 12th September. Le Prince took the train to Dijon where he was to spend the weekend with his brother Albert's family. He had agreed to rendezvous with the Wilsons in Paris on Tuesday, 16th September, and take the night boat to England. On the way back they planned a flying visit to the French Exhibition which John Whitley, Lizzie's brother, had organized at Earl's Court.

After that, they would continue on to Leeds where Le Prince would pick up Joseph Whitley and his machines before heading on to New York.*

Le Prince's visit to Dijon was not simply social. His mother had died in 1887 and the will had still not been settled. Le Prince hoped to finalize the arrangements, but Albert was kept very busy by his commitments as city architect and could not spare sufficient time to discuss the matter. Instead, Le Prince went for long walks with his nephews and nieces in the park and gave them English lessons. He told them all about his children – their cousins – in New York, and how much he was looking forward to being with them all once again.†

Le Prince left Dijon for Paris on Tuesday, 16th September. He missed the morning train. Albert accompanied him in a cab to the station. It was a tense ride. Over lunch Albert had finally consented to talk about the will. They had argued furiously. Le Prince claimed that he was owed at least £1000 and that Albert was deliberately obstructing the legal process. For his part, Albert was convinced that his brother had had more than his fair share already.

They arrived at the station early to be on the safe side. Albert waited to see him off. The argument continued on the platform, attracting the attention of other waiting passengers. Le Prince was adamant that Albert was swindling him. Albert rounded on him fiercely. Why should he be expected to shoulder the burden of his brother's impending bankruptcy? Gus had had all the money there was coming to him. If he'd chosen to squander it on worthless experiments, then that was his lookout. He'd always warned that such extravagance would lead to disaster.

At 2.39 p.m. the train drew into the station. As the locomotive clanked past, the two brothers were momentarily enveloped in steam. When it cleared Le Prince was aboard the train. Albert had already left. They parted without farewell.

Le Prince spent most of the journey wrestling with his appalling situation. More than once, as the train steamed along an embankment or rumbled over a river bridge, he pictured the moment of his leap, watching his body tumble head first and at great speed, into cast iron, stone, immovable oak or whatever other obstruction would ensure a rapid end to his agony.

At 2.39 p.m. the train drew into the station. As the locomotive clanked past, the two brothers were momentarily enveloped in steam. They embraced each other warmly. The will was settled at last. Le Prince climbed on to the train carrying a single black valise. When he reached his compartment he leant out of the window to exchange a few last precious words. Albert wished him luck with the machines. A shrill whistle

sounded. Le Prince promised to send Lizzie and the children Albert's love. As soon as the train began to move, Le Prince waved a final good-bye to his brother and retreated into his compartment. Wasting no time, he opened the black valise and took out a railway timetable.

Two hours later the train stopped at the small town of Tonnerre and Le Prince disembarked. Checking carefully that he was not being watched, he went straight to the ticket office and purchased a ticket. Then he crossed over the tracks to the opposite platform. The Lyons–Marseilles train was due in ten minutes.

In Paris, the Wilsons were awaiting Le Prince's arrival. They had agreed not to dally, to meet him and then take the night boat for London. When he didn't show up, they assumed that he had been detained on business and decided to go on to London without him.

A train approaches a platform at a station in the Midi. It is one of the world's earliest surviving movies, the Lumières Brothers' 1894 *Arrival of the Train at Le Ciotat*. The locomotive passes out of frame, all smoke and steam. The train comes to a halt. Carriage doors open and people flood silently on to the platform. I scan the milling nineteenth-century French crowd, just as I have strained at the faces of arriving passengers in the railway stations of my own life, seeking the smile of a lover, daughter, or friend. Who am I searching for now? Le Prince? My own father? Myself? The man I am searching for is not there. Have I missed him? Did he somehow slip by me? Will he come on a later train?

MISSING

One day in early October 1890 the bell rang at the Jumel Mansion in New York.* Lizzie wandered down the long hall. Who could it be? Surely not Augustin with her father? Their steamer wasn't expected quite yet. She and the children had planned a big welcome down at the dock. An unannounced arrival would have upset all their plans.

She opened the door. A man she did not recognize was standing with his back to her, gazing across the Harlem River towards the farmlands of the Bronx. 'Can I help you?'

He turned at the sound of her voice. 'My name is Mr Rose. I'm looking for Augustin Le Prince.'

Lizzie was confused. 'My husband is not here. He's in Europe.'

The man seemed thrown by her answer and kept looking shiftily into the hall beyond her. 'When may I see him?'

Lizzie's pulse quickened. 'We don't expect him back till next week.' Rose hovered for a moment, then promptly left without another word.

With the imminent arrival of the steamship *Etruria*, Lizzie stopped worrying about the strange visit. Augustin would know what Rose wanted. It was probably some business matter. As the last days slipped away she buried herself in last-minute preparations.

The SS *Etruria* docked in New York on 3rd November, 1890. The whole family went down to the pier for the grand welcome home. It was pandemonium at the quayside. A forest of clipper masts and tangled rigging jostled with the tall funnels of the steamers, overwhelming the skyline. Carts and cabs cut irate pathways through tearful reunions and farewells. Bewildered immigrant families clung to each other, exhausted from ten days in steerage, apprehensive at what lay ahead.

Lizzie watched as the gangplank was wheeled into position. Passengers were crowding the rail, searching the packed quayside for relatives. Cries of recognition rose above the hubbub. Long-separated gazes locked on to each other. Adolphe shouted, 'There he is!'

Marie challenged him. 'Where? I can't see him.'

'There. On the top deck, fourth life belt from the left.'

Silence as they all scanned the deck. 'That's not Father,' Marie said. 'He's not tall enough.'

Lizzie said, 'He's probably below deck with Grandpa.'

A black hole appeared in the side of the ship. Passengers began to emerge, walking hesitantly down the gangplank towards loving embraces. 'How much longer?' Joseph asked impatiently.

'I think they've missed the boat,' Fernand chipped in.

Marie reassured them, 'Grandpa is ill. Father has to help him get off.'

Then the Bath chair emerged. It was Lizzie's father. A straw hat lay askew on his head. He was wrapped in a blanket. How frail he looked with his tousled white hair and beard. She was about to wave to the man who was gently wheeling Whitley down the slatted incline when she realized that he was not Augustin. How strange. Perhaps he was supervising the luggage. Yes, that would be it. He was checking his machines in the hold.

They made their way through the crowd towards the Bath chair. Her father lay back, semi-conscious. He raised half a smile when he saw her. She kissed him and straightened his hat. How poorly he was. The children surrounded him. Marie took his limp hand. 'Hello, Grandpa.' Whitley opened his mouth to reply but no sound came out.

Lizzie brought her face close to his, speaking slowly and clearly. 'Where is Augustin, Father?'

Someone else answered. It was one of Lizzie's cousins from Leeds. What was he doing here? 'Has nobody wired? Don't you know? Your husband has been delayed in France on business. I had to accompany your father in his place.'

Lizzie was astonished. 'Why didn't he tell me? When's he coming?'

'I don't know. Within days. There's no need to worry.'

A blanket of disappointment fell over her, muting the quayside pandemonium. How could he let them down at the last minute? How could she be expected to cope with her father on her own? Her own health was precarious enough. But most of all she just wanted to be with him.

She took a deep breath, bracing herself for the string of explanations that she knew would be demanded of her. 'Children, I want you all to listen to me. Father's been held up. I know it's a big disappointment but he will be here very soon. He's got some last-minute business in France with the machines.'

Weeks passed. Le Prince didn't arrive. Lizzie waited helplessly at the Jumel Mansion, nursing her sick father whose condition grew worse. As the days went by she became nervous. Why hadn't he written or cabled?

She wired Le Prince's address in Leeds. 'Come immediately. Father gravely ill.'

When Le Prince didn't reply, Lizzie wrote to her brother, John Whitley, in London. But John failed to find Le Prince in either Leeds, Paris or Dijon. Faced with the awful prospect that her husband had gone missing, Lizzie asked Richard Wilson to make some enquiries in Leeds. The search was under way.

Wilson's first step was to check that Le Prince's machines were still safe. This meant getting hold of a key to his workshop which had been locked up since his departure to France.

During his last months in Leeds, Le Prince had moved from his father-in-law's home in the outlying district of Roundhay and taken lodgings closer to his workshop in the city centre. Wilson now called on his landlady. She was deeply shocked to learn of Le Prince's disappearance. Like everyone else, she had been surprised not to have heard from him. And such a nice polite man. When Wilson asked her for access to Le Prince's room, she became suspicious. Was he after Le Prince? Reluctantly she allowed him to go through Le Prince's effects. The key to the workshop was in a drawer by the bed.*

Wilson entered the workshop with Mason and Longley. They found everything as Le Prince had left it. The apparatus was safe, crated up for the journey. Tools, materials and plans were untouched.

It was time to call in the police. Wilson contacted John Whitley in London, who gave the details to a Detective Cronin of Scotland Yard. Meanwhile in France, Le Prince's brother Albert got in touch with the Missing Persons Bureau. A Detective Dougan was put on to the case.

In New York Lizzie felt utterly helpless. She cabled her brother repeatedly. What should she do? Should she come over and help in the search? No, John replied, much better to stay where you are in case he arrives at your end.

The search intensified. John Whitley, Richard Wilson and Albert Le Prince kept in constant touch with one another and the various detectives on the case. Systematic enquiries were made at every morgue and asylum between Dijon, Paris, London and Leeds. Every railway station along the route was visited. Messages were placed in all the French national newspapers. They even looked into the possibility that Le Prince had lost his mind and enlisted with the Foreign Legion in some amnesic throwback to his days as an officer during the siege of Paris in 1870.

When nothing came to light at the European end, John urged Lizzie to check the passenger lists of all incoming steamers from Europe. For days on end she and Marie rose early each morning and went all the way

downtown to the port where they traipsed from shipping office to shipping office, asking if the name Louis Aimé Augustin Le Prince had been seen on the ships' registers. Where permitted, they checked the lists for themselves, spending hours running their fingers down the neat, handwritten lists.

It was an exhausting process, mirrored by the cumulative fatigue that showed in the handwriting of the clerks who had drawn up the long lists. The names would begin in neat copperplate, but by the time they reached the six or seven hundredth passenger the lettering became scratchy and impatient.

The lists read like a cross-section of the new America, a braiding of lives into an epic migration. Servants, cotton spinners, labourers, wives, children, glassworkers and distillers crowded steerage. Self-styled capitalists and merchants travelled 'cabin'. But Lizzie and Marie had eyes for only one story.*

In mid-November, they came on the name Prince on the manifest of the SS *Gascoigne*, which had just docked. For a moment they thought it was him, but he turned out to be a twenty-five-year-old merchant from Germany. Their disappointment was brief. Several pages later, in steerage, they found the name L. Leprince. There could be no doubting that. He was described as a farmer, aged twenty-seven, but it was typical of Le Prince to travel incognito in this way. The age discrepancy was probably a ruse, Lizzie reasoned, to put potential spies off the scent. He had arrived.

The next task was to crosscheck with the barge office register, which listed the names of all US citizens leaving the dock to enter the United States. Le Prince had been granted US citizenship in 1888. If he had indeed arrived back, as the *Gascoigne* manifest suggested, his name would surely be there. It was not.

Lizzie immediately explained the situation to a barge office detective, Peter Groden. He was puzzled. The absence of Le Prince's name at the barge office suggested to him that Le Prince had arrived on the *Gascoigne*, but not disembarked. The ship was due to sail the next morning. With no time to lose, Lizzie and Marie went on board. The crew were unhelpful. They had never heard of this Le Prince.

That evening Lizzie sent Adolphe back down to the port with several photographs of Le Prince to try to jog the memories of the *Gascoigne* crew. They claimed not to recognize him.

The *Gascoigne* left port. Lizzie was distraught. Augustin had arrived, yet not arrived, which could only mean that he was being held on board, against his will, or he had been illicitly spirited ashore. She wired John and Albert in Europe, who obtained a special order from the French

office of the *Gascoigne*'s owners, the Compagnie Generale Trans-atlantique, for a thorough search to be made of the ship when it docked.

Then Lizzie's growing anxiety became fear. One morning in early November the Jumel Mansion doorbell rang again. Her heart fluttered. The postman? News of Augustin? She opened the door. It was only a man selling milk. No thank you, not today. But when she tried to close the door, the man would not take no for an answer. What was it about his face? She remembered as he spoke. 'I want to see Mr Le Prince.'

Now she felt panic. Rose was wearing a feeble disguise, but it was unmistakably him. Plucking up her courage, she said, 'I told you before, Mr Rose, my husband is not here. He's in Europe.'

Rose became awkward immediately. 'My name's not Rose. You're mistaken. Where is your husband?'

Lizzie felt weak. Rose knew something about Augustin that she didn't. Perhaps he had followed him from the ship? 'If you don't leave my house now I shall call the police.' She turned and called into the house. 'Adolphe! Marie!'

But Rose stood his ground, repeating his question. 'Where is Mr Le Prince and what is he doing now?'

Lizzie hesitated. At all costs she must avoid mentioning anything about Augustin's experiments. The man could well be a spy, just the kind of person Augustin had gone to Leeds to avoid. 'He's a decorative artist. He's in Europe,' she spluttered. Before Rose could reply he caught sight of Adolphe and Marie approaching down the hall and vanished as suddenly as he had appeared.

This second encounter with Rose persuaded Lizzie to go to the police. A Captain Williams listened to her story. He was smoking a pipe. She told him that her husband, an inventor, had disappeared on his way back to America from Europe. Without telling Williams what it was, she emphasized that Le Prince had just perfected an extraordinary invention that would cause a great stir in the world. When she came to the incident with Rose he asked her carefully about the date and time of the visits, the man's appearance and what he had said. Then she told him about the *Gascoigne* and the barge office.

Williams drew on his pipe, reflecting on what he had heard. Lizzie was relieved to have told him. Involving the police somehow helped her to acknowledge that Augustin was missing, rather than simply delayed. Now the case would be in safe hands.

Williams leant forward. 'Mrs Le Prince, before we can take this case any further we require that you accuse your husband of a crime.'

Lizzie smiled. He had misunderstood. 'My husband is the one who's gone missing.'

Williams nodded, a trifle embarrassed. 'I understood that. But the law in New York states that the photograph of a missing person sought by the police must be posted in the rogues' gallery. It's merely a formality, I can assure you, but one we must comply with.'

Was she hearing right? Accuse her dear Augustin of a crime? Williams swivelled on his chair and began to turn the large wooden pages of the rogues' gallery which hung behind him. Hundreds of small photographs were mounted on each side. Lizzie stared in horror at the grids of wanted faces. A small array of murderers, thieves and kidnappers stared back at her.

'Before we can search for your husband in New York, we have to have his name and photograph published on a criminal charge.'

She drew herself up. This really was most upsetting. 'My husband is innocent.'

'Of course, we know that, Mrs Le Prince . . .'

'Madame Le Prince, officer.'

'I wouldn't propose that you allege murder or theft, Madame Le Prince,' he added cautiously. 'We usually recommend desertion.'

Lizzie recoiled visibly. 'My husband is a gentleman. He would never betray me.'

'We know that, Madame. It's just that the law . . .' He tailed off with a reassuring shrug.

But Lizzie refused to be silenced. 'My husband is a United States citizen.* He was a brave soldier, in active service in the Franco-Prussian War. He is an honourable man. I could never betray him.'

There was no stopping her now. All the pent-up feelings of recent months came pouring out. Williams listened patiently as she told him how Scotland Yard and the French police were taking the case seriously, castigating the American judicial system for its insensitivity and bureaucracy.

When she'd finished he took a file from a drawer. Then he cautioned her. 'This is not a pleasant sight. This file contains photographs of New York citizens found dead abroad. Your husband might be among them.'

Williams opened the file. Images of dead men fell on to the desk in front of her. They had been taken in morgues. She was sickened by the sequence of shrunken eyes and cheeks. Some were horribly wounded. Others had expressions of anguish. But Augustin was not one of them.

Lizzie left the police station with a sense of foreboding. Her anger with Williams was compounded by a more difficult emotion. The photographs of the dead had connected her to a network of loss. Against her will, she felt herself slipping towards a web of grief and bereavement. As she walked back the short distance to the Jumel Mansion she faced

the possibility that her darling Augustin, her Gus, might be dead.

In December the *Gascoigne* returned to New York. With official permission, Detective Groden checked every square inch of the vessel. He found nothing. Lizzie refused to believe him. She insisted on searching the ship herself, but found nothing. The crew were as unhelpful as before. She was infuriated by their Gallic indifference. They even claimed to have forgotten her visit with Marie of a few weeks earlier.

Now Lizzie began to despair. Four months had passed since she had last heard from Augustin. The sequence of events that had followed his disappearance had alerted her to the possibility of foul play. But no one seemed either willing or able to help. On top of which she bore the full responsibility of five children and a sick father, whose condition was worsening with each week.

Joseph Whitley died in New York on 11th January, 1891. He was seventy-four. His death was not unexpected, but it deepened Lizzie's depression, compounding the hollow of Augustin's absence.

They buried him in the wintry ground of Trinity Cemetery at 153rd Street. As the coffin was lowered into the grave, she felt the passing of a generation. Her father came from that increasingly rare breed of industrialists who had faced up to the moral challenge of capitalism. Joseph Whitley had tempered the harsh business reality of his industrial world with a philanthropic vision of science. Now that benign force had vanished. In its place she saw only greed and deceit.

Characteristically, Lizzie drew strength from this comfortless bereavement. Le Prince shared Joseph Whitley's moral values. He envisaged moving pictures as a benign and educative force in the world. Now the strength of these convictions kept alive Lizzie's belief that Le Prince himself was alive, and convinced her that the dark forces who had stolen his invention and kidnapped him would somehow be unable to hold on to him because of the sheer power of his ideals. This conviction fuelled her struggle to find recognition for Le Prince's achievement until the end of her life.

MR EDISON'S LATEST

On a May afternoon in 1891 Mrs Mina Edison, wife of the celebrated inventor, entertained delegates of the National Federation of Women's Clubs to an elaborate lunch at Glenmont, the Edisons' mansion in West Orange.

Mina Edison had been imbued with the value of 'good works' in her childhood. Her father, Lewis Miller, was one of the founders of the Chautauqua Association, a Sunday-school summer camp which had become a thriving literary and philosophical circle providing lectures and courses for ordinary people, based on a Protestant approach. Mina's adult life reflected this upbringing. When she was not running the Edison household or being the good wife to a demanding husband, she threw herself into the affairs of countless charitable organizations.

During Edison's courtship of Mina in 1885 he had been careful to nurture a suitably Christian impression of himself for his future father-in-law. Since then he had contributed to and respected his wife's charitable activities. Sometimes he even spared the time to take part in them. The Women's Clubs' luncheon was one of these occasions. After the meal, all 147 guests were driven the short distance to Edison's laboratory, where they were welcomed in person by the great man and shown upstairs to the Photographic Room.

They were to be privileged with the first public showing of his latest invention. In the centre of the room stood an ordinary-looking pine box, with a small hole drilled in the top. An assistant hovered by it, probably Dickson. One by one, the women were encouraged to step up to the box and peer through the hole. An electric motor whirred. They were amazed by what they saw. The form of a man about one inch high was bowing and raising his hat. His actions were jerky but continuous.

Mina Edison's delegates had witnessed the début of the kinetoscope. The moving picture they saw was probably a negative, a few frames in length, spliced into a loop for continuous running.

During the weeks leading up to this event the press had been alive with expectant stories about Edison's 'latest'. These had been fuelled in large part by Edison himself, to satisfy a public who now craved his new sensations. Although absorbed primarily with his massive iron-ore-

separation project and the reorganization of his electrical interests at this time, Edison rarely passed up the opportunity to deliver a fabulous hyperbole. It made good copy and perpetuated his mythical image.

On 13th May he told the *New York Times* about an electrical novelty he was preparing for the Columbian Exposition in Chicago, three years hence. 'My intention,' he pronounced, 'is to have such a happy combination of photography and electricity that a man can sit down in his parlour and see depicted upon a curtain the forms of the players in opera upon a distant stage, and hear the voices of the singers . . . each little muscle of the singer's face will be seen to work, every colour of his or her attire will be exactly reproduced . . .'

Here was a proposal not for cinematography, which was fantastic enough, but television – in colour. Edison amplified his televisual delusion in the *Photographic News* on 22nd May. 'To the sporting fraternity I will state that ere long this system can be applied to prize fights. The whole scene, with the noise of blows, talk etc., will be truthfully transferred. Arrangements can be made to send views of the fight à la stock and race ticker.'

A few days later, Edison was required by his lawyers to attend court in New York. During a welcome break from the day's proceedings he was approached by a *New York Sun* reporter. Rumours of the prototypical début of the kinetoscope had begun to filter out of West Orange. The reporter asked if Mr Edison had anything new. Edison reiterated his fanciful television idea. The man was impressed. Could he come out to West Orange and see for himself?

The next day Edison welcomed the *Sun* reporter at his laboratory. The man was less impressionable than Mina's delegates. Faced with this more critical eye, Edison scaled down his claims. Nonetheless, the reporter was impressed as Edison 'ran upstairs with the step of a boy and easily headed the procession to the spot where the "germ" was expected to prove that the reproduction of motion by photography was an established fact'. And there he saw the pine box which the 147 women had delighted in a few days before. Unlike them, he saw how it worked. At the bottom of the box he glimpsed machinery and a roll of what he called gelatine film, carried from one spindle, across wheels, past the lens, and back down to another spindle. When the motor was turned on, the roll of gelatine strip was transferred from the first spindle to the second, and, during the transfer, passed under the lens. 'The pictures were of a young fellow waving his hands and touching his hat . . .'

One afternoon in May 1891, while Edison was busy orchestrating the first systematic publicity on 'his' moving-picture idea, Lizzie Le Prince

received a group of girl students from Rutgers College at the Jumel Mansion. After showing them the pottery, with its wheels and special kilns, she gave them afternoon tea.

Teatime was sacred to Lizzie, an English ritual which kept her connected to a Yorkshire past she had never quite lost sight of. She always looked forward to the reassuring certainty of 4 p.m. with its special English teas brewed just so, thinly cut cucumber sandwiches, and her special fruitcake.

That afternoon was like many others. Her maid, Phoebe, wheeled in the trolley. Marie poured. Bone china clinked. The fruitcake crumbled when she cut it. The room buzzed with polite cultural chatter.

Le Prince family life had always centred on a shared love of art. Both Lizzie and Le Prince were accomplished painters and ceramicists. In the 1870s they had opened the Technical School of Art in Leeds. Lizzie had continued with her teaching in New York, taking a post at the New York Institute for the Deaf in Washington Heights where she concentrated on the therapeutic value of working with clay. She also taught art at the nearby Audubon School for Girls. The Le Prince children were imbued with the cultural values of their parents. Marie and her sister Aimée, who had attended Audubon School, were encouraged to follow in their mother's footsteps. By the time of Le Prince's disappearance in 1890, Lizzie Le Prince was in demand as a teacher and played a leading role in the New York Society of Ceramic Artists where her pottery was highly regarded.*

'He noticed that they had always fired their pots at dusk and that this coincided with a desert breeze which always blew up at this time. It's how they get those wonderful bright colours.' Lizzie was explaining a special glazing process which Le Prince had learnt from Mexicans while on a trip to San Diego in 1882.

'They'd been doing it since the time of the Aztecs. The breeze increases the temperature of the firing and wraps the hot air round the surfaces of the pottery.' The chaperone was fascinated. The students had stopped chattering and were listening to her. 'This is what gives Mexican ceramics that special brilliance and translucence. The breeze welds the body and the glaze. My husband was very impressed. When he got back to New York he tried to simulate their techniques. He invented a special gas engine to blow hot air into our kilns.'

The chaperone said, 'I didn't know that your husband was an inventor.'

'Oh yes. For many years now,' Lizzie answered. 'He was trained as an engineer and draughtsman.'

'What does he invent?'

Lizzie was on the point of describing the moving-picture machines when she caught Marie's eye. 'Valves for steam locomotives,' she replied instead.

'Most interesting. Have you heard about Mr Edison's sensational new invention?' Lizzie hadn't, and wasn't sure that she wanted to.

The chaperone continued, undeterred. 'Mr Edison is about to announce moving pictures to the world! It's been in the newspapers.'

She described what the *Sun* reporter had seen at West Orange. The students were gripped by her story. One said, 'Sounds like magic to me.'

'Witchcraft, more like,' said another.

All Lizzie could muster was 'Oh, really?'

She turned to Marie who had started to clear away the tea things rather noisily. The chatter seemed far away. She felt limp and dizzy. Her field of vision greyed at the edges. Then she fainted.

Edison's announcement of moving pictures came as a profound shock to the Le Prince family. The announcement came so soon after the disappearance that their suspicions were naturally alerted. Edison had a dubious reputation when it came to respect for other men's endeavours. Might he not have stolen Le Prince's invention?

When Le Prince sailed for England in April 1887 he left Lizzie with explicit instructions that if anything unusual were to happen she was to go to their friend Clarence Seward.

Seward was a prominent patent lawyer in the firm of Seward and Guthrie. He had an impressive Civil War record and was active in Republican politics. He was also a freemason, like Le Prince. When the Le Princes first came to New York in 1882 Seward had helped them and John Whitley with the commercial launch of a new process for interior decoration called Lincrusta-Walton. Seward's partner, William Guthrie, had given valuable assistance over the patents. Later, as Le Prince had embarked on his first experiments with moving pictures, Guthrie had witnessed trials of the early machines and Seward had offered his professional advice to Le Prince in exploiting the invention in America.

Lizzie had avoided visiting Seward since Le Prince's disappearance, preferring not to involve lawyers until it was absolutely necessary. Now that time had come.

The morning after her conversation with the chaperone Lizzie went downtown to Seward's office to put her case in his hands. She took various documents with her, including several of Le Prince's moving-picture patents. She had not made an appointment.

The office was dark with heavy panelling. A clerk was immersed in a morass of paperwork. It was clearly an inconvenient time but she

persisted, explaining who she was and why she'd come. The clerk was polite but unhelpful. 'Mr Seward won't be able to see you this morning. He's otherwise engaged.'

Lizzie interrupted. 'It's very urgent that I see him. He is a friend of my family.'

The clerk shook his head amiably. 'I'm afraid he's in court, on a case for Mr Edison.'

His words sank in slowly. If Seward were acting for Edison then surely he couldn't act for her as well? It would mean prosecuting his own client, a professional impossibility. Then the penny dropped. Seward knew about Le Prince's work. Could this not mean that Seward, Augustin's friend, had disclosed his invention to Edison?

The clerk was looking at her expectantly. 'May I tell him who called?' But Lizzie did not hear him. She turned and left the office without uttering a word.

The success of the private début of the kinetoscope persuaded Edison that moving pictures warranted a little more attention. In the summer of 1891, Dickson was relieved of his more pressing commitments to the iron-ore project in order to devote more time to the new wonder.

The May début had been very tentative. There were many technical problems to be solved before either camera or exhibiting machine could be put on the market. In July, Dickson took a trip up to Rochester where he ordered four fifty-foot rolls of one-inch-wide coated celluloid from George Eastman. This time, the celluloid was for moving-picture purposes. On his return to West Orange he started working steadily on the camera.

Edison now turned to his patents. So far he had covered his interest in the field only with four rambling and largely impractical motion picture caveats. If it ever came to litigation, which with Edison was virtually inevitable, these would have little legal value. So in June 1891, he sat down to prepare three full patent applications. All were intended to cover the inventions of Mr Edison in the art of 'taking pictures of moving objects, and subsequently reproducing these pictures in an exhibiting machine'. US patent #403,535 covered the method and apparatus for taking the pictures – the camera. #403,536 covered the apparatus for reproducing these pictures in an exhibiting machine – at this stage not a projector but the peephole machine known as the kinetoscope. #403,534 was a composite application, covering both taking and exhibiting machines. Edison signed the specifications for these patents at the end of July and filed them in the United States Patent Office on 24th August, 1891.

SUSPICION

L izzie returned to the Jumel Mansion from her abortive visit to Seward on the edge of despair. Not one of the various private detectives looking into Gus's disappearance had come up with anything. The New York police still would not help her, since the condition of their involvement on the case was that she accuse Gus of a crime – a step that she flatly refused to take. And now Seward, her last hope, turned out to be working for Edison, crystallizing her growing suspicion that the Wizard was somehow involved in Gus's disappearance.

A man was waiting for her in the council chamber when she got back. As soon as she entered the room he launched into a complaint. Her sons, Joseph and Fernand, had been fighting with his boys. She was in no mood for an altercation with a neighbour. As she listened to him she put Augustin's patents down on a table, then went out to call the boys in.

When she returned the man was staring at the documents with great interest. Her hackles rose immediately. Was he another Mr Rose? Before she could say anything he turned to the boys who were hanging back sheepishly. As he grilled them about the cause of the fight, her fears ebbed. He seemed genuine enough.

When the boys left the room, the man turned back to the patents. 'I recognize those.'

'They're my husband's,' Lizzie said coolly.

The man smiled. 'That blue file wrapper is familiar to me.' Lizzie picked up the patents, protectively. He was keen to reassure her. 'I don't mean the serial number.' Lizzie hated herself for being so suspicious. 'Patent law is a hazardous business,' the man added. 'I've just been in England giving evidence in a case. I couldn't help noticing your involvement.' Now she softened. His interest was just a coincidence. Perhaps he might even help her?

Over tea she told him her story. He listened to her carefully, then said, 'Madame Le Prince, I would advise you to be very careful about whom you consult on this matter. There are many disreputable people involved with patent law. When I was in London an attempt was made to bribe me into silence. One has to know whom to trust.'

* * *

For some time Lizzie had been becoming increasingly interested in the work of the Chautauqua Assembly. Since its foundation on Lake Chautauqua to the west of New York state in 1878, the Assembly had founded branches all over the American north-east. Lizzie was attracted as much by its mixture of religion and education as by its provision for the common man. She was particularly impressed by the emphasis on the teaching of crafts. Her life-long involvement in the applied arts had strengthened her conviction of the importance of sustaining craft traditions in an epoch dominated by commerce and technology. It was a view she shared with Augustin, an outlook that nourished their relationship.

The Chautauqua people were also interested in Lizzie. That summer she was invited to teach some art classes at a Chautauqua Summer Assembly at Avon-by-the-Sea in New Jersey.* In the event, her course proved to be one of the most popular of the season. When not tied down by her teaching commitments, Lizzie took the opportunity to attend lectures on other subjects. By coincidence, one of these was about the life and work of Thomas Edison. The speaker was from West Orange. It seemed the perfect chance to hear for herself what Edison was up to, even make a few enquiries if necessary.

It was a reverential talk with lantern slides, given by a man who had worked for Edison for many years. Lizzie sat through it patiently. She heard about a boyhood steeped in Protestant values, in which idleness, pride and indulgence brought the downfall of individuals as surely as they did empires. Young Tom Edison was energetic, enterprising, yet diligent. He embodied the ethics of self-help. Hard work was the key to a life that would succeed through 'one per cent inspiration, ninety-nine per cent perspiration'.

As the talk wore on, Lizzie felt increasingly ambivalent. She had been brought up with those values in Leeds. Her father had built up his brass-founding business from nothing. Born into the working class, he had risen on the tide of the Industrial Revolution through his own efforts. Joseph Whitley, like Edison, had embodied the self-help philosophy underwritten by the Protestant ethic.

But Lizzie had also witnessed the darker side of her father's achievement. She knew that the motivations of capitalists were not always benign. She was familiar with the ruthlessness and double dealing that thrived on, indeed were the product of commercial competition. Often, in the Leeds days, Augustin had returned home after a day's work at her father's brass foundry with tales of treachery, threatened law suits, bank foreclosure. The challenge was, Lizzie thought, to find a way of reconciling the immorality of capitalism with the greatness

of its achievements. If only Augustin were here. He would have had something wise to say.

A wave of laughter swept through the audience. The lecturer was describing young Tom avidly reading a foot of books a week from the shelves of his local library, irrespective of their subjects. Then he came to Edison's inventions. The list seemed endless. His earliest achievements were in printing and telegraphy. She heard about his quadruplex, which could handle four messages in the same wire at once, a great boon for Wall Street. Then came numerous improvements on Bell's telephone, including a loudspeaking telephone which gave rise to the phonograph. This was followed by the incandescent lamp and Edison's expansion into the electrical industry. Thanks to the Wizard, most American cities now had their own generating stations. Young Tom Edison had become the Bringer of Light.

'And as if that wasn't enough for one man,' said the lecturer, 'some of you may have read about his latest experiments.' Lizzie tensed. It was what she had come to hear. 'Mr Edison now has the idea of synchronizing his phonograph with a zootropic device which will exhibit moving pictures that talk. Ladies and gentlemen, Mr Edison is introducing sound and movement to the art of photography.'

After the lecture Lizzie was invited to dine with members of the Assembly. She found herself sitting next to the lecturer.* 'The difference between Mr Edison and other inventors,' the man was saying, 'is that he maintains a staff. He has experts in many different fields. We work as an inventive team.'

'So he doesn't do all the actual inventing himself?' Lizzie ventured.

'By no means, ma'am. But he gives us the lead. He works night and day at a problem and expects us all to do the same. Mr Edison sticks at it until he's through.' He pointed up to a cluster of incandescent lamps hanging from the ceiling. The light wavered slightly as the power from the local generating station surged and ebbed.

She concentrated on the glow of their filaments, seeking the right words for her next question. 'It must be hard enough work keeping abreast of other men's inventions. It would be a great waste of time to spend years perfecting a machine that someone else had already invented.'

'He keeps his ear to the ground, ma'am. He reads the *Scientific American* and many other journals. He watches out for what the competition is up to and makes sure he's first in line at the Patent Office. Do you know what Mr Edison's favourite reading is?' Lizzie didn't. 'Other men's patents. He reads them for pleasure. He even has linguists on the West Orange team who spend their time translating foreign patents for him.'

Lizzie slept fitfully that night. Edison's face kept slipping into her dreams, left to right, right to left, like one of the lantern slides in the lecture. With each image her mood darkened. Those kindly good looks were not what they seemed. What made matters worse was that she had to be up early the next morning for an important appointment in Manhattan. As President of the New York Society of Ceramic Artists she had been called on to give evidence in a suit between the New York Customs and a German importer of china. And Edison was keeping her awake.

In the morning she took the first boat from Atlantic Highlands. The deck was crowded with men in bow ties and straw hats returning from their weekends on the New Jersey coast to another week of making money on Wall Street. She scanned their faces, and saw Edison everywhere.

They passed through the narrows, leaving the ocean behind. An early morning haze lay over the upper bay. The boat rolled gently in the wake of a large inbound steamer. She could make out the word *Liverpool* on its stern. For a moment she let herself hope that Le Prince might be on board, that one of those figures lining the rail for that first glimpse of New York might be her lost inventor. She turned away, back to the crowd of businessmen on the ferry. There was Edison again, deep in conversation with another man. This was getting silly. She looked out across the water and distracted herself by guessing where the city would first emerge from the haze. It was going to be another hot day.

Something was nagging at her. The shape of the man talking to the last 'Edison' she had imagined seeing was vaguely familiar. Cautiously she risked another look. For a few seconds she couldn't put a name to the face, then it came to her. Guthrie. William Guthrie, Seward's partner, who had advised John and Augustin when they first came to New York. What was he doing here?

She threaded had way across the crowded deck to get a closer look at the two men. There was no doubt about it. William Guthrie, who had seen Gus's first machines up in Washington Heights in 1886, was right in front of her. But who was he talking to? She walked past, snatching a backward glance as she went. Tired as she was, her eyes were no longer playing tricks. The man had the same kindly good looks that had invaded her previous night's sleep. It was Edison.

Half an hour later, the bow bumped the pier and the commuters flooded into the city. Edison and Guthrie decided to walk. Lizzie found it hard following them through the crowd. By the time they reached Wall Street she had lost them. When she got back to the Jumel Mansion later that day her housekeeper showed her an announcement she had

read in the newspaper: Mr William Guthrie had arrived in New York City from Europe. So she hadn't been seeing things.

This incident was a terrible confirmation of Lizzie's growing suspicions. It now seemed highly likely to her that Seward and Guthrie had betrayed Augustin's secrets to Edison. And if that were the case, they would almost certainly be aware of his whereabouts.

Lizzie now needed a lawyer she could trust. A friend recommended Mr Field of Broadway. After listening carefully to her story he examined Le Prince's patents. A seal on one of them caught his eye. It read: 'Bruxelles, le 3 février, 1888.' Beneath it was a signature – L. A. A. Le Prince. He shook his head. 'I'm afraid I don't read French, Madame Le Prince. Or Italian, or German, for that matter.' He indicated the rest of the documents.

'He was issued with both American and British patents, Mr Field. I know they're there somewhere.'

Field flicked through the different file wrappers, pausing when he found one in English. 'Here it is. But frankly, it won't be of much help.'

Lizzie was confused. She leant forward and pointed out a date beneath an immaculate mechanical drawing. 'But it's proof. My husband perfected this camera in 1888.'

The lawyer took a deep breath. 'The law is never simple, Madame Le Prince.' His tone was ominous. 'There's a statute relating to the property of missing persons which complicates the issue.' A wave of nausea broke inside her. What was he leading up to? 'According to United States law, these patents remain the property of your husband until it can be legally established that he is deceased. In the case of missing persons, seven years must elapse before death is assumed. In respect of these patents, this means that you have no legal right to prosecute your husband's interests until that time is up.'

'We can do nothing, you mean?'

'Not for seven years.'

'In spite of the fact that a crime has been committed?'

'We have no proof of that fact, Madame Le Prince.'

She rounded on him. 'Mr Edison claimed this invention soon after my husband's disappearance. He's been consorting with colleagues of my husband who knew about his cameras. I've witnessed it with my own eyes.'

Field shrugged sympathetically. 'A lot more than that. I know it's hard, but my advice would be simply to wait quietly. Bide your time.'

'For seven years! While others profit from my husband's invention?'

'Unless his death is proved earlier, yes.'

Lizzie gathered up the patents from the desk and stood up. Field

proffered a supportive hand. She took it limply and said, 'My husband is not dead, Mr Field.'

We shall never know precisely what passed between Edison and Guthrie when Lizzie spotted them on the Atlantic Highlands ferry. When she followed them off the boat and lost them in the crowd, they were, in all likelihood, making for the offices of Seward and Guthrie on Wall Street, the same offices that she had left in despair a few weeks earlier when told that Mr Seward was in court, engaged on a case for Mr Edison.

The case was, in all likelihood, the reason for Edison's visit to Manhattan with Guthrie on that July morning in 1891. For the past year, Clarence Seward had been directing the legal staff of Edison General Electric in the final showdown with Westinghouse over the incandescent lamp. Edison had been called to testify on several occasions, much against his will. He hated the public exposure of hearings. What most rankled was the way they took down everything he said, word for word, to be used against him, he suspected, in some unforeseen litigation years later.

He need not have worried. The verdict came on 14th July. The judge ruled in favour of Edison's lamp patents, confirming the Pittsburgh judgement of two years earlier. Whatever the merits of his rivals, the judge reaffirmed, Edison had developed the filament which enabled the commercial exploitation of the incandescent lamp.

It was a hollow victory. After seven years of litigation the lamp patents had only two years to run. The legal costs had been crippling. And against Edison's better judgement, Edison General Electric was secretly negotiating a merger with his other major rival in the electrical business, Thomson-Houston.

That merger came about early in 1892. It was a body blow to Edison. The pooling of patents and manufacturing facilities in what amounted to a trust went against his competitive instincts. He was still passionately opposed to Thomson-Houston's alternating-current system, yet the merger forced him to come to terms with it. Edison's own share in the new company was minimal. He remained a director, but many of his own men did not.

J. P. Morgan lay behind these developments. As banker for Edison General Electric he recognized that a merger would be in his greater interest, even if it involved a betrayal of Edison.

One of the most important things to Edison was his name. He had an insatiable appetite for credit, even when undeserved. Years earlier, in negotiations over what to call a new English company he had insisted that 'the company shall be called the Edison Electric Light Company

Ltd, or at least shall be distinguished by my name without the name of any other inventor in its title. I am bound by pride of reputation, by pride and interest in my work. You will hardly expect me to remain interested, to continue working to build up my new inventions and improvements for a business in which my identity has been lost.'

As Edison's electrical interests multiplied through the 1880s he got his way, by and large, with company names. Edison Phonograph, Edison Electric Light, Edison Machine, Edison Lamp had culminated in 1889 with Edison General Electric.

Now Edison was in for a shock. The company formed from the merger of Edison General Electric and Thomson-Houston was called simply the General Electric Company. Edison's name was conspicuously absent. His secretary at the time, Tate, wrote later that Edison 'had a deep-seated, enduring pride in his name. And this name had been violated, torn from the title of the great industry created by his genius through years of intensive planning and unremitting toil.' This humiliation hurt Edison more than any other aspect of the deal.

Edison now gradually withdrew from his electric-light interests, intensely bruised by the conflict. He was to spend the next few years immersed in his grandiose iron-ore separation project. In self-imposed retreat in the New Jersey highlands he would take on nature herself with his giant mechanical rock crushers, forcing low-grade metal unprofitably from a hostile environment.

In spite of his three patent applications, Edison's attitude to moving pictures remained lukewarm throughout the early 1890s. He was not convinced of their commercial potential. It was with some reluctance that he was to agree to the opening of the first kinetoscope parlours in 1894. As the movie industry took its first faltering steps, Edison's mind was elsewhere.

This indifference was not to last. When it came to a fight over patents, which it would, Edison would not make the same mistake twice. He had learnt enough from the electric-light saga to ensure that his name would not be sacrificed again. He and his lawyers would see to it that the name THOMAS A. EDISON became synonymous with the invention of moving pictures, irrespective of the rightful claims of others.

In the meantime, Lizzie Le Prince waited patiently for the seven years to pass.

Part Two

THE TRUST

On 19th December, 1908, a rogues' gallery of expressionless movie men in dark suits posed for the photographer on the steps of Thomas Edison's laboratory at West Orange. They were the principal producers of moving pictures and manufacturers of moving-picture cameras and projectors in the United States. They were gathered, at Mr Edison's invitation, to celebrate a deal. In a few minutes they would enter the glass doors behind them and drink a toast to their joint control of the young industry. [Plate IV]

It had been a turbulent year for all of them. Lately they had faced a vociferous barrage by an increasingly powerful church lobby which condemned what it saw as the intolerable violence and suggestiveness of moving pictures and wished to see an end to them. In the view of these killjoys, the spate of shameful one-reelers with titles like *Child Robbers*, *Gaieties of Divorce* and *Beware My Husband Comes*, which had recently flooded the market, were corrupting the morals of the nation. What was needed was a ban, or at least severe censorship.

Thomas Edison, whose companies manufactured and produced more moving-picture machines and films than anyone else, agreed with this diagnosis but differed on the cure. Although removed from the day-to-day realities of film-making, Edison took great interest in his motion-picture output. His recent film releases favoured educational and enlightening subjects. He wanted to foster a self-respecting image of America. Where other film companies turned out countless variations on *Trial Marriages* and *Flirtations in the Sand*, Edison could boast *Daniel Boone – Pioneer Days in America* or *Trip Through Yellowstone*.

Who better, then, to counter the threat to the industry than Edison himself? Late in 1907, when the anti-movie lobby had succeeded in closing down the nickelodeons and vaudeville halls for three successive Sundays, Edison was persuaded to pen a message for the industry in the trade journal, *Moving Picture World*.* It appeared on the front page, beneath a full-face photograph. It was a resonant image. Edison gazed out benevolently. His kindly, lined expression told of those decades of late nights spent wrestling with machines and materials for the greater good of America. He exuded the accumulated wisdom of his sixty years,

71

his expression buffeted by the headwind of destiny. When he spoke, people listened.

'In my opinion nothing is of greater importance to the success of the motion picture than films of good moral tone,' intoned the Wizard. 'The five cent theater will prosper according to its moral attitude. Unless it can secure the entire respect of the amusement-loving public, it will not endure.'

For added authority he signed it, Thomas A. Edison, in that familiar mechanized round-hand which had been stamped on thousands of products from the Edison companies over the years. It was a logo with the public intimacy of the Coca-Cola signature, the hallmark of genius, which, as every schoolboy knew, authenticated the originality of Edison's products and the wisdom of his remarks, the gist of which, on this occasion, was a plea to the industry to put its own house in order before the law did so for it.

On the face of things, the would-be movie moguls on the steps agreed with Edison. They recognized that to adopt the mantle of self-censorship, perhaps even officially, would give them the whip hand over the increasing number of cheapskate film-production outfits which were threatening their lucrative business. Better still, to be seen to be carrying the torch of morality would confer a semblance of legitimacy on their determination to monopolize the business.

But this movie men's alliance was deceptive. Behind the united posturing about morality and their stance against the hordes of unprincipled newcomers to the business lay a decade of fierce fighting. This conflict had been among the manufacturers themselves, the men in the photograph, who occupied the top of the film industry pyramid. It was known as the War of the Patents and had raged since 1897, dominating the infant years of the industry.

The War of the Patents was a ruthless legal battle to determine who was the inventor of moving pictures. The issue was not so much one of getting it right for posterity as the far more immediate question of who held the key patents on motion-picture technology. For he who held the patents controlled the rights to manufacture and use motion-picture cameras and projectors, and therefore controlled the industry.

To the men gathered on Edison's steps on that chilly winter day in 1908, the key patents were those which described the most effective and profitable technology. Better apparatus meant better films, better projected, to bigger audiences. It meant more money in a business that was already turning over $14 million a week and rising fast. If you had asked any of this group of seasoned movie men – Selig, Spoor, Kleine, Smith,

Blackton, Marvin, Kennedy – to describe the current state of the art of motion-picture technology, he would have trotted out a list of indispensable features. These would have included motion-picture cameras with a single lens and projectors which utilized a single, unbroken length of transparent, tape-like film; there would be perforations in the film, a device called a loop, and a form of intermittent mechanism for advancing the film upwards of sixteen times a second past the lens.

To their cost, these men all knew that this ragbag of technical characteristics constituted motion-picture technology in the eyes of the law. For ten years, Thomas Edison had been consistently claiming that he had invented the moving-picture camera, and that since he owned all the relevant patents, anyone else who used a movie camera could do so only under licence from him.

The photographer gestured to the man on the extreme left of the group to move further in. This sinister-looking figure was Frank L. Dyer. Until recently he had been the Edison Company's principal attorney. Now he was general manager. In the past decade he and his brother, Richard, had initiated lawsuits on Edison's behalf against almost everyone else in the picture in an attempt to drive them out of the movie business. For years he had been choreographing prosecutions and appeals, plotting move and countermove, to ensure Edison's dominance over the new industry.

This might account for the worn and battered look of everyone in the picture. Most of them had been forced to their knees at least once, only to bounce back again, setting up their semi-legitimate studios and factories on some Manhattan rooftop or down in a Chicago basement, away from the eyes of Edison's private detectives, preparing to face yet again the full broadside of the Edison legal battery.

One of Dyer's more recent manoeuvres had appeared in the same issue of *Moving Picture World* which had carried Edison's message about movie morals. On the inside pages, past the editorial which commended the Wizard's wise words, was an innocuous-looking article by Frank L. Dyer entitled MR EDISON'S PLACE IN THE MOVING-PICTURE ART.

Dyer began harmlessly enough, reflecting on the complex and collective nature of invention, on how all great inventions were foretold by men of vision in the arts, like Jules Verne and H. G. Wells. Next he scampered through the history of moving pictures, politely doffing his hat here and there to various pioneering inventors, such as Muybridge and Marey, cursorily describing failed inventions that had fallen by the wayside. Then quite suddenly his tone changed. Any pretence to historical impartiality was abandoned as he pinpointed the birth of the

modern moving picture to 1889, 'at which time Edison had constructed a camera possessing all the attributes of the perfected apparatus'.

Having established this authoritative claim, Dyer's true intention emerged. In a series of sharp swipes he reminded the trade of the litigation which, as recently as April 1907, had culminated in an alleged 'final' judgement against Edison's chief competitor, the American Mutoscope and Biograph Company (AMC).

> Mr Edison's position in the moving picture art has been judicially determined. He was the first, according to the decision, to make a motion picture camera using a single lens and with a single film, wherein the film is brought to rest and so maintained during each exposure, and is moved forward during each period of non-exposure.

Then came the sting in the tail.

> Until August 1914, at least as I interpret the decision of the Circuit Court of Appeals, no one can make a camera having these features without embodying Mr Edison's invention and being in infringement of his patent.

These kinds of threatening tactics were not new to the men in the picture. 'Pop' Rock, of Vitagraph fame, standing next to Dyer, had long been wise to them. 'Why, man,' he told *Moving Picture World*, 'all they [the Edison Company] have to do is to draw up a general complaint, print fifty or a hundred copies and file suits in as many cities of the Union. This can be done at very little expense, but look at the thousands of dollars that will have to be spent by the other side in engaging lawyers and defending these suits. And you know what a hanger-on in a fight the Edison mastiff is. When he gets through with the other fellows they'll not even have a bark left.'*

But neither Pop Rock nor Edison had reckoned with the tenacity of AMC, represented in the photograph by Jeremiah Kennedy and Harry Marvin. AMC produced cameras, projectors and moving pictures. It was the largest manufacturer in the movie industry, after Edison. Having held out for a decade, it was in no mood to bow to Dyer's crude threats. Instead, it acquired several key projector patents, countering Edison's allegation that it was infringing his camera patents with an assertion that he was infringing its projector patents.

This game of bluff unfolded throughout 1908. In July, Kennedy and Marvin offered Dyer a deal over a luncheon in New York. If AMC and

Edison pooled their patents as equals, in a new manufacturers' associa-
tion, Edison would be guaranteed $150,000 a year in royalties.

But Dyer turned them down. As the months passed, AMC's financial
position worsened. With no truce in sight, Kennedy and Marvin became
increasingly anxious. By December things had come to a head. Taking
a big gamble, Kennedy issued an ultimatum: if the Edison Company
continued to resist the July peace proposals, AMC would proceed to
wreck the industry by flooding the market with its cameras, licensing all
comers, and so destroying the fragile network of price agreements. The
threat worked.*

The Wizard himself is the one with the cap, a sure sign that he worked
hard for a living. But this day was different. He had taken a break from
the lathes and retorts out back to play host to the would-be movie
moguls grouped around him. He is the only one, except Dyer, who is not
looking tense. Maybe his thoughts were elsewhere. Perhaps the absent-
minded inventor was pursuing his next great civilizing project for man-
kind – a technique for cheap concrete housing, a storage battery, a rapid
transit system.

More likely, Edison was inwardly aglow, confident that Dyer had
found a way to maintain his dominance over the industry. This would
explain why the others in the picture look apprehensive. They had come
to celebrate an end to hostilities, but they did not yet trust the truce.
Having known only how to cheat and manipulate one another, it was a
trifle early to trust the warmth of the various extended palms.

Yet that day their resilience paid off. The War of the Patents was
finally over. Shortly, they would leave those cold steps, sit down in the
Wizard's great library, and raise their glasses to making money out of
movies instead of losing it in costly litigation. They had wheeled and
dealed their way towards the formation of the Motion Picture Patents
Company, which would become known in the industry as the Trust.

A WET DAGUERREOTYPE

Lizzie peered out into whiteness, willing some familiar shape to appear. But neither the Statue of Liberty nor the grim outline of Ellis Island materialized. The fog was so thick that even the nearby lighthouse was invisible. Her only point of reference was the ship itself, the SS *Finance*, a small steamer of 1649 tons.

They were at anchor off Sandy Hook at the entrance to New York harbour. Looking aft from where she stood near the bow, she could just make out the mainmast behind a slim smokestack, but beyond, not a hundred feet from her, the rusting superstructure of the old boat simply vanished.

They had been held up for four days. Every morning she had risen early and made her way up on deck where the same dank fog had penetrated her blue taffeta dress as she leant over the cold rail, praying that the blanket would lift, listening for the tautening anchor chain and thrashing screws which would indicate that at last they were moving.

Articulating the space she could not see came the whistles and blasts of the foghorns of fifty more ships whose passengers and crews were just as keen as her to weigh anchor and get going.

It was 7.20 a.m., Thanksgiving, 1908. Lizzie was shivering and missing her *New York Times*. Every morning, when at home, she scanned it for reports about Edison. Lately, his outrageous claims to be the inventor of moving pictures had been given prominent coverage. Each time she came across these gross fabrications her blood boiled. Phrases like 'his patents' and 'his motion-picture interests' made her seethe. What kind of men were these who would so wilfully distort the truth?

In recent weeks Lizzie had noticed that Edison and AMC were considering a merger of their moving-picture interests. This development had reawakened her suspicions, formed years earlier in the opening engagements of the War of the Patents, that these apparent adversaries had conspired to keep Le Prince's achievement from the world.

She had also become aware of recent pronouncements by Edison on the morality of moving pictures, which made her still angrier. 'The hypocrisy of it!' she muttered to herself. 'How can a man who resorts to criminal immorality in business have the gall to preach morality to others?'

What was unbearable was her powerlessness to act on these feelings. Her anger had nowhere to go. Which is why, at Marie's suggestion, she had recently begun to put some of her thoughts down on paper.

They were sailing to Panama, to visit her eldest son, Joseph, his Cuban wife, and their small daughters Julie and Alice, her grandchildren. Joseph Le Prince was spearheading the fight against yellow fever in the Canal Zone, where the great canal project was approaching completion. Lizzie was very proud of him. He was doing something worthy with his life. Although the less said about that Cuban wife, the better. No matter how much Marie tried to convince her otherwise, she was, in Lizzie's bigoted view, a most unfortunate choice.

Never mind. She had come to terms with Hispanic blood in the family. The grandchildren (whom I would meet eighty years later) were a delight. And above all, she was leaving behind the cold New York winter and the long shadows of Edison's manoeuvring.

Or rather, she would have been leaving it all behind had it not been for the delay. Because now, two miles beyond Quarantine, hemmed in by land she couldn't see, the anger that she had counted on shedding began to reform in the vacuum of her boredom. A familiar knot of anxiety tightened in the fog of her morning, and she found herself saying, 'Move, ship. Please move. If we don't leave today I'll explode.'

At that moment nature seemed to answer her prayers. She looked up and where there had been nothing, she could now make out the unmistakable hulk of the stern.

Up on the bridge, Captain Mowbray had noticed it too. It was 7.25 and the fog was clearing fast. Wasting no time he ordered that the anchor be weighed and rang down to the engine room. Tentatively, at quarter speed, sounding her whistle continuously, the *Finance* began to edge down the narrows, steering well clear of the dim outlines of the other vessels in the immediate vicinity, all of which had also begun to proceed cautiously, whistling and hooting, some inward-, some outwardbound.

The *Finance* was a government ship on a regular run down to the Canal Zone. When the fog began to lift, Mowbray's tension lifted with it. It meant both an end to passenger complaints and a chance of reaching Cristobal on time. There were seventy-five passengers on board. Some were government employees, returning from vacations to their work on the canal. Others, like Lizzie and Marie, were visiting relatives who worked down there.

Down in the hold was a cargo of several hundred mailbags. Some contained the regular shipments of the luxuries and necessities that made life bearable for Americans in the Canal Zone. Others held large

amounts of cash to pay the salaries and wages of the thousands of government employees working on the canal. The passengers' luggage was stowed alongside the mailbags. Some, including Lizzie and Marie, were travelling well prepared. Their elaborate portmanteaus were packed with all that was needed for the tropics. Parasols and straw hats lay alongside appropriate white cottons. There were outfits for the elaborate social occasions thrown by the American community and specially ordered protective wear to combat the insects and the humidity of the region.

Early-bird Lizzie felt the gloom fall away as the *Finance* started moving. Behind her, New York was still cloaked in fog. To the east, a patch of brightness indicated where the sun would break through. Her stiff shoulders, hunched by endlessly frustrated hopes, relaxed a little. She embraced the day as if it were a new leaf to be turned over, the blank page that she would begin on. No longer the suffocating uncertainty of how to start the memoirs. She would begin by describing the memento that was so carefully wrapped in her tasselled silk shawl, cushioned by her blouses in the centre of her portmanteau in the hold, the image which travelled everywhere with her, her lucky charm, her assurance that the truth would be told: the daguerreotype.

'My grandmother told me that she would not take me to England until I had learnt how to take the top off a boiled egg,' Julie said.

'With a spoon?' I asked.

'No. With a knife,' she said emphatically, before dropping from view behind the open lid of her old leather suitcase. 'Now then, what else have I got to show you?'

The exquisitely framed image of the Le Prince family in the late 1840s which Julie produced was no ordinary daguerreotype. It was taken by Daguerre himself. [Plate V] It shows Major Louis Ambroise Le Prince, an officer in the service of Louis Philippe, presiding over his family. Two small boys in frocks stand on each side of his wife, Elizabeth Boulabert, their symmetry echoing her ringlets. On the left, seven-year-old Albert, a little taller than his younger brother Augustin on the right. The family group appears stiff, but their apparent discomfort is due more to the long exposure than to any awkwardness with the photographer. The major was a friend of Daguerre. Albert and Augustin often played in and around his studio whilst visiting with their parents.

I took a closer look at Augustin. He seems to lean in more towards his mother than Albert. Perhaps Daguerre had asked her to pull him more into the picture, or she was simply drawing her youngest closer to her. The child Augustin is not looking at the camera like the others. I

wondered what had caught his eye. Was he displaying the insatiable curiosity of a future inventor, wondering about the strange pieces of apparatus at the back of Daguerre's studio, or just plain bored? I reserved judgement, but Lizzie would have preferred the former interpretation. This talisman of hers was a photograph of her dead husband as a boy, a portrait of the inventor of moving pictures by the inventor of photography.

'She loved that Yorkshire fruit. What do you call it?' Julie asked.

'Rhubarb?' I ventured.

'Rhubarb!' she echoed triumphantly. 'She couldn't get enough of it. She used to grow it wherever she could. We used to get it for dessert all the time. I hated the stuff, but she made me eat it all up.'

There were as many ships held up outside New York harbour waiting to get in as there were inside waiting to get out. One of these was the White Star freighter *Georgic* which, at over 10,000 tons, was much bigger than the *Finance*. She was carrying, among other things, Schmergel's quartet of musical elephants who were due to play in a jungle orchestra at the hippodrome in Manhattan later that week.

Captain Clarke of the *Georgic* was impatient to get moving. The elephants were tiring of their confinement. Fodder was running low and the hold was fetid with dung. At about the same time as the *Finance* started inching east, Captain Clarke, who had also noticed that the fog was clearing, gave instructions to proceed westwards at quarter speed. With regular blasts of her horn, the *Georgic* moved into the main channel towards Quarantine.

At 7.35 Captain Mowbray, aboard the *Finance*, prepared for a delicate manoeuvre. To reach the open Atlantic he had to make a starboard turn south, across the pathway of the incoming ships in the main channel. In spite of the lingering fog, he knew that he had reached the correct position for such a move because above the cacophony of foghorns and whistles he could hear, but still not see, the Number 5 bellbuoy on his starboard side.

All the two captains could later agree on was that they sighted each other when only a few hundred feet apart. Then the argument began. Captain Mowbray claimed that he gave the *Georgic* three blasts and blew the danger whistle, assuming that the *Georgic* would respect right of way to the outgoing craft. But to his horror, the *Georgic* still came on, so he stopped his engines and rang for full speed astern.

Captain Clarke saw it differently. If the *Finance* had proceeded ahead, he claimed, the collision would have been averted.*

* * *

Lizzie was oblivious to the quiet throb of the approaching *Georgic*. She was so immersed in her dark thoughts about Edison that she failed to register the extra-sharp exchange of blasts between the converging ships. When the black bows of the ship lurched out of the fog, she reacted too late. All she could later recall was the sharp intrusion into her reflections of ripping steel.

The *Georgic* hit the *Finance* a slanting blow on the port quarter at 7.40 a.m. The steel cutwater of the larger ship penetrated the *Finance* below the waterline like a knife into cheese, tilting her upwards and over. For a few seconds the *Finance* seemed to lie on her beam ends. Captain Clarke aboard the *Georgic* rang for full speed astern and as the *Georgic* withdrew the stricken *Finance* righted herself. But a great hole now gaped where the *Georgic* had hit her and she rapidly started sinking.

Captain Mowbray reacted quickly, immediately ordering his crew to lower the lifeboats. Passengers ran from every part of the vessel, many in their nightclothes, some with children in their arms. Stokers and engineers clambered up every ladder and companionway from the heart of the vessel, pouring on to the deck. Up on the bridge, Captain Mowbray drew his revolver and threatened a terrified crew member who was pushing his way into a lifeboat. 'Now, men,' he shouted, 'there's going to be no crowding, and the women and children go first.' But his voice was drowned out by the loud rattle of chains as the nearby *Georgic* dropped anchor and ten more lifeboats were lowered down her towering steel sides to join those round the stricken *Finance*.

A dull boom from within the hull of the *Finance* added to the confusion. It was the ammonia tank exploding in the forward hold. Within a few seconds more men appeared on deck from the engine room, supporting Todd, the third engineer, who, overcome by ammonia fumes, staggered to the rail clutching his face, steadied himself briefly, then jumped. The first casualty.

Where was Lizzie? In the pandemonium that followed the collision she was hit hard on her left breast by a falling spar. Numbed by the blow, she was caught off balance by the sudden list of the ship, and toppled over the rail into the water, where, thanks to that taffeta dress which had trapped a large airpocket within its folds, she bobbed doll-like in the brine.

The water was calm but very cold. Lizzie had only one thought, the daguerreotype. She imagined the sea pouring into the hold of the *Finance*, mingling with the bilge water, slopping round her portmanteau. She pictured its seepage as it soaked the sheaf of notes she had drafted for her memoirs, penetrated her carefully pressed tropical wear, wrecked her sketchbook of double Ingres paper, and found its way

through the tasselled silk lace of her mother's shawl to the cosseted daguerreotype.

Lizzie lifted a heavy arm towards the sinking ship, gesticulating with great effort to two crew members trying to break the cramped hold of a terrified black servant girl who would not let go of the rail. 'Rescue my belongings before it's too late,' Lizzie wanted to shout at them. But she couldn't find the words. And anyway, it was already too late. The salty acids had eased their way round the glass and even now were corroding the metal surface that bore the boyhood image of her beloved Augustin.

On deck, the black servant girl, Irene Campbell, still would not let go of the rail. As the water sloshed around her ankles, her screams grew louder. Unable to prise her from the rail, the two crew men gave up and looked to their own safety. At that moment one of them caught sight of Lizzie gesticulating. Thinking she wanted a life preserver, he tossed one towards her and then jumped overboard. Irene Campbell sank with the ship, the second casualty.

In the hold of the *Georgic* the musical elephants sensed that something was up. The noise had disturbed them and they had begun to smell panic in the atmosphere, so Madame Nellie, their leader, decided to add to the brouhaha. Up went her trunk, and to the wail of foghorns and whistles, the rending of steel, the dong of the bellbuoy, the shouts and the screams, she added her trumpeting melody. Shortly she was joined in pachydermic counterpoint by her three anxious companions.

The *Finance* went down in seven fathoms of water, settling quickly on the bottom. It was low tide. The rusting superstructure of the ship remained above the waterline. Captain Mowbray had anticipated this and remained on board where he waited despondently for a boat from the *Georgic*, worrying about the insurance claim and the already clamouring salvage vessels.

There were only four casualties. Everyone else was picked up, including Lizzie, who within ten minutes of falling into the water was shivering on the deck of the *Georgic*.

'You must come below deck now, Mother,' Marie repeated, wrapping a blanket tightly round Lizzie. But Lizzie was as oblivious to Marie's pleas as she was unaware of the injury to her breast. Staring down at the water, she felt like the *Finance*'s deck furniture, already so much flotsam, knocking against the hull in the freshening wind. She was floating in the memory of her belongings, stunned that her most private attempt to embark on telling the world the truth had been sabotaged. Conspiracy. Already she was convinced that somehow Edison himself was the cause of the collision, that yet again he had silenced her, manipulating some unseen magnetic forces to draw the *Georgic* on to the *Finance*.

A few minutes later, she felt a throbbing in her breast. Her whole body began to shudder with the shock and the cold. She could not move. The throbbing became a dull ache, which with each passing minute became sharper, until her whole chest felt as if it were gripped in a vice. Then she lost consciousness.

It was getting dark by the time they brought her ashore at New York's Panama pier. She opened her eyes to night sky framed by strange bobbing heads. She was flat on her back, bouncing along. Where was Marie? A man was sitting next to her. He wore a stoker's hat and coarse woollen overcoat which he insensitively allowed to rub against her cheek. If Marie were there she would tell him to move. The pain came again, like hot needles. She moaned. The man turned to look down at her. He had Marie's kind eyes, and spoke with her voice. How odd. 'We're taking you to hospital, Mother. Not much longer now.'

She looked up through the ambulance window. Was she dreaming? Chariots hovered high in the sky through a rhomboid-shaped window. Manes flowed, legs galloped, wheels spun in a celestial contest defined by a thousand surging pinpricks of white light. It was like a vision of heaven. Or hell. Because now a glowing message materialized above the hoarding, blazing the words LEADERS OF THE WORLD. EDISON PHONO-GRAPHS IN EVERY HOME.

A man's voice was droning in her ear. 'It has 20,000 light bulbs and flashes 2500 times a minute. There are over 70,000 connections.' She craned her neck towards the source of the voice and glimpsed poor Marie, dressed in the woollen coat and the stoker's hat, patiently listening to a man who looked like a doctor.

'Quite something to get it up there,' he continued, pointing up at the advertisement. 'Did you know that it's automatically operated by 2750 switches? Did you see that moving picture, *Ben Hur*? It's based on that.'

Lizzie shut her eyes, wishing the man would shut up. Then she lost consciousness again.

MAKING HISTORY

After posing for the photographer on the chilly steps of Edison's laboratory at West Orange, America's most powerful movie men went inside and sat down at a long table in the centre of Edison's great library where an elaborate banquet had been laid out on a white tablecloth. It was an impressive room. Books lined the walls on all sides, reaching up through two galleries to the ceiling. Panelling, columns and balconies conferred a hushed sense of genius on the room. [Plate VI]

The hungry movie men were not taken in by these blatant aspirations. Nor were they much impressed by the countless photographs of the Wizard in the company of famous people or the patchwork of telling certificates which authenticated his achievements.

Waiters hovered. The movie men talked a little business and kept an eye on the rounded shoulders and straggly white hair of their host who was sitting at a large rolltop desk commanding the room. Apparently oblivious to them, he was pondering the results of his latest experiments to find a synthetic rubber substitute. He was scruffily dressed. His jacket was worn at the elbows. His trousers hung baggily at the knees. A bowtie clung precariously above the strained buttons of his waistcoat. But to the movie men this apparent indifference to appearances was all part of a cultivated image of calloused practicality, through which he conveyed the impression that any time away from the workbench was time lost, that such sumptuous occasions were begrudged luxuries in a world of necessary hard graft.

The buzz at the table subsided. It had been cold out there on the steps and their stomachs were rumbling. When would the meal begin? Frank Dyer had a word in the Wizard's ear. Edison slid down the rolltop of the desk with a clatter and turned to face the room. 'Anything for me to sign yet?' Polite laughter. Instead of joining them at the table, he picked up a bread roll and said, 'You boys talk it over while I take a nap,' before retreating to an alcove, where he lay down on his cot and promptly dropped off to sleep.

Edison could afford to catnap. Dyer had got him a good deal. Not only would the Edison Company retain a major share of the royalties,

but – and this was of more significance to Edison – he would finally be perceived as the undisputed inventor of the motion-picture camera; while from the point of view of the movie men at the table, all parties, including AMC, had now pooled all their patents in the new Motion Picture Patents Company, through which they now held complete sway over moving pictures in the United States.

After the meal, the Wizard woke up and gave a short speech. 'Gentlemen, I welcome this truce. I've spent too much time in the past forty years in litigation. And far too much money.' He paused. A squirt of tobacco juice arced down from the corner of his mouth towards a nearby spittoon. The movie men could guess what was coming, but from now on Edison's lying would become acceptable to them. They had traded the small matter of historical truth for power and dollars.

'Gentlemen, the motion-picture art was created by me,' Edison proclaimed. 'I made possible, for the first time, the securing of a permanent photographic record of a scene including movement, a thing never before accomplished.' He paused, as if challenging them to contradict him. A few exchanged glances. Others chewed their lips. But no one objected.

'Gentlemen, whenever I've produced anything of value, a host of inventors have suddenly sprung up with claims that they preceded me.' Edison eyed Kennedy and Marvin pointedly. 'I remember one fellow who swore he'd invented one of my machines before I did. But we found out where he had his built. And the records showed it was made a long time after I had put my machine on the market. He simply copied my mechanism, rusting it all up to give it the appearance of age. And I was forced to waste good money defending myself against him in the court.'

Laughter. Dyer nodded approval. His plan was succeeding. The Wizard had won them over and was pausing for a chew on his tobacco. 'Gentlemen,' he continued, 'like many of you here, I've learnt that there is no justice in the law. It's all writs and technicalities, argument and paperwork bandied back and forth from court to court, while the lawyers take our money.' Dyer feigned offence for the benefit of the movie men who were tapping their knives on the table, urging Edison along with bursts of applause.

Edison raised a hand. They fell silent. He raised a glass. 'Gentlemen. I'd like to propose a toast to the Motion Picture Patents Company, and the undeveloped land of opportunity which is destined to play an important part in the growth and welfare of the human race.'

Part Three

A BEGINNING

M arie loved her solitary walks by the surf. It meant time away from Lizzie, who had become so demanding of late. She was making for the Point O' Woods lighthouse, that familiar first landfall for transatlantic steamers homing in on New York. Far away, a lone rider receded, leaving a trail of dark hoofmarks across the sand. A great bank of dunes cut her off from a cluster of summer homes. Far out to sea, the smoke of a steamer smudged the clean line of the horizon.

A sharp wind whipped the crests of the waves. Crisp sunlight scorched her winter complexion. A formation of wild duck winged out to sea, turned on a wide curve, and headed back over the dunes to the calmer waters of the bay beyond. Marie strode on, thinking about the day's work and how much more they had to do. Sometimes she wondered whether her mother would ever finish. These days Marie seemed to spend almost all her spare time at the Underwood, typing up Lizzie's scrawled draft. No sooner had she completed one page, than her mother wanted to make some amendment. An emphasis wasn't quite right, or, worse, she'd have second thoughts about the placing of a whole chapter.

This is how they'd begun:

Louis Aimé Augustin Le Prince, the inventor of moving pictures, was born in Metz on August 28th, 1841. His father was at that time stationed at the fortress. He was a major of artillery in the service of Louis Philippe.

Augustin's childhood had the color and movement that belongs to the somewhat nomadic life of an army officer's family.

They had disagreed at once. Marie hadn't liked the phrase 'color and movement'. To her it seemed too obviously prophetic. She preferred 'restlessness', but Lizzie thought the word suggested unhappiness.

Marie had felt the same about what followed. 'Moving from post to post at short notice is often more picturesque than comfortable,' Lizzie had written. 'But children love change, and see things from their own standpoint rather than their mother's. Perhaps meeting many people in varying scenes tills the mind for new thought.'

'It's too contrived,' Marie had said. But Lizzie was adamant that she wanted those words and had accused Marie of wanting to belittle Le Prince's achievement.

She reached the lighthouse. For a few years now it had become progressively landlocked by the sand, swept west by the undertow and now stood at some distance from the ocean. The days of its vigil were numbered. Marie walked round it twice, waved to the keeper, then headed back the way she had come.

One of her pleasures on these long afternoon walks was to retrace the meanderings of her previous footprints in the sand. But today they had been washed away by the rising tide.

Halfway back, she cut away from the surf towards some wooden steps that climbed into the dunes. She found the spot easily, a sheltered hollow, well out of the wind. A column of ants was having some difficulty negotiating its dry sandy gradient. Their efforts were buried by an avalanche as Marie clambered down. At the bottom she picked a small bunch of dune grasses and shaped them into a crude cross. Then, kneeling down, she wrote the words 'In Memory of Dear Adolphe' in the sand with her forefinger and placed the grass cross gently next to them.

Lizzie was lying in her hammock on the veranda, still drowsy from her afternoon rest. The air was thick with the scent of pine resin. Above the insect buzz she could hear the crashing of the waves beyond the dunes. Through open screen doors that led into the living room, she could see the large black typewriter threatening from a low bamboo table. It was surrounded by a confusion of pencilled notes, faded official documents, old dockets and photographs. Beyond 'the work in progress', as Marie called it, her four-year-old husband-to-be stared out from the daguerreotype on the bookshelf. [Plate VII]

Somehow the divers had got it up from the wreck. Working in virtual darkness and near-zero temperatures, they had located her trunk and manhandled it up to the surface. The precious image was wet through but intact. Marie had it rushed to a photographer who saved it from the corrosive effects of the brine.

Looking across at the image of her vanished husband as a boy, Lizzie wept quietly. It was a familiar communion. Lately, she had been unable to indulge her unhappiness in quite the way she liked because she could not get comfortable on her favourite left side. A tender scar and bruised ribs remained where her breast had once been. The falling spar had led to a mastectomy. The trip to Panama had been cancelled and she had spent most of the winter in a New York hospital bed. Now, with summer

coming, she had escaped the city to convalesce at her summer home at Point O' Woods, on Fire Island.

Of course, she knew that if she changed ends in the hammock she would have been able to continue her reverie about Augustin painlessly, by lying on her right side. But she couldn't quite face the tangle and turned over instead to gaze out through a regiment of red geraniums in window boxes, across the scrub and young pines which stretched away from the house to the sand dunes beyond.

Where was Marie? Surely it was teatime? The community was waking from its afternoon snooze. Cries of a disputed score drifted across from the tennis court. A young couple cycled by on the track that passed in front of her house. A flurry of activity outside the kitchens of the yacht club beyond signalled some kind of do in preparation for the evening.

Was that Marie? Some way off, a woman in a cream linen dress and straw hat was making her way slowly towards the house through the dune grasses. Lizzie swung her legs off the hammock, sat up, and composed herself. Marie must not see that she had been crying again. The poor girl had quite enough to put up with as it was.

She picked up a pair of secateurs and turned her attention to the geraniums, snipping away at the wrinkled dead leaves to make space for the bright green shoots which were just pushing through. They were a loyal strain. She had brought a cutting with her from Leeds nearly forty years earlier. Somehow it had weathered the crossing. Through years of judicious pruning and cutting, the glorious red flowers had survived. What she loved about them was how they thrived in adversity. When she was down, as she so often had been in recent yers, she had only to turn to the spirited example of these Yorkshire survivors.

Marie's feet sounded on the wooden steps beneath the veranda. Lizzie left the window boxes and retreated into the living room where she sat herself down at the bamboo table and began scribbling away.

Marie breezed into the room. 'Tea, Mother?'

Lizzie held up her hand. 'In a moment. I've had another go at that opening bit. How does this sound? "He had happy boyhood memories of vacations spent with his mother's relatives in their vineyards on the shores of the Mediterranean. His earliest landscape sketches are of Cette and Montpellier." '

The train pulled out of Wakefield. In the past two hours the flat English Midlands had given way to gently rolling countryside. Le Prince had felt the locomotive labouring up the long shallow gradient into Yorkshire. Sometimes the drivewheel had spun with the strain. Now they were in Pennine Hill country. The colour of the landscape had changed. The

valleys were well cultivated but on the hilltops lush greens gave way to brackenish browns and dark rocky outcrops.

The straining chuffer-chuffer of the locomotive relaxed. The train had reached the top of the last gradient and was beginning to coast. John leant forward and pointed out of the window. They were passing an open cast mine. Men and horses were hauling rickety wagons of coal up the steep tracks that led from the quarry bottom. A few miles away, down in the valley, a pall of coal smoke drifted east from a forest of tall chimneys. It was Leeds.

The two young men had met in Paris. John Whitley had looked up Le Prince on the recommendations of his professor at the University of Leipzig, where Le Prince had been studying optics. The two discovered a shared love of science. They became friends and Le Prince was invited to meet John's family. Which is why, in 1866, this twenty-five-year-old Frenchman found himself on the London–Leeds train in the company of his future brother-in-law.

Since leaving the University of Leipzig Le Prince had not embarked on a professional career. Coming from a reasonably wealthy background, he had had no need, as yet, to earn a living. Instead, he had travelled widely in Europe, devoting his time to painting and photography. This relaxed life was about to change.

John Whitley recognized that his new friend's grasp of modern languages and science made him potentially very useful for the family business. Whitley Partners, brass-founders, of Hunslet, manufactured and supplied pipes, boilers, valves, governors and all things brass to the buoyant Leeds steam locomotive industry. The firm had been established in 1844 by John's father, Joseph Whitley. From small beginnings it had grown rapidly with the expansion of the railways to thrive through the long boom of the 1850s and early 1860s. Trade was not just locally oriented. The mushrooming rail networks of Europe were offering lucrative new markets. John saw that the family firm could benefit greatly with a company representative like Le Prince on the ground in Paris.

The train entered the city outskirts, snaking along a viaduct. The wheel flanges screeched as they negotiated the twists of the track. They were now passing through the mills and forges of industrial Leeds. It had been raining, which, John assured him, was not unusual. Light glistened from the cobbles of streets full of heavily loaded wagons. Across the rooftops a great clock hung over the classical portico of the town hall. 'It was paid for by the employers of Leeds,' John explained. 'The pride of the city.' He pulled out his pocket watch and adjusted it. 'We time the foundry clock to it. It gets the hands to work on time.'

Le Prince took it all in. Showers of sparks leapt from dark interiors as molten metal flowed into moulds. An empty coal train clattered past on its way back to the coal field. The slow counterpoint of connecting rods flashed from the engine house of a textile mill. A crane was unloading huge rolls of raw cloth from a barge. The rhythmic clank of steel against steel punctuated the air. The scale of this industrial development was bigger than anything he had yet seen.

'I was born over there.' John gestured towards a dense cluster of buildings. 'Right by the river, and it stank. A tenement in the middle of town. Some of my father's workers even lived in the same building. We were all crowded in on top of one another. You could hardly tell master from hands.' John smiled. 'Don't worry. We don't live there now. My father had a house built out of town, well away from all this. Our mother wanted us to grow up in the fresh air.'

The train juddered to a standstill. John spotted his father immediately. 'There they are. He's brought my sister as well.' Le Prince looked out of the window. A man of about fifty, sinewy, with a creased top coat and battered beard, was busily organizing porters, at one with them, yet giving the orders. A young woman stood close by him. She smiled and waved at John. 'That's Lizzie,' he said to Le Prince, then, pointing him out to her he mouthed 'Augustin'. [Plate VIII] Le Prince smiled. She dropped her eyes, disappearing from sight as the passengers poured on to the platform.

THE PEET VALVE

The great showcase of Second Empire France was the Exposition Universelle of 1867. This glorious celebration of the decadence and excesses of Louis Napoleon's dictatorship was also, like the British Great Exhibition of 1851, a display of industrial achievements. Whitleys exhibited, hoping to exploit the opportunities opened up by the recent French rail booms which had created an enormous demand for rails, wagons, locomotives and carriages. Although these were for the most part manufactured in France, the components market was wide open. French railway engineers were hungry for the range of reducing valves, regulators, steam traps, disc-lip valves, governors and other steam-related devices which firms like Whitleys manufactured and supplied.

Whitleys did well at the exhibition. That the firm received the Highest Prize Medal for Improved Construction, Excellence and Superior Workmanship was due in part to the efforts of their new French representative.

Le Prince's first visit to Leeds had lasted several months. Through Joseph Whitley he was introduced to the heads of several large engineering concerns. Taking his future father-in-law's advice, he donned overalls and went to work in their machine shops and drawing offices. When the time came for him to return to Paris he had made detailed drawings of many of their products which put him in a good position to act as their representative as well as Whitleys'.

As well as grounding him in the realities of engineering and draughtsmanship, Le Prince's work with Whitleys provided him with a basic experience of business. Whitley was well qualified to teach him. Familiarity with the ins and outs of patent law, for example, was essential in a world where competitors were always ready to poach someone else's process or innovation. Legal battles were endemic to a business in which the perennial quest for loopholes in the shaky paragraphs of patent specifications could take up almost as much time as manufacture itself.

Whitley was fascinated by the process of invention, which was as important to him as commercial success. He was an inventor himself,

keen on evolving new casting processes, and he was always on the look-out for other men's inventions to manufacture under licence. Survival had meant paying careful attention to the small print of patents and contracts, and the driving of hard bargains.

It was a dusty Leeds afternoon. Traffic roared through what had once been the thriving community of Sheepscar, penning in the squat red-brick archive on all sides. Nearby they were sinking the piles for a new mosque. I rang the bell. Keys jangled on the other side of the door. A friendly assistant let me in.

There was a dry quiet inside. I was led up a stone staircase, past fire-control boxes and humidity meters, and shown to my table in the reading room. Several other people were in the room, hunched over documents, embroidering tenuous pathways of history.

A man in a brown coat appeared. I asked for the Whitley papers and followed him back down the stairs. The vaults were full of steel shelving stacked high with boxes of documents. He disappeared down an aisle mumbling, 'Whitley, now then, Whitley, where were they?'

I hovered, overwhelmed by the raw stuff of history. The space was crammed with connections waiting to be made. All around me, tens of thousands of old bills, summonses, letters and bank statements lay dormant, waiting for reanimating discovery by some researcher. In the face of so much material my quest seemed hopelessly arbitrary.

The man in the brown coat reappeared carrying two boxes. 'Christ, these are heavy,' he said. 'What's in them?'*

Back upstairs I opened one box. The first thing that caught my eye amongst the sheaves of documents inside were three hefty brass taps. I picked one up. Engraved in the brass on one side were the words 'Peet Valve Patent 1867'. Beneath that was an insignia with the words *Fit Via Vi* – the Whitley family motto. When I turned the tap, two small brass discs made immaculate closure inside the pipe.

Beneath the taps were hundreds of legal briefs and agreements, each neatly tied with a pink ribbon. They were covered in black soot which had been gathering for a century in some Leeds solicitor's attic. I picked one up gingerly and tugged at its bow. From the shape of the knot I could tell that it had never been untied. The first letter began, 'Dear Mr Peet'.

The Peet Valve episode is an everyday tale of the rough and tumble of Leeds business life. It starred Joseph Whitley. Le Prince had only a bit part, but the story paints a vivid picture of the kind of world he was thrust into.

Mr Samuel Peet of Boston, Massachusetts, invented a valve. It was

designed to withstand the high pressures of steam technology. When turned off, with the valve closed, not even a drip escaped through its cleverly constructed brass mechanism. It came in twenty different sizes. He called it the Peet valve, and patented it.

In the mid-1860s, Joseph Whitley spotted a demand for such a device and agreed with Peet to manufacture it in Leeds, under licence. Whitley would then market the valve at an agreed price on which Peet would receive a royalty.

Manufacture of the valve required the installation of the necessary plant in the Whitley foundry. This considerable investment was in line with John Whitley's ambitions to expand the company. To finance it, father and son solicited a number of £1000 loans from colleagues and friends who agreed to a share of two and a half per cent of the net profits on the sale of the valve.

One of these investors was Le Prince, evidently not short of money at the time. With this loan Le Prince became a partner in the firm. He was also paid a nominal salary for his Peet-related work, part of which involved organizing the French marketing of the valve.

The arrangement with Peet worked for a few years. But then Whitley noticed an unaccountable drop in European sales. On making enquiries he discovered that the Peet patent was being severely infringed on the Continent by firms who had copied the valve and were selling it at a price well below his own. To avoid losing the market Whitley cut his prices accordingly.

Back in Boston, Mr Peet noticed that his royalties were not what they should be and suspected that Whitley was not being straight with him. A rancorous correspondence ensued which resulted in Peet making a clandestine visit to Leeds to find out for himself what Whitley was up to.

The first that Whitley heard of Peet's spying mission was from some of his workers who reported that a strange American had been asking them very specific questions in the pub opposite the foundry, after work. He wanted to know how many Peet valves Whitley was producing.

Whitley was furious at Peet's underhand methods. His anger was compounded when Peet took legal action. In 1873, a Complaint by the Peet Valve Company versus Whitley Partners requested Whitley to present his Peet valve-related accounts. In this way Peet thought he would get a clear idea of how many valves the firm was making and consequently how much royalty he was losing.

To Peet's astonishment, Whitley used this exercise to turn the tables on him, claiming that, due to the size of the capital expenditure that had been necessary to commence manufacture, Peet owed Whitley

back on the excess royalty they had paid him. The furious Mr Peet counterclaimed that the accounts had been falsely inflated to justify the reduction in commission.

An agreement was finally arrived at, by which prices and maximum discounts on the valves were agreed. But not before production had suffered to such an extent that the large investment Whitley had made looked in jeopardy. So much so that Whitley advised Le Prince to settle for thirteen per cent interest on his loan rather than wait for his share of the profits.

It took me most of the morning to wade through the Peet valve documents. The Whitley boxes still contained much that I hadn't examined, but my note-taking was becoming lazy. I looked at my hands. They were black. It was time for lunch.

A handwritten note in the wash room read: PLEASE LEAVE THIS BASIN AS YOU WOULD HOPE TO FIND IT. Sooty water spiralled down the plughole. I dried my hands on the wet tail of a roller towel and hoped that the next batch of papers would yield more about Le Prince himself.

The jarring of the typewriter keys stopped. Marie leant forward and scrutinized Lizzie's handwriting. 'Don't you mean Houdini?' she asked.

Lizzie scoffed. 'No, I don't. I mean Robert-Houdin, not that little Italian escapologist who stole his name.'

It was late afternoon and they were starting to bicker. Suddenly Marie had had enough of pandering to her mother's needs. She snapped back. 'It's no use mentioning Houdin unless you say who he was and what he did.'

This time Lizzie refused to be provoked. Instead, she turned to a much-fingered photograph of Le Prince which lay on the bamboo table. His passionate dark eyes gazed back at her. The twenty-two-year-old Augustin wore a black beard and moustache. Locks of thick wavy hair fell over his forehead. One hand was thrust deep into the pocket of thick dog-tooth-check trousers, the arm holding back a well-tailored top coat. There was an affluent casualness about him, but no sense of arrogance. If anything, he looked withdrawn and self-effacing. No wonder she had fallen for him. [Plate IX]

'We must use this photograph, Marie. He was so very good-looking.'

'So was she, Mother.' It was time to appease her.

Lizzie looked surprised. 'So was who?'

Marie twinkled back. 'We should put in a picture of her.'

Lizzie smiled at the memory of their courtship. It was 1869. Her parents had taken the enlightened step of sending her to study ceramics in Paris. For two years she had been a student of Monsieur Carrier-

Belleuse, learning new pottery techniques. Every time Le Prince visited Paris on Whitley business, they had seized the chance to be together.

Their relationship had flowered amidst the movement of the world's first modern city. They strolled along the new boulevards, stared at holes in the ground where old houses had once been, coughed in the dust of demolition, watched the *poseurs* and *flâneurs* in the Tuileries Gardens, saw Impressionist Paris, visited the Salon, mingled with the crowds as they ridiculed Cézanne and disagreed about Manet.

Le Prince's mother lived in Paris. Lizzie was duly introduced and invited to spend a summer vacation at the Le Prince summer home in the Marne valley. Several of Le Prince's relatives worked small farms and vineyards in the area. Lizzie was welcomed by the family. She was bowled over by the contrast between French and English home life. The French had such style. The food was so much more imaginative. At great reunion dinners she would watch in awe as family members punctuated the endless courses with wittier repartee, riskier family gossip and more acute observations than anything she had been used to around the more hidebound dinner tables of Leeds.

Rat-a-tat. Marie tapped the space bar impatiently. She was waiting for her answer. 'Who was Houdin, Mother?'

Lizzie paused, searching her memory. 'We saw one of his shows on our wedding journey. In one of his tricks he created an illusion of transparent moving figures. Your father was fascinated. He kept going back to see it again.'

'What kind of device was it, Mother?' Marie wanted the facts right.

'I think it involved revolving mirrors, but I can't be sure.' Lizzie waved her hand dismissively. 'It doesn't matter what it was, Marie. Optical toys were commonplace in those days. The point is, Houdin inspired your father with the moving-picture idea. His enthusiasm goes back that far.'

What Le Prince probably saw were Houdin's remarkable banks of dissolving magic lanterns which created an effect of movement across a very large surface.

Robert-Houdin was a celebrated French illusionist. He had started working life apprenticed to his watchmaker father. Years of repairing clocks and building automata inspired him to apply mechanics to magic. By the middle of the nineteenth century his Theatre of Magic had captivated Europe. Audiences flocked to gasp at his act. In the Orange Tree trick, flowers and fruit burst into life 'at the request of the ladies'. His Writing and Drawing Figure was particularly popular too. Houdin would stand next to a carefully constructed automaton and ask, 'Who is the author of your being?' At the discreet press of a button the

mechanical figure bowed, and then proceeded to trace Houdin's signature on a sheet of paper. Other tricks included the Cabalistic Clock, the Inexhaustible Bottle and the Miraculous Fish.

In Houdin's work Le Prince would have found a crystallization of the facets of his latent moving-picture interests. As a young engineer, he would have been attracted to the magician's use of machinery and electricity. His interest in optics and painting naturally drew him towards Houdin as a purveyor of visual illusions. The combination of these skills with showmanship would have very much impressed the young Le Prince. Had he known that at this time the elderly Houdin was engaged in a serious study of retinal optics, he would have been even more in awe.

It was evening. They had fulfilled the day's writing quota and were taking their pre-dinner walk down the lane behind the house. A deer heard them coming and crashed away through the undergrowth. Toads croaked. The roar of the ocean had quietened. Lizzie's feet sank into the dry sand underfoot.

Marie offered her mother an arm. 'So I didn't see much of him when I was a baby?'

Lizzie let out a long sigh. 'None of us ever saw enough of him, my dear.'

THE SIEGE OF PARIS

Lizzie and Augustin began married life in Leeds. They lived with her parents where, quite soon, she became pregnant with Marie. What promised to be a joyful pregnancy soon turned out otherwise. In July 1870 France declared war on Prussia. [Plate X]

At first everyone thought that it would all be over in a matter of weeks. What match was Prussia against the glory of Louis Napoleon's Second Empire? A wave of exultation swept through Paris. France mobilized. In late July, the Emperor led an army of 250,000 men rapidly east towards Prussia.

The early news was promising. Saarbrucken fell to the French on 2nd August. Paris rejoiced at the victory. It was reported that the Prussian Crown Prince had been captured. Defeat of the Prussians seemed imminent. Berlin lay ahead.

It was a short-lived exultation. A disciplined and well-equipped Prussian army of 400,000 was watching from high ground as the French entered the trap. Within six short weeks, culminating in the crushing defeat at Sedan, the Emperor had capitulated to Bismarck. Nothing now lay between the Prussians and Paris.

The Second Empire fell on 4th September. Louis Napoleon was taken prisoner. The heart of Republican France, so viciously repressed for the past two decades, poured on to Haussmann's new Paris boulevards, crying, *'A bas l'empire, vive la république!'* and prepared themselves for the inevitable siege.

Britain's stance in the Franco-Prussian War was officially neutral. This didn't prevent a lively response from the thriving British armaments industry. A war in Europe created a demand for munitions and weapons. There were profits to be made.

For some years, Joseph Whitley had been attracting the interest of gun manufacturers with his methods of centrifugal casting. With the outbreak of the Franco-Prussian War he was summoned to the Woolwich Arsenal to offer his advice. Somehow the press got to know of his visit. When he returned from London he found Lizzie waiting in his office with a man from the *London Daily News*.

It was late in the day so Whitley invited the man home. Over dinner he probed Whitley about his visit to Woolwich Arsenal. In return he told fascinating stories of adventurous assignments. When the time came for him to leave, a violent storm blew up, so Whitley invited him to stay the night. A little while later Le Prince, who had been out for the evening, returned home and met the reporter, who left the next morning. Unknown to the two men at the time, this encounter would save Le Prince's life.

As the situation in France worsened, Le Prince became concerned for his mother in Paris. A Prussian invasion would put her in danger. He consulted his brother Albert in Dijon, who was also worried about his own wife. They decided that Le Prince should go to Paris and take both women back to the safety of Leeds until things had blown over.

This did not prove easy. On reaching Paris, Le Prince went straight to his mother's to help her pack. His plan was to meet his sister-in-law off the Dijon train the next morning, then all three would travel straight on to London.

But in a strange anticipation of his own fateful journey twenty years later, his sister's train was delayed until late afternoon. On the spur of the moment, Le Prince decided to use the time to visit a sick relative, who, when he heard that Le Prince's mother was leaving Paris, asked Le Prince to take her a bouquet from his garden. The flowers were red, white and blue.

The route back to his mother's apartment took Le Prince through Belleville, a district on the edge of the city. When Haussmann levelled the centre of Paris to make way for his new boulevards many of the poor Parisians who had lived in the 20,000 houses he destroyed were forced out to Belleville which had, as a result, become a hotbed of left-wing Republican sympathizers.

On that particular afternoon the people of Belleville decided to make the first of many attacks on the local armoury. They had had quite enough of the empire and the inept blunderings of the Emperor at Sedan. With the threat of the oncoming Prussian armies, they felt it was time to arm themselves and defend the new-born republic.

The local *gendarmes* didn't see things quite the same way and fighting broke out. At this moment Le Prince emerged from a side street straight into the mêlée. Being tall, he attracted attention. His bouquet of flowers immediately alerted the *gendarmes'* suspicions. Red, white and blue were Republican colours, which could only mean that Le Prince was the leader of the mob and the flowers were the signal for revolt.

As the *gendarmes* arrested Le Prince his hat was knocked from his head. It was made of the kind of soft felt worn by German students. One

of the *gendarmes* bent down to pick it up and was alarmed to discover a German hatter's name on the tag. These were days of spy fever in Paris. The city's paranoia had been whipped up by the press. Prussian spies were seen everywhere. Many innocent people had been wrongly arrested and some even executed.

The *gendarme*'s suspicions were confirmed when a search of Le Prince's pockets turned up return tickets to England and foreign currency. What else could he be, they reasoned, but an *agent provocateur*, sent by the Prussians to rouse the Republican rabble against the empire?

Le Prince was now in great danger. He was taken to the local prison. The cells were overflowing with republican rioters who were hurling abuse at the soldiers guarding them. As evening fell the situation became volatile. Some of the soldiers got drunk and started firing randomly through the cell bars to quell the trouble. Le Prince was not hit. But in the middle of the night, as suspected leader, he was taken from the cell and placed under solitary guard to await summary trial and execution.

Le Prince's only chance of survival now lay in bribing the guard, who, in exchange for a watch, agreed to wire Lizzie in Leeds and take a message to Le Prince's mother on the other side of the city. Unknown to Le Prince, the guard got the instructions wrong and sent both messages to Leeds. Before Lizzie had a chance to reply the lines had been cut.

Le Prince's mother, meanwhile, was getting worried. The streets of Paris were notoriously dangerous in these times. When Le Prince still had not arrived the next morning, she got in touch with the editor of *Le Temps*, who ran a short piece about her missing son in that evening's paper.

As luck would have it, the *London Daily News* reporter Le Prince had met in Leeds a few weeks before was in Paris. As a journalist, he read the papers thoroughly and came across the piece about Le Prince, whom he remembered. Immediately he contacted the British ambassador, Lord Russell, who, with the editor of *Le Temps*, organized a search. They found Le Prince at two o'clock the next morning. Urgent negotiations ensued: Le Prince was neither a spy nor a Socialist, but a patriotic Frenchman who happened to be in the wrong place at the wrong time. On proof of identity he was released.

Lizzie was relieved when Le Prince finally arrived back in Leeds with his mother and sister-in-law. The cable had frightened her. It was a short-lived respite. Le Prince's upbringing had taught him that military honour and loyalty to one's country were cardinal values. Now, as the fabric of his country crumbled, he felt morally bound to put his military training to use. *La France* called; Le Prince would answer her call.

Returning almost immediately to Paris, he volunteered for the National Guard and was appointed an officer.

Leeds sees a snowfall most winters. Often it's no more than a few inches in January, quickly turned to slush by traffic and the tramp of feet. Sometimes it's heavy and hangs around for months. Sharp winds blow in from the east. The snow drifts. Houses are hemmed in. Roads become impassable, frozen solid by a temperature that rarely nudges above freezing.

A severe winter came early to Leeds in 1870, paralysing the city. It was even worse up at Roundhay, on the higher ground to the north of the city.

It was December and they had been snowed in for a week. At first it had been a beautiful distraction from Lizzie's anxiety about Augustin. Huge snowflakes gusted in eddies from the overweight sky, covering the ground in less than an hour. All day it snowed, and on through a night of wind whining in the eaves. Lying in bed in the morning, with Marie swelling inside her, she could tell from the cushioned silence around the house that the fall had been heavy. She gasped when she drew the curtains. A great white dune rose up from the lawn. At the bottom of the garden the black branches of the cherry tree had become a white latticework. The rhododendrons sagged pitifully beyond. She wished she could paint it all, there and then, the quickest of ink washes to bring out the contrasts, but she was expected at breakfast.

The short days dragged by, giving way to long winter nights and fresh snowfalls. Drifts buried the house, blocking light from the downstairs windows. The outside doors opened on to white walls of snow. They were virtually prisoners. What had been exciting now became tedious. Time slowed, emphasizing Augustin's absence.

The worst thing was the lack of news. Paris had now been encircled by the Prussians for four months. Since September they had been pounding the French capital, hoping to batter and starve the city into surrender. And Augustin was trapped somewhere inside the walls with two million compatriots, fighting for his country.

In the space of four months Lizzie had received one indecipherable note. It had come via one of the many hot-air balloons which were floated out of the besieged city. These balloons were the only means for besieged Parisians of communication with the outside. They were highly unreliable. Many were shot down by the Prussians and those that slipped through were blown in random directions by unpredictable winds. The balloon which carried Le Prince's long-overdue communication had come down in the North Sea and been picked up by

fishermen. The mail had been drenched. All that remained of his letter was the date and address.

Then for weeks she heard nothing more. Night after night, she sat with her parents and her sister-in-law round a blazing coal fire as Le Prince's mother distracted them all with stories about her family, the nostalgic memories of a woman whose life had centred round soldiery and unquestioning allegiance to the empire which had now fallen.

'On one occasion,' she told them, 'my husband impersonated the Emperor.' She spoke in French. Lizzie interpreted. 'It was learnt that an attack was to be made on the imperial cortège, an attempt on the Emperor's life.'

Firelight flickered on her face as she spoke. 'It was too late to change the route so my husband was asked to take the Emperor's place. He was provided with Louis Napoleon's hat and cloak and duly rode past in his place. For this service to his country he received the *Légion d'honneur*. It was presented to him by the Emperor himself at the Tuileries Palace.' She broke into a girlish smile. 'Ah . . . those Tuileries balls. The Empress Eugénie was such a charming young woman, so well spoken, and so beautiful. I wore a grey brocade gown. It had flounces of Mechlin.'

She paused. Lizzie could almost feel the breeze of the waltz. An exploding coal broke the spell.

The interruption was a relief to Whitley. Such awe in the face of royalty made him feel uncomfortable. Of course they were due respect, but weren't they mere human beings like everyone else? He leant forward and picked up a glowing fragment from the rug.

'All things must pass,' he said, rather solemnly. 'Maybe it was all too much of a good thing.'

Le Prince was greeted by pandemonium in Paris. The Gare du Nord was paralysed by crowds, half of whom were fleeing the city, weighed down by their possessions, while the other half were flooding in from the surrounding countryside in search of shelter from the oncoming Prussians.

The city crawled with troops. Half a million men drilled up and down the new boulevards in preparation for the siege. Cartloads of cannonballs trundled through the streets and were unloaded into unruly heaps at strategic points. Wherever he looked, Le Prince saw the elegant Second Empire city being dug up, chopped down and reorganized. Newly cut trenches scarred the road surfaces. The recently planted trees, beneath which he and Lizzie had caroused, had been felled to strengthen the barricades and swell the fuel piles for the approaching winter. Thousands of sheep and cattle now grazed in the Bois de Boulogne, a living food supply for the privations ahead.

Everything had changed. The posing, sexual city of Baudelaire was now an armed camp. Musket and bayonet practice replaced the promenade. The pervasive red of uniforms, articulated epaulettes and stripes of rank, now took the place of the flashy fashions of modern life that had so fascinated Manet. The civilian waltz was now a military manoeuvre.

The Prussian armies closed the ring around Paris on 20th September. Le Prince found himelf attached to the Medical Corps. The whole bloody business had begun.

Days stretched into weeks. The Prussian bombardment intensified, turning heady optimism into doubt. A great breakout was planned. It ended in humiliating defeat. As weeks became months, the extremes of French politics were thrown into sharp relief by the pressures of the siege. The left blamed the right for the débâcle at Sedan. In their view, France had been brought to her knees by the brutal incompetence of her ruling and military classes. Now was the time for the republic – not a compromised bourgeois republic like the one declared when the empire had collapsed in September, but a Socialist republic led by the Parisian working class so long oppressed by the Emperor's army and police. The centre and right, meanwhile, used all means at their disposal to prevent the left seizing power. As winter drew in, these inner schisms became critical.

The National Guard was the crucible of this conflict. National Guard officers, like Le Prince, were usually bourgeois volunteers, but the ranks came from the working class, and were armed. As an officer in the National Guard, Le Prince was particularly exposed.

The Prussian grip tightened. Food, which at first had seemed inexhaustible, became scarcer. It grew colder. Fuel stocks became seriously depleted. There was still no news from outside. Balloons could leave but not enter. In the vacuum, rumours spread like wildfire. Gambetta was organizing relief. The Prussians were weakening.

Towards Christmas, hunger became famine. People began eating rats, dogs and cats. The bread ration dwindled. Fresh water became scarce. Disease struck.

Up to this point Le Prince's main task had been assisting the wounded. It was dangerous work. When his regiment sortied beyond the walls, he went with them and tended to the casualties. With the spread of smallpox he faced added danger. It was the responsibility of the Medical Corps to dispose of the bodies. As the number of victims increased he became directly involved in the sordid business of removing and burying the corpses.

Paris capitulated to the Prussians at the end of January 1871. Le Prince did not wait for the aftermath. He had no wish to become

entwined in the unfolding drama that within a few short months would lead to the Commune and its bloody suppression. He had had enough of the violence. Instead, he took the first opportunity to get back to Leeds to be with Lizzie for the birth of their first child.

THE ART SCHOOL

L^e Prince returned to Leeds in 1871 a sick man. The stresses of the siege and the months of malnutrition had taken their toll. He was in no state to enter the fray of the Whitley family business. Yet this is exactly what he did.

In Le Prince's absence, John Whitley had taken over the managing directorship from his father and begun to push ahead with an ambitious scheme for the firm's expansion. He revelled in his new powers, visiting Moscow, Vienna and Lyons within the space of a year in search of new orders and contracts.

John's plan was to build a large new foundry on a vacant plot adjacent to the old works. The firm's output would triple. A London office would be required, and, perhaps, one in Paris in due course.*

All this required capital. Up to now, the Whitley firm had been wholly owned by father and son. John now recognized that his plans could be realized only by putting the firm on the market.

By the end of 1873, all shares in the new company had been sold. Joseph and John Whitley remained the major shareholders. Le Prince was among many who were persuaded to make further loans. It remained to secure a £15,000 bank loan to complete the new premises.

Le Prince threw himself into these developments, designing a new catalogue to herald the company flotation. In his office at the foundry he made numerous meticulous drawings of the various Whitley products, straining his eyes with the cross-hatched mechanical detail of reducing valves, shearing machines and steam governors.

But all was not well. To start with John Whitley had great difficulty securing the desired £15,000 loan. No one would underwrite it. Meanwhile, with the new workshops still incomplete, he had to subcontract work to competitors – work for which a number of the new directors suspected John had no secure buyer. And the wretched Peet valve affair dragged on.

Throughout 1874 clouds gathered slowly over Whitley Partners. When some shares came on to the market their price showed an alarming drop. Suspicion rippled through the Leeds business community.

Had the Whitleys deliberately overvalued their company? Had they made a killing at the expense of the shareholders?

Whitley was livid at such inferences. He prided himself on being a man of his word. To be sure, he had driven a hard bargain, but what else did they expect? Unless you gave as good as you got in business, you were done for. No. He knew what the problem was and he cursed himself for having remained silent so long. John was the problem.

In Whitley's view, his son had committed the cardinal error. He had overextended the company when the business wasn't there to support it. All that careening round the Continent had been so much hot air. He had promised what the firm couldn't deliver and, as a result, everything that Whitley had worked for in his life was now in jeopardy. What really infuriated Whitley was John's personal extravagance. His expense account hardly bore looking at. The London office had become a company house in the capital. It was emphatically not how he would have done things. An inevitable showdown now loomed between father and son.

Le Prince was caught in the crossfire of this widening family rift. It was through John that Le Prince had become involved with Whitley Partners in the first place, and through him that he had met Lizzie. They were brothers-in-law and close friends.

On the other hand he had an increasingly intimate rapport with his father-in-law. Whitley admired Le Prince's combination of artistic and scientific interests. He respected the young Frenchman's synthesis of the intellectual and the practical. And above all, he was grateful for the love he had brought into Lizzie's life.

For his part, Le Prince admired Whitley. Any man who sent his daughter to study art in Paris in the 1860s was unusual, particularly a Leeds industrialist. Le Prince also respected Whitley's integrity. Unlike John, the older man was driven not simply by dreams of building a great and profitable company, but also by his love of natural science.

Lizzie was made miserable by this crisis. Ever since she had met Le Prince she had basked in the warmth that bound her father, brother and husband together. Now that was all under threat. And Le Prince was visibly suffering from the conflict. For some time she had been convinced that the constant anxieties of industry didn't suit his withdrawn temperament. It was in Le Prince's nature to direct his energies towards a more introspective creativity. The crisis confirmed what Lizzie had long suspected – Le Prince would be better off leaving the firm.

For years, Lizzie and Le Prince had dreamt of founding their own school of art. In the course of 1874, Lizzie persuaded Le Prince that the time had come to make that dream a reality.

Lizzie was now a qualified art teacher. Le Prince, an accomplished painter and ceramicist, wasted no time in passing the relevant examinations, which at that time were set by the South Kensington Science and Art Department. But teaching skills and enthusiasm were not enough. The new school required suitable premises.

There was also a growing family to be considered. They now had two children, Marie and Adolphe, with a third, who would be Aimée, on the way. Lizzie had spent most of the past years either pregnant or recovering from childbirth. The next few years would be little different. Although Phoebe, their maid, undertook much of the childcare, Lizzie nonetheless centred her life round her children. For this reason she felt that if she was also to play a full part in their Leeds Technical School of Art, it would have to be based in the Le Prince home, a large terraced house off the Leeds to Harrogate turnpike.*

One evening, early in May 1875, Mr Becket Dennison, MP, a friend of the family, was driving past the Le Prince home when he noticed flames roaring from one of the chimneys. It was past bedtime. Fearing the worst, he stopped his carriage to see if he could help.

Panic-stricken, Lizzie answered his heavy hammering. In her arms was three-month-old Aimée, wrapped in blankets. Further down the hall, Phoebe was holding two-year-old Adolphe. Marie sat on the bottom stair, wide-eyed in her dressing gown.

A shout came up from the kitchen, belowstairs. 'Lizzie, I said only leave if I give the signal. Stay inside till then.'

'Where's the fire?' said Dennison. 'We'll soon put it out.'

'It's not a fire, Mr Dennison. At least, not that sort of fire.'

'Not a fire, ma'am! There are flames shooting over the house!'

'Augustin is firing the enamels for tomorrow. They went wrong so he's having to do them again. We are to present them to the Duke.'

Marie started to cry. Dennison wrung his hands. 'But the fire's out of control. He should damp it down.'

'I've asked him, but he won't. We need very high temperatures.'

Just then Le Prince appeared at the top of the stairs in his shirtsleeves. Sweat ran in sooty rivulets down his forehead. 'Where's the salt, Lizzie?' he asked with a calm that infuriated her. Then, with a faint smile and a Gallic shrug, 'Becket, my dear friend. You can see I've got my hands full.'

'The house will burn down, Augustin. The chimney's on fire.'

'I need another ten minutes. It's imperative. If you want to help, Becket, come downstairs and stand by.' He turned to Phoebe. 'Now, where's the salt?'

'In the bin, sir, by the window.' Adolphe writhed in her arms, woken by the commotion.

Downstairs a makeshift kiln roared, yellow hot, in the fireplace. To Dennison's horror, instead of damping it, Le Prince added more wood. It caught immediately, amplifying the rumble of flames in the chimney. Le Prince narrowed his eyes, gauging the colour of the flame. 'That should do it. Quick, Becket, the salt. Over there.'

Le Prince poured the salt on. The flames turned a blinding sodium yellow yet hardly lost their intensity. He poured more on. At last the glow dimmed. But the chimney still roared, well alight.

'Cut off the air,' bellowed Dennison.

'What with?' Le Prince looked round the kitchen. Lizzie, who was standing in the doorway with Aimée still asleep in her arms, watched in dismay as he eyed her best damask tablecloth which was drying on a clothes-horse.

'That'll do,' he shouted, promptly grabbing it and expertly sealing the entrance to the fireplace. The danger was past. And so was the table-cloth.

On 13th May, 1875, the Yorkshire Exhibition of Arts and Manufacture was opened by the Duke of Edinburgh. It seemed as if the whole county had poured in for the occasion. Crowds lined the pavements. Every available window space was occupied by excited spectators. People craned from the rooftops, hoping for a glimpse.

The city centre was transformed for the event. Flowers lined the route of the procession. The streets were festooned with red and gold. Banners hung from every corner proclaiming WELCOME TO OUR SAILOR PRINCE, A YORKSHIRE WELCOME TO OUR ROYAL DUKE, WE MEET OUR SAILOR PRINCE WITH JOY.

At noon the royal train pulled into the station. The band struck up 'God Save the Queen'. Everyone started cheering and waving as the Duke stepped on to the platform to be welcomed by the mayor and mayoress.

Upstairs in the Great Exhibition Hall, Le Prince was putting the finishing touches to case number 30 in the Fine Arts Department. He was penned in by a maze of glass cabinets. Flint arrowheads, stags' horns and stone-spindle whorls from the Lake Dwellings of Wangen pressed in on him. Greek pottery jostled with fine porcelain from Hochst, Amstel and Dresden. The Treasures of the Palestine Exploration Fund competed for attention with war medals, Burmese vases and suits of armour. It was all most improving.

Le Prince stepped back and admired his exhibit. It was the first public

display of his and Lizzie's professional work. A small card described CHINAWARE. PAINTED AND FIRED BY M. AND MME LE PRINCE AND ASSISTANTS AND PUPILS. A variety of ceramic slabs, tiles and plates designed for furniture panels was arranged in the cabinet. They had eyecatching glazes, bright primary colours in raised enamels, designed to bring dark Victorian surfaces to life.

He looked nervously at his watch. All around him people were busy dusting and adjusting the kaleidoscope of Leeds middle-class cultural tastes that crowded the space. There was no doubt about it, he reflected, the hall was badly laid out. Everything competed with everything else so that nothing was shown off to advantage. Now, if he'd been entrusted to design the whole floor, the exhibits would have been able to breathe. But the organizing committee had insisted on exhibiting as much as possible, as if to prove that Leeds could beat London and Paris at Great Exhibitions.

Cheers from outside invaded the preparatory quiet. He heard the rhythmic thud of bass drums and the blare of trumpets. Lizzie returned, none too soon, upset that her still life was all but lost amidst the hundreds of canvases which crowded every available surface of the picture galleries. She agreed with Le Prince. The committee should have settled for less, better shown.

It was too late now, though. The royal party had entered the building. Bowties were straightened and curls patted as the nervous exhibitors steeled themselves for the royal encounter.

Lizzie looked at the miniatures. Le Prince had arranged the enamelled portraits of the mayor and mayoress on a red velvet cushion. He had only recently perfected a method of burning these tiny handpainted images on to metal. Getting the finish right had taken weeks of trial and error, culminating in the drama of the night before. Now that he had succeeded with painting he planned to do the same with photographs, convinced that they would be just the thing for a gift or memento.*

These commercial instincts had been confirmed when the Le Princes were chosen to make a presentation of the miniatures to the Duke of Edinburgh, an encounter which was now only minutes away and explained why both he and Lizzie were nervous. A royal endorsement of their work was exactly the kind of boost their Art School required.

Down in the entrance hall a small orchestra played. The royal party swept in, past the grand organ – 2439 pipes and four manuals – past the six-pounder field gun, the ornamental drinking fountain, the pianos and harmoniums. The Duke lingered at the aviary, delighted with the tropical birds. He smiled at the Abyssinian curly-coated guinea-pigs,

ignored the black wood ants, raised an eyebrow at the edible frogs and moved on towards the Manufactures Department.

The huge space was a microcosm of the Industrial Revolution. Everywhere the Duke looked he saw proud examples of Yorkshire's manufacturing achievements. There were steam engines, woolcombing machines, brick-making machines, steam hammers, card setters, shearing machines, band saws, double-throw crank axles, patent leakless range cocks, self-acting cinder-sifting ash closets and sewer traps. Virtually every mechanical device known to man competed for the Duke's attention in a fanfare of textile and steam technology.

The Duke strolled through the ranks of machines, stopping now and again for the presentation of a working model by an accomplished apprentice or to exchange a few words with a clutch of managers.

Whitley Partners were well represented. They exhibited an array of pumps, valves, heaters, engines and governors. The impression was of a thriving and well-run business. Nothing could have been further from the truth. Yet in spite of the crisis, father and son stood shoulder to shoulder on their stand, determined to radiate confidence. As the royal party came past – the Duke didn't linger – both men nodded respectfully. Then a spasm of pain gripped John's stomach. Sweating slightly, he held on to his smile.

This show of unity didn't fool the managers and owners of other Leeds concerns who were watching from neighbouring stands. The word was out in the engineering community that Whitley Partners were in trouble, a state of affairs many of them relished.

Whitley felt their eyes on him but was determined to ignore it. 'Forget the firm for a day!' he had said to John. 'Let's enjoy ourselves.' What mattered to Whitley that day was that his daughter and son-in-law were being presented to the Duke. That would show the cynics and bad-mouthers. Leaving John on the stand, he followed the royal party up the grand staircase, determined not to miss the cultural safari upstairs.

Lizzie and Augustin watched as various presentations were made. Then it was their turn. It went without a hitch. The miniatures were graciously accepted. Whitley watched proudly with his wife as Le Prince bowed and Lizzie curtsied.

At the civic dinner that evening, Le Prince recounted the story of the previous night's firing. Many were curious about the new process. Lizzie and Augustin received a flood of enquiries from people who wanted to enrol as students. This wave of interest, and the near disaster of the fire, persuaded them that the time had come to find larger and better-equipped premises, closer to the centre of the city.

The success of their Leeds Technical School of Art was mirrored by

a continuing decline in the prospects for Whitley Partners. John's stomach pains grew worse. The bank had finally had enough, and said so in no uncertain terms. Whitley Partners were at 'the extreme length of their tether'. Why had not a call been made on the directors, as they had advised? Instead of the remedial steps they had expected, they were now being called on to honour yet more large bills for copper and out-standing wages. Why hadn't the managing director acted? Where was he, for that matter? What was going on?

John Whitley was nursing his sore gut at a health spa in Derbyshire. The pressure had finally become too much for him. Pathetically, he wrote to his board of directors that his complaint was much worse than expected and that it would, doubtless, modify all his future arrange-ments. The crisis had given him 'diarrhoea of a violent nature' which, if he wasn't careful, would shortly become chronic and take the manhood from him.

These pleas elicited little sympathy. Joseph Whitley, the company directors and the bank all agreed that John had to go. At the end of July he resigned. But the crisis was not over yet. Share values now dropped catastrophically. Acrimonious letters flew back and forth between the directors. Why hadn't Whitley acted to prevent his son's ruining the company? How come a man of his experience had kept quiet? Was he simply unwilling to rebuke his son?

Whitley watched helplessly as the bank advised stopping the works immediately. His life's work teetered on the brink. In September the chancery court ordered the company wound up. All but a handful of employees were laid off. Neither Le Prince nor any other creditors were likely to see their money again.

As things turned out the Whitley firm survived the wreckage. After much haggling, the bank agreed to underwrite a much-reduced opera-tion, on the condition that Joseph Whitley came out of semi-retirement to resume his former managership.

John Whitley went to live for a few years in France beyond the reach of the official liquidator and a horde of angry creditors. But he had far from given up his business ambitions. Within a few years his extraordi-nary entrepreneurial energy revived and he conceived a new venture which, once again, involved Le Prince. And just as it had been primarily John's influence which had brought about Le Prince's move from France to Leeds in 1866, it would be John, once again, who would be responsible for the emigration of the whole Le Prince family to America in 1882.

ART AND SCIENCE

'I can't seem to get the shape of the little rock right, Mr Le Prince,' said a voice from behind him.

'Just a moment, Mrs Grimshaw.'

He was at Cow and Calf Rocks with his art class. While they struggled with their renderings of great stones, he had stolen a few minutes to take in the view. It was spectacular. He could see clear across Wharfedale to the Dales some twenty miles to the north. Immediately below him lay Ilkley, a small spa town within easy reach of Leeds. Its sedate streets criss-crossed their way towards the River Wharfe which snaked eastwards through the glacier-shaped landscape. All around, the gentle green curves of the cultivated valley floor, articulated by a dry-stone wall latticework and clusters of farm buildings, swept dramatically upwards to wind-blown moors where sheep sought shelter behind the stone traces of bygone megalithic communities.

Ilkley Moor lies on the northern boundaries of the Yorkshire West Riding. The contrasting geology of the region had been one of the spurs to the industrial revolution in the late eighteenth century. A ready supply of raw wool from the flocks of sheep on the moors, coupled with the easily available motive power of the rivers below and the particular suitability of the water to the process of wool scouring, had set the stage for the Yorkshire textile industry.

The structure of this industry had been shaped by the landscape, which unfolded eastwards from the watershed of the Pennines. The wool came from the high ground, was cleaned, combed and woven to worsted in the mills of Halifax, Huddersfield and Bradford, before being finished and tailored in the clothes-conscious city of Leeds.

Leeds also lay on the northern edge of the Yorkshire coal field, close to the main energy source for steam power, which replaced watermill power as the prime mover of industrialization early in the nineteenth century. Lying at a geological crossroads, Leeds was uniquely placed to seize the industrial and commercial initiative over its Yorkshire neighbours. By the mid-nineteenth century, its thriving textile industry had been joined by a prosperous steam engineering industry of which Joseph Whitley was a part.

None of these industrial realities could have been further from Le Prince's mind as he scanned the panoramic Yorkshire landscape from Cow and Calf Rocks on an afternoon in the late summer of 1877. For three years now he had been out of the stressful orbit of the engineering business. While Whitley battled on with the rump of his firm, casting this way and that in the vain hope of a breakthrough, Le Prince and Lizzie had thrown themselves into the cultural life of Leeds. A little land speculation coupled with Le Prince's private means had enabled them to buy a large house in the centre of Leeds, where they moved earlier in the year with their Technical School of Art and their rapidly expanding brood of children.*

Not that Le Prince had in any sense broken with Whitley. Although he no longer worked directly for the firm, he still undertook translations for Whitley of tricky proposals about pumping machinery for potential French clients. And sometimes he would accompany a crated-up engine or box of valves to Paris, for delivery to John who would place them in a suitable exhibition. But these trips were made primarily for their art school rather than Whitley Partners, in search of both materials and skilled craftsmen for the school's ceramics department.

The Le Princes' speciality was the firing of images on metal and porcelain. This ranged from the kind of exquisitely painted miniatures burned on to enamel plates of the kind they had presented to the Duke of Edinburgh in 1875 to methods of glazing painted miniatures and photographs on to china. There was clearly a demand for this kind of portraiture. He received special honours for his entries at the Paris Exhibition in 1878. Of the many commissions that came his way that year, one was for the Prince of Wales. He also undertook more conventional portrait commissions in oils and pastel.†

Le Prince's skills as a painter were the reason for his presence at Cow and Calf Rocks that afternoon. As an elected critic of the Leeds Fine Art Club, he occasionally accompanied groups of amateurs on painting expeditions, weather permitting, and offered them his professional advice. This week they had chosen the ancient Ilkley rock formation as their motif, named after its resemblance to a cow and her calf.‡

His pupils, mostly middle-aged and middle class, were facing away from the view. Some were dabbing away with ink and wash while others concentrated for all they were worth on drawing the great static forms. Le Prince had been impressing on them the importance of drawing, which to him was tantamount to seeing.

'I can't seem to get the shape of the little rock right, Mr Le Prince.'

'Use your eyes, Mrs Grimshaw. Look for all you are worth. "To draw is to see" as the Japanese say. It will help you grasp nature's workings.'

And with that pearl, he turned back to contemplate the view. It was a panoramic vista. To his left the upper reaches of Wharfedale and to his right the chimneys of Otley bled to nothing at the limits of his peripheral vision. The scene was of a breadth that would have been difficult to squeeze into the frame of a conventional landscape. Such a challenge required the grander solutions of the great painted panoramas which had proved such a popular attraction earlier in the century and which were set for a revival. Embraced by those limitless canvases the spectators were seduced into believing they were actually there.

The landscape was also dynamic. Far to the north, over Blubberhouses Moor, white cumulus gusted across a blue sky. In the dale below, a train steamed into Ilkley. A clump of pine trees swayed in the breeze. Even here, in this slow rural environment, the picture was in movement. This was not simply a question of the movement of objects through the landscape, but of the dance of the light that defined it.

Le Prince would not have been the first painter to make such observations. The 1870s were the decade of Impressionism. Inspired by the dynamism of modern Parisian life, which Le Prince and Lizzie had experienced during their courtship in the late 1860s, Monet, Pissarro, Renoir and Sisley were striving for techniques which captured the movement of landscape. They sought to depict the play of light on water, on trees, on the faces of lovers on river banks, in the billows of steam from locomotives, such that the arrested moment possessed the life of passing time.

Until the advent of photography, Western painting had enjoyed a virtual monopoly on visual storytelling. In the mid-nineteenth century this was exemplified in the epic history paintings of the French academic tradition, in which the painter's powers to create visual illusion ensured the credible movement of narrative on the canvas. But by the 1860s many people came to see photography as capable of realizing more effective visual illusions than painting. Denied narrative movement, there is a sense in which painting depicted movement in other ways, in the fracturing of brush strokes and judder of complementary colours which characterized Impressionism.

The Impressionists had been outraging and entertaining Paris since their first exhibition in 1874. As a frequent visitor to Paris, Le Prince could not have failed to be aware of the new movement. His surviving painting suggests a muted influence. It has little of the spectral vision of the Impressionists, nor the modernity of their subject matter, yet the broken touch of his work in pastel, gouache and ink has an impressionistic feel, as if he too were using these techniques to imbue his still lifes and portraits with a sense of life and movement.

* * *

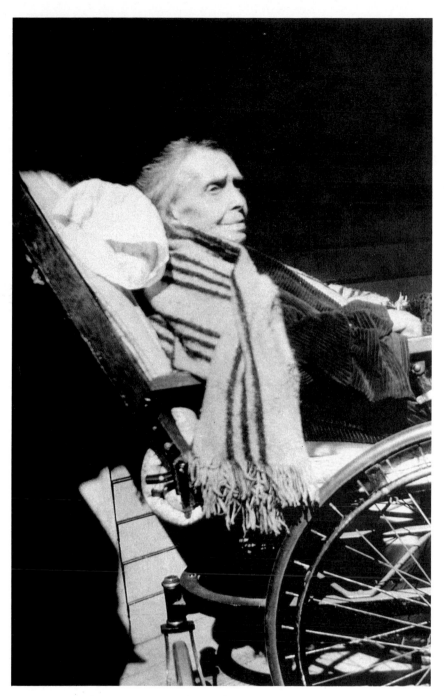

Plate 1 *Lizzie Le Prince, Memphis, 1926*

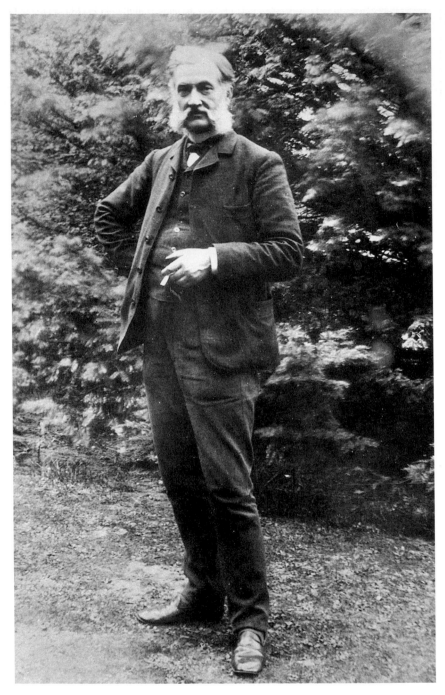

Plate II *Augustin Le Prince, Leeds, 1889/90*

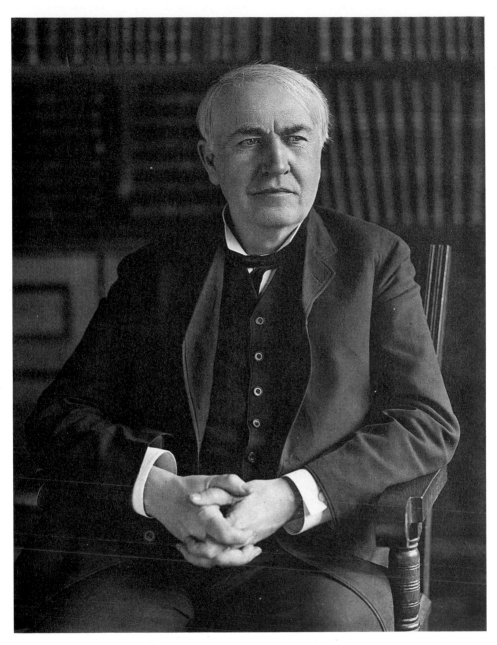

Plate III *Thomas Alva Edison, c. 1906*

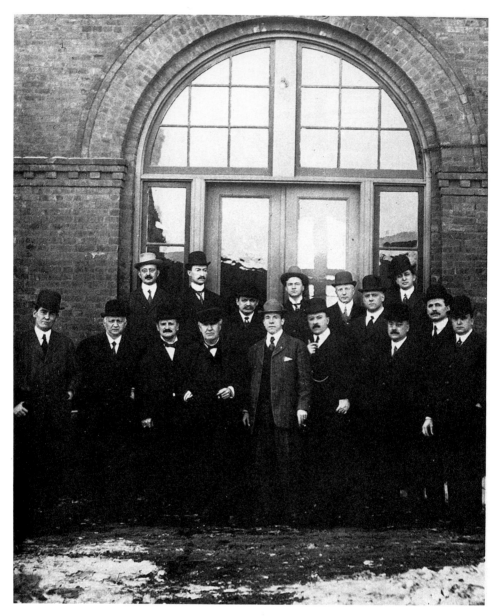

Plate IV *The leading lights of the Motion Picture Patents Company gathered on the steps of Edison's Laboratory at West Orange, 19th December, 1908*

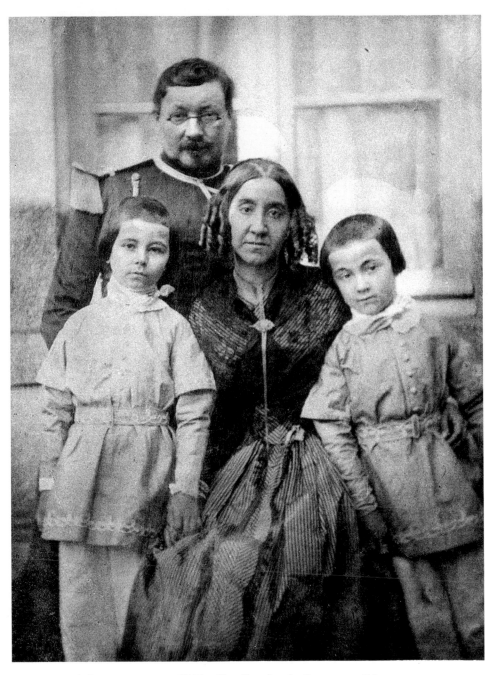

Plate V *A daguerreotype, c. 1847, allegedly taken by Daguerre, of the
Le Prince family. Left to right: Albert Le Prince (brother), Major
Louis Le Prince (father), Elizabeth Boulabert (mother), Augustin
Le Prince*

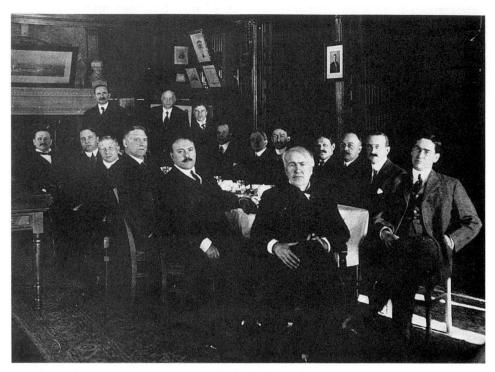

Plate VI *Edison hosting a banquet for the leading lights of the Motion Picture Patents Company, 19th December, 1908*

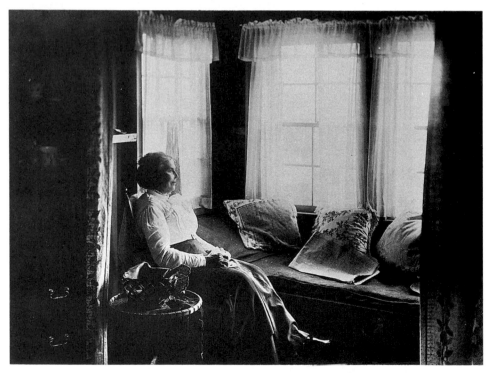

Plate VII *Lizzie Le Prince sitting at her bay window, Point O'Woods, c. 1910*

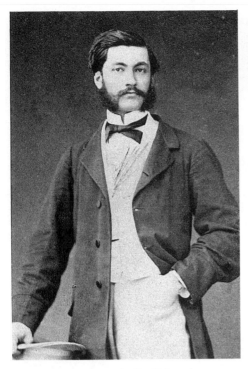

Plate VIII *Augustin Le Prince in his early twenties*

Plate IX *Augustin Le Prince as Lizzie might have met him in 1866*

Plate X *Oakwood Grange, the Whitley home where, in 1866, Lizzie got to know Le Prince and where, in October 1888, Le Prince conducted the first trials of his single lens camera*

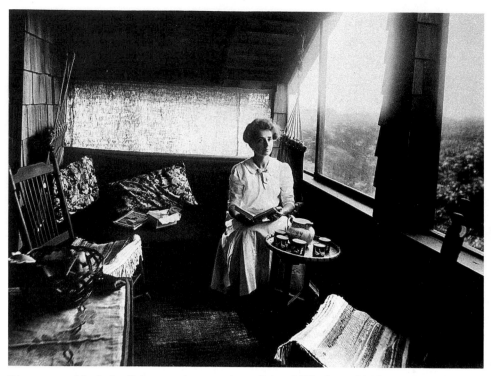

Plate XI *Marie Le Prince on the veranda at Point O'Woods, c. 1910*

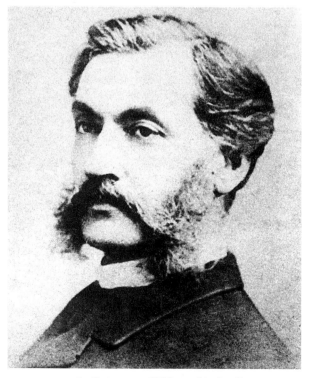

Plate XII *Le Prince, c. 1880, as his family*
preferred to remember him

Plate XIII *A cyclorama, New York, 1886*

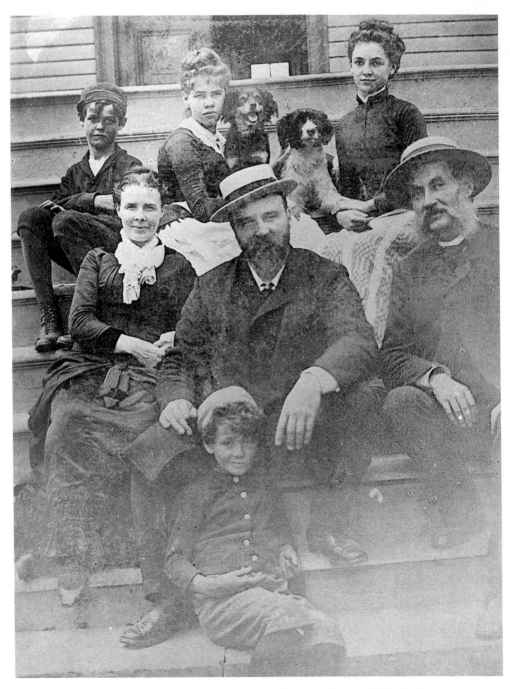

Plate XIV *The Le Prince family on the steps of Belmont House, 1885. Back row: Joseph, Aimée, Marie; middle row: Lizzie, John Whitley, Augustin Le Prince; front row: Fernand*

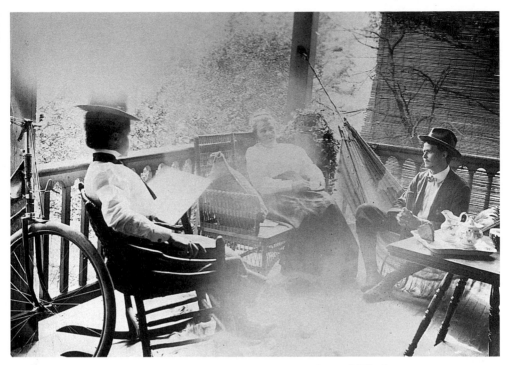

Plate XV *Aimée, Lizzie and Fernand on the veranda at Point O'Woods*

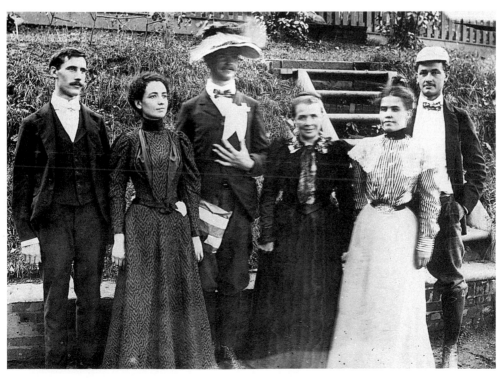

Plate XVI *Left to right, Adolphe, Marie, Joseph, Lizzie, Aimée and Fernand, New York, c. 1899*

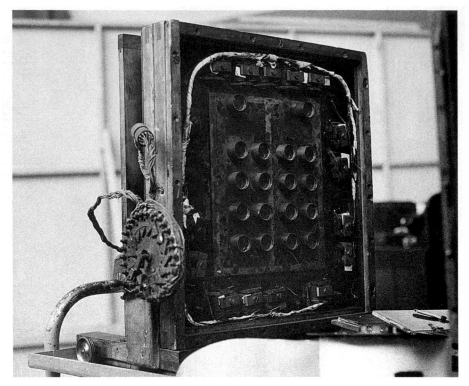

Plate XVII *The remnant of Le Prince's sixteen lens camera, constructed in Paris 1887, now in the Science Museum, London*

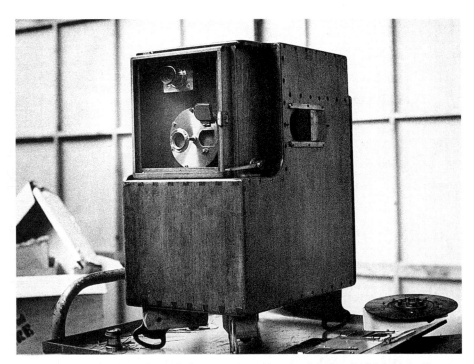

Plate XVIII *Le Prince's single lens camera, constructed in Leeds, March–April 1888, now in the Science Musuem, London*

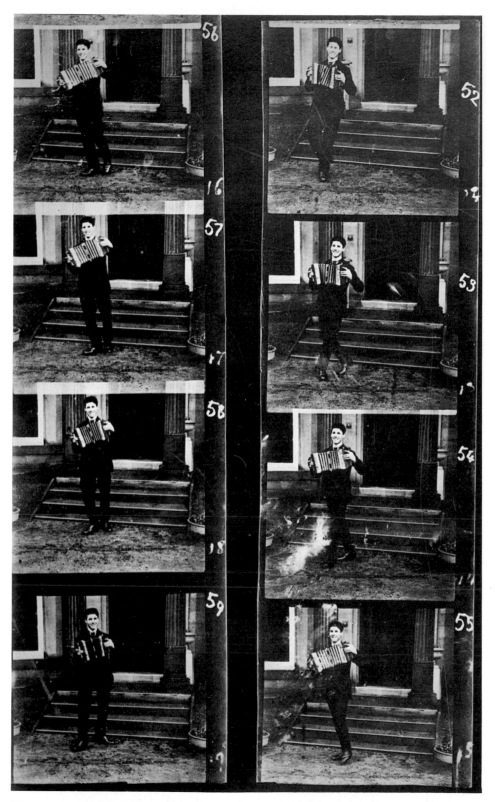

Plate XIX *Eight of the surviving twenty frames of Adolphe playing the melodeon in the garden at Oakwood Grange, October 1888*

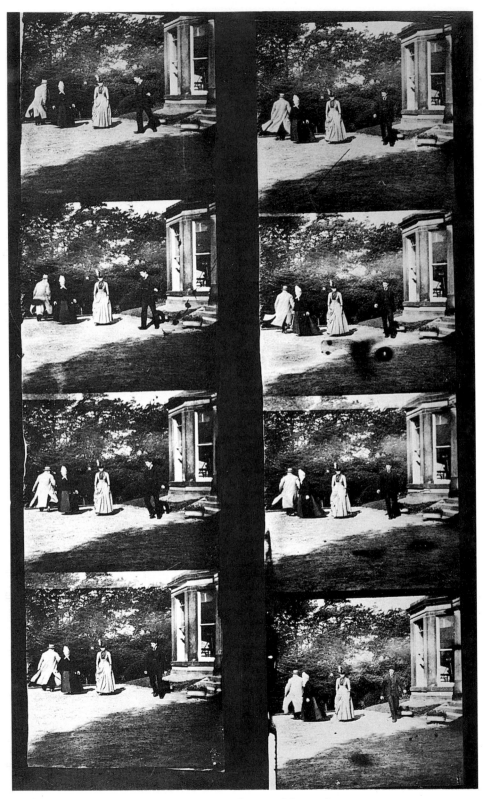

Plate XX *Eight of the surviving twenty frames of the garden sequence,*
Oakwood Grange, October 1888

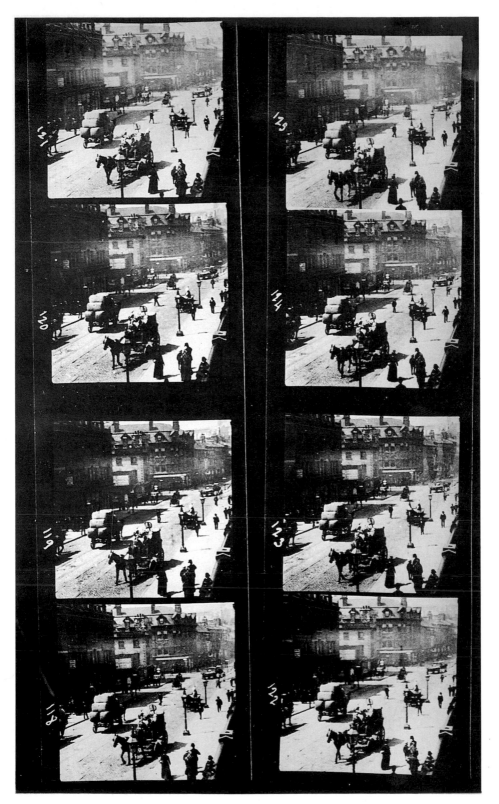

Plate XXI *Eight of the surviving twenty frames of traffic crossing Leeds Bridge, possibly taken summer 1889*

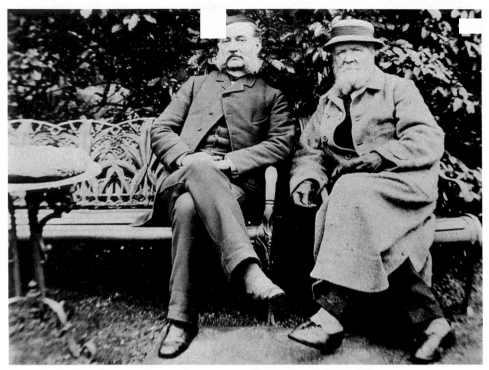

Plate XXII *Augustin Le Prince and Joseph Whitley, Leeds 1889/90*

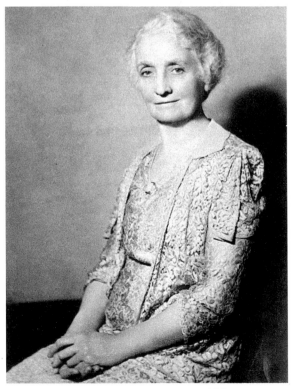

Plate XXIII *Marie Le Prince, c. 1930*

At about the same time, in a great barn of a laboratory set just off the New York–Philadelphia railroad, deep in the New Jersey countryside, Thomas Edison, now aged thirty, was wrestling with the telephone.

Throughout the early 1870s, the young inventor had been preoccupied with the improvement of communication through wires. Since his youthful days as a telegrapher he had become obsessed with making the telegraph system work more efficiently. First he had perfected an automatic telegraph, enabling much faster transmission than was possible with the old manual morse-tapping process. Next he had invented the Duplex, which allowed two messages to be carried simultaneously on a single telegraph line. Most recently, his Quadruplex potentially doubled, yet again, the capacity of the existing telegraph network.

Although he formed his own companies to manufacture these inventions, Edison's paymasters during this period were, alternately, Western Union and the Atlantic & Pacific Telegraph Company, owned by the notorious 'robber-baron', Jay Gould. Between them, these giants controlled much of the North American railroad and telegraph system – the prime communications networks of the day.

Edison's inventiveness was a key element in the fierce competition that raged between these rivals. For them, the telegraph was not so much a means of communication between people as a way of moving information on stocks and shares. Improvements were spurred by the needs of Wall Street rather than philanthropy.

Yet in spite of the windfall profits Edison had brought these two adversaries with his various inventions, they treated him with a meanness that frequently led him to the edge of bankruptcy. Western Union paid him little and late, whereas Gould, once he had poached the young inventor from his rivals, proceeded to renege on his royalty agreement. Edison also had to cope with the reluctance of either to invest sufficient capital, which put intolerable pressures on the manufacturing side of his business. Increasingly, constant anxieties over cashflow and industrial organization – the stuff of manufacturing – denied him the imaginative space required by the process of invention.

This frustration was compounded when the Gould–Western Union tangles led to disputes over what Edison had invented and for whom.

Even this early in his career, Edison was no innocent when it came to patent law. In the seven years since 1869 he had taken out over one hundred patents. The path to the US Patent Office in Washington was said to be hot from the frequency of his visits. Many of these applications were knowing infringements, made in the full knowledge that others had entered the field before him. Such apparently unprincipled behaviour was acceptable. US patent law was notoriously slow and full of

loopholes, a corrupt system in which bribery thrived and where there was always a good chance that deliberate delaying tactics and the prohibitive legal costs of initiating litigation would confuse and discourage potential rivals.

But this experience had not prepared Edison for the wrath of Western Union when he defected to Gould. He now got his first serious taste of patent litigation, which was to consume such a large part of his life. It was a blooding in which he found himself attacked as a 'rogue inventor' and a 'professor of duplicity and quadruplicity' who had 'basely betrayed' Western Union.

These debilitating events combined to persuade Edison to pull out of manufacturing for the time being, so that he could focus his energy on what most mattered to him – inventing. In 1876 he moved with his growing team of highly skilled assistants to a purpose-built laboratory at Menlo Park, some twenty-five miles south-west of New York City, where over the next decade he was destined to build up the world's first industrial research laboratory, a kind of factory for inventions which would include the phonograph and the incandescent lamp.

Not that Edison severed his links with the world of commerce. Indeed, what distinguished him from inventors who came before him was his insistence on exploring only those inventions which he believed had commercial potential. Until the 1870s, the typical inventor had been a man of privileged background and education working for the advancement of science in a privately financed laboratory which would have been, as likely as not, in his own home. Edison's achievement was not so much the numerous inventions to which he laid claim, as the transformation of invention itself into a systematic industrial process involving carefully orchestrated teamwork. His greatest invention was Research and Development.

Edison's retreat to Menlo Park was both an escape from the realities of business and an assertion of independence from his financial masters. Freed temporarily from the chains of manufacturing, he would offer his inventive genius to industry, selling not so much products as the process of invention itself. Battered from his first encounters in the Telegraph Wars, he would also strive to be less personally exposed in future litigations, surrounding himself with a ring of no-nonsense lawyers who would resort, if necessary, to a ruthless defence of his corner and, better still, carry the attack to the enemy. Quite soon this resolve would be put to the test. The Telegraph Wars were followed rapidly by the opening of hostilities around the instrument that was to eclipse the telegraph, the telephone.

When Bell first approached Western Union with his telephone

patents, the bosses of the great telegraph monopoly were uninterested. Why bother with a new device, went their reasoning, when the telegraph worked perfectly well? Besides, if the telephone really was the revolutionary invention that Bell claimed it was, let others take the risk of proving its practicality. If it came to it, they would resort to the usual tactics of imitation and deliberate infringement, protecting themselves by initiating a string of bogus lawsuits designed to wear down the opposition, irrespective of the justice of their claims. And with this cynical mentality, they declined Bell's offer.

But the Western Union men hadn't bargained for the sensational impact of the telephone at the Philadelphia Centennial Exposition in 1876. To make matters worse, Bell acquired financial backers who were already making plans for the first local telephone exchanges. Perhaps the device constituted a threat after all.

Bell held the US patent on his telephone by a whisker. There had been talk of dirty business at the US Patent Office when the chief examiner overlooked a similar application by Elisha Gray, made only three hours before Bell's. Sensing that this rumour was a possible trump card for future litigation, Western Union decided that it was time to make a move.

Although Bell held the US patent, there were problems with the commercial feasibility of his apparatus. The transmitter had a very limited range. It had come to Western Union's attention that Edison, who was still smarting from their appalling treatment of him in the unfinished telegraph litigation, had been tinkering half-heartedly with an 'acoustic-telegraph' idea, without getting far. Now they ate humble pie. Could Mr Edison see a way to increase the range of the transmitter while circumventing Bell's telephone patent, thus creating an opening for Western Union in the field? Why yes, replied Edison, for a price.

Lizzie lay in that delicious half-waking state, resisting the pull of full consciousness. A tiny frown creased her brow as the babble of young children drifted out through the open screen doors on to the veranda. It was Marie's pottery class. A dozen young children of neighbouring Point O' Woods families were having their weekly hour of fun. It was late afternoon and Lizzie had been taking her usual nap in the hammock. Why were they disturbing her snooze? [Plate XI]

A girl's voice peaked above the rest. 'My snake keeps breaking in the middle, Miss Le Prince.'

Marie struggled against squeals of laughter. 'You're rolling it too hard, Beulah. Do it gently, like this.' There was quiet as they watched her. 'Then you build it into a spiral. First the bottom. Then the sides.'*

Lizzie dozed off again. A young Yorkshire voice piped up, 'Has dat ol' granma gone yet? It's my turn to come in 'tudio now.' Was it young Adolphe's voice, or Aimée's? Or perhaps little Joseph's? It was dusk on one of those early winter evenings at the Leeds house in Park Square. An elderly lady had overstayed her hour's painting tuition with Augustin. The children wanted their father. Phoebe had been trying to keep them in the nursery upstairs until the lesson was over, but they clamoured that it wasn't fair because the time after his teaching and before their bedtime was their special time with Papa, time for fighting over a place on his knee, storytime. 'Has dat ol' granma gone yet?'

Phoebe's scolding rose above splutters of laughter. 'Aimée! That's no way to speak!'

Lizzie brushed a fly from her forehead. Without doubt, they were the best years of her life, the Leeds years with Augustin and the children before they came to America.

Another memory floated up. Adolphe's birthday. A cab drew up outside. The bell tinkled. Her father appeared at the door, grinning under the weight of a great box. The children crowded round him. 'Clear the road!' shouted Whitley.

'What have you got, Grandpa? What is it? Is it just for Adolphe?' they chanted.

'Wait in the drawing room and you'll see. Come on now, out of the road.' Whitley staggered into the drawing room with the box.

Four pairs of eyes watched him unpack it on the table. Augustin joined them from his laboratory at the back of the house. His familiar shape leant against the mantelpiece. A coal fire blazed in the grate. 'Draw the curtains, Marie,' commanded Whitley. 'Fetch me a white sheet, Lizzie.'

'Phoebe, I want a white sheet,' she echoed.

'I know what it is!' cried Adolphe.

'It's for all of you,' said Whitley, as he pulled the magic lantern from the box. 'Can you work this thing, Augustin?'

Le Prince set up the magic lantern, fuelled the burner, lit the flame. 'What are you going to show us, Grandpa?'

Whitley reached into his pocket and handed a package to Le Prince. 'Chinese Fireworks!' There was a hush as Le Prince put in the slide.

A vortex of colours appeared on the makeshift screen. 'It's only a pattern,' someone said.

'Just you wait,' replied Le Prince, turning a handle on the slide. Cries of delight filled the room as a whorl of colour spiralled outwards.

'Can you make photographs move?' Adolphe said. Or was it Marie? The slide whirled. Lizzie changed her position in the hammock, churn-

ing in the eddies of her memories. Later that evening, thirty years earlier, she had lain in bed waiting for Augustin to come up. The children were all asleep. He was playing the 'Appassionata' in the drawing room. His touch yearned its way through two floors of the house, finding her. He finished, yet for some reason the music continued. She heard his slow footfall on the stairs. His towering warmth entered the room. He sat on the bed and held her hand as they shared the afterglow of another children's birthday party.

Together they conjured up the fire of their courtship, laughing at the recollection of first glances. They relived their honeymoon. She teased him about his obsessive visits to Houdin's dissolving magic lantern show. He said, 'I will make photographs move.' [Plate XII]

Another night now. As so often, he was very late to bed. She tossed and turned, getting crosser as the dull chimes of the drawing-room clock marked off the quarters. He was out in his laboratory, teaching himself photography. When he finally came he would be reeking of gun cotton, hyposulphite of soda, cyanide of potassium, nitrate of silver and all those other long names which made up the brews with which he coated his precious glass plates.

A child started crying. Joseph. Phoebe padded downstairs. The crying stopped. Further away, the kitchen door shut. He had finished. Halfway upstairs she heard him pop his head into the nursery. '*Bon soir*, Phoebe.' The clock struck three. The gaslight in the street threw a slit of yellow against the bedroom wall through the crack in the curtains. Again, his footfall on the stairs and the creak of a carpeted board. She touched her swelling abdomen where their fifth child was growing.

He tiptoed into the room. 'It's all right. I'm awake,' she said.

'I've just broken ten glass slides. I knocked them off the bench with my elbow.'

'You're tired out, my darling. Come to bed now.'

He paced the room restlessly. 'They fell one after the other, in a stream. I saw the gaslight reflected in each image.'

He lay awake until dawn. She dozed in the field of his alertness. The town-hall clock struck six. Factory hooters from distant parts of town answered the call. Leeds was rising for work. Little Joseph woke for his feed. The new baby turned in her womb. Aimée and Marie started playing noisily on the landing. 'Shhh,' said Phoebe, 'Mama and Papa are asleep.'

But Phoebe's pleas had no effect. The children's babble crescendoed into the hot sunlight of a Fire Island afternoon as Marie's class broke, scampered out of the house, past Lizzie, towards the wooden veranda steps.

Marie followed them out, waving as they disappeared through the pines. Lizzie suddenly said, 'I think what really sparked him off was that accident with the glass slides.'

Marie was puzzled. 'Sparked what off, mother?'

'The moving-picture idea.' She eyed the deserted typewriter on the table.

'It couldn't have been that simple.'

'If Adolphe were here he could tell us,' Lizzie said huffily. 'He knew exactly what your father accomplished.'

Marie turned away from the jibe to wave at little Beulah whose distant voice carried faintly across the dunes. 'Goodbye, Miss Le Prince. See you next week.'

They were driving through dark Leeds streets in a cab. The window was down. As they passed the town hall, a great male 'Gloria' burst through the open doors, fanning out under the Greek columns of the portico to break over them. One thousand Yorkshire miners were rehearsing Handel's 'Christmas Oratorio'. Many of them had walked miles from outlying districts, braving all weathers to get there. The cab passed on, chased by the tremors of the organ's great bass pipes. They would attend the performance next week. Tonight they were heading for the annual phil. and lit. conversazione, where several hundred of the élite of town society were converging on the Philosophical Hall for a grand Christmas get-together.

Was it 1878 or '79? Did it matter? Every year saw the same grand occasion. As they turned the corner into Park Row, she could make out the numerous couples stepping from a jam of cabs halfway down the street. A cloud of umbrellas hovered over the scene. The light of the street lamps reflected in the glistening road surface.

Their cab pulled up. Augustin held the door open as Lizzie stepped on to the pavement. Everyone was so well dressed. There were Mr and Mrs Lupton, hello, and the Kitsons, good evening. Then Augustin caught sight of Richard Wilson going in with his wife and Lizzie said, 'Now promise you won't end up in a huddle with him all evening. It's not a lodge meeting.'

She took his arm. They made their way through the throng. The brassy melodies of Spencer's Band welcomed them into the warm place. It seemed so much brighter than last year. The floor was covered with crimson cloth. Plants and shrubs graced every corner, breathing life into the solemn stony space. It was all so much of an improvement. She must remember to compliment the committee.

'It's electric,' said Augustin, following a wire with his finger to one of

several carbon arc lamps that illuminated the area. 'I saw them in Paris. They've hung them up all along the Avenue de l'Opéra.' He shook his head sadly. 'No more gas!'

The dazzling blue light was so intense that she could look at it for only a few seconds. It smelt and spluttered as well, giving off a veil of smoke which made her cough. 'I think I prefer gas.'

Augustin shrugged. 'Indoors, perhaps. But outdoors, just you wait and see.' They made their way through various rooms towards their exhibit, passing model steamships in glass cabinets, a collection of stuffed birds, a magneto-electric machine. Paintings by local amateurs crowded the walls. They spotted Cow and Calf Rocks several times. Then they bumped into one of Augustin's pupils and exchanged pleasantries about the overworked motif.

The room where the Le Princes' miniatures were exhibited was dominated by a working model of a new hydraulic gun-loading apparatus. Lizzie found it ugly. Augustin agreed. They moved on to the room where her watercolours were hung. It was also the room with the telephone which had drawn a large crowd of people who watched as a man shouted into the transmitter, then handed the receiver to willing volunteers. Augustin watched with amusement. One by one, their expressions veered between fear and astonishment as they discerned a faint human voice. No one was looking at her watercolours, which made her feel hungry, so she left Augustin with the telephone and went downstairs to the buffet before the speeches started.

By the time she got back to the watercolours, Augustin had left. She found him upstairs in a knot of people, all captivated by a demonstration of the phonograph. He beckoned her over. A man was turning a crank. What looked like a tin cylinder revolved at great speed. The name Edison was clearly visible on the side of the strange instrument. Then, to her astonishment, a mangled voice came from a small pipe that rested against the cylinder. Barely audible, but unmistakably, she heard the words 'Hey diddle diddle'. Everyone clapped.

'This is magic,' she whispered.

'It's science,' Augustin replied.

The Philosophical and Literary Society formed the hub of Leeds middle-class cultural life in the 1870s. It provided an ambience in which the divide between art and science, which we take for granted in this century, was far less pronounced. The high point of the society's activities was the annual conversazione, where fossils and phonographs, watercolours and arc lamps, stuffed birds and telephones, coexisted in a kaleidoscope of aspirations and interests.*

Throughout the year eminent speakers were invited by the society to

give lectures. One week would witness a talk on Raphael and Rembrandt, followed the next by one on electric railways or the value of India to England. This rich mix sprang from a conviction in both the progressive nature of science and the need to keep a check on its excesses. People might marvel at the latest invention, but the suffering of the early years of the Industrial Revolution was still fresh in the collective liberal mind. One of the purposes of art was to restrain science's tendency to dehumanize.

'The wonderful range of exhibits at this conversazione declares that the humanizing quality of art and literature, allied to science, will ensure a progressive outcome for our civilization, considerate of the needs of humanity.' Augustin turned to Lizzie with an approving nod. Lord Harewood was echoing his sentiments. He joined in the polite applause that rippled round the room. Most of the people attending the evening owed their wealth to the cut and thrust of Leeds industrial life. Talk of a benign capitalism massaged their consciences, fuelling the liberal side of their outlooks.

'My Lords, ladies and gentlemen,' Lord Harewood concluded, 'tonight I would like to drink a toast to the future of science, tempered by the compassionate hand of art.'

Someone shouted, 'Hear, hear.' Augustin raised his glass to the general murmur of 'Art' and 'Science'. He thrived in this climate. Now in his late thirties, he and Lizzie ran not a school of fine art but a technical school of art in which scientific understanding of metals, clays, firing and photography underwrote the more traditional craft approach to the applied arts. Beyond this he believed passionately in the civilizing power of science. Human injustice was the product of ignorance and misunderstanding. Inventions like the telephone and phonograph heralded an epoch in which the forces of science would be harnessed to help people communicate with each other.

Just then the Wilsons came over. Mr Wilson wanted to know whether Augustin could inlay several glazed ceramic portrait tiles into a special piece of furniture he had come by.* Mrs Wilson wanted to be shown Lizzie's watercolours.

When the two women had left the room, Wilson took Le Prince to one side. 'Where's the obelisk?' he asked quietly. Le Prince led him to an adjoining room where a model of Cleopatra's Needle occupied pride of place in the Whitley Partners exhibit.

Joseph Whitley had cast several of these bronze follies to commemorate the erection of the obelisk on the Embankment in September 1878. This was no arbitrary whim. In the doldrums of uncertainty that surrounded the future of his business, Whitley's imagination had been

fired by the dramatic circumstances of the arrival of Cleopatra's Needle in London early in 1878.

The obelisk had been presented to the British nation by Mohammed Ali, Viceroy of Egypt, in 1819, in gratitude for Lord Nelson's victory over Napoleon at the Battle of the Nile. For the next sixty years it lay prostrate in the sand at Alexandria. But recently, in a perilous operation, it was encased in a buoyant iron cylinder, rolled into the sea and towed through the Mediterranean, out into the Atlantic towards England. While crossing the Bay of Biscay a violent storm blew up. The cables snapped and six crew were lost before the obelisk was recovered.

Throughout 1878, the Cleopatra's Needle saga became a kind of therapy for Whitley's damaged self-esteem. In his view, the dramatic circumstances of the voyage only heightened its symbolic importance – men had sacrificed their lives for the gift. When it finally arrived in London and preparations were made for its erection, he was determined to become involved.

The gift of Cleopatra's Needle was not quite the open gesture of inter-national friendship it appeared to be. The highly complex operation of shipping it was initiated, funded and organized by Freemasons. Egypt played a major part in the amalgam of fractured mysticism that consti-tuted masonic belief. The obelisk was said to symbolize both Ra, the Sun God of Creation, and Osiris, God of Rebirth, Fertility, the Nile Flood and Everlasting Life, whose penis became mysteriously lost when, as an Egyptian king, he was murdered, and in the absence of which stony substitutes were constructed.

Freemasonry thrived on this kind of occult mythology. The object which pokes at the sky from the Embankment in London is intrusively phallic, a symbol of the secretive male bonding which constituted the Brotherhood. Rising in the heart of the British capital, it proclaimed the fertile power of Freemasonry within the ruling fabric of the nation. Lon-don was not alone. Paris, Washington and New York also acquired needles at this time, thanks to the efforts of the Brothers.

Whitley went at this new venture like a child towards a new toy, find-ing in it a release from all his pent-up frustration in business. For the obelisk itself, he constructed an airtight cylinder containing various documents and objects of the time which were to be sealed in the foun-dations to mark the significance of the event for posterity. This time-capsule included enamelled miniatures of the Royal Family, executed by Le Prince. Whitley also cast the bronze tablets, with inscriptions, that were built into the four sides of the base.*

Then came the phosphor bronze models. His first thought was to cast a whole run, offering one to every city of the British Empire. This

half-serious scheme promised a sideline in obelisk manufacture which
would be both worthy and profitable.

As the project advanced, endless pestering letters flowed from the
foundry to the engineer in charge of the erection, John Dixon, himself a
Freemason. Casts were taken from the great object as it lay on its side on
the Embankment. Careful drawimgs were made. At one point Whitley
even considered casting full-scale replicas for great American cities.

When it came to embellishing the models, Whitley was at a loss as to
how best to proceed, so he decided to consult Le Prince. He did so
knowing that his son-in-law was not only a knowledgeable artist, but
also a Freemason. In 1875 Le Prince had joined Leeds' Fidelity Lodge,
where Richard Wilson was treasurer. Whitley hoped that Le Prince's
knowledge of the ancient arts would solve his design problem. Le Prince
duly drew various insect and plant motifs which both baffled and
satisfied Whitley.

Spencer's Band played their finale. Everyone agreed that it had been
the best conversazione ever. The demonstration arc lamp spluttered
out. An assistant started dismantling the wires. The evening was defi-
nitely over. It was time to go home, but where was Augustin?

Lizzie found him still deep in conversation with Wilson in front of her
father's model obelisk. Neither man noticed her at first as she watched
them from the doorway. Augustin was explaining the meaning of one of
the motifs. They were surrounded by Whitley's engineering models, the
familiar Allen steam governor and the steam pump.

Whitley had not been present at the conversazione that evening.
Although he had lent working models to the phil. and lit. conversazione
over the years, he had never been a member of the society. The atmo-
sphere was a little too precious for a man of his practical bent.
Perhaps, also, the liquidation was too recent for him to have felt com-
fortable in such influential company. He probably owed most of them
money.

The last guests trickled through the room. Lizzie let Augustin know
that she wanted to leave, but he insisted on reading out an inscription
etched on the model.

'They're father's couplets, Lizzie, written for the obelisk.' But she
didn't want to hear them. The display depressed her, filling her with
Whitley's sense of his own failure. Suddenly all the boundless Whitley
energy that she had been brought up to believe in felt merely eccentric.
The model obelisk now struck her as the desperate gesture of a man who
knew that he had been supplanted by more competent industrial spirits.
She wanted to be far away from it all.

Augustin's voice flowed into her thoughts. He read with such quiet

passion that they could have been his own words. The lines softened her mood.

We greet the future with a thought
On Man's progression here

And argue now from what he's wrought
A nobler career

In choice selective he will find
A purer physique mien

Controlling which by force of mind
Will bless his common being

Then art and science still will soar
But not for sordid self

No slave will groan as heretofore
To gain for others wealth

Thus to the future we bequeath
This sacred thought today:

When man shall know himself in truth
Then wrong will pass away.

JW, September 4th, 1878.

TECHNICAL WIZARDRY

Edison's sensational speaking machine launched him from backroom celebrity to become a household name in the Western world. Until 1878 his fame was largely confined to the telegraph industries within which he worked. But the magical qualities of the phonograph seized the popular imagination. It was at this time that he began to be nicknamed the Wizard.

Rumours multiplied. The locals of rural Menlo Park reported strange midnight apparitions of figures carrying lights in the fields surrounding the laboratory. It was said that Edison had invented a machine which could hear cows munching grass in distant fields, and a device that could eavesdrop on farmers. Edison's inventive powers apparently knew no bounds and the press loved it. An April Fool story in the *New York Graphic* claimed that Edison had invented a machine that could 'Feed the Human Race, manufacturing Biscuits, Meat, Vegetables and Wine out of Air, Water, and Common Earth'. It was picked up by other newspapers and run as a true story. A series of cartoons in London's *Punch* showed EDISON'S ANTI-GRAVITATION UNDER CLOTHING in which parents blew weightless children around their living rooms and the gallery-going public fanned its way through the spaces of picture exhibitions, floating up for glimpses of previously inaccessible canvases.

Then, in August 1878, Edison embarked on the project which was to keep him more or less fully occupied for the next ten years. It began when Grosvenor P. Lowrey, general counsel to Western Union, sent Edison a report of the arc lamps on the Avenue de l'Opéra in Paris.

Edison was not very interested at first, but a few months later he was invited to witness a demonstration of eight arc lamps at the brass works of William Wallace, co-inventor of the first American dynamo, in Ansonia, Connecticut. A soon as the introductions were over, the dynamo was brought up to speed, switches were thrown and brilliant blue light flooded the space.

'Edison was enraptured,' wrote a *New York Sun* reporter who had followed him to Ansonia in the hope of a scoop. 'He ran from the instruments to the lights and then again from the lights back to the electric instruments. He sprawled over a table and made all sorts of calculations

. . . the power of the instruments and the lights, the probable loss of power in transmission, the amount of coal the instrument would use in a day, a week, a month, a year.' He also observed the characteristic fumes and splutter which had fogged the Leeds phil. and lit. conversazione on the other side of the Atlantic. At the end of the demonstration he told Wallace with his usual bluster that he did not think he was working in the right direction and that he could beat him to making a successful electric light.

Edison's approach to the electric light provides a model of his approach to invention as a whole. Until 1878 he had only toyed with the idea. But once inspired by the shortcomings of Wallace's arc lamps, he became obsessed with it.

In place of toxic and blinding arc lamps, he envisaged clean electric lamps of the comforting intensity of gas jets. In place of uneconomical lighting for factory and public spaces he foresaw a cheap and safe system of power distribution, whereby electricity would displace gas in every home and workplace. Ironically, this grandiose energy-generation scheme required a smaller-scale solution. In Edison's opinion, the intensity of the arc lamp had to be 'subdivided' before it could be brought into domestic use, an insight which prompted him to seek a radically different solution.

Edison lost no time in unfolding this vision to the *New York Sun* reporter. 'I am working on an idea for a central station for electric lighting for all New York, from which a network of electric wires will extend in all directions, delivering current for small household lights. I hope to have it ready in six weeks,' he said with characteristic optimism.

It took Edison most of 1879 to take the first crucial steps. For months on end he locked himself away with his expanding and increasingly skilled team of assistants at Menlo Park. The legendary breakthrough came in October, in the form of the incandescent lamp. But it was three long years before the complete system underwent its first trials.

Edison was late into the electric-lighting field. As with the telephone a few years earlier, and as with moving pictures ten years later, his inspiration came from the achievements of other inventors. Farmer, Brush and Sawyer had been working away at the arc lamp in the United States for some years. The revelation of the arc lamp at Ansonia set him on the path to the incandescent lamp, but even this radical idea was not new. Men had been using electricity in various attempts to incandesce substances in a vacuum for forty years. In England, as long ago as 1860, Joseph Swan had taken out patents on a lamp in which a carbon filament glowed in a vacuum. Stumped by a problematic filament and the difficulty of achieving a perfect vacuum, Swan had put his experiments

to one side. But recently he had taken up the challenge again.

As Edison embarked on his gargantuan search for the right filament material, the familiar warning signs of impending litigation began to show themselves. This was not to be simply a matter of the lamp. Edison's vision of a commercially viable system of power generation and consumption also involved dynamos, wiring, switches, junctions and metering devices. Each of these needed inventing or improving in a field in which many patents on different parts of the system had already been granted to inventors wary of infringers.

Invention on this scale required major backers. Lowrey, who had nudged Edison towards the electric light, now set about forming a syndicate to finance the Wizard's costly experiments. As an experienced patent and corporation lawyer, Lowrey was ideally placed to convince Wall Street of the value of investing in Edison's scheme. Before long he had become instrumental in the formation of the Edison Electric Light Company which counted Vanderbilt, Twombly, Western Union president Norvin Green and J. P. Morgan's partner, Eggisto Fabbri, among its investing directors. Morgan himself, the nation's number-one banker, was centrally involved, but preferred to remain out of sight. These men represented or owned some of the most powerful railroad, telegraph and financial interests in the country. Their support for Edison was an unusually adventurous move for traditionally conservative Wall Street. It owed something to their foresight, but rather more to a combination of Edison's reputation, Lowrey's manoeuvring and the prospect of controlling the nation's future power-producing industry.

It was a clever arrangement that afforded minimum risk to the backers. The new company had 3000 shares of which 2500 went to Edison himself. The remainder were subscribed by the investors to a total of $50,000 which was paid to Edison for his experimental work.

In exchange, Edison contracted to assign all his inventions and improvements in electric lighting to the syndicate for the next five years. In effect, this meant that the investors, not Edison, owned his patents in the field for the duration. From the outset, the Edison Electric Light Company was a patent-holding company which sought to dominate the industry worldwide through its power to license manufacture. Central though Edison was to this set-up, he remained in the power of his backers. Edison was to learn about the pitfalls of this dependency through the litigation and financial manoeuvring of the next decade. Thirty years later he would put this hard-earned wisdom to work when the Motion Picture Patents Company was formed to secure him dominance in the motion-picture industry. As a patents holding company, the Motion Picture Patents Company echoed the form of Edison Elec-

tric Light with the crucial difference that Edison himself, and the cartel of which he was part, owned the patents.

When it came to financing the actual production of the lamps, wiring, switches and fixtures required by the new industry, the backers showed their true colours. As financiers they were wary of the risky practicalities of manufacture itself, preferring to depend for their profits on the clean flow of royalties from licensing agreements. Others could get their hands dirty.

This left Edison with no choice but to re-enter the field of manufacturing himself. With a few of his associates he incorporated the Edison Lamp Company, setting up a factory in Newark for the production of lamps. Other companies followed for the manufacture of fixtures, fittings and dynamos. Meanwhile the Electric Light Company – the syndicate – drove its half of the bargain on Edison himself, demanding the royalties to which its ownership of Edison's patents entitled it. So Edison's vision for a new electrical industry came into being, not cleanly, but hamstrung by the sordid realities of vested interests. Capital that should have been reinvested in the expansion of the business was creamed off, adding to the already mounting stock of bitterness which Edison harboured against financiers. Not that he did badly out of it. The shareholders, and Edison was one of them, were promised a substantial accumulation of profits.

The clerk handed Whitley the letter. He read it and threw it down irritably. It was those lawyers after Augustin again. 'How many times must I tell them I do not know the particulars of Mr Le Prince's private affairs?'

The clerk nodded patiently, his pen poised over a blank sheet of paper. 'What shall I say, Mr Whitley?'

'Write "To all whom it may concern . . ." '

'To the lawyers, I mean.'

'Damn the lawyers! We'll see to them later. Take this down instead.' He started pacing the room. 'Know ye that yesterday betwixt the hours of five and six in the presence of my chief clerk I entered into a sacred bond with Mr Samson Fox upon terms mutually agreed by which I have empowered him to make shell castings by my patent process.'

Samson Fox owned the Leeds Forge which specialized in iron and steel production and the manufacture of large steam boilers. It was a huge operation which made Whitley's firm look tiny by comparison. When the prospect of a collaboration with Fox materialized Whitley was overjoyed. A good contract would put an end to his company's misfortunes.*

Fox's speciality was the Fox corrugated boiler flue. The boiler flue is a

pipe, or system of pipes, running through the centre of a boiler. It is the critical site of heat exchange in a steam engine, where heat from the furnace is transferred to the water, converting it to steam. Whitley had invented a method of centrifugal casting with a machine which he called the Spinner. In his view it was ideally suited to the manufacture of Fox's flues.

Seizing his opportunity, Whitley aranged a demonstration for Fox, who was duly impressed. 'If you will be faithful to me and say naught about this,' Fox said, 'I have the trade and the money and I can find the means for you to make these shells. It's just what I want. Stay faithful to me and there'll be a lump for you.'

'Give me your hand,' Whitley replied, reaching out. 'This is my bond sacredly. You know me. I'm too old to break such an agreement.'

And with that, pending the full contract, the deal had been done.

'Get this down.' Whitley searched the air for words as his chief clerk waited expectantly.

> They say the mill will start today
> To corrugate a shell
> If so, the Leeds Forge will display
> A fact that time will tell.
>
> Thus guided still, by natural law,
> That company leads the way
> The ridged line or buckling flaw
> Does Fox's tubes display.
>
> Then hail to Fox's progress fine
> 'Tis formed the world to bless
> All natural laws alike divine
> Are blessings when unfurled.

'What d'you think? Will he like it?'

The clerk scratched away in the letter book. He was secretly amused by Whitley's poetic excesses but dared not say so, knowing how significant the Fox deal was to him.

'I'd be most flattered to receive it, Mr Whitley.'

'I think it warrants another time capsule too. I wonder what Fox would think of me placing a couple of sealed caskets under the foundation stone of his new foundry chimney. Nothing too elaborate. I thought p'raps a scroll recording the attainment of metallurgical arts at this date, with a few details about my spinner and Fox's flues. And in the other casket we could put a selection of the usual artefacts. A few

photos, coins, magazines, that sort of thing, so as future generations may know what man was doing today.'

The clerk looked up. 'I'm sorry to disturb your train of thought, Mr Whitley, but I think that this letter needs some attention.'

'Creditors!' Whitley exploded. 'They're all the same mean bunch. No sooner has a man got some prospects than they fall on him like carrion crows.'

'They're not after you, Mr Whitley. It's Mr le Prince. They want to know where he is.'

'Tell 'em I don't know. No, better still, tell 'em he's not in Leeds because he's now upon the Atlantic Ocean *en route* for Liverpool. We expect him in three or four days. Why are they asking me? They should write to his home in Park Square!'

AMERICA

Two days later a letter arrived for Le Prince at Park Square. When Lizzie opened it and discovered that Le Prince was in debt, she panicked. In a hurriedly penned reply she wrote that it was impossible to send word to her husband as he was on the sea on his way home. 'Cannot things await his return,' she implored, 'which is now in a few days? If you can send word "yes" it will be a great relief. I do not know what best to do under the circumstances. Yours sincerely, Lizzie Le Prince.'*

Lizzie was anxious enough without this added complication. For the past few months Augustin had been in the United States with her brother, John. Together, the two men had been exploring the feasibility of a joint business venture. Gus was due back in two days with a momentous decision. If all went to plan, it would mean uprooting their six children and moving permanently to New York.

The prospect of such an upheaval gave her mixed feelings. After fifteen years of settled married life in Leeds, she faced, at John's instigation, the prospect of leaving the life of the city she had been born in and to which she had contributed so much. For what? What did America offer that she and Augustin didn't already have in Leeds? Was this just another of John's unreliable schemes? Perhaps he'd seduced Augustin into it with his dangerous combination of charm and energy. Yet that wasn't likely, she reflected. Augustin knew John too well.

After the liquidation of Whitley Partners in 1875, John Whitley, whose extravagant ideas for the company's expansion had been primarily responsible for the disaster, had become an unpopular man in Leeds. *Persona non grata* in his home town, he had settled in Paris, where he escaped the round of harrowing court examinations and angry creditors and recovered his health and self-esteem.

As John's energies revived, he began casting round for new schemes. Le Prince saw John frequently at this time during his visits to Paris on Technical School business. In spite of the crisis, the relationship between the two brothers-in-law remained close. John kept in touch with Lizzie and Le Prince's successful Technical School venture.

During their years of teaching and developing processes in applied

arts at their Leeds Technical School of Art, Le Prince and Lizzie's interest in decorative ceramics had broadened to embrace interior decoration as a whole, an area in which they had become highly skilled designers and technicians.

John Whitley was aware of this expertise and in 1880 he acquired an interest in the patent on a process called Lincrusta-Walton. This method of producing decorative linoleum involved rolling a plastic compound on to fabric, which was then mechanically stamped with a pattern in high or low relief. The word Lincrusta was a contraction of the words lino and encrust. It had been invented by Francis Walton in 1877. The flexible end product could be applied to all kinds of interior surfaces where it would be suitably tinted, chased or grained to resemble tapestries, leathers or hardwoods.

John's plan was for Le Prince to join him and Walton as artistic designer of the Lincrusta-Walton Company. He envisaged a partnership based on the manufacture and supply of ready-made designs. It did not take much intelligence to spot the demand. Victorians expressed their wealth through the elaborate adornment of the walls and ceilings of their homes. What the modernist eye sees as busy clutter, the nineteenth century took as a measure of social status. By involving Le Prince and Lizzie, John foresaw a thriving business, producing fashionable and inexpensive designs. Their clientele, however, would not be the English but the newly affluent New Yorkers.

Le Prince arrived in a country in the throes of fundamental change. What had been a fragmented agricultural society was becoming a unified continent of great cities. What would shortly be the world's foremost industrial nation was emerging in great leaps and bounds.

His first glimpse of New York had been the pandemonium of the waterfront. As the steamer docked, he looked down on to a quayside teeming with bewildered humanity. For a while he had second thoughts. Was it wise to be leaving Leeds for this bedlam? Then he caught sight of John, waving from the crowd. His anxiety fell away. He was one of the few passengers with someone there to meet them. Looking around, he read signs in English, and heard the shouts of the longshoremen, in English. He spoke their language, unlike the hordes of impoverished Germans, Jews, Poles and Italians who within days of docking would, if admitted, be pleading for shelter on the Lower East Side. And unlike most of them, he had means. The Le Princes, although not wealthy, would be part of a privileged migration to the New World.

Le Prince returned to Leeds at the end of April 1882. After weighing up everything, he and Lizzie decided in favour of going. There wasn't much

time. Le Prince planned to be back in New York by the end of June. Lizzie would join him with the children and Phoebe in September, by which time he would have found them all a home and set up the basis of the new business with John.

When Lizzie gave Le Prince the letter from the lawyers, he read it without saying anything. They were demanding repayments of an outstanding £350 loan made to Le Prince ten years earlier. It was a considerable sum, especially when set against the financial demands of the approaching move. A few days later he repaid £30, put the question of the balance out of his mind, and concentrated on selling the house and winding up the Technical School. By mid-June he was on his way to New York.

In mid-September, Whitley was jolted from his obsession with his new casting process by a request from Lizzie for help. It was only a matter of days before she and the chilren were due to sail and she hadn't yet started packing. The prospect of crating up her life had brought on a paralysis of inaction. She didn't know where to begin.

Whitley came to the rescue. Just as Lizzie was beginning to despair the doorbell rang. Six packers arrived from the foundry. Within minutes they were swarming all over the house, packing everything into numerous large wooden crates. They went at it as if they were dispatching Whitley's bronze slabs. Lizzie feared for her belongings.

Gradually the house became bare and resonant. Late in the afternoon, the last crate was loaded on to the wagon. Filled with apprehension and sadness, she watched it pull away to the station. But there was no going back.

She was shocked from these feelings by a crisis. What had they done with her clothes? That morning she had carefully laid out her travelling clothes and the dress she had chosen for a farewell reception, which she was due to attend in a few hours' time at the Philosophical Hall. A presentation was to be made in recognition of her and Le Prince's 'services for art culture' in Leeds. But now she had nothing to wear. The men had followed Whitley's orders to the letter and packed 'everything'. Her clothes were *en route* to Liverpool.

In the event, Lizzie rushed out and bought a new dress and travelling clothes just before the shops closed. That evening she received a silver coffee service, an illuminated scroll and much admiring applause from the art-loving community of Leeds.* A few weeks later, in New York, the dress reappeared. It had been packed in a coal scuttle.

Part Four

PANORAMA

We were at cruising altitude somewhere over New Mexico. The plane was late. TWA's fragile hub-and-spoke schedule had desynchronized at Kennedy. There was a phone on the plane. Joseph Whitley would have loved it. I toyed with the idea of calling LA to say that I would be late and, incidentally, that I was hurtling westwards six miles above the desert. But I thought better of it. It would have cost me ten dollars. Instead I craned my neck towards the screen. Some dreadful comedy was playing. I opted to watch it in silence.

My viewpoint was acute. The screen was like a vertical slit. This made little difference to the appalling quality of the image. It was a badly dubbed tape, projected out of focus on a machine in which the colour balances were all wrong. Le Prince would have hated it. In disgust, I turned to look out of the window, raising the blind a few inches. Crystal sunlight flooded in. A stewardess passed with a frown. My neighbour moved restlessly. But I didn't care. I had a right to watch the movie outside.

Far below, the fractal shoreline of a vast man-made lake had etched its way into parched desert. The earth was pale brown in every direction, modulated by the gash of canyons and the folds of low mountain ranges. An occasional road cut the landscape in a straight pale line. A century earlier, Le Prince and John Whitley had crossed this same terrain on horseback. I recalled Lizzie's description of the trip. Somewhere beneath me Le Prince had observed Mexican Indians firing their pots at dusk, and noted how the evening breeze intensified the fire, producing brighter and more translucent glazes.

Le Prince's first years in America were disappointing. The Lincrusta-Walton business turned out badly. Le Prince chided himself for not having foreseen the problems. John's mismanagement of Whitley Partners was still a painful subject in the family. He was so obviously unreliable as a business partner. Yet somehow Le Prince had fallen for his overpowering charm and energy once again.

After many difficulties, John finally disposed of the Lincrusta-Walton patents and persuaded Le Prince to accompany him on a trip

west. On the rebound from yet another failure, he set out with Le Prince
to find a ranch and establish a colony for his friends. It was to be a haven
from the pressures of commerce, a 'promised land' remote from the
kind of business stress which John had brought down on himself and
others in such good measure.

In the event, these illusions fell away piecemeal on the gruelling over-
land journey. It was a punishing and dangerous environment. By the
time they reached California, John had abandoned the idea.

Back in New York, Le Prince set up his own interior-decoration busi-
ness. In spite of the earlier setbacks, he remained interested in the
Lincrusta process. The firm of Le Prince & Pepper traded from 1321
Broadway and undertook the design and decoration of public buildings,
private homes and yachts. Lizzie, too, was involved in the practical side
and wrote a short manual on Lincrusta-Walton decoration, illustrated
by Le Prince.* But the new venture was only a qualified success. In spite
of his years of experience with Whitley Partners, Le Prince lacked a
sharp business sense. The art of dealing was not in his nature. Before
long they found that their designs were being copied by rival firms who
promptly underbid their quotations.

Although well off by the standards of the thousands of poor immi-
grants who crowded New York's Lower East Side, the Le Princes were
not rich. They had brought their maid Phoebe with them from Leeds,
but that was to be expected in any self-respecting middle-class family.
Besides, there were six Le Prince children to look after, ranging from
twelve-year-old Marie, through Adolphe, Aimée, Joseph, Fernand,
down to three-year-old Jean.† A brood of that size required help.

These financial realities meant that both Lizzie and Augustin had to
be breadwinners. With the demise of Le Prince & Pepper in 1884, Lizzie
threw herself full time into art teaching, her real love, inaugurating and
taking charge of the art department she had dreamt of at the New York
Institute for the Deaf in Washington Heights. Le Prince also became
involved with art therapy for the deaf at this time, helping with the stage
designs for the school's pantomimes and organizing a school exhibit at
the Cotton States International Exhibition at New Orleans in 1884. But
this was voluntary work. Le Prince needed an income. The break came
later that year with an offer of work that was to change the course of his
life and within six short years bring it to an end. He was forty-three.

It was one of many critical moments. Le Prince was leaning against the
rail of a platform at the centre of a large circular studio, five hundred feet
in circumference. Fifty feet above the ground thirty riggers were precari-
ously balanced on the lip of a massive timber ring attached to the studio

walls. Down below, a dozen more were feeding great folds of canvas from a large wooden box. The men above hauled on ropes attached to its top edge. They sang as they worked, unifying the rhythm of their heaving so as to put least stress on the unfolding material. Le Prince held his breath. One careless move and the canvas would start tearing at its seams, a disaster for which he would be ultimately responsible.

The great drapes emerged, a dazzling expanse of 20,000 square feet. Then the hammering began, drowning out the singing, as the men nailed the canvas to the wooden ring. When the two ends of the canvas met, completing the white circle, a sailor was lowered from the top in a bosun's chair to stitch the lap together. Down below, more stitchers were working a wide hem which would hold a heavy iron ring designed to stretch the canvas perpendicularly.

He looked at his watch. They were falling behind schedule. A dozen house painters were due the next morning to prime the immense stretched surface with a ton of whiting and the ring was not yet in place.

By the time Le Prince started working for Theodore Poilpot in 1885, panoramas had been in and out of vogue for nearly a century. They were the invention of a Scottish painter called Robert Barker. In 1788 he patented his first small circular view of Edinburgh. The new visual entertainment seized the popular imagination, spreading quickly through Europe and North America.

Barker described his first 360° painting as 'AN IMPROVEMENT ON PAINT-ING, Which relieves that sublime Art from a Restraint it has ever laboured under'. He was referring to the picture frame which, in his view, anchored painting permanently in the realm of artifice. Barker believed that the visible rectangular limits of the painted image prevented the spectator from experiencing a perfect sensation of reality. Gilded wood intruded on the artist's painted illusion, proclaimed the means, prevented the suspension of disbelief.

The object of the panorama, on the other hand, was to give spectators the sensation that they were actually present within the scene depicted. To achieve this, the physical limits of the panorama were either beyond the peripheral vision of the spectator, or skilfully concealed by various *trompe-l'oeil* effects. Various optical compensations also had to be worked out.

There was room for only six spectators in Barker's first panorama, a tight squeeze that left them a mere ten feet from the canvas. On this scale it proved impossible to sustain the illusion. But quite soon much larger panoramas appeared. By 1800, Barker had his own panorama building in London's Leicester Square, where he exhibited *The Grand*

Fleet at Spithead, a circular canvas of 10,000 square feet in which all the tricks worked. The crowds who flocked to see it felt that they were actually there, reviewing the fleet alongside royalty. Barker followed up this success with a series of views of English cities. One of the great nineteenth-century forms of popular spectacle had been born.

After Barker's early successes, panorama rotundas sprang up all over Europe and America. Landscapes and cityscapes were followed by great battle scenes. Crowds queued to witness *The Battle of Alexandria* in Phildelphia, *The Battle of Navarino* in Paris, *The Battle of the Nile* in London.

By 1830 the heyday of the panorama appeared to be over. The revival began in 1872, with Henri Philloppoteaux's epic *Siege of Paris*. At this time the French capital was still reeling from defeat by the Prussians and the carnage of the Civil War that followed. Large areas of Louis Napoleon's new city had been destroyed. Philloppoteaux's panorama restored a modicum of pride to humiliated Parisians. It was a box-office hit.

This success ushered in a rash of new battle panoramas. New rotundas sprang up all over Europe. London became a simulated battle-ground. Waterloo was re-experienced in Victoria; the Charge at Balaclava in Leicester Square; Sebastopol at the Alexandra Palace.

Quite soon the new generation of panoramists ran out of European battles. The Crimea was exhausted and the Franco-Prussian War played out, which left only the Napoleonic Wars, already beyond living memory. But it was a different story in the United States, where memories of the numerous battles of the Civil War were still vivid.

The European panoramists now turned to this new market. Philloppoteaux's son Paul painted no less than four magnificent Gettysburgs, one of which opened in Boston in 1884. The Battles of Atlanta, Missionary Ridge and Bull Run followed from other artists. Most large American cities now boasted at least one panorama building. Throughout the latter part of the 'eighties these great images of America's recent past were transported from city to city, to be exhibited for a year here, a year there. Although the emphasis was on Yankee victories, their nationwide popularity suggests that they served a broader therapeutic function in the long process of national reconciliation which followed the 'Rebellion'.*

Theodore Poilpot, the French Salon artist, was already famous for his panoramas of *The Charge at Balaclava* and *The Storming of the Bastille*. In 1884 he arrived in New York to work on his first American panorama, *The Battle of Shiloh*. It opened to great acclaim in Chicago on 1st July, 1885.

The making of a panorama involved carefully orchestrated team-work. The undertaking was too great for one man. It required experts in many different fields. The creative process echoed that of the great Renaissance frescoes and anticipated the division of labour within the movie industry. A single artist usually had the idea and designed the image, but directed its realization by others. In addition to numerous craftsmen and labourers, Poilpot worked with a dozen Ecole des Beaux Arts painters, each of whom had his own speciality – horses, uniforms, backgrounds, skies or guns.

Such undertakings required a good manager. Le Prince got the job. It called on a wide band of his considerable talents. When he wasn't drawing, painting or taking photographs, he was acting as interpreter to the largely French team.

Poilpot's next panorama was the *Monitor and Merrimac Engagement*, an important Civil War naval battle.* The first stage of the new project involved a period of detailed research. All available reports, eye-witness accounts, sketches and photographs were scrutinized in order to work out the overall shape of the narrative. Then came the visit to the actual battleground where the viewpoint was selected. For a month or more, careful sketches were made of the land and seascape in all directions.

Le Prince was admirably suited to this kind of work. As a painter he had a sure command of landscape, and his military upbringing and experience at the siege of Paris gave him a feel for the visual details and movement of battle.

Once back in New York the team embarked on the first plan, a circular model on canvas, one-tenth of the size of the final work. Here Poilpot came into his own, determining the overall composition of the piece and the most dramatic figure-arrangements, enabling the rest of the team to embark on sketches of their own specialities.

When the general dispositions of the figures had been established, they were refined through a series of life studies. These often took place outside, in people's gardens. Le Prince was actively involved at this stage, organizing and improving the poses of models in appropriately battle-scarred uniforms. Passers-by would be forgiven for mistaking the scene for a real battlefield. Confederate and Union casualties littered the lawns. Wounded soldiers were placed on stretchers. Sailors struggled ashore. The only give-aways were half a dozen artists at their easels, scattered through the action, and the frozen poses of the models.

The next stage involved transferring the initial composition, or dummy, to the main canvas and brought Le Prince's photographic skills into play. First, the forty-foot-long dummy was divided up into a grid of

several hundred squares. Le Prince then made a glass transparency of each one, which he carefully coded.

It was night. Le Prince was standing on the top level of one of the six tall wooden cars designed to give the painters access to all areas of the main canvas. Next to him, a magic lantern threw a square of white light on to the primed linen. Down below, half a dozen men were pushing the hefty structure along iron tracks laid into the studio floor. Grunts and curses welled up from the darkness. The timber creaked as the canvas moved slowly past him. The surface had been squared up like the dummy, but the grid was ten times larger. Each square had a code which corresponded to a transparency.

When G17 came into view, Le Prince shouted stop and the car ground to a halt. Then, turning to a box containing the hundreds of numbered slides he had had made, he selected G17 and placed it in the magic lantern. A detail of the composition appeared on the canvas. It showed a shell exploding among a rescuing party.*

A painter stepped into the beam. Le Prince watched him trace the image on to the canvas. Several other beams cut the darkness to each side of him, above and below, as other members of the team traced different projections. For a moment Le Prince found himself imagining the effect of hundreds of magic lanterns covering the whole surface with the vast composite image of a battle. Then the fantasy ran away with him. If the slides were tinted, there would be no need for painting the canvas. The whole effect of the panorama might be realized photographically.

As Le Prince worked day and night to keep the evolving panorama on schedule, these kinds of reflections led him inexorably towards a different kind of image-making. [Plate XIII]

Once the dummy had been enlarged on to the surface of the main canvas, the real process of painting the panorama began. The studio became a hive of activity. Painters worked all over the canvas surface on different levels of the wooden cars which were spaced round the studio perimeter, filling in the traced photographic enlargements.

Poilpot stood on the central platform like a general on a real battlefield, viewing the progress of the work through a pair of field glasses. Now and then he consulted a sketched figure composition, pinned to the rail in front of him. Next to him, two veterans of the engagement were sharing reminiscences, commenting on the emerging image. Poilpot listened carefully to what they were saying. He was on the lookout for a few more incidents with which to flesh out the battle, which

had seemed a little thin when the dummy was enlarged. He also paid attention to what they found inaccurate about the work. Authenticity was of great importance to good press reviews and a good box office.

Removing the canvas from the studio was a delicate procedure. A huge spool was constructed and fitted to bearings placed top and bottom of the tallest car. As the car was pushed slowly along the tracks, the riggers carefully detached the canvas from the top ring, cranking it slowly on to the spool. The rolled-up panorama, now weighing several tons, was then lowered into a long box, ready for its hazardous journey from the studio to the rotunda.

Once the canvas was in place in the rotunda, Le Prince began work on the *faux terrain*. This 'false terrain' was a sculptural extension of the painted image into real space, filling the ground between spectator and canvas. Its object was to heighten the illusion by creating a genuinely three-dimensional foreground which receded into the two-dimensional image. The skill lay in disguising the point of transition from real to pictorial space.

The bottom of the canvas had been left bare to a height of about ten feet above the floor where the *faux terrain* was set to emerge. Le Prince scrutinized the canvas at this level where, at one point, it showed a man in the stern of a small boat pushing off into the water on a long pole. The front half of the boat and the bottom end of the pole were missing. The challenge here was to complete the missing parts in three dimensions so that the painted boat and pole became imperceptibly real. Likewise, a line of wooden stakes had been painted emerging from the sea, calling for a continuation of the line with real stakes driven into the real sand of the shoreline.

Work on the *faux terrain* proceeded. The rotunda space became littered with props: real boats, coils of rope, cannon, sandbags, logs and bushes would be used to achieve the illusion. Le Prince concentrated on the vegetation and the figure arrangements. The problem with using real vegetation was that it quickly died, calling for frequent replacement. Le Prince got round this by introducing dried foliage, dyed in appropriate colours. The figures also presented problems. It wasn't just a question of getting the elaborate poses right. A successful illusion required complex diminutions of scale, from the foreground to the point where the *faux terrain* met the canvas.

He was wandering along the simulated shoreline, close to the canvas. The reduced scale of the figures made him look like Gulliver in Lilliput. A wounded sailor was slumped against a stake. His pose was not life-like. Le Prince stooped to adjust him, turning to Poilpot who was giving him instructions from the platform. Poilpot's animated gestures

contrasted sharply with the frozen movements of the figures which filled the intervening space. Increasingly, of late, the static nature of both the painted-figure compositions and the sculptured models had struck Le Prince as inadequate to the task of sustaining the illusion. All too soon, he reasoned, the artifice declared itself.

Le Prince was not the first to feel these limitations. The subjects of early panoramas were predominantly landscapes and cityscapes. Stillness was inherent to these scenes and therefore felt natural. But as soon as the subjects took on a narrative, they became more dynamic and the lack of movement began to undermine the credibility of the illusion.

Various solutions to the problem were attempted early on. One was the diorama, the invention of Daguerre in 1822. Instead of being surrounded by the image, the spectators were oriented towards a single view, framed by a proscenium. One of Daguerre's early dioramas showed a receding Gothic colonnade in ruins. It was painted with such skill that spectators felt as if they were sitting inside it, chilled and imprisoned by the thick fog which obscured the landscape beyond. But as they watched the fog slowly lifted, revealing a magical snowscape. Craggy mountains towered over a valley floor covered in pine forests. Sunlight chased away the desolation.

These effects were achieved by a skilful combination of transparent canvases, silks and subtle lighting changes. When the first tableau had completed its cycle, the auditorium rotated, revealing another change of season in *The Castle and Town of Heidelberg* or the effects of sunlight on *The Interior of Canterbury Cathedral*.

Another solution to the challenge of movement was the moving panorama. As with the diorama, spectators were confronted with a proscenium rather than a 360° surround. A long canvas was mounted on two spools and unwound across the opening. The painted subjects were usually lengthy journeys through remote parts of the world. A lecturer invariably acted as a guide, sustaining the audience's sense that they were actually passing through the landscape. In England, the public paid to travel from *London to Hong Kong in Two Hours* (1860) or to ascend *Mont Blanc* (1852). In the United States, John Banvard toured his *Mississippi* (1840s) the length and breadth of the country. More than half a million people paid to see it. A host of imitators sprang up to satisfy popular demand.

The success of moving panoramas stimulated an appetite for even more action. Rain fell, lightning flashed and waves broke, requiring complex machinery. Variety acts and bands joined the shows, which became more and more cumbersome as they toured town to town, country to country.

On the eve of the Thomas Cook Tour, the moving panorama brought the world inexpensively to a public eager but not yet affluent enough to experience the real thing. Of all the variations on the panorama phenomenon, it was the most direct forerunner of the movies.

But in spite of these developments the panorama phenomenon was ultimately incapable of reproducing movement in any but the most rudimentary fashion. Le Prince recognized this. As a photographer he was now convinced that the key to the animated panoramic illusion he sought lay not in painting, but in photography.

The early development of photography was driven by the desire to improve the visual reproduction of reality. Fifty years before Le Prince began his first serious moving-picture experiments, the limitations of easel painting and the diorama had set Daguerre on the road to the daguerreotype. Within ten years of his breakthrough, the stereographic camera was invented, adding the third dimension to the already astounding imitative powers of photography. Where art had failed, it now seemed that science might succeed in fulfilling the dream of creating a perfect reproduction of reality. Attempts to reproduce movement followed rapidly. In the early 1860s, men like Dumont and Ducos du Hauron patented several imaginative but, for the time being, ineffectual devices.

When Le Prince set out late in 1884 along the arduous moving-picture trail, he was inspired not so much by a need to expand the possibilities of photography as by a desire to improve on the illusionistic powers of the panorama. Three tributaries of Western image-making were joined in his mind when he took his first practical steps in this direction: his experience as a painter; his panorama work; and his knowledge of photography. To this he brought his experience as an engineer and his knowledge of optics. It was a unique combination which was to inform the direction of all his subsequent work.

Le Prince's goal, in his own words, was to create a photographic equivalent of a 'moving panorama in colour'. His ultimate ambition was to fill an area the size of a panorama with moving images, projected by banks of synchronized projectors. Colour was to be achieved by tinting each photographic frame. The vision didn't end there. Just as the panorama created the illusion of three dimensions, so too would his moving pictures. His new machines would be stereoscopic, taking and delivering images that not only moved across a virtually boundless screen but also had all the plasticity of life itself. He would realize Pygmalion's dream.

* * *

After he had adjusted the poses of some of the figures, Le Prince joined Poilpot up on the platform. Both men surveyed the completed panorama. The *faux terrain* now worked well, sustaining the impression of three dimensions deep into the canvas, where a ship went down in flames on the horizon. The long work was over. Tomorrow the turnstiles would be revolving.

Just as Le Prince was about to head home for a much-needed rest, Poilpot turned to him and invited him to manage his next panorama. It was to be *The Battle of Manassas*, bigger and better than anything he had yet done, planned to open in Washington DC early in 1887. Was Le Prince interested?

Lying in bed later that night, Le Prince pondered Poilpot's proposal. If he undertook another bout of panorama work, when would he find time for the moving-picture experiments? But if he turned the job down, where would the family bread and butter come from?

FIRST EXPERIMENTS

It was hot outside. The Memphis heat beat down on the treetops. Inside, the air conditioner hummed. Julie had gone for her rest. I had been left with the stuffed ducks and the rifles to sift through the material on my own.

I picked up a photograph of a house. It was a large timber-frame building with balconies and verandas, surrounded by trees. The sun shone. A man stood in the foreground with an expectant dog at his feet. Perhaps he was holding a ball. I could not make out his face, but from the way the sun caught what could have been a mutton-chop whisker I thought he might have been Le Prince. At any moment I expected him to throw the ball and the dog to rush yapping after it.

I turned the print over. On the back someone had written 'The Old Belmont House, 169–168th Sts, West of Broadway, 1885–6.' I recognized the address. It was the house where the Le Prince family had lived during their first years in New York. The building had long since been demolished. It had once stood in a large field of clover towards the top end of Manhattan Island. The New York Institute for the Deaf, where Lizzie ran the art department, was close by. It was a thinly populated area in those days, well beyond the leading edge of the city's northward expansion.

I picked up another photograph, a milky print of the Le Prince family sitting on the wooden front steps of Belmont House with John Whitley. Everyone was there except Adolphe. Perhaps he was taking the picture?

It was the first time that I had seen a photograph of more or less the whole family together. There were seven people and two dogs in the picture. [Plate XIV]

'Keep him still, Aimée!' Adolphe shouted from beneath the black cloth. Bowman was panting with excitement, and kept making sudden lurches for the ball which had rolled under the steps. Aimée held him tight, turning her back on her younger brother, Joe, who kept whining that he wanted to hold Bowman, who was his.

Marie sat straight-backed next to Aimée, with another dog, wishing Adolphe would hurry up. 'You can hold Pounce if you want, Joe,' she

said, keen to smooth out the conflict that simmered next to her.

'Not now,' Adolphe called, 'I'm almost ready.'

'Come on, Adolphe,' Aimée called, 'I can't hold him much longer.'

'Don't hurry him,' said Le Prince, who was sitting two steps down. Then, turning to Adolphe, he added quietly, 'I don't think the camera's level. It will come out lopsided.'

Adolphe didn't catch the advice. 'I can't get you completely in, Father.'

Le Prince, who was being edged out of the picture by John Whitley's expansive presence at the centre of the group, had been watching Adolphe carefully, throwing out hints, keen that his son should learn about photography. He was on the point of suggesting that Adolphe move the camera back a few feet when he thought better of it. The children were restive and Bowman was barking. 'Never mind. Take it anyway,' he called back.

They were celebrating Uncle John's visit. The Lincrusta-Walton débâcle was a fading memory. The idealistic search for a community out west had been shelved. John Whitley had pulled himself back yet again from the brink of disaster to plunge into his next venture, a series of great international exhibitions to be mounted on a bare triangle of cinders in an area of West London called Earl's Court, hemmed in by the city's metropolitan railways.

The reason for John's presence in New York was the first of these great shows, the American Exhibition, planned for 1887, now two years away. It was to be a showcase of the New World to the Old. In John's stirring words, Britain was 'to hold out the right hand of friendship and affectionate greeting to their kin beyond the sea', hosting this 'first attempt by the citizens of the United States to exhibit to the inhabitants of the Old World some of the gigantic strides made by the principal nation of the New World on the broad and solid highway of peace'.*

Naturally, John's philanthropic jargon masked more down-to-earth motives. His travels in America had exposed him to both the rapidly expanding industrial base and the vast untapped resources of the nation. His American Exhibition was aimed at extending trade and commerce between the two continents, showing European capitalists, who were entering a long recession, the extraordinary investment potential of the United States. In recent months he'd been setting up the financing of the project and wooing potential exhibitors. He was particularly keen to involve Edison. The Wizard had already committed himself in an advisory capacity. Now John was pushing him to take charge of the electrical exhibit, illuminating the show as he had at Crystal Palace four years earlier, and perhaps even arranging to show

a few electrically powered cars on an elevated railway – on a small scale, of course. There was a role for Le Prince too, if he wished.

John sat between Lizzie and Le Prince, as physically and emotionally expansive as the nation he was busily promoting, waiting for Adolphe to release the shutter. To all appearances, he was host, not guest, of those around him. On his right, Lizzie sat stiffly, leaning slightly in towards her brother to stay in the picture. John's charisma often overawed her. His visits were like a whirlwind, tugging her between the roles of his younger sister and mother to her large and demanding family.

Adolphe said, 'Ready, everyone?' John grinned at the camera, legs splayed and straw hat cocked rakishly. Fernand, his favourite nephew, sat beneath him, thrilled by Uncle Jack's visit.

Le Prince had long been used to John's domineering attempts to involve him in his precarious projects. This time he had resolved not to get swept in. When not involved in panorama work he was devoting all his energies to the moving-picture idea. A few days earlier, he had told John about the experiments. Immediately, John grasped the commercial potential of the idea and began proposing all sorts of ways in which it might be exploited. Somehow he hoped that Le Prince might be persuaded to exhibit the new machines at the American Exhibition. Le Prince was more hesitant. The project was in its infancy.

John persisted. Wouldn't Augustin at least consider showing the apparatus to a lawyer friend, Mr William Guthrie, who could offer sound advice about how best to exploit the new invention commercially? Le Prince had been noncommittal at first, worried about exposing the work too early.

The shutter clicked. Aimée said grumpily, 'About time too, Adolphe,' releasing Bowman who shot under the steps for the ball. Le Prince and John got up and sauntered across the clover field. Mosquitoes and bees rose up all around them. Was Guthrie to be trusted, Le Prince wanted to know. He didn't want the wrong people getting hold of the idea. John reassured him. Guthrie had helped out with the American patents on the Lincrusta-Walton process. He was a patent lawyer, in partnership with Seward.

Mention of Seward reassured Le Prince. Since John had involved him in the Lincrusta business and sought his help with Whitley's Spinner, he had grown to know and trust Seward. Recently Seward had put him forward for membership of New York's élite Lotus Club. Le Prince had declined, but the two men had remained friends.

'If anyone knows the best way to go about making an invention public in the United States, Guthrie does,' John said.

Le Prince nodded reluctantly. Guthrie was expected that evening.

The showing was to take place in the makeshift workshop at the back of the house.

That night Le Prince showed John Whitley and William Guthrie an animated photographic image, possibly of a young girl skipping. It was a very short sequence and predictably uneven. Whether it was projected or seen through some viewing device is uncertain. Marie later claimed that when she made her unwelcome intrusion on Le Prince in his workshop at the New York Institute for the Deaf, at about the same time, she saw moving images projected on to the wall. Whatever the mode of viewing of these first snatched sequences, Le Prince clearly demonstrated the principle of his invention at this time.*

Guthrie liked what he saw. 'This is a most interesting scientific invention,' he said to Le Prince 'but how are you going to make it commercially viable?'

Le Prince looked at John, who was momentarily thrown, then said to Guthrie, 'That's what we hoped to hear from you.'

The three men left the workshop, still talking. A bell rang upstairs in the house. It was Phoebe, announcing bedtime for the young ones. Fernand's nightly squalls echoed down the stairwell. Phoebe's voice rose above the clamour. 'You'll do as you're told, young man, or your father will hear about this!'

Downstairs, Le Prince acknowledged the commotion with a tolerant smile. He was a firm believer in early to bed. Then Lizzie's voice joined Phoebe's. 'Into bed this minute, Fernand. Do you hear me?' Guthrie raised his eyebrows in complicity as if to say 'Children!' Le Prince shrugged back a 'What can one do?' That afternoon Fernand had released his older brother's precious collection of mosquitoes.

'Why's Joe allowed to stay up and not me?' Fernand bawled.

'Because you broke his mosquito jars, that's why. And Marie's helping him tidy up the mess. And don't you ever go near them again. Do you hear me?' Phoebe grasped Fernand firmly. The boy struggled. 'It's all right, ma'am, I can manage him.'

'I don't want to go to bed,' he spluttered.

Lizzie walked out on to the landing and leant over the banister rail. Fernand went suddenly quiet. She let out a sigh of relief. What would she do without Phoebe? Down below, the three men crossed the Persian rug in the hall. Their voices drifted up through the unexpected silence.

'I've been considering taking it to Mr Edison,' Le Prince was saying.

'First things first,' Guthrie replied. 'When you've drawn up the patent, we'll see what we can do to help. But don't delay.'

* * *

I picked up a magnifying glass and looked closely at Lizzie. She was sitting on a cane seat in the corner of the veranda at Point O' Woods. I couldn't make out her expression because of the halation on the print, but her pose looked resigned, battered by events. There was no date on the photograph, but I guessed it had been taken around 1900. I decided on 1899, the second year of the great motion-picture litigation between Thomas Edison and the American Mutoscope Company.

Aimée was sitting next to Lizzie in a rocking chair, dressed for cycling. Her bike was propped up against a wooden column. On the other side of Lizzie, a more grown-up Fernand swung gently in a hammock, nudging himself to and fro with a tennis racquet. The china was out on the table with the perennial lump of fruitcake. It was another of those teatimes and I wanted to join them. [Plate XV]

Adolphe was not in the picture. He was probably back in New York, tracking down the recollections of witnesses to Le Prince's work to use as evidence in the family's struggle to gain recognition.

Aimée seemed to be saying, 'Everything will be all right, mother, you'll see. We'll win in the end. Adolphe will make sure of that.'

Fernand wasn't so sure. 'I don't think we stand a chance. Why can't we just accept the fact that Father's not coming back?'

'No one says that in my house,' Lizzie fumed.

'How could he still be alive?' Fernand mumbled.

'They're holding him captive. That's how,' Lizzie replied. 'And they'll continue to do so until our claims are legally recognized, when they'll no longer have any reason to keep him. Then we'll find out the truth. Not that we don't know it already,' She waved a letter at Fernand.

It was a reply from William Guthrie, dated 23rd March, 1899. Lizzie read it aloud. 'All that I can remember after the most anxious effort to recall, is that I went to Belmont with Mr John Whitley in 1886, and that I was shown a curious invention; but I cannot recall what the invention was.'*

She tossed it away in disgust. 'Poppycock, and he knows it,' she snapped. 'I was there when he visited. Your father demonstrated the machine to him.'

Guthrie's letter of denial had been no great surprise to Lizzie. Ever since she had spotted Guthrie deep in conversation with Edison on the Atlantic Highlands ferry in 1891 she had suspected that he had played a part in Le Prince's disappearance. This event had compounded the shock of discovering that Le Prince's friend, Clarence Seward, Guthrie's partner, who she had hoped would help fight Edison's fraudulent claim to have invented moving pictures, was working for Edison. In the emotionally charged aftermath of Le Prince's disappearance she had

become convinced of both men's complicity, a conviction now strengthened by Guthrie's disgraceful letter.

'Do you remember Guthrie's visit to your father's workshop at Belmont, Aimée?'

Aimée sighed. 'No, Mother. I'm sorry.' All she could recall was her girlish curiosity about what went on in the forbidden workshop. Several times she had crept in, drawn by the rows of little photographic dishes filled with special chemicals. Once she had been on the point of dipping a finger in for a taste, but was cut short by the sound of adult footsteps in the corridor.*

Another photograph. Lizzie stood surrounded by her five children on a pathway at the bottom of a short flight of garden steps. The image was undated, but from the apparent ages of the children it seemed to be the late 1890s again. [Plate XVI]

Far right, Fernand stood slightly separated from the others, looking sporty in a white cap and bow tie, apparently less touched by the family tragedy. He was only twelve when Le Prince disappeared. For the young Fernand, this final absence was perhaps merely the culmination of a boyhood during which his father was rarely at home. Now aged twenty-one, he stared directly at the camera, announcing his determination to be free of the past.

Next to Fernand, Aimée in a white frock stared away to the left, a little cross at having to pose with her family when she would far rather have been out with her friends. She had argued with her mother about it. Each had dug in stubbornly. It was a special occasion, Lizzie had insisted. In the end Marie had persuaded Aimée to stay. Lizzie stood next to her, a small, racked figure in a dark dress, fists clenched at her sides. She was tense, both from her recent squabble with Aimée and from her continually frustrated attempts to gain recognition for Augustin.

Joe towered over her, looking mad in a broad-brimmed bonnet which he had just grabbed from his mother's head. He was playing clown to defuse the tension. As a middle child, Joe had found himself increasingly negotiating the balance between Lizzie, Adolphe and Marie's unswerving determination to find recognition for Le Prince and the other children's need to live free of that shadow.

Adolphe and Marie stood solemnly to the left of the picture, hands at their sides, almost at attention. Their gazes crossed Aimée's, fixed on some distant future far away to the right. Perhaps they had glimpsed justice, the long-sought relief for the stiff loyalty of their postures? As the oldest children, they had borne the full weight of Le Prince's

disappearance. A sibling pact seemed to hover in the intense space ahead of them. Both were utterly dedicated to the vindication of Le Prince's frustrated life's work.

Adolphe looked tired. Perhaps he was recovering from another attack of malaria, contracted some years before from the mosquitoes that thrived in the clover at Belmont. More likely, he had been up all night, scrutinizing the testimonies of those precious few witnesses who had recalled Le Prince's first moving-picture experiments in New York, searching for corroboration of his own clear recollection that Le Prince had constructed both one- and four-lens prototype machines at this time.

I looked up from the photograph. Billy came into the room shaking his head, followed by Chick. 'That's the lot,' Chick said. 'We can't find no more.'

'There was a whole trunkful, I'd heard,' Billy said with regret, 'but when Aunt Marie died it all got thrown out. Very little survived.' My heart sank.

I appealed to Chick who shrugged back, adding, 'Trouble is, they just didn't know the value of it. It was disgraceful.'

In my mind's eye I watched as the old trunk was dragged out to be left with the garbage. Its lid was half off. Overflowing with bills, drawings, letters, it contained the answers to all my unresolved questions. It was the key to the mystery, the original Le Prince documentation so carefully nurtured by Lizzie, then Marie after her, preserved for posterity like one of Whitley's time capsules, waiting for someone like me. A diesel roar drifted through the trees. The garbage truck rolled into view. I looked on helplessly, damning the injustice of history. A gust of wind caught a photograph of Le Prince – a good one I would now never see – tossing it up into the air and away. The truck pulled up at the house. Four cursing men shouldered the irrelevant load, dumped it, then drove off down the road, leaving me alone with the breeze in the pines and the rising chatter of the crickets.

Throughout the latter part of 1885 and into 1886, whenever not engaged in panorama work, Le Prince devoted all his spare time to the design and construction of his first models. He worked on his own, in his studio at Belmont and in the workshop of the Institute for the Deaf where he conducted trials of the apparatus. Nothing has survived from this early period. The only indications of what he might have achieved lie in Adolphe's uncertain references to machines with one and four

lenses; in his first patent application, filed at Washington in November 1886, and for which no model was furnished; in the testimonies of witnesses gathered by Adolphe; and in a handful of surviving drawings and scribbled notes.

It was with this skimpy and sometimes unreliable evidence that I now tried to get a picture of what he had achieved in those first years. I began with the testimonies. I was on tricky terrain. Sworn testimonies are no substitute for hard evidence. They rely on the accuracy and honesty of recollection, often many years after the event.

Take William Kuhn, for example, a mechanic who assisted Le Prince between 1885 and 1887. In 1899, Adolphe tracked him down. 'I constructed an apparatus of sheet tin,' Kuhn declared, 'somewhat in the shape of a magic lantern, which had in it perforations for lenses, and spindles and doors to operate the lights.' Kuhn also recalled fitting gas burners to the apparatus at this time. Clearly he had worked on one of Le Prince's early projectors. He mentioned lenses rather than one lens, and spindles which suggested interior moving parts. But beyond this, the testimony was frustratingly short on detail.

The other testimonies on Le Prince's early New York work were almost as vague. Joseph Banks, who had been chief engineer at the Institute for the Deaf at the time, remembered seeing an apparatus resembling a large magic lantern in the kiln room. 'Near its base,' he wrote, 'it had a scroll decoration cut out in the sheet iron sides, there was one lens used in this instrument . . . I made several appliances for the said Mr Augustin Le Prince as a favor, and did such work as drilling, and filing some of the parts of the machine he brought to me.'

Henry Woolf, one of Le Prince's partners in the Lincrusta-Walton business, was slightly more specific. He recalled seeing several appliances, including a single-lens machine, for producing moving pictures. Le Prince showed him 'a moving figure of a man . . . exhibited on a screen . . . in the latter part of 1886'. Woolf was hazy about mechanical detail, but remembered 'seeing the pictures, one over the other, mounted on long rolls of cartridge paper, inside the machine, and that a handle was turned to start them working. Fastened on the back of the studio door he had a model to get at the method of moving the film; it consisted of several rollers and a crank with a handle and gear to move the film forward as wanted.' Woolf was sufficiently impressed by what he saw to offer to raise capital so that Le Prince could market his invention and give public exhibitions. He concluded by adding, 'I had grasped the manner of working the apparatus enough to know that on reading Edison's account of the Kinetoscope in the papers of May 1891, that it was an infringement on Le Prince's machine.'*

* * *

A few months after my first visit to Memphis, I heard from Billy again. Something else had turned up. His mother had held on to a few additional bits and pieces in an old cardboard box which she had kept quiet about for fear that one of her sisters would throw it out as had happened with so much else. Billy had unearthed it in another of his forays through the attic. He hadn't yet looked through the material thoroughly, but it seemed to him as if it were part of the collection of old papers upon which Lizzie had based her memoirs.

'Shall I send them over?' Billy's voice echoed down the line. A week later a three-inch-thick wad of photocopies arrived. I was staggered by the size of it. If this much had survived in bits and pieces, whatever had Marie stowed in the lost trunk? The document on top was a design for limelight burners. It was someone else's drawing, not Le Prince's practised draughtsmanship. It reminded me of Kuhn's claim to have fitted gas burners and his references to lenses in the plural. These were probably his drawings for the projector lights, which judging by the number of burners would have had four lenses. It spoke well for the truth of his testimony and confirmed Adolphe's description of a four-lens machine.

The next sheet was covered in sketches and scribbled notes. I could tell from the curls on the *d*s that it was Le Prince's own handwriting. A scrawled list read B. BILL, BARNUM, SURF . . . HUDSON RIVER BOATS, N.Y. BAY, BDWAY FROM OFFICE, CENTRAL PARK FASHION AND BOATING, BASEBALL, GIRL THRO' PAPER DISKS ON TIGHTROPE . . . and so on. After a moment's bewilderment I recognized a list of possible subjects for filming. The 'B' of B. Bill, I realized, stood for 'Buffalo'. Most of his choices were characterized by movement and spectacle, and seemed to have been selected for their entertainment value. The specified locations were all in New York, suggesting that the sheet dated from the time of Le Prince's first experiments.

The drawings were mainly circles of interlocking gear ratios. In one corner there was an absent-minded doodle of a young woman, perhaps the teenage Marie. In another were two profiles of a strange camera-like device with sixteen lenses. There was no sign of a machine with either one or four lenses.

AVOIDING THE SHARKS

Lizzie was torn between feelings of exhilaration and claustrophobia. Only yesterday the narrow railroad had been hemmed in by towering granite peaks. This had now given way to a boundless flat desert. She had been travelling west for several days. The sluggish brown eddies of the Mississippi were a fading memory. They had passed through vast stretches of empty grassland. At first these had receded to an infinite horizon, broken only by the occasional herd of buffalo or a farmstead. Much later, the landscape had started to roll, gently at first, then in bolder folds as they approached the great barrier of the Rockies.

It was a specially chartered train, full of teachers of the deaf on their way to a convention in Berkeley. Lizzie had been chosen to represent the British government.

Since becoming head of the art department at the New York Institute for the Deaf her work had become widely respected. It was a demanding job, involving weekly contact with several hundred students. She had also begun writing for art magazines, which kept her up late into the night. But it was work that she enjoyed and she was reasonably paid for it.

That was just as well, she reflected, as the train rolled its way across Utah. Le Prince's moving-picture experiments were proving a bottomless pit as far as money was concerned. The gruelling process of trial and error required costly tools, workshop space and raw materials, not to mention the various specialized craftsmen whom Le Prince employed. Above all, there were the countless hours of his own time.

This work was all self-financed and since Le Prince's own private means were insufficient to support both a family and the ongoing moving-picture experiments, he was dependent on both his panorama work for Poilpot and on Lizzie's teaching income.

It was a stressful time for Lizzie. In addition to her teaching, she had the responsibility of caring for and schooling the children. The situation had become so critical recently that she had had to tell Phoebe that they could no longer afford her. Luckily, good old Phoebe had refused to leave, offering to work for nothing until things improved.

It was late afternoon. The desert was beginning to assume the redder hue of evening. It was thanks to Phoebe that she had been able to make the trip west with a clear conscience. What time would it be in New York? Early evening. She would have fed all the children and prepared the younger ones for bed. She would be about to serve Augustin dinner. They would all be well cared for.

Poor Augustin. She wished he'd been able to make the trip west with her. But he'd had to stay behind for more panorama work. It was a frustrating situation which was sapping his energy for his experiments.

Thoughts of family meals made her feel hungry. Wasn't it teatime? Where was the conductor with his little bell to summon them all to the dining car? Just then the train juddered to a halt. Nervous faces craned down the gangway for an explanation. Had there been a hold-up? Was it Indians?

Soon the conductor arrived. 'Ladies and gentlemen, I'm sorry to have to announce that we've lost the dining car.' Fears turned to laughter. 'She was accidentally detached at the last stop. When we've taken on some water we'll head back and collect her.'

Lizzie didn't find that funny. Things fell apart if she didn't get afternoon tea on the dot. It upset the rhythm of the day. There was only one thing for it. If they wouldn't provide tea then she would. Watched by a coachful of curious faces, she made her way down the gangway, got off the train and headed for a nearby farmhouse. She did not have much time. The stationary 'Dong, dong' of the locomotive marked the passing minutes. The engine whistled, announcing its departure. Anxious passengers scanned the horizon. 'There she is!' someone cried, and everyone clapped as Lizzie staggered towards the train armed with bagfuls of cookies. Once on board, she pulled out her teabasket, which went everywhere with her, and threw an impromptu teaparty.

Back in New York, Le Prince's panorama work took longer than expected to materialize. He welcomed the delay, throwing himself into his invention. By the summer of 1886 the work was far enough advanced for him to begin drafting his first patent application.

It was exacting work. The Patent Office required precise specifications, down to the number of teeth on each gear wheel. Such demands were not a problem for Le Prince, who had his experience of engineeering draughtsmanship at Whitley Partners to call upon.

In September, Lizzie returned from her trip to California to find Le Prince immersed in his experiments. She was full of the convention. The delegation had been treated like royalty, fêted with huge bouquets on arrival, welcomed at a grand reception given by none other than

Governor and Mrs Leland Stanford. And it hadn't stopped there. Between sessions of the convention, the Stanfords had personally superintended sightseeing trips round the Bay area. This had led to Lizzie's being invited to the Stanford home. Now came the real news. Mrs Stanford was so impressed by Lizzie's teaching methods and their results that she had offered her the position of Director of Art at Leland Stanford University.

Le Prince listened calmly as Lizzie poured it all out. 'She wants me to transfer my art department. They are wealthy people. I would have all the resources I needed. We could restart the Leeds Technical School.'

'And we would all move to California,' Le Prince said impassively.

Lizzie's face fell. 'Well, of course. But you could continue with your experiments out there.'

He was silent. She added, 'They're offering a good salary. For both of us. It would mean an end to all our money worries.'

Years later, Lizzie wrote in her memoirs: 'When Fortune leads a victim to the gates of Paradise she first blindfolds him.' The cruel irony was that back in the summer of 1886, she was not aware that Leland Stanford had financed Muybridge's photographic experiments. Mrs Stanford had been a keen supporter of Muybridge's work when her husband's enthusiasm was on the wane. Had Lizzie known, she might have broken Le Prince's desire for secrecy and mentioned his moving-picture work in the hope of gaining financial support. But events fell out differently. The Stanfords remained in ignorance and Le Prince was unconvinced by the Californian offer.

He shook his head slowly. 'Moving pictures will solve our money worries. Just you see. The financial returns will dwarf anything we might make from a new art school venture.'

But Lizzie did not see. What use was Augustin's optimism about the lucrative future of moving pictures when present financial realities loomed so darkly? Le Prince was only too aware of the problem. He had recently been on the point of confiding the invention to Edison, with a view to securing some kind of backing. He had even got as far as setting out one morning to do so. But fate intervened. On the way he bumped into a friend who advised strongly against such rashness. For all his publicly acclaimed genius, Edison was known, even at that time, for less than entirely scrupulous behaviour when it came to other men's inventions.

'I've been thinking about Grandpa,' Le Prince said. 'He might help.'

Lizzie frowned. 'Can we ask him for capital? I don't think he's got it.'

'I wasn't really thinking of money.'

'What then?'

'The foundry. It has everything I need. Space, tools, materials and skilled men.'

Le Prince watched her in silence. She said nothing at first. Then tears came to her eyes. He tried to put an arm round her, but she pulled away sharply.

'So it's no to my plans for California, but when it comes to your invention you expect us all to pick ourselves up just like that and go back to Leeds.'

'Not all of us. Just me,' he replied. But this just made matters worse.

Lizzie turned on him angrily. 'While we stay in New York on our own?'

'It wouldn't be for long. A year at most. Time enough for me to build the machines as I want them and to secure foreign patents.'

'A year's a long time.'

'You shall visit,' he said, as if the decision were already made. 'Spend the summer in Leeds. The children will love it. A year will pass quickly. Then I'll return to New York for the launch of my invention and all our worries will be over.'

But Lizzie was not reassured. She saw only his absence.

When Le Prince's letter arrived in Leeds, outlining the scope of his new invention, it was just the thing Whitley needed to lift him out of his depression. The years since Lizzie and Le Prince's departure for New York had gone badly. Samson Fox had been at the centre of his troubles. In exchange for half the rights on Whitley's patent, Fox had undertaken to manufacture corrugated boiler flues using Whitley's spinner. 'I'll have 'em in production within three months,' Fox had vowed.*

'I'll give you six,' Whitley replied, before eulogizing his new colleague in verse. That had been four years ago and Fox had done nothing.

Things had recently come to a head when Whitley read a report of his spinner in the *Engineering Journal*. The invention was credited to Fox. This kind of betrayal cut him to the quick. 'Why should this appear without my name?' he raged in his diary.

After that things hit rock bottom. When confronted by Whitley, Fox told him, 'There's simply nothing in your process and everybody says so. It's a failure. There's no trade in the country for bronze spinning anyway. It's all finished. There's nothing in any of our patents.'

'And you have the nerve to tell me this after keeping me waiting for four years, without ever once having tried the process properly!' Whitley raged. 'You have not honoured your obligations!'

That had been July. It was now mid-October 1886, and Whitley was sitting at his desk in the study of his Roundhay home staring fixedly at

the sky through the window. There it was again, the distinct retinal impression of the window frame, persisting in the temporary darkness.

'Sarah!' he called out to his wife. 'Come in here a minute.'

Mrs Whitley padded in from the hall. She was dressed for chapel. It was Sunday. 'You'll harm your eyes if you keep that up much longer. It's not good for them.'

'I'm just proving the point.' He waved Le Prince's letter in the air. 'Augustin has invented an artificial retina of mechanical accuracy, which will retain moving images. I can understand that bit, but he plans to retain sound as well. How will he do that?'

'Heaven knows. It sounds like witchcraft to me. Now stop staring out of the window or we'll be late.'

Whitley snapped his fingers. 'I've got it. He'll probably use a reversing phonograph, linked up.'

Mrs Whitley was used to these flights of inventive fantasy. For the forty years of their marriage Whitley's mind had rarely stopped speculating on scientific possibilities. His sudden energy for Augustin's project was the latest in a long line of such enthusiasms, which had included flooding the Sahara and manufacturing Bell's telephone. She was pleased. It kept him from brooding about Fox. And it might lead to her seeing more of Lizzie and the children.

'I don't think they'll all come,' Whitley said. 'It'll just be Augustin to start with.'

'Well, don't you go promising him too much. I couldn't stand another family crisis over business. Not this late in life.'

'I'm not thinking about capital,' he said abruptly. 'I'm thinking about the works. We're tooled up for a job just like this. I've got workshops lying idle, and craftsmen with nothing to do. Trade's that bad. This is just the thing to put us back on our feet.'

Whitley scarcely noticed as his wife left the room. His mind had started steaming down familiar tracks. It was one of those inventions that furthered communication between peoples, like the telephone, which had made the world a better place and its inventor a lot of money. One day, no doubt, millions of people would own them. If he wasn't mistaken, Augustin's proposal was similar.

He picked up his quill, determined not to let his imagination run away with him. The first thing was to warn Augustin. It was clear from his letter that several people knew about the invention already, and that was several people too many.

'We are delighted with your buoyant hope for the near future,' he wrote to Lizzie in his scratchy old man's hand, 'but are afraid of any partnership before the patent is secured, or any delay. I shall be glad to

hear when the patent is secured, and have tracings and legal drawings and terms Augustin has made, with some dollar margin in exchange for his own brain power, hand labour, and experiments. Tell Augustin to write to me, and if we can engage to make the machines for the million, we will do so. I do not want to disturb Augustin's thoughts which I trust will be all he anticipates but if I could assist I should be delighted to do so.'*

He read over what he'd written. The thin paper was covered in smudges. How wobbly his handwriting had become. Now if his clerk were here, he could simply dictate it. Or better still, one of those typewriters. Now that was an idea! Typewriters for the firm. An end to all that copious copying into letterbooks.

Where was he? Augustin . . . patents. Perhaps he hadn't put the point over quite strongly enough. 'Pray keep us advised,' he emphasized, 'not on the particulars of the invention' – Whitley thought it too risky to send details by post – 'but upon securing it to your own future interest. I congratulate you, my dear child, and trust that your husband may keep clear of the sharks who are swarming in every part of the world to pounce upon the work of nobler minds. This fact I know to my sorrow, and of this very time while I write.'

The hall clock struck ten. His wife was making leaving noises in the hall. This morning he would pray for Fox's soul and ask forgiveness for his anger towards the man. He closed his eyes, not in prayer, but to quieten his retina for one last exposure to the white sky. The October wind rattled the window pane. He opened his eyes wide. Another summer gone. The tired green leaves of the sycamore were draining to dull orange. A hedgehog snuffled its way towards the rhododendrons. The black silhouettes of two crows wheeled in the wind, cawing their discontent. Whitley beamed with pleasure. What a sight. What a glorious thing sight was, for that matter. Never mind Fox. Thank God for sight!

Wheels crunched on the driveway. 'Joseph,' his wife called. A horse whinnied. Hurriedly Whitley scrawled a few last words of encouragement to Lizzie for Le Prince: 'Indeed, in very deed, we are fearfully and wonderfully made and how god-like are those who discover the laws that govern the phenomenon of life and more so those who apply them to the requirements of the times through which we are passing. Your very affectionate parents, J & S Whitley.'

Le Prince took Whitley's advice. On 2nd November, 1886, he filed a patent application to the US Patent Office in Washington. On the same day he wrote enthusiastically about his new project to his friend, Richard Wilson, in Leeds.

The patent will take a couple of months before issuing through the offices at Washington, and I shall then secure it in France, England & co. It is in the line of Dioramas and Panoramas but with figures in lifelike action; this wants keeping secret till secured.

I am now making apparatus to work it practically, and if as successful as I anticipate, it will bring me back to England to work it out there. I will be delayed a little by Panorama work which I expect in a week or two, but which will help me otherwise financially. Remember me to our Bros. at Fidelity, and hoping to read you soon, I shake hands most heartily and remain, yours *dévoué*, A. Le Prince.*

But Le Prince's hopes of an early return to Leeds were soon frustrated. He had not bargained for the maddeningly slow progress of his patent through the Patent Office.

QUEER THINGS

I was finishing my breakfast. The letterbox was emitting sounds of paper under stress as the postman wrestled with an extra-large package. Finally it hit the doormat with a thud.

Le Prince's US patent is the clearest surviving indication of his thinking about moving pictures in the early New York years. The package was big because they had sent the file wrapper as well. The file wrapper contains a record of all the haggling correspondence thrown up by the original patent application. It details clauses disallowed by the Patent Office and its reason for doing so. It shows the tortuous process of amendment required to get the wording just right. A careful reading of this finicky paperwork often reveals as much about an inventor's intentions as the patent itself.

I swept away the toast crumbs and found a space for the documents. The application opened with a flourish, as was customary.

> November 2nd, 1886. Be it known that I, AUGUSTIN LE PRINCE, of the City, County and State of New York, have invented certain new and useful improvements – THE ART OF PRODUCING ANIMATED PICTURES OF NATURAL SCENERY AND LIFE ON GLASS, CANVAS OR OTHER PREPARED SURFACES of which the following is a full, clear and accurate description.

It was a typewritten document submitted by Le Prince's patent agents, Munn & Co., who were also publishers of the *Scientific American*. I took a deep breath and put my head down. The going was hard. It required great concentration.*

Several sheets of drawings were included. I recognized them immediately. They were detailed designs of the pencil sketch which Billy had found in his mother's cardboard box. The apparatus appeared to have sixteen lenses, a variant confirmed when, a few clauses into the specification, I came across a description of 'a system of three, four, eight, nine, sixteen, or more lenses of equal focus'.

The first inconsistency emerged quickly. Adolphe's New York witnesses, Banks and Woolf, had recalled seeing one-lens machines in

Le Prince's workshop at this time. Adolphe had referred to his father constructing one- and four-lens machines in 1886. While the four-lens variant was covered by the patent, I found no specific reference to either a one-lens camera or projector in the US patent. Surely Le Prince would have included the single-lens option in his patent application if he had been developing it at the time? Had Adolphe been mistaken? Were his witnesses reliable? In the absence of hard evidence, I could only assume that Le Prince's first moving-picture machines had multiple lenses.

This too was puzzling. Why propose a battery of lenses when a single lens would have been so much simpler? The answer lay in the thicket of mechanical description which lay before me. I had no option but to wade through it, line by line.

Le Prince's sixteen-lens camera employed two rolls of film which were advanced alternately past the lenses by an intermittent mechanism geared to the release of the shutters. The lenses were arranged in a square, made up of two double columns, each of which was two lenses wide and four high. When the camera was cranked, one band of film was advanced into position behind one double column of lenses, while the other band of film received eight images, exposed in vertical sequence. As the second band was advanced, so the first received its eight exposures. This alternating process went on for as long as the two rolls of film held out. [Plate XVII]

Once exposed, the film was processed into individual transparencies. Two rolls were then made up. In each roll the transparencies were fitted in pairs, side by side, between perforated metallic ribbons in positions which corresponded to those in which they had been exposed.

These picture bands were then exhibited through the projector, which was, effectively, the camera in reverse with the addition of a system of lights and reflectors behind the lenses and a film transport mechanism which engaged teeth in perforations of the metallic ribbons.

As I wrangled with the smallprint, I was struck by what seemed to be the perverse complexity of the contraption. It wasn't simply the multiplicity of lenses, for which I still had no explanation, but the cumbersome individual mounting of transparencies in the rolls. Again I found myself asking why Le Prince had not taken the apparently easier route and designed single-lens machines from the outset, which in turn would have required only a single and continuous flexible film roll?

The answers were disarmingly simple. Le Prince described the film for the camera (the negative) as 'an endless sheet of insoluble gelatine coated with bromide emulsion, or any convenient ready made quick acting paper such as Eastman's paper film'. Whereas for the projector,

A. LE PRINCE.
METHOD OF AND APPARATUS FOR PRODUCING ANIMATED PICTURES
OF NATURAL SCENERY AND LIFE.

No. 376,247. Patented Jan. 10, 1888.

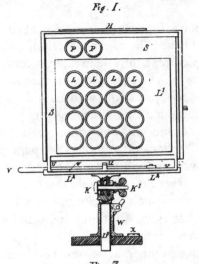

Fig. 1.

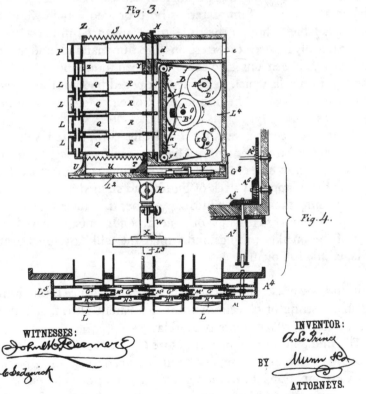

Fig. 3.

Fig. 4.

WITNESSES:
John W. Reemer
C. Sedgwick

INVENTOR:
A. Le Prince

BY Munn & Co.
ATTORNEYS.

Le Prince's sixteen lens camera; US Patent application

'the transparencies were to be mounted on a transparent flexible material – such as gelatine, mica, horn'. In both cases, the word celluloid was conspicuously absent. No such material was available to Le Prince in the summer of 1886.

Then things fell into place. From the beginning Le Prince had grasped that his apparatus would have to be capable of taking and projecting up to 'many thousands' of pictures a minute in rapid succession in order to sustain the illusion of movement. A lightweight material of low inertia like Eastman paper film could just about withstand the stresses of being moved intermittently through a single-lens moving picture camera at around sixteen times a second without either tearing or shaking the machine to pieces. But when it came to projection, paper film was inadequate, and the alternatives – individually mounted gelatine, mica, horn or glass transparencies – were far too cumbersome to be advanced at such a rate. Only a material such as celluloid was light and strong enough to withstand such stresses. Anything else would have destroyed itself and the machine in no time.

But by multiplying the number of lenses, Le Prince enabled the fragile and weighty film materials he proposed, which were the only ones available to him at the time, to be advanced much more slowly. This radically reduced the stress on both film materials and machine. In the case of sixteen lenses, to achieve sixteen frames per second, each of the two film rolls which Le Prince proposed had a full half-second to advance into position behind its bank of eight lenses, while the other was at rest.

What had seemed an almost wilfully complicated solution now struck me as rather eloquent. His approach was beginning to make sense. I was now eager for more of this highly technical story. I reached for the file wrapper. A fleck of butter had stained a corner of the first page, turning the opaque white copy paper translucent. Before sinking into the morass of crossings-out and amendments, I cleared away the rest of the breakfast things and wiped the table. By lunchtime I had grasped the full picture.

Within a few weeks of filing his application, Le Prince found himself up against a string of objections from the Patent Office, calling for the reformulation of a number of key clauses.

The first objection came just before Christmas. The application was thought to embrace two separate and distinct inventions. 'Upon preliminary examination,' the examiner wrote to Le Prince's patent lawyers, 'a division is considered necessary, under Rule 41, Rules of Practice.'

By two inventions, the examiner meant the camera and the projector.

The application contained two subclasses and should reflect that from the point of view of official classification. 'When properly presented,' the letter intoned, 'the alleged invention will be examined on its merits.'

Le Prince pondered this request over the holiday. These kinds of snags were to be expected, even welcomed. They enabled applicants to clarify the nature of the invention, making for a clearer cut case in the event of future litigation.

Le Prince's original application had described two viewing methods. The first was a projector, for the throwing of transparent pictures in quick succession on to a screen. This was effectively the camera in reverse, with minor modifications of the lenses and film advance and the addition of lights. The second was a smaller peephole apparatus of entirely different construction. Perhaps an amendment to omit all references to this second device would satisfy the Patent Office's request for a division?

No such luck. A month later his amendment was deemed insufficient. Now they spelt it out. Lines nineteen and twenty, on page one, figure seven, first and last paragraphs of page sixteen, first and fifth clauses of the claim . . . and so on. In other words, any references to separate viewing apparatus, including the larger projector, should be eliminated or be the subject of a separate application.

It was a frustrating time. One request for a division was a possible advantage, but a second could reflect badly on the applicant. Le Prince approached his friend, Clarence Seward, with the problem. Seward had cut his teeth in combat with the whims of the Patent Office. He'd know what to do.

'They're sticklers for the rules,' Seward told him.

'But they don't understand,' Le Prince said. 'If my proposal was merely an improvement on photography then a division would make sense. A camera doesn't require a magic lantern. A magic lantern doesn't need a camera. They are two apparatuses. But in my invention camera and projector are inseparable. You can't have one without the other.'

Le Prince had defined his aim as 'The Production of Animated Pictures of Natural Scenery and Life'. The term 'production' involved both taking and showing, each of which was an integral aspect of the invention.

'It's a problem of classification,' Seward told him. 'You're claiming a new art and they don't have a class for it. So they file you under Cameras and Stereopticons. The old divisions.'

'They haven't grasped what I'm after.'

'Well, go down there and tell them in person,' said Seward, and offered to write a letter of introduction to the chief examiner.

Le Prince followed Seward's advice and took the train to Washington, where it became immediately clear to him that the examiners had not understood the scope of his invention at all. At first he was suspicious. Whitley's recent warnings were still ringing in his ears. Had the misunderstanding been somehow deliberate? Had they intended such a lengthy delay? But they seemed nice enough, even helpful.

Slowly he talked them through it again, step by step. Finally one of them grasped his intention. 'It's a wonderful invention!' he exclaimed. 'Good thing for you we're not still living in the age of witchcraft.' Everyone laughed. But rules were still rules.

The next day Le Prince locked himself away with his patent lawyer. For several hours the two men went through the application with a fine-tooth comb, erasing all references to a separate projector. This was not a concession. Through cunning rephrasings and the substitution of clauses, the specifications and claims now read as variations on the same piece of apparatus, a single invention which enabled both the taking and projecting of moving pictures. It was 'an apparatus [singular] for producing animated pictures and delivering the same upon a suitable surface', the proposal now concluded, 'whereby the camera may serve the twofold purpose described, substantially as set forth'.

In reality, Le Prince's sixteen-lens camera was never to double as a projector. Separate machines were required. But the modifications to the patent application now satisfied the Patent Office. Le Prince returned to New York reassured that at last the Patent Office would get down to the business of evaluating the invention itself.

It was a brief respite. A few days later the Patent Office wrote to say that Le Prince's claims were untenable in view of the prior state of the art. In plain English, someone had got there before him. They cited two British patents to Dumont, dated 1861 and 1865, and a US patent to Muybridge, dated 1883.

To an inexperienced applicant this might have seemed a setback. It wasn't. A patent was often strengthened by the honing of clauses which an initial rejection of claims often entailed. The claims in a US patent are detailed statements of every possible combination of the new ideas involved in the invention. They need to be watertight. Tactics are of great importance in their formulation. Broad initial claims are often an advantage. They force the examiner to a thorough search of the Patent Office files of the relevant divisions and subclasses of the invention, so that any prior art in the field of which the inventor may have been unaware is smoked out. This process shows the inventor exactly where he stands, enabling him to narrow his claims accordingly, defining precisely what is new about the invention, making it less vulnerable to predators.

On 5th April, 1887, Le Prince and his lawyers conceded to the elimination of the three claims, as requested by the Patent Office. But they added one more, covering the variable focus of the lenses, and elaborated the general description of the invention in order to distinguish it more clearly from the Dumont and Muybridge patents. 'The above amendment,' they wrote, 'is believed to remove all objection from this case and an early allowance is respectfully requested.'

But the haggling was set to continue. A fresh search by the examiner revealed the new claim to be anticipated by one Wing, US #78,408. A new bout of tampering ensued. Then at last, on 23rd April, 1887, US patent #217,809 to Le Prince was allowed.

Or would have been, if Le Prince hadn't had second thoughts about erasing the claim which the examiner had previously disallowed on the basis of the earlier Muybridge patent. On the same day that the patent was allowed Le Prince requested its withdrawal, asking for a restoration of the claim which he felt entitled to. The claim described a camera 'provided with a series of lenses, in combination with a series of shutters, and means substantially as described for operating the shutters successively and continuously'. In Le Prince's view, this claim clearly distinguished his invention from Muybridge's through the use of the word 'continuously'.

Le Prince sailed from New York to Liverpool at the end of April 1887. It was a tricky time to leave. The issue of Claim 2 was left hanging. Further communications with the Patent Office would have to take place by letter or wire, through his lawyers, leaving plenty of room for misunderstanding. He would have preferred to give it his direct attention.

Lizzie was heartsick and depressed at his going. A few days before his departure she poured out all her feelings. But it was too late to change plans.

'I'll be safer away,' he said, gravely.

'What do you mean?'

'There's queer things going on at the Patent Office,' Le Prince replied softly. 'They shouldn't have disallowed my second claim. Nor should my lawyers have accepted it.'

Lizzie was alert. 'They can't be acting together?'

He shrugged. 'I don't know. It's just important that I take out patents in Europe as soon as possible, just in case.'

Le Prince's suspicions were well founded. On 4th May the Patent Office rejected the re-presentation of Claim 2, citing Muybridge again.

MUYBRIDGE

Le Prince's ship berthed in Liverpool on 5th May. He was just in time to catch the three o'clock train to Leeds, where he arrived tired and hungry early in the evening. The Whitleys were thrilled to see him, eager for news of Lizzie and the children.

Le Prince lost no time in preparing for work. The morning after his arrival, Whitley took him all round the foundry, showing him what tools, materials and men were available. Later the same day he met Richard Wilson at Brown's Bank, to discuss financing the experiments.

But his attempts to get started were repeatedly hampered. The first weeks back in England were hectic. To begin with, there was the opening of John's American Exhibition at Earl's Court, which had been one of the reasons for returning at this time. John had originally hoped to *première* his brother-in-law's invention there. Le Prince said no, but, typically, this didn't stop John from pressganging him into helping with last-minute arrangements for the exhibition itself.

The show was a resounding success. Le Prince was impressed more by the entertainments than the vast industrial exhibits. Buffalo Bill was the star attraction, followed by the Switchback Railway, the Toboggan and Dan Godfrey's Band.

Whitley and his wife travelled down from Leeds for the opening. That evening the whole family celebrated John's success and Le Prince's return over dinner. Halfway through the meal, a Queen's Messenger arrived. Her Majesty wished to attend the exhibition the next day. All that night florists and decorators came and went at Earl's Court. The next day John and various committee members were presented.

And then (Lizzie could scarcely believe Augustin's letter) her own husband, her Augustin, led his niece forward to present the bouquet. Later it was said that the Queen turned to her lady-in-waiting and said, 'That's one of the handsomest men and the loveliest child I have ever seen.'

That same night Le Prince left for Paris, where his mother had been taken seriously ill. It soon became clear that he would be there for some time. Rather than lose still more time, he decided to find an electrician

and a mechanic in Paris, so that at least he could make a start on the machines while looking after his mother.

A few days later he heard that the Washington Patent Office had again disallowed his second claim. 'As it stands, the clause involves no invention,' the examiner repeated, 'in view of the prior state of the art, shown more particularly by the patent of Muybridge already cited.'

This further rejection galvanized Le Prince into action. It was time to make clear once and for all how his invention differed from Muybridge's.

When Le Prince embarked on his moving-picture project in 1885, he would almost certainly have been aware of the recent work of a number of men in what was known as 'series photography'.

The most prominent of these was Muybridge, whose methods and results had been well publicized. Since arriving in New York in 1882, Le Prince had had several opportunities to attend one of the great photographer's famous lectures on animals in motion, illustrated with animated pictures by means of the zoopraxiscope.

Muybridge, an Englishman, became well known in the 1860s for his stunning stereographs of California. In 1872 he was commissioned by Governor Leland Stanford to photograph a horse. Myth has it that Stanford, a great horse-lover and racing man, wanted to settle the controversial question of whether all four hoofs of a galloping horse were off the ground for at least part of the animal's stride.

Using a special rapid shutter, Muybridge showed that the horse's feet were momentarily clear of the ground. The experiment whetted Stanford's appetite. A few years later he commissioned Muybridge to carry out a far more elaborate experiment.

In the earlier experiment Muybridge used just one camera, which was reloaded for each pass of the horse. The 1877 experiments were more complex. On Stanford's private trotting track at Palo Alto, Muybridge built a shed containing twelve cameras arranged in a horizontal series. When the horse trotted by it tripped twelve strings which released twelve electromagnetically operated camera shutters in sequence.

The resulting photographs showed twelve sequential images of the horse's movements taken in the period of about a second. The distance between the first and last lenses was about twenty-five feet, each lens being about two feet apart. This meant that each image was taken from a slightly different viewpoint. Although the horse remained centred in each frame, the background shifted in accordance with the shifting viewpoint – a phenomenon known as parallax.

Muybridge's work caused a sensation in the press. In France, it came

quickly to the attention of the French physiologist Jules Marey who for some years had been analysing animal movement by attaching strange measuring devices to the limbs and wings of unsuspecting animals and birds. Muybridge's example showed Marey that photography would give him much better results, so he set about designing apparatus of his own. This work came to fruition in 1882 with the photographic gun. It had a single lens which revolved intermittently on a turret, exposing a circle of twelve images on to a fixed photographic plate.*

That same year, Muybridge embarked on the second great phase of his work at the University of Pennsylvania. His subjects were animals of all descriptions and the naked human figure in motion. Children ran, elephants ambled, men wrestled and pole-vaulted, women spanked young boys or climbed into bed.

While Muybridge's techniques remained essentially the same, his apparatus underwent a series of improvements. He constructed new cameras which were much more compact. By radically reducing the distance between the lenses, he minimized the effects of parallax. He also varied his viewpoints. Previously, his subjects moved laterally to the camera, across the field of vision. Now, in addition, he set up his cameras on axes which were both diagonal and head-on to the movement of the subject. This called for new lens configurations. Some were arranged vertically and others in three by four 'batteries' of twelve. He also constructed a clockwork switching device which triggered the shutters electrically, replacing the crude string-tripped device of Palo Alto.

At first sight Le Prince's multi-lens moving picture camera appears merely derivative of Muybridge's battery lens cameras. A moment's scrutiny of Le Prince's patent, however, reveals radically contrasting intentions and different technical means for realizing them.

Le Prince's intention was to produce 'animated pictures of natural life'. Show business – his desire to improve upon the panorama experience – was his point of departure. The entertainment of an audience with moving pictures was uppermost in his mind from the outset. It required both apparatus for taking the pictures, the camera, and a technically related apparatus for exhibiting them, the projector.

Muybridge's primary aim, on the other hand, was the analysis of human and animal motion through a sequence of rapid series stills. An audience was not essential to this process. His lectures were a spin-off from the main event, a means of making scientific findings public rather than entertainment *per se.*

Not that a Muybridge evening was unentertaining. Muybridge himself provided a scintillating commentary to his sensational sequential

stills, all of which led up to the crowdpuller, the extraordinary zoopraxiscope.

The zoopraxiscope was essentially a variation of the old phenakista-scope. A dozen images of a horse, for example, were drawn on the periphery of a glass disc in consecutive stages of motion. When this disc was rotated in conjunction with a counter-rotating slotted disc and har-nessed with a powerful magic lantern, a repeating image of the horse in motion was projected on to a screen. Muybridge was not able to transfer his series photographs directly to the zoopraxiscope. Although the stills of animals in motion were the source, the image on the glass disc required elongation in order to be seen in proportion on the screen, a result which could be obtained only by hand drawing. The technologies of Muybridge's zoopraxiscope and his battery cameras were thus inde-pendent of each other, separate lineages which were reflected in the nature of his evenings.

Zoopraxiscope sequences were based on only twelve images and were therefore very short. Little more than half a second elapsed before the cycle repeated itself. The same brevity was true for the taking of each series of photographs where the number of sequential images was lim-ited to the number of cameras in the battery, usually no more than twelve. Once exposed, the glass plates had to be removed from their holders and replaced manually for the next sequence. But since Muybridge was not after the indefinite duration of the series, he had no need of an apparatus that advanced film mechanically.

These split-second sequences were plainly inadequate for Le Prince's concept of moving pictures as entertainment. A whole evening of repeating sequences was hardly likely to hold an audience for long. Reasonable duration was a prerequisite and demanded radical technical innovations, of a kind Muybridge never proposed. Hence Le Prince's proposal of long bands of sensitized material and a means of advancing them intermittently past the lenses.

Le Prince was absolutely clear on these points. His US patent des-cribes 'sensitive film stored on two drums . . . presenting a flat surface facing the lenses for exposure . . . [which] . . . ultimately wind over an upper set of drums'. After detailing the mechanism, he summarized his camera as 'a photographic receiver provided with a series of lenses, a series of shutters, and means for operating them successively and con-tinuously, in combination with film drums and means for operating them intermittently . . .' A similar mechanism served to advance the picture bands, also stored on drums, through the projector.

It required no great feat of imagination to arrive at the idea of a rolled picture band. It was a commonsense solution and had precedents. The

French inventor Ducos du Hauron had made the suggestion as long ago as 1864, in his invention for taking and viewing sequence photographs.

There were also more recent indications of the idea from other quarters. In the very year, 1885, in which Le Prince embarked on his first moving-picture experiments, George Eastman revolutionized still photography with his rollholder, a long band of film rolled on to a spool which was wound, frame by frame, on to a second spool as each exposure was made. Even closer to home, in yet another sphere, Le Prince would have been familiar with the mechanical unrolling of the continuous bands of images that made up a moving panorama.

Much more challenging to Le Prince was the problem of inventing a mechanism which would advance these film bands intermittently. He had identified this fundamental requirement of moving-picture technology by 1886. It was a many-faceted challenge, in which the weight and speed of moving parts, the synchronization of film advance with shutter mechanisms, and, not least, the strength, translucence and flexibility of the film material itself, were all critical factors.

Neither Muybridge, Marey nor any of the earlier pioneers had yet found solutions to this problem because it was not on their agenda to do so. By tackling it, Le Prince was entering uncharted terrain. He was to spend the rest of his life grappling with the knot of technical problems he encountered there. Within a few years, he would be joined by many others.

I ploughed on through the file wrapper. Le Prince wired his final amendments to his patent lawyers in May 1887. Once again, he agreed to remove the alleged Muybridge-infringing claim which he had wanted restored a few weeks earlier. But he now added two further claims, which were far more specific.

One of these caught my attention immediately. In it, Le Prince claimed 'the method of photographing a changing or moving body, or object, or scenery, which consists in successively and continuously photographing the object or scenery at regular intervals from the same point of view, substantially as set forth'.

It seemed to be a cover-all claim, which, by not stipulating either a single lens of a series of lenses, appeared to leave the way open for either. But the phrase 'same point of view' was ambiguous. If interpreted loosely it could mean a small battery of lenses. But if taken literally it could only refer to a single-lens machine. The latter reading supported Adolphe's recollection of Le Prince experimenting with a single-lens apparatus in New York in 1886.

What caught my attention was that someone had drawn a line

diagonally right through the claim. In the margin a hurried hand had written, 'Erase per Q. June 15th 1887.' Who?

The new claim was accompanied by a blunt letter from Le Prince's patent agents. 'Muybridge desires to produce different pictures from different points of vision,' they clamoured, 'while applicant produces pictures from the same point of vision so that there is no interruption in the scene which would be continuous and without a break, and if an object was moving across the scene it would be taken until it disappeared and the effect would be natural and lifelike. Muybridge never contemplated anything of the kind.'

This irate letter evidently failed to sway the Patent Office. On the last page of the file wrapper I found a final letter from the examiner, in which the key claim was found, yet again, to be anticipated by Dumont.

And there, beneath this brief disallowal, was the incriminating letter of consent. Nearly two months after Le Prince's departure for England, his agents appeared to have authorized the erasure of the crucial claim without consulting him.

THE EDISON PATENTS

At first a disappearance seems more bearable than a death for the bereaved. All the confused emotions of alarm, depression and disbelief are tempered by the hope of reappearance. When the Le Prince family faced the fact of Le Prince's disappearance in the autumn of 1890 they were convinced that it was only a matter of time before he would return.

Yet over the next few months detectives in New York, France and England signally failed to uncover any trace of him. Lizzie was bewildered by their lack of progress. It increased her anxiety. At the same time, the absence of either a body or a smoking gun was strangely reassuring. Since there was no proof of his death, she reasoned, he was not dead. But it was not like Augustin to remain silent. She was used to his weekly letters. Therefore something must have happened to him.

Her suspicions were fanned by the sequence of strange events which followed the disappearance. Who was the man Rose, who had made two visits to the Jumel Mansion, urgently seeking Le Prince? Why had he come in disguise the second time? Why had Le Prince's name been on the manifest of the SS *Gascoigne*, indicating his arrival in New York on 10th November, 1890? Shortly after that, she had paid her disastrous visit to the office of their lawyer friend, Clarence Seward, and been told that Seward could not see her since he was in court, engaged on a case for none other than Edison. Seward knew about Le Prince's invention. Had he, or Guthrie, entrusted it to Edison? Why had the New York police refused to take up her case? Wasn't it too much of a coincidence that Edison should claim moving pictures as his own invention within months of Le Prince's disappearance?

These unanswered questions still tumbled within Lizzie's thoughts long after Le Prince had vanished. In spite of what seemed to her to be numerous clues and leads, the mystery remained unsolved. The worst thing was not knowing. It gnawed away at her hope. However painful a death, it was at least certain. But with Augustin there had been no witnessed dying; no funeral to celebrate the net of love and friendship which was his life; no rite of passage to mark his passing ritually. In short, no grieving. None of the natural processes of mourning. Instead,

her children's endless and unanswerable questions: where is he, when will he come, is he coming? Instead, forlorn faces at the window, raised hopes at every tinkle of the doorbell, flutters of apprehension with each visit to the letterbox.

Like Lizzie, the law also assumed Le Prince's survival, adding a cruel twist to her emotional impasse, preventing her from prosecuting his patents until seven years had elapsed from the date of his disappearance.

Trapped in this psychological vacuum, the Le Prince family lived life as best they could. While the children continued with their education, Lizzie threw herself into her teaching at the New York Institute for the Deaf. She also became a founder member of the New York Society of Decorative Arts and continued giving her art classes at Chautauqua Assemblies in the summer months. Their home remained the Jumel Mansion for several years, but the financial burden of maintaining such a place was more than they could afford. By 1894 it had become painfully clear that the mansion's great council chamber would never witness the world's public début of moving pictures, so the family took a nearby apartment. In the same year, a Chautauqua Assembly for the New York City area was founded at Point O' Woods on Fire Island. Lizzie acquired a plot and over the next few years the Le Prince boys, now in their late teens and early twenties, built a large timber-frame house close to the ocean, which became their summer home.

These were difficult times. The lengthening shadow of Le Prince's disappearance hung over all of them. Almost worse was the agony of watching his invention made public by other men. Following legal advice, Lizzie had decided to wait quietly, drawing minimal attention to Le Prince's patents until the seven years were up and she had the legal power to administer them. So she looked on helplessly as first Edison, then the Lumières Brothers, the Lathams, Thomas Armat, Robert Paul, Birt Acres, William Dickson, Herman Casler and many others brought moving pictures flickeringly into the world. The resulting family pain was fertile ground for suspicion. As the years passed, the unresolved emotions of their loss hardened around the conviction that Edison was somehow responsible.

The truth was that although Thomas Edison had presided over the development of a working moving-picture camera and viewing apparatus by the summer of 1891 (largely by exploiting the achievements of other inventors), he was by no means convinced of the novelty's commercial viability.

This lack of conviction was not sufficient to prevent him from filing

three patent applications on the invention. But his half-hearted attitude was reflected in the lack of vigour with which he pursued them.

Of the three applications, the first covered both the camera and exhibiting apparatus – #403,534; the second covered only the camera – #403,535; while the third covered only the exhibiting apparatus – #403,536 – the kinetoscope.

After much wrangling between Edison's principal lawyer, Richard Dyer, and the examiner at the Patent Office, the kinetoscope patent was granted to Edison on 4th March, 1893. The other two applications had a much tougher ride. The combined camera and kinetoscope application fared very badly. The examiner rejected all its claims, citing the prior work of Le Prince, Donisthorpe, Friese-Greene and Dumont. After a few skirmishes, it was allowed to fall into abeyance. To all appearances it was dead. In reality, by craftily lodging appeals on the eve of a sequence of deadlines, they were to ensure that it remained dormant.

The camera application did little better. Of Edison's twenty-three claims, the examiner rejected twenty-two as being anticipated by, among others, Le Prince, Donisthorpe, Friese-Greene and Dumont. After a year of fruitless exchanges with the examiner, Richard Dyer pushed it no further. Two years later, on 9th November, 1894, the application officially lapsed.*

Edison was uninterested in moving pictures at this time because he was expending his energies elsewhere. Sixty miles to the west of New York, up in the New Jersey highlands, he was building himself a village called Edison on a fir-clad mountainside that overlooked the Delaware River valley. This was no idyllic community of the kind that John Whitley had gone in search of with Le Prince ten years before. In spite of the recent bruising he had received at the hands of those who had taken over his electrical interests, and in spite of recent betrayals by close friends, the village of Edison, New Jersey, was no contemplative retreat.

The first thing that greeted the occasional journalist who managed to find his way to this remote region was the dust and the noise. Edison was literally moving mountains. A vast acreage of trees had been cleared. The buckets of great steam shovels swung into gaping holes to re-emerge laden with ton-weight lumps of rock which they dropped crashing into the wagons of a waiting train. Then the warning whistle blew. Men crouched behind jagged outcrops for protection. The blast shook the mountain. A cloud of dust rose as the bucket swung in once more.

When the wagons were full, the little train puffed its way towards the mill where vast rollers broke the rock down. The din was infernal. Headsized bits of rock emerged from the crushers on to a network of

conveyors, rising up to be dropped through more mills, pulverized stage by stage, until the mountain was reduced to dust. Finally the dried powder ran a gauntlet of several hundred powerful magnets which separated the iron ore from the sand.

Somewhere in there was the Wizard himself, fascinated by the power of the steam shovel, personally supervising the work of several hundred men who crawled over this, his greatest scheme to date, his gargantuan ore-separation project.

The Wizard had nursed this dream of providing cheap iron ore to the steel producers of the north-eastern seaports for the best part of a decade. Now, awash with dollars from the sale of his interest in the General Electric Company, he was trying to make that dream a reality.

The photographer caught up with him during a break between shifts. Edison posed on a battered swivel chair outside his office. His work suit was filthy, as befitted the togs of a working man. Knees crossed, leaning back slightly, he clutched his lapel and stared defiantly into the distance. It was a self-conscious image. Perhaps he was trying to convey something to those financiers far away to the east, the men who, having had enough of his idiosyncratic ways of doing business and his stubborn refusal to entertain the far more efficient alternating-current system, had kicked him out into the cold, stripping the reorganized General Electric Company of his, Edison's, sacred name. Perhaps he wanted to show those Wall Street hustlers, who had never done an honest day's hard work in all their soft lives, that, far from nursing defeat, the Wizard was now taking on nature herself. The 'Napoleon of Invention' had become a Titan.

Well, not quite. In fact, not at all. The harsh truth was that for the first time in his life the Wizard's legendary powers were beginning to fail him. No matter how much of his considerable fortune he sank into the project, it would not come right. The mills regularly broke down under the strain of crushing the huge lumps of rock. Foundations cracked and subsided. Worse than that, the resultant iron was impure and not popular with the ironmakers who found it difficult to process. By the summer of 1895 the price of ore had dropped significantly and Edison had lost more than a million dollars.

'The Ogden Baby', as Edison called his ore-milling fiasco, was not the only one of the Edison offspring to give him trouble at this time. He was also having problems with his favourite baby, the phonograph. The challenge, as always, was how to ensure the profitable commercial exploitation of the invention while keeping control over it.

The heady days of the first breakthrough with the phonograph in 1877 had been followed by gruelling years of perfecting it. When, in

1885, Edison was approached by the Bell Company with a proposal that they manufacture the phonograph under licence, he was appalled to discover that they had been granted a patent on a machine, the graphaphone, which very much resembled his phonograph. True to form he said no and filed a lawsuit. These people had no right to mimic his phonograph, which was his baby. Then, to make sure that he held on to the initiative, he threw himself into two years of improving the device.

Meanwhile, the Bell Company sold its graphaphone patent to a millionaire called Lippincott who took over the American Graphaphone Company. When Lippincott discovered that the graphaphone was inferior to the phonograph, he made Edison an offer for his phonograph rights. The deal went through, but not before Edison discovered that he had been swindled by one of his closest friends and associates. Vowing that he would never trust anyone again, Edison undertook to supply phonographs to Lippincott who licensed them to a nationwide network of dealers through what now became the North American Phonograph Company.

The new arrangement was not successful. For one thing, the phonograph was not well enough developed. Edison's 1890 model was a forerunner of the dictaphone, an office recording and reproducing machine. One of the problems was how to power it. Foot treadles, water motors and electric motors were all tried unsuccessfully. Sound quality was poor. There were also no instruction books and service back-up was hopeless. The result was that there were very few takers. There were even fewer for the graphaphone. By 1891 Lippincott had lost most of his fortune. He died shortly afterwards.

Confronted with this mess, which was largely due to his own chaotic way of doing business, Edison set out to reclaim the rights on the invention which he had thought his all along, hoping to compensate for some of the vast losses he was making with the ore project. His actions were unprincipled and ruthless and made him many enemies. In a series of moves which bordered on swindle, he seized control of the North American Phonograph Company, then forced it into bankruptcy. His colleagues were horrified. But to the Wizard, virtually any means were justifiable when it came to staking his claim. The result was fifteen more years of litigation.

Edison wasn't interested in toys. For a long time he resisted developing the phonograph as an object of entertainment, preferring to exploit its more serious business potential, where in his view the profits were to be made. At first he extended this attitude to moving pictures. But unlike the phonograph, Edison saw no business use for the kinetoscope.

Which is why, in the early years, moving pictures came low on his list of priorities.

Other men around Edison felt differently and began to press him to allow the commercial exploitation of the kinetoscope. The business took off slowly. First the famous Black Maria – the world's first motion-picture studio – was built at West Orange, where assistants sneezed, monkeys performed, and Mae Lucas danced before a primitive Edison camera. The plan was to exhibit these first short films in a bank of ten kinetoscopes at the Columbian Exhibition in Chicago in 1893. Edison authorized construction to begin, but only one was completed in time. The Wizard's lack of urgency prevailed. The real commercial début had to wait until April 1894 when the exhibitors Raff & Gammon, under contract to Edison, opened the first kinetoscope parlour on Broadway. The public response was rhapsodic. For the rest of that year, and the next, Raff & Gammon spawned parlours all over the country.

Then something happened which was to change the whole subsequent development of the movies. William Dickson, who had carried out and supervised virtually all of the 'Edison' work on moving pictures, left his master's employment. There were several reasons for the split. For years Dickson had been responsible for key breakthroughs at the West Orange laboratory for which Edison had claimed and taken all the credit. Dickson's resentment had recently been heightened by Edison's reluctance to allow him to develop a moving-picture projector. 'If we make this screen machine,' Edison had said, 'it will spoil everything. We are making these peepshow machines and selling a lot of them at a good profit. If we put out a screen machine there will be a use for maybe about ten of them in the whole of the United States. With that many screen machines you could show the pictures to everybody in the country – and then it would be done. Let's not kill the goose that lays the golden egg.'

It was another example of Edison's blinkered vision and had the effect of driving Dickson to experiment clandestinely with the Lathams, who had been running a kinetoscope parlour in New York and recognized that only screen projection would satisfy the mushrooming demand for moving pictures.

Dickson's move did not escape the attention of Edison's new troubleshooting general manager, William Gilmore, who had been brought in to sort out the phonograph business. Sparks flew between the two men from the start. Dickson resented the extension of Gilmore's authority over kinetoscope production, which he regarded as his sphere. Dickson's 'betrayal' was the excuse Gilmore needed.

In April 1895 Dickson ended his eight-year association with Edison and joined forces with a group of men who were determined to build a moving-picture concern that would rival Edison's. The outcome was the formation of the American Mutoscope Company (AMC).

Dickson's profound knowledge of moving-picture technology was of great value to the new company when it came to building its own apparatus. But he had to tread extremely carefully. Edison was convinced that he had been doublecrossed, that another of his 'babies' was being appropriated. Dickson was familiar enough with his old employer's litigating ways and knew that he could not risk being seen to be designing machines for AMC. To complicate matters, he was faced with designing machines which would not infringe the Edison apparatus, for which there were patents still pending, a challenge made much easier by the fact that Dickson had designed the 'Edison' apparatus himself and so knew precisely what to avoid.

Dickson embarked on this project with Herman Casler, who, with Harry Marvin, ran a small machine shop in Canastota, New York. By the end of 1895 the new outfit had its own camera, the mutagraph, and its own peephole viewing device, the mutoscope. The American Mutoscope Company commenced business in January 1896, capitalized to the tune of $200,000 by the New York Security & Trust Company. It was a runaway success. They shot their first films in an open-air studio on the roof of their Broadway headquarters. Dickson operated the camera. Within a few months they were shooting on location, at Atlantic City and on the Pennsylvania Railroad.

The opening of the first mutoscope parlours dealt a mortal blow to the kinetoscope. Crowds preferred the mutoscope's clarity of image and found the subjects more interesting. Raff & Gammon looked on in horror as their kinetoscope business fell away.

They were saved by an approach from a Washington inventor called Thomas Armat, who claimed he had solved the problem of moving-picture projection. Highly sceptical, they visited for a demonstration and were unexpectedly convinced.

Now Raff & Gammon had to persuade the Edison establishment to manufacture Armat's machine, a difficult task considering Edison's continuing lack of interest in moving pictures and reluctance to acknowledge that someone might have succeeded in a field of invention where he had so far failed. After several stormy sessions at West Orange they emerged with an agreement. In the process they betrayed Thomas Armat.

The new machine was named the vitascope. It was proclaimed as 'Mr Edison's Latest'. The deal was distinctly shady. It presaged the dishon-

esty which was to characterize Edison's tactics in the now imminent moving-picture patent war. 'No matter how good a machine should be invented by another,' Raff & Gammon smarmed to Armat, 'and no matter how satisfactory or superior the results might be, yet we find that the greatest majority of parties who desire to invest in such have been waiting for the Edison machine and would never be satisfied with anything else . . . While Mr Edison has no desire to pose as inventor of this machine, we think we can arrange with him for the use of his name to such an extent as may be necessary for the best results.'*

They concluded by assuring Armat that as soon as they 'reaped the respective rewards', they would make it their business to attach Armat's name to the machine as inventor, confident that he would eventually receive the credit that was due.

The world, meanwhile, gained a different impression. A press review was held at West Orange early in April 1896, carefully orchestrated by Edison's manager, Gilmore, Richard Dyer – his principal lawyer – and Raff & Gammon, to set the stamp of Edison's genius on the vitascope. For a couple of hours reporters huddled round an old stove in a dark corner of the works as *Annabelle's Skirt Dance* and *The English Derby* were thrown up on to the screen. To their amazement, the image was steady. The Wizard had done it again. He paced up and down in his overcoat, chuckling and joking with his assistants. 'No one was more pleased at the success of his work than the great inventor himself,' New Yorkers read in the newspapers the next day.

A few weeks later this lie was given another shove towards the history books when the vitascope received its public début at Koster & Bial's music hall on 34th Street. The programme announced 'Thomas A. Edison's Latest Marvel'. While Armat sweated with his machines out of sight in the projection room, Edison watched from a box for all the world to see, silently accepting the credit.

The success of the vitascope rescued Raff & Gammon from their flagging kinetoscope business. The screen art was now set to displace the peephole machine. As if alerted by the imminent take-off of the moving-picture business, and with Edison beginning to show interest, Richard Dyer turned his attention once more to Edison's dormant patent application on the moving-picture camera and exhibiting apparatus, #403,534. It wasn't just that the Lumières Brothers had presented the world début of screened moving pictures four months earlier in Paris, or that Armat had in reality beaten Edison to a successful projector. Much more of a threat were the film-production activities of the American Mutoscope Company on Edison's doorstep, which not only had its own camera and the mutoscope peephole machine, but also was

rumoured to be developing its own projector which, if the mutoscope were anything to go by, could turn out better than the vitascope. It was time to act.

Two days before the vitascope début and on the last day allowed by the Patent Office, Edison and his lawyers opened an appeal on the pending patent #403,534, which had been filed in August 1891 and rejected on all its claims. Their strategy was cunning. By grafting on to the all-but-dead #403,534 a series of amendments which were in fact the rejected claims of Edison's already abandoned #403,535, they breathed new life into an old application. These amendments, which described such key aspects of moving-picture camera technology as the use of a tape-like film, the provision of an intermittent mechanism, and the use of a single camera (lens) had been previously denied to Edison on the basis of the prior work of Le Prince and Marey. Richard Dyer's retro-active move was of questionable legitimacy, but for the time being nobody noticed. The revived application once again started ticking away like a time bomb.

OPENING SHOTS

Although ignorant of the machinations of Edison's lawyers, the Le Prince family could scarcely have missed the fanfares that accompanied the launches of the kinetoscope, the mutoscope and the vitascope. Packed viewing parlours were on the streets of New York for all to see. The newspapers clamoured about Mr Edison's 'latest'. It was a testing time for all of them. The seven-year period was not yet up. They were still powerless to act.

Finally the brouhaha became too much for Lizzie. The injustice of it all was so blatant. She decided to act for herself. Where detectives had failed she would succeed. During the summer of 1896 she paid a visit to France and England with her daughters, determined to reopen trails of enquiry which had by that time gone cold.

It was a fruitless journey which coiled her suspicions all the more tightly without providing any answers. She began her enquiries in Leeds.

One day, after seeing the girls off on a visit to some friends out of town, she took a cab from the station to her father's foundry. She wanted to question the foreman on a few points about Augustin's last days in Leeds.

The place filled her with gloom. Whitley had been dead five years. The firm was finally being wound up. Her father's life work lay in disarray. Rusting stock was heaped in great piles.

While she was talking to the man, the telephone rang. He answered it, glanced at her, then said: 'Aye, five minutes ago. Do you want to speak to her?' Whoever it was rang off abruptly.

The old foreman held the earpiece away from him, staring at it with a frown. 'Someone askin' if you'd arrived, Mrs Le Prince.'

She felt suddenly faint. 'But no one knows I'm here. I told nobody.'

Lizzie's fear that she was being followed was heightened a few days later when she visited Le Prince's old landlady. The poor woman had suffered a severe stroke, so Lizzie was not allowed to see her. Instead she took tea with her daughter.

'My mother wanted you to have this.' It was the key to Augustin's workshop on Woodhouse Lane. 'She wants you to know that just after

185

your husband left for France, some men came to this house. They tried to get that key from her. They wanted to break into his workshop.'

Lizzie was confused. Had the old landlady mistaken Richard Wilson for a villain when he had come for the workshop key shortly after the disappearance? Or had there been another group of men?

The daughter continued. 'My mother was very upset when your husband disappeared. One of her other boarders committed suicide shortly after.'

Lizzie sipped her tea nervously. She didn't want to hear that kind of detail.

'These men . . .' The woman lowered her voice. 'My mother says they were up to no good. She thinks they still have him fast somewhere.'

The next day Lizzie decided to call on Jim Longley, Augustin's principal assistant. Longley had been in and out of the workshop frequently in the weeks leading up to Augustin's ill-fated journey to France. Perhaps he would shed some light on the identity of the men who had tried to break in.

Longley lived in a working-class area of Leeds where the houses were packed tightly together and washing lines hung across the streets. As the cab approached his house, her sombre mood was amplified by the sour hues of Leeds red brick which overwhelmed the gardenless district.

Mrs Longley answered the door. 'Jim's away in Newcastle on a rest cure. He's been very poorly of late. If he'd known you were coming he'd've stayed. Such a pity. Will yer stop for a minute?'

Lizzie was shown into a cramped but immaculate front room. Mrs Longley launched into her version. 'Jim's convinced he was the victim of foul play. Why else would he vanish? Jim told me that he expected to do well out of it. Someone else cottoned on, that's what happened. There were those who wanted to forestall him.'

Lizzie left Leeds no wiser than when she had arrived. The same ill luck dogged her in France. In Paris she went to the Bureau des Recherches Pour Familles which had undertaken the original search for Augustin in 1890. But Monsieur Dougan, the detective who had had charge of the investigation, had left the bureau some years before and no one knew of his whereabouts.

She asked to see the dossier on the search in the hope of gaining fresh clues. But all she discovered was that the photograph of Augustin which she had supplied in 1890 had gone missing.

A visit to the relations in Dijon was equally fruitless. She went over all the details of Augustin's final weekend with his brother Albert. It was the same old story. He boarded the train in good health and high spirits on the afternoon of Tuesday, 16th September, 1890. Then silence.

* * *

Lizzie returned to New York to find the new screen art blossoming nationwide. The vitascope was spreading state by state as fast as manufacture would allow. The Lumiéres' cinematograph had swept New York in her absence. In October, Mutoscope's projector – the biograph – made its début. It was as good as the Edison camp feared it would be, benefiting in clarity and steadiness from frames which were eight times the size of those produced on the Edison cameras.

Behind the scenes, the shady tussling to control moving pictures continued. In February 1896, two months before Edison filed his dubious amendments on his camera patent, AMC had filed a patent application on their camera, the mutagraph. Throughout that year the two rival applications drifted through the Patent Office procedure alongside each other. Then in March 1897, Edison's time bomb went off. The Patent Office declared an interference.

An interference is declared to decide who should get priority when two or more parties claim the same invention. On one side there was AMC's mutagraph, and, lo and behold, on the other was Edison's amended #403,534. And if the examiner wasn't mistaken, Edison's patent application was filed years before AMC's, in August 1891.*

AMC's Herman Casler reacted furiously. He could see what Edison's lawyers were up to all too clearly, and informed the Patent Office in no uncertain terms. Edison's current application was the virtually abandoned shell of an old application, fattened up with claims which had already been rejected on the basis of the work of Le Prince, Marey and Friese-Greene. The effect of these so-called amendments was to change the character of the old application so fundamentally that, in Casler's view, it constituted a new application. Since Edison's amendments were filed after AMC's application, there could be no question of an interference. AMC had priority.

Casler went further. Patent Office rules stipulated that if an invention had been in public use for more than two years it was unpatentable. The Edison Company had been using their camera to make kinetoscope films since 1893, if not earlier. Dickson himself had built the camera and operated it, and declared as much to the examiner. Surely then, the interference was invalid on these grounds as well?

The examiner agreed. To AMC's delight, he dissolved the interference. Edison's lawyers conceded that the invention was not patentable.

But matters didn't rest there. Although the interference had been dissolved and Edison appeared to have relented, in fact his lawyers invoked their right to appeal to a higher authority, the commissioner of patents himself. Horrified at this double dealing, Marvin, AMC's

second vice-president, petitioned the commissioner to suspend all proceedings on the Edison patent. In his view, the dissolution of the interference had clearly invalidated its claims.

Casler's petition was denied. In spite of his cries of oversight and utter neglect on the part of the Patent Office, on 31st August, 1897, six years after his original application, Thomas Edison was granted letters patent #589,168 for an alleged improvement in photographic cameras, which, his lawyers claimed, in acknowledging him as the inventor of the moving-picture camera, gave him sole rights to its exploitation. The battle lines were now drawn up for the War of the Patents to begin.

The opening shots were fired on 7th December, 1897: Thomas Edison filed a lawsuit against Charles Webster and Edward Kuhn, designed to prevent them from continuing in the moving-picture business.

More lawsuits followed in rapid succession. On 8th January, 1898, he brought actions against Sigmund Lubin in Philadelphia and Edward Amet in Illinois. In February he set his sights on the Eden Musee Company in New York. In March, Augustin Daly and Walter Isaacs were the targets.

The Le Prince family were shocked when friends told them of these developments. It wasn't so much the painful reality of Edison's claims on moving pictures, which they had known about since the time of Le Prince's disappearance, as the fact that Edison was invoking a patent at all. Through the past difficult years of watching moving pictures burst upon the scene, they had always drawn comfort from the assumption that Edison had never actually been granted a patent, that eventually, when the seven years were up, Le Prince's patents would prevail.

Joseph Choate was such a nice man. He'd been recommended by friends. It was said that he had few rivals as a trial lawyer, that a case placed in his hands was almost guaranteed success. Everyone had heard of his spectacular defence of Bell's telephone patent, his duels with the Standard Oil Trust, his sorties into railroad litigation. It was even rumoured that he gave his services freely to worthy public causes and clients in need. He was, in fact, just the man to take up their case.

Lizzie called on him in February 1898 at his residence. She took all Le Prince's patents with her, determined to give Choate as much to go on as possible. They met in his library. He was charming and witty and filled Lizzie with confidence.

'Just as I thought. Your lawyer was quite right,' he said, turning from a wall of books with an open tome in his hand. 'Seven years must elapse from the time of the disappearance before you can take legal action on the patents.'

As the evening drew on Lizzie poured out her story. Choate listened intently. When she reached the bit about Seward and Edison, he stopped her. 'What did you do when told that Mr Seward was not available?'

'What could I do? I just left, in despair.'

Choate sat quite still for a moment, staring intently, then said: 'And there, Madame Le Prince, you made the mistake of your life.'

'I don't have a legal mind, sir. Mr Edison was Mr Seward's client.'

'I don't think that there would necessarily have been a conflict of interests.'

'But Mr Edison had already claimed my husband's invention.'

'It would have been better to have talked to Seward, as your husband advised, if only to clear your mind. Who's to say that Seward was acting for Edison's kinetoscope interests?'

Lizzie said nothing. There was no point in making veiled allegations against fellow lawyers. She had come to see Choate about her conviction that Edison had infringed Le Prince's patents, not embroil him in a tenuous criminal enquiry.

Choate got up and started pacing the room. 'A pretty case, a very pretty case,' he said, shaking his head slowly. 'I'll take a look at those, if you don't mind.'

She handed Choate the patents. He leafed through them slowly. In addition to the US patent, Lizzie had brought the British, Austrian, Belgian and Italian patents, all filed and granted after Le Prince's return to Leeds in 1887.

He was impressed. 'I'd like you to leave these with me.'

She was reluctant to part with them. Choate reassured her. 'They're much too valuable to be left lying around a private residence. They'll be better off in my safe.'

How could she argue with that? It would have seemed untrusting of a man of Choate's reputation. Besides, he seemed so genuinely concerned. For the first time in years she felt encouraged. Someone influential was taking an interest. As they parted she promised to send him further details.*

A few weeks later a letter from Choate shattered Lizzie's revived hopes. After thorough investigations he was sorry to say that he could find no way in which Edison had infringed Le Prince's patent. As far as he could make out Edison had simply occupied the field left open by Le Prince's claims, which was unfortunate but perfectly legitimate. Choate enclosed the opinion of a colleague, which was much blunter. 'I have looked at the kinetoscope papers. Your view is perfectly right. There is

not a chance in a hundred thousand of the courts sustaining the Le
Prince patent against the Edison apparatus. There is absolutely no
infringement.'

On one point Choate offered a glimmer of hope, but immediately
dashed it. Now that the seven years were up it was perfectly legal for
Lizzie to initiate legal action on Le Prince's patents. 'But if your only
object in desiring to do so was to prosecute any possible claims you
thought you might have against Mr Edison,' he wrote, 'I would not
recommend your incurring the expense and the trouble.'

'Shall I mail the papers to you?' wrote Choate in a postscript.

'No,' Lizzie replied. 'I'd rather send a messenger than risk the mail.'

On 13th May, 1898, the very day Lizzie received this depressing news
from Choate, Edison's lawyers made their long-expected move against
the American Mutoscope Company. Pressing the advantage of the
recent interference victory, they now filed a suit against AMC for its
infringement of Edison's moving-picture patent. The recent string of
alleged infringers had gone down like ninepins, unable to risk the costs
of protracted litigation. As Edison was to find to his great cost, AMC
would prove a much tougher adversary.

It's worth pausing for a moment before entering the thicket of intrigue
which accompanied the commercial birth of the movies to draw up a
cast list of the key actors in the drama which was about to unfold.

On one side sat Edison, finally awakened to the potential of moving
pictures. Surrounding him stood a small army of lawyers, whose job it
was to press every possible advantage, explore every legal loophole, spot
every infringement, outmanoeuvre all opposition by whatever means
seemed justified, in the protection and prosecution of all the Wizard's
patents on all fronts. Chief among these was the firm of Dyer & Dyer,
patent attorneys. Richard Dyer was senior partner. His younger brother
Frank joined him in 1897, and almost immediately took the initiative in
Edison's unfolding moving-picture affairs. His defence of the Wizard
served him well. In 1903 he would be invited by Edison to join him at
West Orange to take full charge of all the Edison legal affairs. By 1908 he
would displace William Gilmore as general manager of the Edison
Company. Lastly, there was S. O. Edmonds, a junior partner in the
Dyers' firm, who would conduct much of the actual questioning and
cross-questioning when it came to the hearings.

On the other side stood the American Mutoscope Company. Of the
four founders, by 1898, Dickson had returned to his native Great Bri-
tain. Koopman, who had financed the syndicate's first steps, remained

in the background, leaving Herman Casler – a skilled engineer – and Harry Marvin – the manager – to face the Edison onslaught on their own. Their chief patent lawyer was Parker Page of the firm Kerr, Page and Cooper.

Each side also had their experts to advise on the technical details of the case. Professor Main acted for AMC, Dr Morton for Edison.

The opening weeks of the engagement were devoted to building up the defences for the long series of hearings that were to follow.

Parker Page, for AMC, immediately embarked on a meticulous exploration of the history of moving pictures to date. Guided by Professor Main, he undertook definitive searches of the US and other patent offices worldwide for any patent, anywhere, which might be construed as anticipating Edison's moving-picture claim. This evidence was supplemented by the patient sifting of past editions of *Scientific American*, the *British Journal of Photography*, *La Nature* and so on, for articles that described moving-picture innovations. The whole process required highly technical minds, equipped to grasp the significant detail of evolving inventions. Lastly, they sought witnesses to put on the stand, men who could argue the case and, where possible, swear to evidence that contradicted the Wizard's outrageous claims. Which is how, during the summer of 1898, Page came to approach Adolphe Le Prince with the request that he testify on his father's work in the defence of AMC.

Of all the Le Princes, Adolphe had the fullest grasp of Le Prince's work. He witnessed the first experiments in New York at the age of twelve. He worked alongside Le Prince in Leeds from 1887 to 1889. Throughout this time he became increasingly familiar with Le Prince's vision of moving pictures and knowledgeable about the evolving machines.

Adolphe's understanding was enhanced by a scientific education. Following in Le Prince's footsteps, he began studying chemistry while in Leeds. Inspired by his grandfather's love of metals and frequent exposures to the practical realities of his foundry, it was natural that Adolphe's interests should be steered in the direction of assaying – the study of the composition of metals. He continued with these studies on his return to New York in 1889, when not preparing the Jumel Mansion for the planned exhibition of moving pictures. At the time of AMC's approach in 1898, he was studying chemistry at Columbia University.

Lizzie was full of doubts about the wisdom of co-operating with Page. Wasn't his primary aim a Mutoscope win? Surely the truth about Le

Prince was relevant to him only in so far as it advanced his clients' case? She pondered on whether to consult Mr Choate. This was a tricky decision. Not only was she still smarting from Choate's pessimistic view of Le Prince's patent, but several months had gone by since her first visit and Choate still had not returned the patents which apparently 'could not be found'. If Mr Choate couldn't be trusted to keep his word, why should they trust another party's lawyers? In her view they needed their own legal advisers.

In spite of these misgivings, Lizzie sent Adolphe round to seek Choate's advice. Adolphe felt ill at ease waiting in the grand hallway of the Choate residence. He could hear the buzz of a dinner party on the floor above. How he hated intruding. Choate was far too important to bother at this time of night. Shortly, Choate himself drifted down the stairs, all smiles and cigar smoke. Adolphe was full of apologies.

'Don't talk nonsense, my boy. I've offered to help your mother and I'm a man of my word.' He indicated a doorway. It was to be another of those library encounters.

Choate gestured Adolphe towards a large leather armchair. 'Now, then. What is it, my boy?' All Adolphe could think of was Choate's dinner growing cold on the plate. Falteringly he described the approach of AMC's lawyers.

Choate thought for a moment, then said, 'It will be all right. Tell the truth and it can do no harm.'

And that was that. It was exactly what Adolphe wanted to hear. It would enable him to put the full extent of Le Prince's achievement on the record. His testimony would be used against Edison, exposing the Wizard's false claims for what they were.

As soon as he returned home, Adolphe told the others the news. Marie lapped up every word. She had lately become quite infatuated with the celebrated Mr Choate, and was the regular butt of Adolphe's teasing because of it. 'What was he wearing? Who were the guests?' she asked.

Lizzie was much cooler. 'I don't care about his charm,' she said abruptly. 'I just want the patents back.'

But Adolphe was adamant. 'I have to testify, Mother. Don't you see? It'll mean Father's release. As soon as his work is recognized by the court, which it will be, whoever's kidnapped him will let him go. There'll no longer be any point in their holding on to him.'

It was a flimsy rationale. But it convinced Lizzie.

So Adolphe turned detective. In the summer of 1898 he was granted a year's leave of absence from his course at Columbia to assemble the

evidence of Le Prince's achievement, in preparation for his testimony for AMC.

He began by writing to Richard Wilson in Leeds, who had wound up Le Prince's affairs after the disappearance. In 1891 Wilson had sent over a block of lenses and shutters – all that remained of the sixteen-lens camera. Now Adolphe wanted to know whether anything else had been kept.

Wilson's answer was encouraging. When clearing up Le Prince's workshop he had put aside a number of drawings, some photographic strips and a moving-picture camera which he had thought too delicate and bulky to despatch.*

It was a good start. Key evidence had survived. The next step was to collect it and gather sworn testimonies from everyone who had been associated with Le Prince's work in Leeds.

The resulting cloak-and-dagger trip would have seemed very eccentric to anyone unaware of the family tragedy. Adolphe knew differently. Business rivals would stop at little to achieve supremacy. No precaution was too elaborate. True to the family conviction that Le Prince was being held by agents of Edison, and that their movements were being watched, Adolphe took elaborate care to avoid being followed, changing his surname to Whitley, so that the name Le Prince did not appear on the ship's passenger lists. He also decided not to leave the United States from New York, but to find a less obtrusive port.

He was keen to keep communication to a minimum. Everyone knew of Edison's long association with Western Union. For all Adolphe knew, the Wizard might have had spies at Western Union, on the lookout for relevant cables. Just to be certain, he decided to wire only if it was absolutely necessary, and in that eventuality, to use code.

Part Five

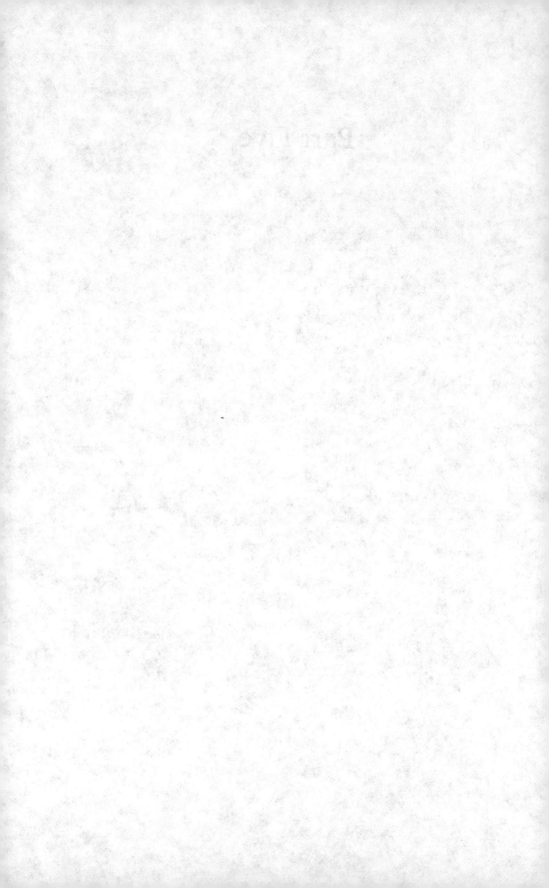

WAR

Equity No. 6928, in the United States circuit court for the southern district of New York, opened on 27th June, 1898. The first hearings took place at Page's offices on Broadway, before Benjamin Barker, the standing examiner of the court. Harry Marvin, vice-president and manager of AMC, was first to testify. He gave a defiant performance, prepared carefully beforehand. As he laid out the ground of AMC's defence, Richard Dyer and his assistant, S. O. Edmonds, took copious notes.

'This defendant,' Marvin began, 'denies that the said Thomas A. Edison was the original, first and sole inventor or discoverer of the said invention and denies the fact that he created the art of photographically representing the natural movement of objects.'*

Dyer shrugged at Edmonds. It was the kind of opening they'd expected. Page caught their exchange and couldn't resist a smile. In the corner, the court reporter scribbled. From now on, it was all on the record.

'On the contrary,' Marvin continued, 'this defendant avers that the apparatus for taking and exhibiting photographs of objects in motion was well and widely known prior to the alleged invention of the said Edison.'

Richard Dyer knew what was coming. Marvin was about to trot out that familiar list of pioneers who had tinkered with this and that in the years leading up to Edison's fundamental breakthrough. Right on cue, out they came. Lincoln (who was he?), Muybridge, Le Prince (huh), Donisthorpe, Blackmore (he hadn't heard of him either), Demeny (yes), Gray, Eames . . . and so the list went on.

It was a short opening round as these things went. Marvin wound up by requesting more time to assemble further witnesses and evidence. It was granted.

A few weeks later Marvin took the stand again, this time at the offices of Dyer & Dyer. The grilling was about to begin. Edmonds took the lead. 'The American Mutoscope Company has been engaged in handling apparatus for taking and exhibiting pictures of animated scenes, has it not?'

'It has.'

'And this has included the manufacture of apparatus for the taking of such pictures . . .'

'It has.'

'. . . between 31st August, 1897 (the date on which Edison was granted his patent), and prior to 13th May, 1898 (the date of Edison's suit) . . . ?'

'Yes, yes, yes . . .'

There was no question of denying it. AMC was in the business of manufacturing moving-picture apparatus, of making films, and of licensing both machines and films to exhibitors. And they intended to continue doing so. Adjourned.

In September, it was the Edison camp's turn to make a statement. There was some smirking between Page and his assistants when Frank Dyer took the stand. He was about to be questioned by his own brother. It was obvious why they'd chosen him. Frank Dyer had successfully prosecuted Edison's camera patent the previous year. He was familiar with the details and the arguments. And passionately partial to the Wizard.

Frank began by trumpeting his own credentials. He had studied physics and chemistry. In recent years he had been entirely engaged in work as a patent lawyer, frequently testifying in patent suits. He was even something of an inventor himself, having made forty applications in his own name to the Patent Office. All of which qualified Frank L. Dyer admirably, did it not, to present the truth of Mr Edison's claims?

And what a truth that was! It was a wonderful and startling invention! It was marvellous! He was full of admiration for it! Page squirmed at his obsequiousness.

'The patent in suit relates to an art,' Frank Dyer went on, 'which, so far as I know, was created by Mr Edison and was first developed by him.' Page raised an eyebrow. What was this word 'art'? Frank Dyer read his thoughts. 'I refer to the art of effecting by photography a reproduction of a scene including animal or mechanical movement. Such photographs when properly reproduced are more typically called "moving pictures".'

Page paused before questioning him further. The man was clearly no fool. Although the patent in suit concerned only the camera and the

film, he had suggested that proof of its efficacy required an operable viewing device as well. A camera alone wouldn't do. Page knew perfectly well that many of the prior inventors AMC planned to cite in the litigation had not entirely solved the problem of viewing motion pictures. Their inventions were limited to the cameras. He decided to counter.

'Will you give your understanding of the term "art" in the sense in which you have used it?'

'It is the doing of something not before done, which shall be of value to mankind, in a commercial sense or otherwise.' Then, sensing the weakness of his answer, Dyer followed up quickly. 'There can be no halfway condition. The art which Mr Edison created was that of taking photographs in such a manner as to secure a faithful and natural reproduction of moving objects, and anything less than that is outside of that art.'

Page found it a cunning definition. But he wasn't fooled. By contrasting the totality of Edison's achievement with the partial nature of the inventions of his predecessors, Frank Dyer was drawing the fire away from more fundamental issues. For example, had Edison in fact invented anything significant in the field of moving pictures?

Page now displayed his trump card. He knew that during the convolutions of the interference case between Edison and AMC the year before, Edison and his lawyers had admitted that their claims on the moving-picture camera had been anticipated by earlier inventors, acknowledging that the invention was unpatentable. Frank Dyer knew about that, did he not? Was he not one of the attorneys involved?

Dyer wriggled. 'I do not know. As I said, I did not appear in the case during the interference.'

Page closed in. 'But you signed the appeal against its dissolution! And the appeal admits that the invention at issue was anticipated!'

Dyer squirmed.

Page pressed his advantage. 'Now, please explain the grounds for your present belief that Mr Edison is the first and sole inventor of the moving-picture camera.'

Dyer huffed and puffed, avoided answering the question, pulled himself up and said aggressively, 'It has never been admitted that, prior to Mr Edison, anyone was able to obtain the natural reproduction of a moving scene, nor did anyone conceive of such a possibility!'

It was a risible reply, awash with generalization. But for all his evasiveness, Frank Dyer did succeed in defining the fundamental technical characteristics of the moving-picture camera around which the whole ensuing conflict would be fought. Firstly, such a camera should

photograph from a fixed and single viewpoint. Secondly, it should use a
sensitized tape-like film. And lastly, that film should be advanced by an
intermittent mechanism.

Unknown to either the Edison or AMC camp, Adolphe Le Prince was at
that moment looking at just such a camera in Richard Wilson's box
room in Leeds. It was completely unlike the sixteen-lens machine which
Le Prince had described in his US patent. It filmed from a single view-
point, through a single lens, and used a sensitized tape-like film which it
advanced intermittently past a single lens, answering Frank Dyer's defi-
nition of a moving-picture camera on all counts. Adolphe had witnessed
its construction in 1888. Wilson also showed him three sets of photo-
graphic strips taken with the camera. [Plate XVIII]

Adolphe also took the opportunity while in Leeds of collecting
several sworn statements from surviving witnesses of his father's work.
He returned to New York in October, armed with the single-lens
camera, the strips and the statements. With the remnant of the sixteen-
lens camera, he was now well prepared for his forthcoming testimony
for AMC.

When Adolphe showed Parker Page the single-lens camera he could
barely disguise his triumph. He was convinced he had the evidence that
would not only give AMC victory over Edison, but also establish Le
Prince's achievement once and for all. Page was stunned by the device.
Adolphe watched as he examined it carefully, inside and out.

'Well?' Adolphe asked, eager for a response.

Instead of answering, Page turned from the camera to scrutinize Le
Prince's American and British patents which lay side by side on his desk.

'What do you think?' Adolphe prompted again.

Page nodded cautiously. 'Most interesting,' he said quietly.

'Is there something wrong?' Adolphe asked. Page's initial enthusiasm
had waned.

'We may have a problem,' said Page, scratching his head. 'Your father
gave very detailed specifications for his sixteen-lens camera.' He indi-
cated the sixteen-lens remnant before turning to the single-lens camera.
'But as far as I can see, he failed to describe this machine in his patent,
which could mean that . . .'

Adolphe interrupted him. 'Not in his American patent, but it's there
in his British one. Have a look.'

Page shook his head. 'It's the British one I'm talking about.'

'But he specifically refers to it. Listen.' Adolphe took the patent from
Page and read it out loud. ' "When the receiver is provided with only one
lens as it sometimes may be, it is so constructed that the sensitive film is

intermittently operated at the rear of the said lens which is provided with a properly timed intermittently operated shutter . . ."' He looked up. 'That's how this camera works. It couldn't be much clearer than that.'

Page had been dreading this moment. 'I'm afraid it could, Adolphe. Your father gives no details of how this apparatus might be constructed. The patent is no proof that he built this apparatus.'

'I have proof, though,' Adolphe said confidently. Thrusting his hand into his pocket he pulled out a short strip of images mounted on cardboard. 'These were taken by my father on that single-lens camera in 1888, and I can prove it.'

As Page scrutinized the images, Adolphe told him how they would clinch the authenticity of the Le Prince single-lens camera. Page seemed to warm to his argument. For the rest of the morning the two men rehearsed the sequence of questions and answers which would make up Adolphe's approaching testimony.

On the morning of 7th December, 1898, Adolphe set out with a friend on the long journey downtown to Page's offices. On the cab floor, carefully boxed, sat Le Prince's single-lens moving-picture camera and the remnant of the sixteen-lens machine.

The offices were on Broadway, in the financial and legal heart of the city, where men like Morgan and Vanderbilt were used to determining the fate of nations with the stroke of a pen. Adolphe's pulse quickened as the street numbers dwindled. He had been building up to this day for weeks. He ran through his answers and was seized by a sudden bout of panic. Had he left the photographic evidence behind? He slapped his pockets, then sat back in relief. The three carefully prepared strips of images, mounted on cardboard, were there.

They were unloading the cameras outside Page's offices when Page came out on to the street. He extended a warm welcome. 'No need for those at present,' he told Adolphe. 'They'll be much better off out here in the cab, where you-know-who's attorneys can't peep at them. We'll call for them when we want them.'

Somewhat puzzled, Adolphe followed Page's advice and left his friend to guard the cameras in the cab. The lawyer was reassuring. 'We have the photographic proof, the patent, your testimony, and if necessary, the apparatus. That should do the trick.'

Page's voice reverberated up the stairs. A niggling doubt entered Adolphe's mind. Page had used the word 'patent' in the singular. Did this mean he was intending to submit only one patent in evidence?

'You haven't forgotten that my father's British patent is different from

the American one?' he asked nervously. 'It incorporates his single-lens camera.'

'Of course we know that. That's precisely why both his US and British patents are among our exhibits.'

That was better. If they really had decided to submit just one, then it went without saying that it would be the British patent, which was the more comprehensive of the two.

After the round of introductions, the examiner went straight into the proceedings. The case was identified, the lawyers named, and Adolphe duly sworn in. Then Page opened the questioning.

The Federal Archive at Bayonne, New Jersey, lies in the heart of the Military Ocean Terminal on a spur of reclaimed land that juts out into the Upper Bay of New York harbour. It was December. I walked the last mile from the bus stop, passing giant plastic Santas in garbage-strewn gardens and faded billboards which read Bayonne Grease Nipple Company. It seemed an unlikely place to find the records of Equity 6928.

A notice at the entrance read ALL UNAUTHORIZED PERSONNEL TO REPORT TO THE GATE HOUSE. I presented my credentials and was issued with a card. A battered army bus was ticking over close by. 'Records Office?' the driver grunted. I nodded, and took a hard seat. He slammed the door shut and we rattled on to the base.

We drove for nearly a mile, passing rows of huge warehouses. On the quayside, cranes swung great loads into the holds of grey supply ships. As far as I could make out, the purpose of the place was to supply half the US Navy with Budweiser, video recorders, Levi's and anything else urgently required for the defence of the Western world.

A friendly archivist brought me Equity 6928 on a trolley. He hovered as I dipped into the first sheets. 'I'm trying to nail Edison,' I told him.

He beamed with pleasure. 'We've got all his cases in here. Just tell me which one you want and I'll find it.'

I came on Adolphe's testimony early.

'Please state your name, age, residence and occupation.'

'Louis Adolphe Whitley Le Prince; age twenty-seven; residence, 622 West 152nd Street, New York City; occupation, student.'

Page paused, then addressed the examiner. 'The defendant's counsel now offers in evidence a printed Patent Office copy of the United States letters patent to Augustin Le Prince, Number 376,247 . . .'

Adolphe looked hesitantly at Page. Surely he had meant to say 'British patent'? Page reassured him with a nod and went on with the questioning. Adolphe relaxed. Clearly Page knew what he was doing.

'Are you the son of A. Le Prince, patentee of patent 376,247?'

'Yes.'

It had begun.

'Did your father reside in New York in 1886 at or about the time when the application for his patent was filed?'

'Yes.'

'How long did he remain in this country after that time?'

'Until about the middle of April 1887.'

The court reporter was taking it all down.

'What was his business at that time?'

'At that time his business was entirely with his machine, that is, constructing the machine.'

'Did you see or assist in making or using this apparatus?'

Page was referring to the sixteen-lens machine. They had agreed to save their trump card, the single-lens camera, until last.

'Yes. I saw the shutter and camera apparatus in Paris. I saw my father using it and assisted him in taking pictures.'

PARIS–LEEDS, 1887–8

Throughout the summer of 1887, Le Prince remained in Paris, looking after his sick mother and, when he could find the time, working on his sixteen-lens moving-picture apparatus.

He found himself in a city in the grip of a new movement in painting which espoused many of the values that had nourished his vision of moving pictures. Georges Seurat and his circle of Pointillists believed passionately in the integration of science with art. Like cinematography, Seurat's work was based on the study of optics. While moving-picture technology was based on a grasp of the principles of the persistence of vision and the physics of light, Pointillism embraced colour theory and a simple psychology of hue, tone and line. For Seurat, who was an anarchist, the expression of a scientific order in painting was a harbinger of the ordered harmony that science would bring to the world. For Le Prince, who believed in the benign potential of capitalism, the fusion of science with art in animated pictures opened the way to peace through understanding.

Once he had found himself a workshop and a mechanic, Le Prince constructed a working model of his elaborate lens and shutter mechanism, which he had recently rethought by substituting an electromagnetic armature and circuit closer for over-complicated mechanical gearing. By late July he was ready to put it to the test.*

Somewhat bewildered-looking, in white overalls, Le Prince's mechanic turned the corner of a Paris street as his employer turned the crank of the prototype mechanism. Since it was only a trial of the shutters, the apparatus had neither bands of film nor film-advance mechanism. Instead, Le Prince made eight rapid-sequence exposures on to a single gelatine plate. In August he sent Lizzie the results, proudly boasting that he had taken eight photos in about a quarter of a second. 'So I can take thirty-two photographs *per second* and I may take more by revolving quicker any moving object or objects. That is quite as many as required. I'll keep you posted as I go. I am getting nearer every day and now shall not leave it till *done*.'†

Lizzie was familiar with her husband's over-confidence. 'Nearer every day' meant 'quite a while yet'. The letter also alluded to problems

Augustin was having with the lights for the projector, suggesting yet more delays. Realizing that she could not count on his return to New York by the end of the year, Lizzie decided to take her summer vacation in Leeds, with the children.

By the time they had arrived, Le Prince was back in Leeds. The death of his mother had released him from his long stay in Paris. He was at last in a position to give his experiments the full attention they required.

The whole family stayed at Roundhay. Lizzie's parents loved having them all back again, even if only for a few weeks. On the day of her arrival, Lizzie and Le Prince stayed up late into the night, discussing the future.

Finances were near the top of the agenda. The experiments were eating up money. While offering the material support of the foundry, Joseph Whitley was in no position to lend Le Prince money. In this respect, Le Prince's mother's death could not have come at a better time. After weighing up the options, Lizzie agreed with Augustin that his share of her estate should be devoted to the moving-picture work.

Then there was Adolphe, who, it was decided, should remain behind in Leeds as Augustin's assistant when the others returned to New York.

Lastly there were the suspiciously drawn-out proceedings at the US Patent Office. 'Why,' Lizzie wanted to know, 'did your American patent lawyers concede a claim which you specifically wanted included, without consulting you?'

'It's what comes of entrusting others with matters they don't understand.'

'Why can't you insist?'

'I will insist. But it means going back to Washington in person, which I can't do until I've finished my work here. It'll just have to wait.'

As things turned out, Le Prince did not question the US Patent Office's denial of this claim any further. He was to spend the rest of 1887 engrossed in the construction of his multi-lens machines. By the time he began serious work on his single-lens moving-picture camera, in January 1888, his US patent had been issued without any reference to the single-lens option. It was an omission which he would rectify when it came to submitting the specifications for his British patent later that year. It was also an oversight which would emerge to haunt Adolphe ten years later.

Lizzie returned to New York with the children at the end of the summer. Adolphe stayed behind with Le Prince. Now the long haul began. He had constructed a sixteen-lens moving-picture camera which worked after a fashion. The task now was to perfect a means of projecting the results. For the rest of the year he threw himself into

developing a test version of a sixteen-lens projector and a portable stereoscopic viewing projector. He called the former his small deliverer.

Having drawn up the plans and specifications for the new device, Le Prince now had to get it built. It was a complicated process which involved putting work out to a number of small firms and craftsmen. The nerve centre of the operation was Le Prince's workshop on Woodhouse Lane. From here, he co-ordinated the mechanical construction by a small engineering firm called Rhodes Brothers, the fitting of the lenses at Whitley Partners and the making of hundreds of small wooden frames by the young apprentice joiner, Frederick Mason.

From the point of view of security it was a useful arrangement. No single party ever possessed the whole picture. But from the practical point of view, it was a nightmare. Plans and specifications are one thing, practical realization quite another. Tedious toings and froings ensued. Small modifications created new problems, demanding rethinks of previously sound solutions. Progress was slow. 'It is stupefying to find the amount of forethought every detail and every point requires,' Le Prince wrote to Lizzie in late November, 'and to imagine the delays required to get the right articles to be made to meet the causes as they occur.'

Then, just before Christmas, things took a turn for the better. Adolphe was due to spend the holiday in London with his cousins. 'I could not possibly go with him,' Le Prince told Lizzie. 'The Rhodes, who have been very slow, are just finishing my machine which was to be ready tomorrow afternoon so I can have it home and try parts during the Xmas holidays, and have the "to be or not to be" settled next week . . . I am getting sick of these delays, and it is a great help to me to be with dear Grandpa and Grandma and our growing Adolphe, who is getting on very well . . .'

Over Christmas, Le Prince played with his new toy. The actual trial had to wait until he got back into his workshop in the New Year. In the meantime he turned the crank and watched with pleasure as the shutters opened and closed in sequence, synchronized with the intermittent and alternate movement of the take-up spools. It was a mechanical delight. Late one night he crept into Whitley's bedroom to tell him the good news. The old man was still awake, writing up his journal.

'1.56a.m. 28 Dec. 1887,' Whitley scrawled after Le Prince had left. 'Mr Le Prince came to my bedside and said: "I have done it!" Viz: a new mode of photography for mechanical exhibition.'*

But Le Prince's optimism was premature. When he got the machine to the workshop he discovered that the lenses had been fitted wrongly. 'It's a fearful tale of blundering all round,' he ranted to Lizzie. 'Grandpa

consoles me (at least, he thinks so) by telling me it is always so for a while.'*

Whitley had been observing Le Prince's difficulties with sympathy. A lifetime of inventing had taught him that the process consisted largely of failure and disappointment, the dogged path of trial and error. Le Prince was now encountering the real stuff of invention for the first time in his life. Pig-headed persistence was the only way forward.

But the old man's wisdom only partially relieved Le Prince's frustration. The plan had been for Le Prince to return to New York in the New Year to film some winter views of sleighing and skating for his moving-picture début at the second of John Whitley's great international exhibitions at Earl's Court, the Italian, which was due to open in the spring of 1888. But because of the delays, that trip was now postponed, which for Lizzie meant no Le Prince.

He consoled her by sending a bit of Leeds in his place, 'a little pansy just freshly bloomed in the bed on the east side of the house, a bit of jessamine from the west side, and a holly leaf, ditto'. Then he added, 'I cannot tell for a few weeks when I can come back, as I mean to have all done here that I can. Matters would be much worse in America, both for time, cost and quality. I am glad to see from Aimée's letter to Adolphe that you are not having a very cold winter, and I hope that with care you will escape all those dreadful fevers and throat complaints. Bye bye, my darling, I try to keep patience and temper. You all do the same and be jolly and hopeful.'*

Lizzie did her best. Her flagging spirits were not helped by what shortly became the worst winter on record. While Leeds basked in precocious January sunlight, New York was paralysed by the great blizzard of 1888 which seized up the city for months.

Le Prince, meanwhile, turned his attention to patents. His US patent was due to be issued on 10th January. For absolute security, it was important to enter all his foreign patents before that date. In the event, he managed to file the provisional specification of his British patent application on the last day. Later that week he left his assistants at Whitley Partners in Leeds with instructions to reposition the lenses while he paid a flying visit to Paris to open negotiations on his French application. He also took the opportunity to discuss the progress of his mother's will with his brother, upon which the future financing of his experiments now depended. On his way back to Leeds he stopped over in London to hammer out the detailed specifications with his London patent agents. 'Stress the intermittent character of the projection,' he urged them, 'and the appreciable duration of the successive projections.'†

Back in Leeds, the small deliverer was finally ready for trial. One evening in late January a small group of assistants gathered at the Woodhouse Lane workshop as the final preparations were made. Two hefty picture bands were loaded into the projector. Each consisted of a double row of gelatine transparencies in small wooden frames mounted on a flexible belt. Two large gas cylinders fed a mixture of hydrogen and oxygen to limelight burners positioned behind each of the sixteen lenses. The taps were turned on. Gas hissed. A match was applied and the burners spluttered into life. It was like lighting a giant square birthday cake on its side. Then Le Prince turned the crank.

Was it a man with an apron at work? Was he waving a hammer? A blacksmith, perhaps? Or was it the series he took in Paris of life on the Parisian boulevards? No one could clearly recall, but they all saw something move. Perhaps over the next weeks of trials and modifications it was all of these. Whatever it was that was shown, Le Prince was dissatisfied. 'I have succeeded in producing the movement of a man walking,' he told Lizzie, 'but I still have violent shocks in the machine, and I am working to reduce them. I shall soon arrive – I have satisfied myself that the effect will be absolutely natural, *but it is hard going*. I believed I could arrive faster, but each step seems to cost an infinity of tests and trials.' Then, to reassure her that he would not be in Leeds for ever, he added, 'But also each step confirms me in the assurance of an early success, both excellent and practical . . .'*

The truth was that the small deliverer was very noisy, and the shockwaves set up by the incessant alternate stopping and starting of the heavy picture bands created intolerable jarring in the image. Le Prince was unperturbed. The machine had confirmed the practical principles of his design. It was now time to progress from the small experimental machine to the large commercial projector, the big deliverer.

Naturally this meant more delays in Le Prince's return to New York. Lizzie was still expecting him to make a quick trip to take film of New York for John's Italian Exhibition, at which he still planned to exhibit moving pictures. The spectacular aftermath of the blizzard was a tempting subject. But Lizzie was to be disappointed again. In March he wrote to her, 'I'm afraid I shall not be coming for some time as the exhibition is getting so near and I have only just time to get ready for it; I must give up the idea to go and spend a little while with you and take snow scenes; 'tis hard, for I long to see you all. The machine is progressing – I mean the large projector – but every step is slow and wants personal watching. I have had very difficult problems and got through them all – I think – but' – she read the familiar qualification with foreboding – 'until I have the commercial machine finished I cannot assure you that absolute

practical success is attained. It cannot be long now, though from past experience I cannot tell to a week or a two – something unforeseen often turns up, and means more changes . . .'*

The big deliverer was aptly named. Years later Frederick Mason recalled a massive machine, 'fifteen feet long and twelve feet high'. Although probably magnified in Mason's memory, it was nevertheless a large apparatus, solidly built to withstand the vibrations of moving parts and the shocks of inertia. It was also an elaborate undertaking which took over a year to complete. Le Prince's hopes of exhibiting it at the Italian Exhibition were wildly optimistic. It was still not even completed for the Spanish Exhibition a year later.

Edison once said that invention was one per cent inspiration and ninety-nine per cent perspiration. With a clear idea now of what he was aiming at, Le Prince sweated his way through a process of modifications to the sixteen-lens projector. The evolving specifications of this apparatus also necessitated changes to the sixteen-lens camera which Le Prince had completed in Paris, 'to fit it to work for the former', as he put it.

This proved to be more difficult than it sounded. After a frustrating few months spent tinkering with the sixteen-lens camera, Le Prince made a momentous decision, the significance of which he was largely unaware of at the time. In March 1888 he decided to construct a single-lens moving-picture camera.

VISION

I was gazing at the two Le Prince cameras which Adolphe had taken with him in the cab to the hearing. They were now in a cabinet in the Science Museum, where they had finally come to rest in the late 1930s. Reflected in the glass were the illuminated efforts of other movie pioneers. The cameras and projectors of men like Friese-Greene, Robert Paul, the Lumières and Edison himself jostled for priority in the background. But for the time being, I only had eyes for Le Prince.

A technician approached with a key, opened the Le Prince cabinet, and lifted both pieces of apparatus on to a trolley. I had arranged to examine both of them in the privacy of the museum workshop.

The single-lens camera was an oblong mahogany box, two feet high. A crank stuck out from one side. At the front were two lenses, of which one was the viewfinder. Behind the taking lens was a rotating shutter with an adjustable aperture. At the back, a removable panel revealed the interior. There were two ebonite spools inside. I wound the crank tentatively. The machine rattled into action. By a clever gearing arrangement, the top spool pulled a wide band of paper film intermittently upwards past the lens, where a cam-operated pressure plate held it firmly for each exposure. It was a beautiful object.

The other exhibit was more baffling. A tangle of electric wires led from a cranked circuit-closer to sixteen electromagnetic armatures which released the sixteen shutters of the sixteen lenses. Neither shutters nor film-advance mechanism had survived, but I seemed to be looking at the remnant of the sixteen-lens camera which Le Prince built in Paris in 1887.

In the presence of both objects, familiar questions resurfaced. Why hadn't Le Prince put more of his energies into a single-lens camera earlier than 1888? Why did he go to the lengths of a sixteen-lens camera when a single-lens machine was so much simpler? I believed that I understood why he undertook the sixteen-lens projector. The complex lens configuration was dictated, I assumed, solely by the lack of a film material that could withstand the stresses of projection.

But the camera didn't operate under such constraints. The film material neither had to withstand the heat of limelight burners nor be

transparent. Eastman paper film sufficed, as Le Prince indicated in his patent. So why did he devote so much time to a sixteen-lens camera when far fewer lenses, even one, would do?

One obvious answer was conformity to the projector design. Both were born of the same conception. It followed that if the projector required sixteen lenses, so too did the camera. Yet this didn't seem reason enough for him to have followed the more complex path.

There was an additional puzzle. If Adolphe was to be believed, his father had constructed a preliminary model of a single-lens camera in New York in 1886. Why, then, did he wait nearly two years before pursuing it further?

Answers to questions like this are often obscured by the wisdom of hindsight. Western culture encourages us to believe that history converges on present realities as if they were somehow inevitable. For example, we assume that today's prevailing moving-picture technology is simply the realized vision of the pioneering inventors; that, apart from a few maverick eccentricities, a single corridor of cameras in glass cabinets evolved purposively towards today's state of the cinematographic art.

This is hardly surprising. For a century now, films have, with few exceptions, remained fundamentally unchanged. Of course, sound and colour have arrived; the advent of television has, by sheer contrast, focused the nature of the cinematic image; the aesthetics of storytelling have shifted; screens have widened, lenses resolve sharper images. But the convention of gazing at a rectangle within which various stories are played out photographically has hardly altered. Like most of us, I have eagerly subscribed to the habit, welcoming improvements but rarely questioning the basic paradigm of the framed and relatively flat image.

The same is true of film technology. For all the crystal-sync motors, zoom lenses and steadicams of today's state-of-the-art moving-picture camera, the principles of the technology have remained the same: a photographically sensitized film is advanced frame by frame past a single lens where it is arrested momentarily and exposed.

The single lens is significant. It confers a single viewpoint on every frame of a filmed sequence and a unifying aesthetic on the viewing experience. More practically, the single-lens camera gives the image a steadiness that is extremely difficult to achieve through the differing viewpoints of multiple-lensed cameras.

But the single-lens moving-picture camera has a significant limitation. Precisely because of its single viewpoint, it cannot match the plasticity of human binocular vision, which requires the twinned viewpoint of two eyes.

As I worried at the strange remnant of Le Prince's sixteen-lens camera which lay on the Science Museum trolley, I realized that I was seeing it with the eyes of a present-day filmgoer. Putting myself in Le Prince's shoes, I remembered that the framed and flat storytelling to which I was accustomed was not his primary goal. His point of departure was his desire to improve on the panorama experience, an ambition which called for the reproduction of a vast area of movement in three dimensions. Le Prince strove for a cinematic spectacular, the aim of which was not so much storytelling as the re-creation of reality itself.

Le Prince was not alone with this obsession, but part of a tradition of attempts to realize a vision of 'total cinema' which went back virtually to the origin of photography itself. Men before him had tried and failed to realize stereoscopic, or three-dimensional, moving pictures, as have many men after him. Likewise, the panoramic vision of pictures originated before photography and has continued to inspire inventors throughout this century.*

Over the years I have glimpsed these latter-day attempts to break out of the technical and aesthetic straitjacket of mainstream film-making. As a boy, I gasped when the square black-and-white image expanded into the enormous technicolour spaces of a cinerama mountainscape, just as audiences thrilled thirty years earlier when in Abel Gance's *Napoleon* one screen expanded to become three. Less successfully, the striving for a three-dimensional cinema has simmered on through the decades. Gance included a short three-dimensional sequence in *Napoleon*. In the thirties MGM devised a few short three-dimensional movies. These were revived in the 1950s under the name of Metroscopix – MGM's answer to the threat posed by television. Murders and rollercoaster rides were popular subjects. I recall peering through spectacles with red and green lenses to see a lion rush out at me from the screen.

But these experiences, although liberating, always somehow fell short of the dream. While conventional cinema developed within a limited frame, and the sheer power of good visual storytelling and great performance created an emotional impact in which the limitations of the convention were its strengths, the 'total cinema' tradition suffered from the sheer scope of its ambition. Cinerama, for example, attempted to set its frame beyond the audience's field of vision, so luring us into the sense that we were there. But I could always see the joins. It was judged by its failure to achieve absolute illusion. Similarly, the three-dimensional experiments were never wholly convincing. Viewing paraphernalia intruded on an experience only partial at the best of times.

A century ago, Le Prince was gripped by the same bug. Gazing afresh

at the unusual object in the Science Museum, it became clear that I was looking at a conception of stereoscopic cinema. The four columns of lenses could be seen as two double columns of horizontally twinned lenses. In each double column the lenses were about three inches apart, corresponding to the configuration of the human eyes that enables us fully to perceive three dimensions. Seen this way, the camera had eight pairs of eyes. It was designed to see as we do – in depth – just as the sixteen-lens projector was designed to reproduce movement as we see it – in depth.* [Plate XVII and p. 165]

Small wonder that Le Prince found the realization of this vision extremely difficult. Small wonder that throughout the winter of 1887-8 he and his assistants laboured on modification after modification, shuttling betwen the sixteen-lens camera and the evolving versions of the sixteen-lens projector, to bring the dream to fruition.

Nor were his stereoscopic experiments limited to the sixteen-lens projectors. Late in 1887 Rhodes Brothers constructed the stereo viewer which Le Prince had described in his US patent. When the handle was turned, two miniature 'ferris wheels', with sequential photographs fixed to their rims, revolved alternately, exposing first one side, then the other, to left and right eyes respectively. 'On looking into the eyepieces,' Adolphe later recalled, 'the moving pictures were seen in relief, giving a vivid impression of life to the series.'

The essence of taking stereoscopic moving pictures lies in recording successive images through alternate lenses, positioned like a pair of human eyes. The key to their exhibition lies in distributing the successive images alternately to left and right eye, enabling the visual cortex to synthesize each into an impression of three-dimensional space.

Le Prince's stereo peephole device shows that he fully grasped these optical principles. But whereas the effect of relief was relatively easily accomplished with a double eyepiece, where the image reaching each eye could be controlled, stereo projection was infinitely harder to achieve, and still is to this day. The technical challenge lies in devising a means of separating successive left and right frames from the single-screen format, exposing them to alternate eyes. That's what my red and green spectacles were for in the fifties. Successive frames of the film were tinted alternately green and red, allowing the green image through the red lens of my specs, but not the green, and the red through the green lens, but not the red, alternately.

The optical mixture of red and green images has the effect of draining the image of colour. This is a drawback in an age which expects its movies in colour. To get round this, a more sophisticated method utilizes lenses of different polarities.

The red-green technique was established for projected still stereo-scopic photographs as early as 1853 by a man called Rollman. It came to be called 'anaglyphic', which meant literally 'again-sculpture'. By 1887, Le Prince was evidently applying the anaglyphic stereo method to moving pictures. According to Adolphe, he used a pair of peculiarly constructed eyeglasses while projecting the stereo pictures.

Today, Le Prince's dream is closer to fulfilment, yet still falls short of full realization. The technologies of Imax and Omnimax offer screen experiences which envelop the viewer in a near-total visual field. Advances in holography and digital image-making herald extraordinary breakthroughs in three-dimensional moving pictures. Allied develop-ments in stereophonic and holophonic sound promise an equivalently dynamic aural space. It is possible that within the foreseeable future these technologies will be integrated in the creation of a 'total cinema' which utterly convinces. Perhaps. More likely, the chase after illusion is in itself an illusion. And the delight in the chase rests in the tacit under-standing that total illusion is unattainable. In this sober version of events, instead of an increasing proximity to 'the real thing', we're merely part of a hunt in which the quarry – the reality which we seek to reproduce seamlessly – is no more than a shifting projection of our own changing values and desires. I vividly recall how impressed I was by stereo sound in the sixties. Yet it pales beside the 'fidelity' of today's digital technologies. What will they offer us tomorrow?

Equally, where is the threshold of 'life-like-ness' in the televisual march of progress from 405 lines through 625 to high-definition 1250 and beyond? Or when, in the quest for high resolution, will the increas-ingly finer and faster emulsions of Kodak's latest filmstocks be finally deemed fine and fast enough? Perhaps never. In a commodity culture which is built on the premise that human desire for things is insatiable, and yet which holds out the promise that this desire can be satisfied through possession, the fostering of visual illusions has become big business. In the realm of the image this takes the form of a spiralling scramble for verisimilitude, in which the values of ever sharper focus (and crisper sound) aspire to reality itself. Yet the images of tactile perfection which we are persuaded to reach out for are perhaps, in reality, mere simulacra – identical copies 'for which no original has ever existed'.*

It was in the face of the ever-increasing complexity of his stereoscopic and panoramic ambitions that in March 1888 Le Prince decided to embark on the more modest single-lens camera idea, which, according to Adolphe, he first experimented with in 1886. Already two years into

experiments from which there had been no financial return, he needed quick results. It was now apparent to him that neither the sixteen-lens camera nor projectors would produce commercially viable results for some time to come. Any further delays meant an unacceptable postponement of both his public début and his return to his family in New York.

Characteristically, he burnt no bridges when he decided to go ahead with the single-lens camera. Work on the multi-lens stereo machines proceeded in parallel. With all the options kept open, Le Prince was now advancing on a precariously broad front.

THE GARDEN

Page popped the question as they'd planned it. 'Previous to the time of his disappearance, had your father pursued his work in the taking and exhibiting of pictures beyond the making of the camera about which you have already testified?'

'He made a one-lens camera.'

Edmonds raised an eyebrow. Page continued, unperturbed. 'Please state briefly what he did in this connection, and where the work was done.'

Adolphe could scarcely contain his excitement. 'He built this camera at his laboratory, in Leeds, England. He made a number of trials with it and took several pictures while I was with him, and delivered them on a screen.'

'What material did he use for the negatives in this camera?'

'Eastman paper films.'

'Have you any specimens done by the work of this camera, and if so, will you please produce them?'

'Yes, I have.'

Adolphe took the photographic strips from his pocket and handed them to the examiner.

'The photographs produced by the witness are offered in evidence and marked Defendant's Exhibit Le Prince Photographs C, D and E, respectively,' said Page as the examiner scrutinized the strips.

Each consisted of four consecutive positive frames of a movie sequence. In the first, four figures appeared to be dancing round one another in a sunlit garden in front of a bay window. In the second, horse-drawn traffic and pedestrians were crossing a sunlit bridge. The third showed a young man playing a melodeon on the steps of a house.

Edmonds took the strips from the examiner, looking at each with great care, frame by frame, as if comparing them. He did not like what he saw.

'Do these exhibits show the entire series of pictures of the scenes they represent?' Page asked Adolphe, barely able to conceal his delight at the effect of the images on Edmonds.

'No, they are just part of the strip, portions which I mounted myself.'

216

'When were these photographs taken, if you know?'
'They were taken about October 1888.'

Sunday 14th October, 1888, to be exact. It was one of those balmy autumn Leeds days when it feels as if an elusive summer has finally arrived. The roses were still in bloom. The trees were still green. The great lawn that stretched away from Whitley's imposing stone home had been neatly trimmed by the gardener.

Anyone snooping around that morning through the thick rhododendron hedge which surrounded the garden would have spotted three figures far across the lawn hunched over a large wooden box on legs in front of one of the bay windows.

The single-lens camera was a heavy machine which required sturdy legs to prevent it shaking when the crank was turned. Le Prince was positioning it so that by afternoon the sun would be behind it. Adolphe was hanging a heavy weight from the chain to prevent the tripod legs from splaying. Whitley stood back, holding a large black cloth which Mrs Longley, Le Prince's mechanic's wife, had sewn specially.*

By the end of the morning they were ready. Mrs Whitley and Annie Hartley, her companion, returned from chapel and everyone sat down for lunch. Over the meal Le Prince explained his plans. That afternoon he was going to try out the single-lens camera for the first time with film. He wanted them all to take part.

Adolphe was the first volunteer. He appeared awkwardly on the front steps, playing his melodeon. 'Move around a bit,' Le Prince called from the camera before disappearing beneath the black cloth. 'Try a little dance.' As Le Prince wound the crank, Adolphe played and did a little hoppety jig. [Plate XIX] The sound of the instrument drifted across the lawn, all open and summery. A wood pigeon clattered out of the trees.

This brief initial sequence lasted about ten seconds before it was time to reload. Le Prince disappeared beneath the black cloth again and Adolphe ran into the house to call the others.

The next sequence was a crowd scene by comparison. Le Prince asked everyone to dance in a circle by the other bay window. They gave a shambling performance, but it was the movement that counted. Adolphe led the way, striding down from the steps. Whitley and Mrs Whitley got the hang of things quickly, she shuffling slowly after his long coat tails which flapped in the breeze. [Plate XX]

Annie Hartley was a little confused. She stood stock still, staring at the camera as if to say, 'Do you mean now?' Or perhaps she was saying, 'I don't think Mrs Whitley should stay out too long, Mr Le Prince. She's puffing a bit.'

Because not long after, the old lady reached out for Annie and said, 'Give me your arm, lass. I've come over all weak.' Then she collapsed.*

They had been magic months for Adolphe. As dusk fell on Manhattan and his day's testimony drew to a close, the sound of the melodeon seemed to fill Page's drab office. The schoolboy thrill of a year spent at his father's side came rushing back to him. He had served what amounted to an apprenticeship in photography. He had watched as the single-lens camera took shape, one of the informal team of assistants that Le Prince had assembled.

Most of the woodwork for the camera had been carried out by Frederick Mason, then aged twenty, in a timber yard two doors away from Le Prince's studio. Mason also made the patterns for the metal castings.

The metalwork was executed by Jim Longley. Of all the assistants, Adolphe remembered, Longley was the least dispensable. After working on the sixteen-lens projector at Rhodes Brothers, he began working directly for Le Prince. Longley was no mere helper, but something of an inventor in his own right. He was known locally for his ticket-issuing machines which were later fitted on Leeds omnibuses and on the turnstiles of a city cricket ground. One of his devices issued brass checks. A later machine produced boxes of matches. Le Prince found in Longley a mind already grappling with the mechanics of advancing identically shaped components. It was to serve him well when it came to problem-solving in the field of moving-picture technology.

On his trip back to Leeds in September 1898, Adolphe had succeeded – where Lizzie had failed two years earlier – in tracking Longley down. Longley had poured out his reminiscences, delighted to be of help. He had vivid memories of making 'an improved camera of one lens for taking photographs at a great number per minute'. Neither Longley nor Mason had been present on that day in Whitley's garden. The strictures of class difference prevented it. But Longley remembered seeing the results screened by the various projectors he had worked on through 1888 and 1889, 'the series of pictures of Mr Joseph Whitley and his wife, and a young lady dancing in the garden at Roundhay; also a series of Mr Adolphe Le Prince dancing and playing the melodeon'.

'I'll do anything to help you get your rights,' Longley told Adolphe. 'I'd come to America if you required me to, without thinking of any gain to myself – if you would do as you say as regards salary and guarantee as to work. I can assure you if I had been a man of money, I should have been in New York now, standing by your side and doing all in my power for you.'†

Adolphe had declined Longley's offer, which would have proved too

costly. Instead, he settled for the mechanic's sworn testimony and the single-lens camera itself, which was still under guard in the cab downstairs, ready at a moment's notice to be whisked into the hearing as evidence.

The decisive moment was approaching. Adolphe felt in his pocket for the clinching evidence, incontrovertible proof that the short sequence of frames of the dance in the garden at Roundhay were taken in October 1888.

'When were these photographs taken, if you know?' Page held up the garden strip.

'They were taken about October 1888. I can fix the date exactly by the fact that my grandmother died on 24th October, 1888.' Adolphe pulled another photograph from his pocket and passed it across the table. Edmonds scowled as he pored over the image. It showed Mrs Whitley's grave in Roundhay churchyard. The date of her death was clearly incribed on a bronze memorial tablet.

I pushed open the heavy iron gate. It squeaked like a Dracula sound effect. A rook cawed on cue. Great beeches pressed in on the churchyard from all sides. Their roots had levered the surrounding dry-stone walls out of true. I walked slowly up towards the church through regiments of headstones. They were elaborate memorials, each competing with the next for upward reach and theatrical effect. Dark yews clutched at the skies. The simple stone spire of the church disappeared into the early morning mist.

I found Mrs Whitley's grave in a thicket of willow herb. Behind the splash of mauve flowers, a memorial was set into a wall which ran alongside the church. A bronze plaque read, 'In loving memory of Sarah Robinson, beloved wife of Joseph Whitley, died 24th October, 1888. Also, Joseph Whitley, died 11th January, 1891.'

Adolphe was right. Old Mrs Whitley, who appeared in the Roundhay garden sequence, lay beneath my feet, the date of her death clearly inscribed. It was conclusive proof that Le Prince had filmed the sequence before 24th October, 1888. Her collapse during the camera trial had been a prelude to her death.

The plaque was framed by a surround of ceramic tiles. The artist had worked confidently, touching in fecund swathes of foliage which tumbled down a column of urns in a cascade of yearning colour harmonies. Vibrant glazes, which had defied a century of Leeds frosts, drew me into a weave of Victorian longing. I surrendered to an imaginary soundtrack. Full piano chords echoed from the dark woods beyond the graveyard. A lone tenor sang in German:

'I blame thee not, although my heart must break,
Love who art lost to me, I blame thee not.
I see thee shine in diamond splendour bright,
but not a ray falls in thy heart's dark night.'*

At the foot of the memorial the tiles vanished into the earth. Down on my knees, I scraped at the soil to reveal the whole design. On the bottom edge of the lowest tile I found the letters ALP 1889 – Le Prince's signature. Its cryptic design resembled an Egyptian hieroglyph. To my suggestible mood, it looked like some masonic device.

I left the churchyard and went in search of the garden, which I knew to be nearby. The path took me along the edge of Roundhay lake where on clear summer days young couples spooned in ancient clinker-built rowing boats. Perhaps Lizzie and Le Prince had murmured sweet nothings on this same stretch of water more than a century earlier, though not on a day like this. The mist had thickened and the only living beings I encountered were occasional cold anglers and dogs out for brisk walks. The water lapped at the edge. I gazed out into unfocused whiteness. The other side of the lake was completely obscured, to all intents as distant as the other side of the Atlantic.

What I took to be the Whitley house was now an old people's home. I wandered in through the back gates, past the side of the house, to the garden beyond. The vast lawn stretched away, as it did in the photograph. An elderly man in a dressing gown with white straggly hair stood motionless among some apple trees at the bottom of the garden. I turned to look back at the house. A young man was coming down the front steps, making straight for me. Gaunt, toothless faces watched the encounter from the bay window.

'Can I help you?' he asked suspiciously.

'I'm writing a book,' I explained, 'about a pioneering inventor of the movie camera who vanished without trace from a train in France in September 1890.'

He looked confused. Then I added, 'He shot his first film at Oakwood Grange. In the garden here. In fact, on this very spot.'

A nurse passed us, making for the old man among the apple trees. The young man said, 'Well, you'll have to get permission to come in here. You must write to the area health authority.'

I wanted to stay in the garden and soak up its atmosphere. It was time for the thriller gambit. 'They say he was murdered by agents of Thomas Edison.'

'Oakwood Grange?' he asked, curiously. I could see he was hooked. I nodded. He said, 'This is Oakwood Manor. Oakwood Grange is next door. At least, it was.' My heart sank.

The nurse led the old man past us. 'This way, Mr Bancroft. We can't have you catching cold now, can we?'

The young man had noticed my disappointment. 'There is one thing I could show you, though. Follow me.'

He walked back round the house and out through the gates, but instead of turning back up the way I'd come, he beckoned me on down the lane towards two monumental stone gateposts. 'Is this what you're looking for?' he asked, pointing to the flaked traces of a name on one of the gateposts. Hardly legible were the words 'Oakwood Grange'.

I nodded bleakly. In place of gates was a solid brick wall. I pulled myself up for a look. A tasteless neo-Georgian housing development now stood where Whitley's proud stone house had once presided.

'Criminal, it was,' said the young man. 'They knocked it down twenty years ago.'

A few weeks before the tests of the single-lens camera in Whitley's garden, Le Prince turned once again to the tedious business of patent applications.

In January 1888 he had submitted the provisional specification to the British Patent Office. This was followed in quick succession by detailed applications for French, Belgian, Italian and Austro-Hungarian patents. These described the sixteen-, or multi-lens moving-picture camera and projector. In all significant detail they were identical to his US patent, which was finally issued that month.

British patent law required Le Prince to file the complete specification – the full working details of the invention – within nine months of making his provisional application. But since submitting this, he had evolved his single-lens camera, not yet tried and tested, and completed his stereo viewing device. In early September 1888, with a few weeks to spare, he entered into a hurried correspondence with his London patent agents as to the best course of action.

There were two main decisions to be made. Should he include the stereo viewing device, his stereoscope, in the application? And should he describe the single-lens camera?

The first issue was clear. The stereoscope was a separate invention and warranted a patent of its own. The second issue was more pressing. 'It will perhaps be required to introduce the extreme case where the series of lenses is reduced to one lens,' he wrote to his patent agents. 'The combined action of shutters and drums . . . is, I consider, the most important point of my patent and should be secured for any number of lenses including one.'*

Le Prince now modified his 'complete specification' accordingly. A vital clause was introduced.

When the receiver [camera] is provided with only one lens, as it sometimes may be, it is so constructed that the sensitive film is intermittently operated at the rear of the said lens which is provided with a properly timed intermittently operated shutter; and correspondingly in the deliverer [projector] when only one lens is provided the band or ribbon of transparencies is automatically so operated as to bring the pictures intermittently and in the proper order of succession opposite the said lens.*

And in the series of claims that concluded the complete specification, the phrases 'one or more lenses' and 'one or more shutters' were added wherever relevant.

The patent was submitted to the Patent Office one day before the deadline. It was issued on 18th November, 1888, with the single-lens option covered. Or so Le Prince assumed.

Adolphe had assumed the same thing. The British patent was proof that his father had invented a single-lens camera. So when, in spite of reassurances, Page presented only the US patent, which omitted any reference to a single-lens camera, in evidence at the hearing, Adolphe was not at first unduly concerned. After all, the sequences of his grandmother in the Leeds garden were incontestable proof of the authenticity of the camera.

But when Page refrained from even referring to Le Prince's British patent, Adolphe began to get nervous.

'Do you know whether your father took any steps to exploit this single-lens camera in this country?'

'No.'

'When did you return to the United States yourself?'

'I returned in September 1889.'

'And had your return to this country any connection with this camera?'

'I came over supposedly a few months before my father. He was to come over and exhibit his machine. By "supposedly" I mean that it was well understood my father would have been over by that time.'

'After your father disappeared, did his family take any steps to patent his devices in this country?'

Adolphe hesitated. Surely 1888 was the year they should be talking about, not 1890? Why was Page jumping ahead? It was vital that the examiner be made aware of Le Prince's British patent. He took a deep breath, determined not to be rushed. He would squeeze in what had to be said, even if it meant not answering the question directly.

His answer was garbled. 'He intended to, if necessary, take out a patent for this one-lens machine, but he considered he was sufficiently covered in his first, but had written to his English patent agents, asking them whether they considered he was not already sufficiently protected, and if he wasn't, it was his full intention to take out a patent which would cover his rights.'

Page looked at him impassively, his reassuring smiles gone. Adolphe lowered his eyes and continued. 'The family took steps to protect his invention, but, owing to his disappearance, it was impossible for us to act until the legal seven years had elapsed.'

Adolphe looked up at Page, a hint of defiance in his eyes, expecting the question about the British patent. It never came. The examiner broke the silence. 'This hearing is now adjourned,' he said, stretching and looking at his watch, 'until tomorrow morning at 10 a.m.'

Documents were put into briefcases; the court reporter began typing up the record. Page crossed the room and took Adolphe's hand. He seemed suddenly friendly again. 'Very good, young man. Very good. Tomorrow it's Mr Edmonds' turn to ask the questions.'

'Just a few queries,' Edmonds said. 'They'll only take a few minutes.' He shook Adolphe's hand, then turned to Page with a smile. Adolphe watched as the two lawyers went out into the lobby together, deep in conversation. He was puzzled. Weren't they supposed to be adversaries?

Outside in the cab, his friend was still guarding the cameras which had not yet been submitted in evidence. 'How did it go?' he asked. Adolphe hardly heard him. He had begun to dwell on a nagging suspicion. It had all gone too smoothly. Why hadn't Page introduced the British patent? Was there something between Page and Edmonds? Had they come to preliminary agreement?

THE THIRD SCENARIO

I took a break from the hearing at lunchtime. The woman at the desk told me that I'd find a Burger King at the other end of the base, that a military bus passed the front of the Archive every half hour and would take me down there. It was one of those crisp New York days. I decided to walk.

On my way to the distant fast-food sign, I lingered at a bay where a truck with erect chrome mufflers was disgorging its overnight cargo into a vast warehouse. Men in uniform consulted fat clipboards. A guard saw me watching. He was wearing a revolver. I felt in my pocket for my pass and walked on.

The salad was yesterday's. I should have settled for a quarter-pounder and fries like everyone else. I chomped my way through a mound of dry lettuce and wrestled with a problem. Throughout the morning, as I had read and reread the flimsy typescript of Adolphe's testimony, I had had the growing feeling that something was missing. Now I realized what it was. Neither the Le Prince single-lens camera nor the remnant of the sixteen-lens camera had been presented in evidence. Why, when Adolphe had brought the single-lens camera back from Leeds for the specific purpose of the hearing, had Page, so far, failed to ask him to produce it? Why, when it was within Adolphe's power to clinch the Le Prince case with the actual machines, had he, so far, not insisted on doing so? I had no documented answer to the question. Yet there had to be a reason.

It was a tantalizing enigma. I took the only action left open to me. I speculated. Shutting out the peeps of the Burger King tills, I retreated into a world of possible scenarios. The first was unthinkable. I dismissed it straightaway. It would return to haunt me later on.

The second seemed more plausible. Perhaps Page's initial reservations about the single-lens camera had disguised inner alarm? It was a more sophisticated machine than he'd expected. Far from helping his client's defence against Edison, Page might have reasoned, the Le Prince machines could prove to be AMC's own undoing. In the hands of hostile lawyers the Le Prince family could establish priority not just over Edison, but AMC as well. The only way to avert this dangerous

possibility would be to keep Le Prince's actual machines out of the hearing. This would be done by giving Adolphe the impression that he would introduce them as evidence, but failing to do so, by which time it would be too late for Adolphe to do anything about it.

I toyed with this option on the long walk back to the Archive. Between the sterns and bows of the ships I caught glimpses of downtown Manhattan. The magnificent island fortress seemed to float on the water. The sun kicked off the twin towers of the World Trade Center, dwarfing the Statue of Liberty and the maze of streets beneath where ninety years earlier AMC and Edison had joined battle for control of the movies. Anything was possible in the jungle of patent litigation.

Yet this second scenario would have been a convoluted conspiracy. It seemed somehow unlikely. AMC were keen to conclude a litigation which was already proving very costly. They would have leapt on any evidence which enabled them to get on with their business, undeterred. Provided it was watertight.

This afterthought prompted the third scenario. Back at the Archive, instead of immersing myself in the reams of testimony that made up the rest of the litigation, I sat back and toyed with what seemed to be by far the most likely solution.

It went like this: when Page first searched Le Prince's British patent for a description of the single-lens camera which Adolphe had brought back from Leeds, he found a rudimentary reference to it, but no detailed specifications. In spite of Adolphe's photographic evidence, and in spite of numerous testimonies to the fact, there was no incontestable proof that the apparatus before him was the same camera that had taken the film in the garden at Roundhay. To present it as evidence of Le Prince's priority over Edison was an open invitation to the Edison camp to question the authenticity of the machine, which would weaken not only Adolphe's case, but also, more crucially, AMC's.

A far better bet, in Page's view, was for Adolphe to testify about the single-lens camera and offer his photographs in evidence, but avoid risking exposure of the actual machine. The same argument, to a lesser extent, went for the sixteen-lens remnant. Only a block of lenses and tangled wires had survived. In the absence of the complete apparatus, it constituted no proof.

When Adolphe reached home after his first day of giving testimony, he confided his anxieties to Lizzie. She was immediately suspicious. 'Mr Page is frightened by your father's achievement,' she told Adolphe. 'If he produces the cameras to defeat Edison, what's to say we won't produce them at a later date to defeat both Edison and these Mutoscope

people?' It was my second scenario.

Adolphe refused to accept this dark version of events. 'He'll present them tomorrow, Mother. You'll see.'

Lizzie was not convinced. 'I said all along that we should have our own lawyers.'

The next day, Adolphe returned to Page's office to face Edmonds' cross-examination. As before, he left the cameras in the cab, in the care of his friend, ready for instant introduction to the hearing.

They reconvened at 10 a.m. Edmonds began by objecting to the whole of Adolophe's testimony of the day before as immaterial and irrelevant. This scathing dismissal shocked Adolphe, coming from a man who had seemed mildly friendly the day before.

Then Edmonds opened his assault. The outcome confirmed Lizzie's worst fears. 'I understand from your direct examination that the sixteen-lens machine, although made in France, was used both in Paris and England. Is this true?'

'Yes.' Adolphe replied cautiously. Where was this leading?

'And that the one-lens machine was both made and used only in England?'

'Yes.'

'You have testified that you returned to the United States in September 1889, expecting that your father would return a few months after, but that it was not until September 1890 that your father disappeared. Why did he not return a few months after you, as expected?'

'I cannot tell.' Adolphe now caught Edmonds' drift. He knew perfectly well that his father had been held up by his experiments. But to say as much would amount to acknowledging that something had gone wrong. A cupped whisper broke into his thoughts. It was Page. 'It's a trap. Don't admit the experimental nature of your father's work.'

'I suppose that you corresponded with him?' continued Edmonds.

'Yes.'

'After you left, do you know whether he continued to work and experiment on the machines about which you have testified?'

It was the trap again, but this time more blatant. To acknowledge the word 'experiment' would imply that Le Prince had not exploited his machines commercially. In US patent litigation, proof of an invention's commercial viability was often used as a measure of a patent's validity. The truth was that although Le Prince had intended to put his machines on the market, he had not got round to doing so before his disappearance. He had 'continued to experiment', driven by an infuriating perfectionism which, in Adolphe's view, was the main reason for his delay. But he could hardly say that.

'Yes,' he replied limply.

Edmonds intensified his attack. He had found Adolphe's weak spot. 'Did you understand that he continued his efforts to develop and perfect these machines during the period enquired about?'

'Yes.'

'How long did you remain in the United States after your arrival in September 1889?'

Adolphe hesitated. He daren't let slip that he had been in Leeds a few weeks earlier. It would prompt Edmonds to ask what he had been doing there and cast doubt on the authenticity of his evidence. He settled for a white lie. 'I have been here since,' he mumbled, looking down at the floor.

Edmonds charged on. 'Did you ever see your father's sixteen-lens machine after you came to this country in 1889?'

What was this? Was he questioning the existence of the apparatus? 'Only dilapidated parts of it.'

'When was that?'

'In 1891, when it came over.'

'Did you ever see any part of the one-lens machine after you returned to this country?'

'Yes, in this year, 1898.'

'What time in 1898?'

'October.'

'In whose possession?'

'In my possession.'

Edmonds looked at him challengingly, as if to say 'If you've got it, then let's see it'. The moment had arrived. Adolphe turned to Page, expecting him to say 'Defendant's Exhibit Le Prince cameras F and G are hereby produced by the witness and offered in evidence.' But the longed-for request never came.

Edmonds was also expecting the evidence. Instead, silence. He looked at the AMC lawyer quizzically, but Page avoided his gaze. Now he couldn't believe his luck. The Le Prince son had claimed possession of what sounded like a dangerous piece of apparatus, yet failed to produce it. Taken with the unexplained delay in Le Prince's return to New York it was beginning to look very much as if this much-trumpeted single-lens camera had never existed. AMC had tried to perpetrate a hoax and failed miserably. True, there was the patented Le Prince sixteen-lens contraption to contend with and a few dubious photographs, but these were hardly a threat to Edison's claims.

'No further questions,' Edmonds said smugly.

'This case is adjourned to meet upon notice,' said the examiner with finality.

* * *

Adolphe was in a terrible state when he reached home later that after-
noon. He could not fail to see the conclusions Edmonds would have
drawn from his ineffectual answers. The opportunity to vindicate Le
Prince's work was slipping away, yet Page seemed utterly indifferent.
Lizzie had been right. Why hadn't he insisted to Page that they show the
single-lens camera? It was an unforgivable mistake.

Everyone at home wanted to know how the cross-examination had
gone. 'How did you feel?' Lizzie asked.

'Feel!' Adolphe blurted out. 'I felt between the devil and the deep blue
sea!'

Marie tried to comfort him but he would have none of it. 'They didn't
call for the cameras,' he sobbed.

Lizzie said calmly, 'They betrayed us, just as I said they would.'

'No! No!' Adolphe spluttered. 'I betrayed him! I told them I didn't
know why father was delayed in Leeds after I left, but we do know. It
just took him longer than he thought. I made it sound as if he'd failed.'

Later on he calmed down a little and wrote a note to Page, asking if he
could change some of his answers. 'I think there would be no objection,'
Page replied. 'I can probably secure Mr Edmonds' consent to its being
written in, in place of what now appears on the record.'

Lizzie, Marie and Adolphe discussed what he should say. The next
day Page received a sheet of explanations.* He was clearly unimpressed.
Adolphe's second thoughts never appeared on the record.

The chastening experience of the hearing had the effect of reconciling
Adolphe to Lizzie's view that they would get justice only if they under-
took the fight on their own behalf, rather than as witnesses for other
people.

Early in 1899, as Equity 6928 continued its slow progress through the
legal machinery, with the outcome for the Le Princes unknown, the
family took their first independent steps in the struggle for legal recog-
nition. Against Mr Choate's better judgement, Lizzie wrote to his firm,
requesting it to initiate, on her behalf, a litigation against Edison for his
infringement of the Le Prince patent. She enclosed a cheque and signed
bond, fully aware of the likely costs of such an action.

The one cautionary note came from Richard Wilson, in Leeds. 'I
should never have advised you to take up your father's case,' he wrote to
Adolphe. 'And even now I should say do not risk in it any of your
mother's or sister's money but keep it a real reserve in necessity. At the
same time I admire very much your decision to go on, your pluck and
perseverance and the care with which you are building up your case.'†

SLEIGHTS OF HAND

When Equity 6928 resumed in the New Year of 1899, Parker Page put AMC's expert, Professor Main, on the stand. Main was a consulting engineer and chemist from Brooklyn. He was a keen photographer and had conducted many of his own experiments with photographic materials. Furthermore, he had been frequently called upon to testify in patent litigations, once for George Eastman himself. Now AMC turned to his knowledge of photography to help it fend off Edison's attack.

Main began with a thorough run-down of the history of the art of producing the illusion of motion to date, citing the work of numerous pioneers, from Plateau's phenakistascope in 1845 down to Friese-Greene, Marey and Le Prince in the 1880s, to show clearly that the moving-picture art was not new when Edison filed his patents on 24th August, 1891, but on the contrary, highly developed, all its principles being thoroughly understood by that time.

Then he turned his attention more specifically to Le Prince's achievement. In line with what was almost certainly Page's decision not to present the Le Prince cameras, Main restricted his argument to the patent evidence. More precisely, to two patents. Perhaps as a result of Adolphe's vivid description of the single-lens camera at the hearing in December, and his presentation of the photographic strips, Page now introduced Le Prince's British patent into AMC's defence, alongside his American patent.

Main began by tackling the sixteen-lens machine. In their opening brief, Edison's lawyers had dismissed it as inoperative, as described in the patent, and more cunningly, as a 'plurality of cameras'. Even if its complicated gearing could be made to work, they implied, the camera was incapable of producing a steady image since it did not film through a single lens but, as they put it, through 'several cameras'.

In a long defence of the sixteen-lens camera, Main argued that the distance between the lenses – about two inches – was small enough not to matter; that it amounted to the 'single standpoint' which Le Prince had proposed; that human beings looked through two eyes and didn't regard themselves as seeing the world from different points of view; on

the contrary, 'so far from introducing confusion, when this distance [between the lenses] does not materially exceed that between the eyes, the only result is to produce a stereoscopic effect which enhances the appearance of reality.' Main had touched on Le Prince's ultimate goal which he now emphasized: 'Several of the earlier inventors in the art of producing the illusion of motion proposed to complicate their apparatus for the sole purpose of producing this stereoscopic effect.'

Yet when it came to the crux of the single viewpoint, Main was on shaky ground. He knew that the sixteen-lens configuration had been as much dictated to Le Prince by the need to move the film slowly as by his stereoscopic ambitions. Now he was forced to acknowledge that in a square of sixteen lenses, the distances between the outer lenses might be 'too much for the best effect. This, however,' he added unconvincingly, 'would be entirely within the control of the constructor of the apparatus, or the adjuster of the scene to be photographed. With a plain background . . . there would be no apparent shifting or wavering of this background. With objects which are not very close to the camera this extra space between the lenses would not be objectionable.'

Le Prince would have been horrified by such a defence of the sixteen-lens arrangement. The perfectionism of his vision allowed no constraints on what he filmed. It had been precisely the problem of parallax in the multi-lens camera – the effect of foreground objects and background shifting in relationship to each other from frame to frame – which forced him to shelve his stereoscopic goals and take the single-lens route.

Main would have been aware of the flimsiness of his sixteen-lens argument. But this was just his opening. He now cited Le Prince's description of a single-lens option in his British patent. In line with Page's probable decision to keep Le Prince's actual apparatus out of the litigation, he did not produce the machine, but he had seen Adolphe's strips taken with the single-lens camera. 'The strips of positives arranged in a single line series were, as I understand, printed from films which had been operated upon by that form of the Le Prince camera in which but a single lens was used, as referred to in the British patent . . . these proofs are roughly taken and mounted but show very plainly gradual and successive stages of an object in motion.'

They were walking on very thin ice. Page knew perfectly well that the important question was how such a single-lens camera was constructed and that the Achilles' heel of the whole Le Prince argument lay in his failure to detail the specifications of the single-lens camera.

One of the tests of the validity of a patent, according to US patent law, lay in the ability of a skilled mechanic to construct a working model of

the invention from the given specifications. Le Prince's description of his single-lens camera read: 'When the receiver is fitted with only one lens, as it sometimes may be, it is so constructed that the sensitive film is intermittently operated at the rear of the said lens which is provided with a properly timed intermittently operated shutter . . .'

Although the single-lens camera which Adolphe had brought back from Leeds broadly fitted this description, it would have been impossible to deduce its construction from the vagueness of this clause. As Page had tried to explain to Adolphe, the absence of these details severely weakened the value of the machine itself, opening it up to allegations of fraud. Hence his decision not to produce it.

But having cited the single-lens camera, there was no dodging the vital question. Could such a single-lens camera be constructed from the detailed specification of Le Prince's multi-lens patent?

Main prepared his ground carefully. By subtle sleights of hand, he argued that it could. Let's follow his logic.

Le Prince had specified a sixteen-lens camera in the patent, but also proposed combinations of three, six, eight, nine or twelve lenses. 'It is obvious,' Le Prince wrote in his patent, 'that the details of the mechanisms forming my apparatus might be greatly varied without departing from the spirit of my invention.'

Main now pursued this suggestion. 'It is perfectly obvious,' he told the hearing, 'that in carrying out Le Prince's idea, the different numbers [of lenses] specified will be arranged symmetrically and so related to the strips of film as to allow these to advance at equal intervals of time, each strip receiving an equal number of impressions. Thus a group of nine lenses would work upon three parallel strips of film, each strip receiving the impress of three lenses while at rest.'

Now came the clever bit. 'The system of three lenses would resemble a group of nine, in that it would act upon parallel strips of film, each strip receiving one impress [image] between movements, and having as a period available for each movement the time during which the other two strips were receiving impressions.

'The three lens camera possesses some special interest,' Main continued, 'from the fact that each strip would contain a series of pictures, taken at equal intervals of time, and corresponding strictly in the nature of the product to the action of a single lens camera.' Abracadabra! The scene was set for Page's fundamental question, which he now put.

'Suppose that a Le Prince camera, such as that described in Le Prince's British Patent of 1888, were provided with only one lens, as is suggested in that patent, what modifications from the three lens camera described

in your last answer would be required to produce such a camera?'

'Objection! This question is objected to as improper!' Edmonds had spotted the sleight of hand. Main had deduced the design of a Le Prince three-lens camera from the sixteen-lens specifications. So far so good, but to infer the design of a putative Le Prince single-lens camera from the speculative three-lens camera was going too far.

But Main persisted with his answer. 'Such a single-lens camera would be produced by leaving out two of the lenses with their corresponding portions of the mechanism.'

Page nodded in gratitude. He knew that it was a vulnerable answer, particularly since Le Prince's single-lens camera could not have been arrived at by this process.

It was 7 a.m. and still dark. I was making for the Edison Archive at West Orange, New Jersey. I wanted to know how the Edison camp had responded among themselves to the arguments for Le Prince's achievement put forward in AMC's defence.

A biting wind ripped down Eighth Avenue as I walked up from 34th Street to the Port Authority bus terminal. The last deals of a long night were taking place in dark corners. Paper cups gusted. Figures stepped out of the shadows offering me this and that in low murmurs. I declined. Bodies lay huddled over subway vents, warming themselves in dry blasts of stale air. Raw hands reached out for spare change. I kept my eyes on the sidewalk and counted cast-iron Con-Ed covers, while beneath my feet fat cables channelled power in the Wizard's name. The man was everywhere. By the time I reached 40th Street the whole city was turning on. I pictured dials leaping with the early morning power surge at the nearest Con-Ed generating station. Not that the megawatt binge had let up much overnight. In this Mecca of Energy the needles rarely read LOW.

I stood shivering at a DON'T WALK sign. The lights of an Edison parking lot came on across the street. Traffic was begining to build up. I listened dispassionately to the echoing clamour of cab horns. A cop car whooped by. An ambulance snarled.

I concentrated on the sounds. There was something more persistent behind the street brouhaha which I couldn't make out, a sound of such serial insistence that I had failed to notice it. Now I heard it and it overwhelmed the surface clatter around me. It was the fugue of electricity – the whine of commutators, the hum of bearings and buzz of great transformers – as the millions of electric motors which powered the fridges, escalators, cranes, trains, air conditioning, power tools, pumps and elevators of New York began to turn. The sign changed to WALK. This white

noise of the city was the Wizard's heritage. I crossed and bought my ticket to West Orange.

It was still dark when we came out of the Lincoln Tunnel. Over the Hudson, cross-town streets shimmered in the convection of car exhausts. Layers of neon office lights towered vertically in an orgy of photons. I had seen this sight before, but it still took my breath away. I wanted to applaud this monument to electricity. My heart softened towards Edison.

We headed west against the early morning scramble into true Edison country. It was hard to tell how much the desultory marshlands and estuaries of the New Jersey landscape owed their grim appearance to the heavy hand of industry and how much to natural ugliness. Either way, it was a landscape not to be lingered in. Newark wasn't much better. A clutch of new buildings at the centre rose above a city of decay, fertilized by the rot of closed factories and dingy housing. In those same streets, Edison had opened his first machine shops more than a century earlier. Now cars lay abandoned outside boarded-up diners and children poked sticks into toxic puddles.

The bus dropped me at West Orange. I followed signposts to the Edison National Historic Site. A water tower acted as beacon. High up on the circular tank the name Edison rusted against flaking paint. The place had seen better days. Great concrete frame buildings, multistoreyed, which had once manufactured all manner of the Wizard's inventions, now lay abandoned or had been let out to various mail order and novelty companies. There was even an Edison car wash. I reached the laboratory, religiously preserved since the great man had died more than half a century before. I walked up the same steps which Frank Dyer and Edison had posed on for the photographer with their former rivals to celebrate an end to hostilities and the formation of their newly forged moving-picture monopoly in December 1908.

Inventions crowded the entrance hall. A guide took me past incandescent lamps, stock takers and kinetoscopes. The laboratories were full of specialist machine tools, hefty metal against dark wood. The whole place had a mothballed feeling, as if frozen in time at the moment of Edison's death in 1931. The guide moved with the respect people have for deceased heroes and gave me the authorized version in hushed tones.

We passed labs which had been devoted to synthetic rubber research for tyres. A sign on a door read PHOTOGRAPHIC ROOM. A large store room held racks of strange organic materials. The Wizard's imprint was everywhere. Notices at every turn proclaimed the virtues of hard work and not smoking. We looked into the great library where the movie men had

toasted their shady alliance with Edison. In the centre of the room a large rolltop desk was littered with the business which Edison had left unfinished in his last days.

The Archive was mountainous and largely disorganized.* The Edison papers comprised hundreds of linear feet of half-sorted documents relating to all aspects of the man's sixty-year career. It turned out that a comprehensive project was in progress, still some years from completion, in an attempt to bring order to at least some of the material. Meanwhile, I faced an index which read like an indecipherable code. I felt the jigsaw despondency of the child I had once been, faced with ten thousand bits of sky. I made for 'motion pictures', turning much-thumbed pages. The entries were full of crossings-out and renumberings. Where could I possibly start that would make any sense? The chance of making any connection seemed remote.

My gloom was short-lived. Quite soon I stumbled on 1898 and the familiar case, Equity 6928, Thomas A. Edison vs American Mutoscope Company. An assistant unscrambled the handwritten references. Within minutes I had eight large boxes on the table in front of me. My first strike came early. In one folder I found a letter to Edmonds from the Edison expert, Professor Morton. I scanned it quickly. Le Prince's name leapt off the page. That brink-of-a-find shiver came over me.

THE UNTHINKABLE SCENARIO

As I sank into the boxes, the strategy of Edison's attorneys became plain. Adolphe's description of the Le Prince single-lens camera at the hearing had rattled them. Realizing that it would destroy Edison's case, they had set about undermining its credibility.

They employed devious tactics, with characteristic ruthlessness. First, they renewed their assault on the sixteen-lens camera, arguing that since it was inoperative any variation deduced from its specifications would also be inoperative. And even if it had worked, they argued, it would have been impossible to deduce the design of a single-lens version from the given specifications. The mechanical requirements of each were too different.

As Edmonds prepared his case, Morton wrote to him:

> I understand that Main regards this suggestion as anticipating Edison's camera. I cannot accept this view . . . what Le Prince intended by this indefinite reference [to a single-lens camera] is left wholly to conjecture. The apparatus he specifically describes and illustrates is useless in that it is constructed on the wrong principles and is, in addition, defective in its capacity to operate even on that principle, and it therefore seems to me impossible to find in the indefinite suggestion of the use of one lens an intention on the part of Le Prince both to change the principle of the camera and at the same time correct the defects of its structure . . .*

Then came the bombshell. Halfway through one of many complainants' briefs I came upon a section headed 'Testimony of Le Prince's Son'. It was almost certainly the expert work of Edmonds and the Dyer brothers, intended to wipe the Le Prince claims off the map once and for all by discrediting Adolphe's testimony.

> A doubt is cast upon the entire story by the failure to produce these models or parts of apparatus, which are apparently in the hands of the witness Le Prince, who is friendly to the defendants and whose interest is to glorify as far as possible the work of his

father. It requires no argument to establish the proposition that the failure to produce apparatus in support of a prior claim is absolutely destructive of the defence unless the construction of the apparatus is conclusively proved and the failure to produce it adequately explained. But a prior use based on testimony, showing that the original apparatus is in existence but not supported by the production of the apparatus itself is necessarily condemned at the threshold of the enquiry.*

The inference was all too clear. It set my head spinning. I sat back and pondered the consequences. Some brown paper fragments of the Edison documents had floated on to my trousers. I brushed them off irritably as the corrosive prose of the Edison lawyers worked its way into me. Their conclusion shouted from the page. 'The work was evidently purely experimental and not completed at the time of the inventor Le Prince's disappearance. There is evidently nothing to the Le Prince story except the patents.'

My unthinkable 'first scenario' of why Adolphe had not presented the cameras at the hearing, which I had so readily dismissed over the Burger King salad, now returned and would not go away.

It was simple enough. Page did not present the cameras in evidence because Adolphe never had them in his possession in the first place. He had lied at the hearing. There was worse. A remnant of the sixteen-lens camera perhaps existed somewhere, but the single-lens camera had never existed. The apparatus I had viewed in the Science Museum was fraudulent, constructed years after its alleged date of invention to prove the Le Prince claims retrospectively.

This devastating option challenged not simply the truth of Lizzie's memoirs and Adolphe's testimony, but also that of the numerous sworn statements which Adolphe had collected from witnesses. To accept it would invalidate all my work. I would have to acknowledge that I'd been deceived by the Le Prince family's deliberate falsification of history.

Was this possible? Could I have been that naïve? I thought about the people involved. Through the years I had grown to know them, I had found that they were to be trusted with their versions of events. When it was possible to cross-check their claims and recollections against passenger lists, Patent Office file wrappers, censuses and so on, their accounts usually tallied. Occasionally Lizzie's lack of technical knowledge or the wishful thinking of her old age caused her to get details wrong.

Adolphe was always reliable. Besides, he was too naturally honest and

naïve to sustain a hoax of these proportions. And Lizzie had far too much respect for the integrity of Le Prince himself to lie about his achievement.

Edison's lawyers, on the other hand, made their living from spinning webs of deceit around the Wizard's accomplishments. When it came to discrediting the achievements of others, they were experts. Helped unwittingly by the Le Princes, they had done a good job. Their innuendoes had got to me. I now felt bound to disprove them.

My first thought was Adolphe's photographic strips. Surely these were conclusive proof of Le Prince's achievement?

My relief was short-lived. Adolphe's proof rested upon the presence of Mrs Whitley in the garden pictures and her subsequent death a few days later. Up to now I had assumed that the portly old lady in the sequence was Mrs Whitley, as Adolphe had alleged. Yet I had never seen a comparable photograph of the woman. Why should it have been her? There was only Adolphe's word for it.

I gave my suspicions full rein. What if Adolphe's Mrs Whitley ploy was a magnificent decoy effect? Perhaps the vivid proof of her memorial plaque and the romance of the churchyard setting had distracted me from the real point at issue. How can we be sure that it's her?

It was time to take a long, hard look at the blurred frames. I picked up a magnifying glass. Adolphe was just recognizable, young and full of energy. And there was Joseph Whitley, with his familiar soft hat and the swaying tails of his light coat. But, try as I might, I could not resolve the grainy smudge that purported to be Mrs Whitley's face into features I would recognize. Nor would a comparable photograph have helped. The blown-up emulsion conceded nothing. I was looking at mere chemical patches.

My suspicions about Mrs Whitley set off a further chain of doubts. The Roundhay garden sequence was filmed in bright sunlight, allegedly in October 1888. Yet the shadows cast by the figures on the lawn seemed too short for that time of year. The sun was too high in the sky.

Alarmed now that I might have become the latter-day victim of a hoax, I looked up the latitude of Leeds. With a bit of crude geometry, taking account of the earth's tilt, I then calculated the maximum noon angle of the sun in Leeds in early October to be about 37°. But the angle of the sun in the garden sequence seemed much higher, suggesting that it was filmed closer to midsummer. Any earlier than October 1888 now seemed unlikely, since the single-lens camera had only recently been perfected. Which could only mean that the sequence was taken in the summer of 1889, nearly a year later than Adolphe had claimed, nine months after the 'death' of Mrs Whitley. It was a frightening hypothesis.

The key evidence was cracking up under scrutiny. And if this wasn't to be trusted, what was?

I decided to double check by setting up a model of the sun shining on to the Roundhay garden lawn at noon in early October. It was an eccentric procedure. Using a heavy torch for the sun, I focused it on fine beam and rigged it at an angle of 37° down on to a sheet of white paper. Four matchsticks stuck on to the paper simulated the figures in the sequence. Orienting myself on the axis of Le Prince's camera and at an angle that corresponded with his low camera angle, I compared the apparent lengths of the shadows against the heights of the matchstick figures which had cast them, then compared these ratios to the corresponding dimensions in the original sequence. To my great relief, they were similar. In my sudden distrust of the evidence, I had not taken account of the foreshortening of the shadows by the low camera angle, which had made the sun seem higher in the sky than it in fact was. Now, instead of confirming my worst fears, my crude experiment showed the garden sequence could, after all, have been filmed close to noon in early October 1888.

But even this didn't banish my doubts, which kept returning in more devious forms. For example, while accepting that the sequence could have been filmed in October 1888, what proof was there that it was filmed with Le Prince's single-lens camera? Couldn't it just as easily have been filmed with the sixteen-lens camera?

The way to find out was to compare the relative positions between static foreground and background objects in a vertical and horizontal axis from frame to frame. Any variation would indicate the kind of parallax, or shift of viewpoint, which we would expect from a multi-lens camera. Consistency, on the other hand, would indicate that each frame was shot from precisely the same viewpoint, through the same single lens.

Using a finely calibrated ruler, I made a series of careful measurements. There was no variation. The sequence was indeed the work of a single-lens camera. Just to make sure, I checked the other two sequences. In the melodeon sequence, the bay window of the house bore a consistent relationship to the edge of the frame from image to image.* Adolphe, moreover, looked about fifteen, which is what he would have been had the sequence been filmed in 1888.

The third sequence was of traffic crossing Leeds Bridge. Street lights, parapets, distant buildings retained a consistent relationship to one another and the image format from frame to frame, confirming that this sequence, also, was the work of a single-lens camera.

These experiments were reassuring, but not conclusive. I needed

more to go on. Perhaps there was something I had missed in the testimonies of the various witnesses. My thoughts turned again to Richard Wilson and Jim Longley.

'I forwarded to his family certain of his possessions and retained some which were either too bulky or too delicate to despatch,' Wilson had said. 'These latter included a camera fitted up with machinery for revolving a shutter before the lens and passing a long roll of paper from one drum to another, such paper while in transit being behind and pressed against the back of the lens.' This could only have been the single-lens camera. Wilson continued, 'The above mentioned . . . had been in my possession until this year [1898] when I handed the same to Adolphe Le Prince . . .'*

'I commenced work for Mr Augustin Le Prince in the latter part of 1887,' Longley had testified. 'I was with him about three years. During this time I made an improved camera of one lens for taking photographs at a great number a minute. The best pictures I saw were of Leeds Bridge, where the tram horses were seen moving over it, and all the traffic as if you were on the bridge yourself. I could even see the smoke coming out of a man's pipe who was lounging on the bridge.'†

If these were lies, they were extremely well orchestrated.

Leeds Bridge crosses the River Aire a few hundred yards north of the Whitley Partners' foundry, which still stands (with the initials WP clearly visible over the door). The bridge lies in the busiest and oldest part, close to the docks and the railway station, linking the main commercial and industrial parts of the city.

I worked out Le Prince's camera position from a frame of his surviving Leeds Bridge footage. The building he had filmed from was still there.

A man from the Water Board let me in. 'I hope you're insured,' he said with a snigger. 'It's lethal in there.' He was right. In virtual darkness I found my way across the devastated old shop to a rotting staircase. It was lighter upstairs. There were floorboards missing everywhere. I moved cautiously from room to room. In one a dead pigeon lay beneath a closed window. In another, rain had poured in unchecked for years through a hole in the roof. 'It's listed,' the man said. 'But don't ask me why. They should've knocked it down years ago.'

I found his camera position without difficulty. Give or take the odd traffic light and hoarding, the view was the same as it had been a century earlier when Le Prince had filmed the midday traffic.

The location was a drab substitute for the trip to Spain which Le Prince had planned for the summer of 1889, to take moving pictures of a

bullfight for John's Spanish Exhibition. But it was the liveliest spot in Leeds. The constant movement on the bridge was an ideal subject.

Twenty frames survive from this camera trial. They show that Leeds was doing business with much the same bustling energy as it does today. Carts and wagons were moving in and out of the city. A man was crossing the road, urgently threading his way through the traffic. On the pavement, two more men were leaning over the parapet of the bridge, deep in conversation. One was smoking a pipe. Beneath them the brown river slid eastwards. [Plate XXI]

As I pictured the machine at the window, heard the grinding of its gears and the brassy slap of its intermittent motion, it occurred to me that I had never examined it closely, that an analysis of its actual construction might yield vital clues as to its provenance. It struck me that if English construction could be confirmed, it would add weight to Adolphe's story. Better still would be some idea of a date.

That evening I tabled a long list of questions to the Science Museum. A few weeks later, they replied. Their answers were encouraging but inconclusive. The camera body was made in a light Honduras mahogany, a timber favoured by British cameramakers around the turn of the century. Its construction suggested typical British workmanship, rather than American, and indicated a joiner's work rather than that of a cabinetmaker, which supported Mason's claim that he had executed the woodwork. The hinges were a British design, patented in Birmingham in 1881. Although they could have been exported to the United States, they might equally well have been purchased at Hicks the Ironmongers on Leeds Bridge. Information on spools, screws and lenses was less helpful, but on balance the Science Museum technicians concluded, 'the evidence would seem to favour English construction'.*

But there was no indication of a date of construction.

The big question remains. What happened to Le Prince? In its wake lie two more. Why did he fail to give detailed specifications of the single-lens camera in his British patent? What kept him in Leeds for nearly a year after Adolphe returned to New York in September 1889?

One hypothesis is cruelly simple. Le Prince failed to supply detail on the single-lens camera because it wasn't a priority for him at the time. His decision to build a single-lens camera was prompted by the shortcomings of his sixteen-lens camera. It was a short-term solution, dictated by the need for a commercial result. Since the new machine was technically incapable of realizing his ultimate goal of taking stereoscopic moving pictures, he saw it as compromising his ambitions and consequently devoted too little attention to it in the British patent.

Le Prince's single lens camera, 1888

Preoccupied with ensuring the multi-lens description was watertight, and dangerously close to the Patent Office deadline, Le Prince settled for a cursory paragraph on his single-lens camera, intending, as Adolphe inferred at the hearing, to take out a separate patent on it later.

It was a fatal oversight. For the next two years he became so overwhelmed by solving the problems of projection that he simply never got round to making the new patent application.

It is one of the ironies of the history of cinema that Le Prince's single-lens camera, conceived as a stopgap measure, resulted in the world's first conventional moving-picture camera. It is one of the tragedies of the history of the cinema that Le Prince could not see this. The sheer scope of his ambitions eclipsed his capacity to secure the safer, less ambitious route which he had unwittingly embarked upon, and which within five years would constitute the mainstream of movie technology.

The reason why Le Prince was delayed for a year in Leeds after Adolphe's return to New York is more complex. 'The work was evidently purely experimental and not completed at the time of the inventor Le Prince's disappearance,' Edison's lawyers had concluded. They were wrong about his work on the camera. The beautiful object had survived. I had found the circumstantial evidence so overwhelming

that its authenticity was no longer in question. But the Le Prince projectors were a different matter.

Le Prince's projectors followed a parallel development to his cameras. Initially, he had hoped that the noise and vibration of the small sixteen-lens projector would be overcome by the sheer scale of its much larger commercial sister, the big deliverer, enabling him to keep his dream of stereoscopic projection to the forefront, even though it would be, for the time being, restricted to non-stereo film shot on the single-lens camera. But in spite of its far greater robustness, the stopping and starting of the heavy film belts and the rapid reverses of direction of the oscillating shutters still set up intolerable shocks and vibrations.

So, early in 1889, Le Prince reluctantly took the single-lens route for the projector, as he had done a year earlier with the camera. But as he well knew, the technical challenge of projection was far greater than that of the camera. The single-lens projector option, although far simpler than its multi-lens forerunners, was no exception. It was slow, noisy and handicapped by the lack of a suitable film material.

Part Six

DÉJÀ VU

Nineteen eighty-eight has become 1989. A year of writing has gone by since I first found Le Prince testing a single-lens projector in the workshop at Woodhouse Lane in the summer of 1889. Since then I have been trying to pin him down, to reconstruct the semblance of a life from the bitter and incomplete memoirs of his widow, from the notes of a devoted son, from the testimonies of loyal friends and witnesses, from my nosings and delvings into dusty old records. An elusive figure has emerged, encountered out of focus in the interstices of other people's emotions. I know him, if at all, in the look of others as they took bearings on his absence.

Now, like the looped movie of an Edison kinetoscope, or even the continuous spiral belt of Le Prince's own ineffective single-lens projector, the same pictures have rattled round once again. I am on the threshold of the last year of Le Prince's life, the final months for which Adolphe had such difficulty in accounting at the hearing.

But the picture has cleared somewhat. When Adolphe left Leeds for New York in September 1889, it was not simply a question of final tests and adjustments to the single-lens projector that caused Le Prince to remain behind. He was about to start work on a new projector, and at the same time begin experimenting with a new film material which finally seemed to answer his requirements.

Now I see him. In full stereoscopic panoramic ultravision hovers a hologram of a man, standing six foot four in his socks. He is stubbornly locked into solving the problem of moving-picture projection. His good-natured and patient exterior hides a defiant single-mindedness. The odds are against him, but there is now no going back. He faces a winter of backbreaking work with no certain outcome. Only the best will suffice. He is determined to achieve his end, even if it means risking the love, their love, that sustains him from the other side of an ocean.

The key to successful moving-picture projection lay in finding a suitable film material: celluloid. As I entered Le Prince's last year, the words of his joiner, Frederick Mason, came drifting back to me. In 1931 he had testified:

It would be in the early autumn of 1889 that Mr Le Prince came to me in high spirits to say he had obtained some rolls of sensitized film called celluloid. As these were too wide I cut them in halves on a lathe, working with a red lamp at night. The incident is clear in my mind because I had to wait until it was dark. The coming of celluloid solved the last difficulty.*

It did not. A year after my first trip to Memphis, I returned to take a first-hand look at the box which Billy had unearthed in his mother's attic after my first visit. Although he had sent me photocopies of everything it contained, I felt the need to check, just in case.

The trip was justified. At the bottom of the box I found an envelope which Billy had overlooked. A note on the outside, in Lizzie's ageing handwriting, read 'Piece of Celluloid Used by Le Prince'.

It was a fragment no larger than my thumbnail, brittle and fogged with age, with no trace of an image. I looked at it more closely. It had tiny bubbles on its surface, which would have prevented an even transmission of light. And it was thick, too thick, it seemed to me, to wind up into long rolls. If this was Le Prince's celluloid, then Mason's recollection was no more than the crystallization of a wish.

It wasn't that I doubted Mason's statement that Le Prince tracked down some celluloid at this time. The material was available from a photographic supplier in London who had probably imported a batch of John Carbutt's sensitized celluloid sheets from the United States. It was more a question of its quality. In spite of the cutting into strips, the splicing into long rolls and punching of perforations along the edges, the new film was, as yet, too stiff and coarse for motion-picture purposes.

So too, incidentally, were George Eastman's first fifty-foot rolls of celluloid, the availability of which in November 1889 Frank Dyer claimed marked the moment of Edison's invention of moving pictures.

There has been much partisan clamouring over the years that suitable celluloid was available to the various inventors grappling with the movie challenge in autumn 1889. But in spite of the claims of Mason for Le Prince, of Friese-Greene for himself, and of Edison's army of loyal supporters for Edison, it seems that they all had to wait at least another year for a material that was thin, clear and strong enough to answer the requirements of moving-picture projection. By which time, it was too late for Le Prince.

As the end of 1889 approached, Le Prince reluctantly returned to gelatine as his film base, a material which, because it was too brittle to roll, forced him to abandon the idea of an unbroken band of images. Instead,

he reverted to mounting each image individually in guides set into parallel cloth or flexible metal ribbons.

The weight of these picture belts once again dictated the new projector design. The gravity-feed single-lens solution had not worked. Nor was a single-belt run past a single lens feasible. The sheer inertia encountered in intermittently advancing such an object raised the old spectre of intolerable vibration. So Le Prince reverted to a multi-lens, multi-picture-belt solution which enabled slower movement of the pictures.

'We made a one-lens deliverer,' Longley told Adolphe later, 'but it gave blurs . . . so your father would not have any more to do with it. We got the best results from the three-lens deliverer which we considered perfect.'

The new machine combined the principle of the sixteen-lens projector with the advances of the single-lens camera. Like the three-lens camera which Main was to speculate about at the hearing a decade later, this projector employed three picture-belts which were advanced consecutively one frame at a time past three lenses. A single rotating shutter, geared to the intermittent mechanism, served all three lenses, overcoming the vibrations Le Prince had previously encountered with

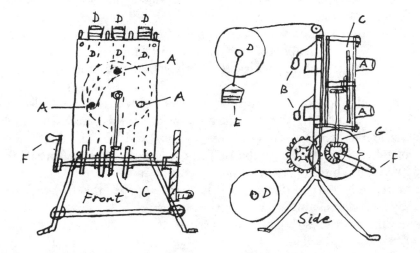

Front and profile sketch of Le Prince's three lens projector made by Longley for Adolphe in 1898. Three picture belts (D) are advanced frame by frame, in sequence, past respective lenses (A) by means of crank (F) and gearing (G). (C) is a rotary shutter which allows the appropriate image to be projected through the appropriate lens in the correct sequence. (E) is a tension weight. (B) are the lamps.

reciprocating shutters. The great advantage of such a design to Le Prince was that it enabled him to incorporate his stereoscopic ambitions. Although limited for the time being to pictures taken with the single-lens camera, Le Prince intended the three-lens projector for stereo moving pictures when problems with a stereo camera had been ironed out.

'So far it works almost as easily as a sewing machine multiplied by three,' Le Prince wrote to Lizzie early in 1890. 'But of course I have to add the weight of the pictures.'*

These were lonely months for Le Prince. Adolphe had returned to New York. John Whitley was in London. Even Joseph Whitley's enthusiastic company was not what it had once been. Mrs Whitley's death had sent the old man into a decline. While his business tottered on the brink of collapse as it had done for most of the decade, Whitley slowly withdrew from his life's work. He now needed caring for and spent more and more time in and out of nursing homes.

The Roundhay home, which had nurtured Le Prince and Lizzie's love, in which he and Whitley had shared their love of nature and science in front of blazing fires long into far distant nights, which had resounded to the squeals of his own children, which had witnessed the first trial of the single-lens camera, this home, which was so deeply familiar, now became a shell in which lone clocks ticked away the emptiness and the approaching winter winds howled in the casements. So he left and took lodgings in the centre of the city, within easier reach of the workshop on Woodhouse Lane. This had become his second home, where he laboured all hours, stiff-backed and smoking too heavily.

It was a bachelor life, dedicated utterly, conducted in great secrecy. His main companions were his assistants, Jim Longley and Fred Mason. Occasionally he would socialize at dinners thrown by his two closest friends, Mr and Mrs Wilson. But none of the guests knew what this quiet Frenchman was doing on his own in Leeds at this time. They remembered him well from the 1870s, at the heart of Leeds cultural life with Lizzie Whitley, his wife. Where was she now? On her own with the children in New York, it was said. What had happened that he had been away for so long? And what about the poor children? Only the Wilsons knew the answer, and they kept his secret.

THE WRIT

Le Prince usually reacted calmly to the news of other men's work in the moving-picture field. When he read of the achievements of men like Reynaud and Anschutz in the photographic journals, he remained undeterred. Muybridge's triumphant tour of Europe in 1889, which took in Leeds, posed no threat. These men were pursuing entirely different photographic and mechanical principles. Marey's latest camera, to be sure, came close to his own single-lens machine, but was of a slightly later date. If it came to a contest, which was unlikely since the eminent French physiologist was apparently not interested in the commercial exploitation of his invention, then Le Prince had the edge with his patent.*

But in February 1890, when Le Prince was still wrestling with his three-lens projector, a long article appeared in the *Photographic News* announcing 'A Machine Camera Taking Ten Photographs a Second', the invention of two men by the name of William Friese-Greene and Mortimer Evans. It was not the kind of news to boost confidence. They were clearly working along very similar lines. 'The object is to obtain consecutive pictures of things in motion, which can afterwards be rapidly projected on a screen, so as to reproduce, say, street scenes, with the horses, human beings, and other living things, moving as in nature,' Le Prince would have read.† A detailed description of the camera followed, revealing a sophisticated piece of apparatus which incorporated many of the features of Le Prince's own single-lens camera and a number of additional refinements. To be sure, the Friese-Greene/Evans patent was only just about to be issued, a good year later than his. But their detailed specifications of a single-lens camera highlighted the absence of detail on the single-lens option in his own patent.

It was evening. Le Prince was bent over his workbench, tinkering with the picture-belts. This kind of news simply added anxiety to what had been several strenuous months. He need not have worried unduly. He wasn't to know, but the rival machine took only one exposure for each turn of the crank, putting the critical rate of sixteen frames a second well beyond its reach. And Friese-Greene's idea for projection was little

more than a complicated magic lantern, rigged to dissolve from one image to another at a maximum of five a second.

He stood up straight, stretching his long arms, stiff from the long hours of hunched effort. The town-hall clock struck midnight. He had little choice but to continue working. So much time had been lost. First Longley's illness, then his own. Then the loss of Longley's baby from bronchitis, a terrible thing, which had cost him more time. Then Lizzie, darling Lizzie, and her illness which was surely the consequence of his interminable delays. They had discussed her coming over. He had even stopped work on the machines to make extra money to pay her fare – it had come to that – and then she had changed her mind.

Money. A pit opened up in his chest at the thought of it. What would happen if he failed yet again? 'I'm not ready!' he had said to Adolphe and Grandpa and Lizzie and Longley and all the others who had pressed him to go public with imperfect results. And month by month, as the result he sought continued to elude him, he had edged further and further out, over an abyss of unsustainable debt. The cost of the work was stupendous. He had had no significant income now for three years, and his resources were dangerously low. Glancing along the workbench, past the racks of tools and neatly arranged columns of Mason's wooden frames, he saw the spike thick with unpaid bills. Hartnell was demanding payment for the arc lamp, claiming that it couldn't be taken back since it had been designed to Le Prince's requirements. Cromptons were seeking payment for the dynamo, and wanted it back.* There was the rent on the workshop, invoices from photographic suppliers, and the relentless weekly wage packets to be paid out to Longley and Mason. And Nelson.

The business with Nelson had been thoroughly humiliating. He had not dared tell Lizzie, for the shame of it. It was a long-standing debt that went back fifteen years to the time when Le Prince was first getting established in Leeds. It was 1873 when a Mr George Nelson had lent him the considerable sum of £350.

Nelson had not appeared unduly concerned about repayment. Nine years had slipped by and Nelson died. To Le Prince's surprise, his executors then demanded settlement. Coming on the eve of the Le Prince family departure for New York, with the immense costs of such an upheaval, £350 seemed a huge amount, much more than he could afford to repay at the time. So he stalled them. He paid £30 on account, and, while not exactly dismissing the balance, he hoped that once he was in America he could put off a settlement indefinitely.

No such luck. Le Prince had not anticipated returning to Leeds. Although his need for secrecy had demanded an unobtrusive return, it

was hard to arrive unnoticed in the relatively small middle-class circles of the city. The word got about.

The creditors finally caught up with him in November 1888, a few weeks after Grandma Whitley's death. A mere clerk turned up at Roundhay with the writ. Le Prince received it in person. 'Are you Louis Aimé Augustin Le Prince?' asked the youth before handing him the summons. He was shocked by the amount. With interest, the loan now totalled more than £600.

I was surprised when the writ turned up among the Whitley papers in the Leeds City Archive. My picture of Le Prince was of an honourable man. The disgrace of a summons seemed inconceivable. Yet here it was, with the judgement, which showed that Le Prince failed to appear in court. In his absence he was ordered to pay £607 7s 4d and costs. In the bottom right-hand corner someone had kept a record of his repayments: £10 in December 1888; £7 10s in January 1889; followed by the same sums in April and August; then there was nothing until July 1890. They were meagre amounts reflecting either meanness or his inability to pay.

As I tried to reconcile my clean image of Le Prince with the evidence, I recalled Frederick Mason's description. 'Extremely just,' he had said, 'and insisted on paying his account each week.' Now this posthumous character reference became suspect. Why bother to raise his straight-dealing nature unless there had been something to hide?

My thoughts turned to Lizzie. In her memoirs she had written: 'My husband's mother died in France in 1887, and we agreed to use his inheritance for patents and improvements. That is why his debts were unimportant when inquired into.' Until the appearance of the writ I had assumed that these were insignificant debts incurred by his experiments. It was now clear that his problems ran deeper. Was Lizzie ignorant of this crisis at the time? Or had she tried to hush it up for fear of what else it implied?

I folded the incriminating document and tucked it back into the morass of sooty correspondence where I'd found it. The myth had become a person, flawed by murkier traits than the impossible perfectionism of his vision. My thoughts turned to Adolphe, who would have been in Leeds when the writ was served on Le Prince. Would he have been aware, at the time, of his father's approaching crisis? Or did the fracturing of his paternal myth come much later?

Le Prince worked on through the night as Leeds slept. At intervals he went to the window, lifted the blind a fraction, and looked out on to the

gaslit main street. For some weeks now he had noticed a man skulking on the other side of the street, watching who came and went at the workshop. He had no idea who it was but the man's persistence had begun to alarm him. If he was trying to get a look at the machines, how had he found out about the workshop? Had Longley talked too much, as he was prone to do? Or was the man one of Nelson's wretched debt collectors, waiting for the right moment to break in and seize his apparatus, on account?

There was nobody there. He returned to the workbench and resumed the tedious process of fitting each of the several hundred framed positives into the guides of the three cumbersome picture-belts. But the spectre of his debts would not leave him.

Nearly three years had elapsed since Le Prince's mother had died and Lizzie and he had agreed to devote the legacy to his work. What sustained him now, barely, was the knowledge that a substantial part of that money was still due to him. When Wilson urged caution, which as his banker, friend and fellow Mason, he felt himself bound to do, Le Prince reassured him of the imminent payment. But deep down, he was worried. He had made numerous trips to Paris to sort out these family affairs with his brother, yet they remained unresolved.

The key, he reminded himself, was to remain confident of ultimate success, of the imminent financial rewards that the commercial début of the invention would bring. They could badger him as much as they liked about showing it soon, but he would not be hurried. Why succumb to the pressure? There was great danger in going public too early, in revealing vulnerable secrets to predators before they were perfected. Why risk everything for the sake of a few months?

It took him hours to finish mounting the pictures in the belts. When they were neatly rolled on to the three hefty spools he decided to give the machine a dry run, without the arc lamp.

He fitted the three rolls to the machine and started turning the crank. At first the belts seemed to pass before the lenses unimpeded. There was a small squeaking sound, but it was probably no more than a dry bearing. He continued winding. The machine was definitely smoother than either the sixteen- or the single-lens deliverer. The small squeak increased and became a tearing sound. It no longer sounded like a bearing. He stopped winding and checked the take-up spools. Too late, he contemplated the disaster. Was it his exhaustion? Could he have fitted the pictures wrongly? Or was the machine fundamentally flawed? Most of the guides which held the pictures had been torn. They would take days of refixing.

He wrote to Lizzie the next day:

I had an accident at the belt of the machine which will put it back some few days for trial. I grudge it as time is so precious just now. Every other part of the machine works well but there can be no result till the damage is repaired. I hope to send the word 'it is' in my next and also some cash which unfortunately I have not at hand – and it makes me feel very uneasy as I know you do not make much just now. Grandpa is very well though restless whilst what he most requires is rest. I shall see him on Sunday and send thee news.*

It was a short train ride from Leeds to Ilkley, where Whitley was staying in a nursing home. Le Prince welcomed the chance for a breath of fresh air. He had been holed up in the workshop too long.

When he spotted Le Prince across the broad drawing room, Whitley bounded over with the manufactured purpose of a man who could not accept growing old. 'I'm so glad you came, John,' was the first thing he said. Then he lowered his voice and indicated the nodding white heads and vacant stares of his companions. 'I can't put up with these cronies for much longer, John. You've got to get me home.'

Le Prince gave Whitley his arm. Something about his gait must have nudged the old man's swirling memory. As they shuffled out into the garden, Whitley began to get his name right.

'Did you not bring the children, Augustin?'

'They're with Lizzie, in New York,' Le Prince replied gently.

After tea he had a word with Whitley's doctor. 'He may live many years,' Le Prince was told. 'He's very well physically, but not quite well in the head. It happens to all of us. A slow softening of the brain. He will always need looking after.'

Le Prince thought about the situation on his way home in the train. What would happen when he returned to New York? John was in London. Whitley would have no one. It looked very much as if the old man would have to join them in New York. He only hoped that Lizzie would be able to cope. At least there would be room. Judging from Lizzie's description of her strenuous efforts to redecorate the Jumel Mansion for his début exhibition of moving pictures, the place was vast.

The train was crossing the Kirkstall viaduct. When the spiky Leeds skyline came into view, the precariousness of his current situation revisited him with a rush. Money. He was in deep need of money. And there was no one to turn to. Whitley was past helping, either with manufacture of the machines or with cash, being on the verge of bankruptcy himself. John was as hard up as ever, in spite of his successes with the exhibitions. There was the legacy, but the legal processes had been so

drawn out that he had begun to give up hope of ever receiving it. He had pressed Albert hard. Too hard. To broach it again quite so soon would mean another argument, a confrontation which he didn't have the heart for. That left Wilson, who had already warned him of the dangers of his position and was reluctant to extend his arrangement with the bank any further without a guarantee of a result.

That night Le Prince wrote to Lizzie about her father. The letter included the usual update on his progress.

I have had another redoing of the picture carrying belt of the machine. It has been slave work with accompaniment of lumbago and I was awfully down about it when your nice letter and Marie and Adolphe's came. So I feel better for a start on Monday – all else seems right and ready for the final – next week will settle it.*

But it didn't.

CONSPIRACY

It was a six-hour journey from New York to Washington DC through some of America's less interesting landscape. Philadelphia and Baltimore broke the tedium. Sudden expanses of water punctuated the drab flatness. Otherwise the panorama which wound past the window was distinctly monotonous.

Adolphe didn't mind. He had too much to think about to be concerned with the view. For the first time since his father's disappearance he felt a semblance of control over events. The days of clinging to the coat-tails of the AMC people seemed a thing of the past. They were now fighting Le Prince's case on their own behalf, as Lizzie had wanted it all along.

Adolphe's strategy was to build the case against Edison. Of course, the gruelling business of prosecuting the suit through the courts would be left to the lawyers, their lawyers. But he had undertaken to amass the evidence himself, this being, in his view, the only way to outmanoeuvre the partisan approach of hostile or, at best, uninterested lawyers whose main concern was a win for their clients rather than the truth.

His chief concern was to establish once and for all the authenticity of his father's single-lens camera. He adopted a two-pronged approach, which required reconciling his clear recollections with further testimony of witnesses and the careful scrutiny of past patent applications.

The first prong entailed writing an account of his father's work, situating it against the claims of others, particularly Edison. The idea was to publish the piece in a prominent journal while the Edison–AMC case was still grinding through the courts and while their own suit against the Wizard gained momentum. The public stir thus created around Le Prince would, he hoped, influence the outcome of both litigations in their favour.

The second prong involved working closely with the lawyers to strengthen Le Prince's claims to a single-lens camera, which Adolphe felt had been weakened by the treacherous conduct of the AMC and Edison attorneys at the hearing and by his own weak performance.

This was not going to be easy. Adolphe was well aware of the cursory nature of the claim as it existed in the British patent and its total absence

from the US patent. This meant that even if the British patent survived a further inevitable onslaught from the Edison lawyers, who had already dismissed it as unspecific, Le Prince's single-lens camera was still not patented in the United States.

If, on the other hand, it could be proved that Le Prince had conceived his single-lens camera in New York, before returning to Leeds in 1887, there was a chance of establishing a US claim and strengthening the British one.

Adolphe, of course, was convinced that he had done. Young though he was back in 1886, he had clear recollections of his father's work at that time. Among the prototype models Le Prince had constructed were a single-lens camera and projector, similar in construction to the ones he built later in Leeds. But the AMC hearing had taught him that the unsubstantiated memories of a close relative, however truthful, did not add up to proof. When it came to legal proceedings, it was hard to dispel suspicions of family loyalty. It was this need for less partial evidence which had led him to seek the testimonies of other witnesses. In the past few months he had located twelve people who knew that Le Prince had succeeded in actually constructing moving-picture machines during his early work in New York. Seven of these recalled seeing moving pictures projected on a screen. The snag was in getting them to testify. For some reason, people got cold feet at the thought of signing statements in the presence of legal authority. And even when secured, the testimonies were often weak. Witnesses found it hard to recollect vital details of what they had seen so many years earlier, or what Le Prince had said to them. Particularly on the crucial issue of the single lens.

The solution lay in finding documentary proof. Adolphe now knew, to his cost, that as far as patent law was concerned, it was the incontrovertible black and white of patents that counted.

This is why he was on his way to Washington, where for the next few days he would hole himself up in the search room of the Patent Office for a painstakingly thorough read of Le Prince's US patent application.

When Adolphe scoured the amendments and correspondence of his father's file wrapper, as I was to do ninety years later, he was determined to right a wrong and unearth the cause of an injustice. In this bullish frame of mind he found what he was looking for – the additional claim which Le Prince had inserted and which had been subsequently erased.

He read the claim slowly. It described 'The method of photographing a changing or moving body, or object, or scenery, which consists in successively and continuously photographing the object at regular intervals from the same point of view . . .'

He stared at the bold typeface in disbelief. Less partial eyes might have interpreted things differently. What stunned Adolphe was the diagonal line that had been ruled right across it. In the margin someone had written 'Erase per. June 15/87'. Overleaf he found, as I was to do, the letter from Le Prince's lawyers in which, apparently unauthorized by Le Prince, they had accepted the Patent Office's demand that the claim be eliminated.*

To Adolphe nothing could have been clearer. In his passionate resolve to prove the authenticity of his father's 1888 single-lens camera, he took the phrase 'same point of view' to embrace the single-lens option. Here was proof of his recollection that Le Prince had conceived of a single-lens camera as early as 1886.

Adolphe's assumption was almost certainly wrong. In 1886, Le Prince was preoccupied with specifying his multi-lens machines. In this context, the phrase 'same point of view' was intended to cover not a single-lens camera, but a tightly bunched battery of lenses which, strictly speaking, filmed from slightly different points of view.

Adolphe was in no mood to admit this distinction in 1899. What leapt off the page of the file wrapper was the line of rejection drawn through what he saw as Le Prince's crucial claim, covering the single-lens option. Why had it been disallowed?

The examiner cited a prior patent of Dumont's of 1861. This was a seriously flawed judgement, in Adolphe's view. Le Prince's work was quite distinct from Dumont's, which was concerned with still, rather than moving, pictures.

To Adolphe, who was still dazed by the ruthlessness of the Edison legal machine and who was still convinced that Le Prince was being held captive by men who had stolen his invention, such an oversight could mean only one thing. The Patent Office, Le Prince's patent agents and someone who had wanted to sabotage Le Prince's work had conspired to deny him the key claim.

The locomotive blared its way down the track, warning stray animals of its approach. On the same return journey to New York, I pictured Adolphe's train, many years before, cutting a smoky line through the New Jersey landscape. In place of the dozing commuters who were my travelling companions, I conjured up Adolphe, full of righteous anger as he put the pieces of the jigsaw together. Suddenly it all seemed to fit: the inference of the Edison lawyers at the hearing that the single-lens camera was non-existent or fraudulent and Le Prince's disappearance were just part of a conspiracy that had originated in the Patent Office as far back as 1887.

Adolphe looked up. The regular blasts of the horn had escalated. The train slowed, then squeaked to a halt. He got up and leant out of the window. They had made an unscheduled stop at a small railway station. Up ahead, through a cloud of steam, he could just make out the guard and the driver helping a farmer herd his cattle from the track. Then he noticed the name of the station. It was Menlo Park, where the Wizard had sprung to fame with the incandescent lamp and the phonograph twenty years before. And like the short-lived glare of one of those early Edison lamps, Adolphe's anger became premature triumph as he resolved to defeat Edison.

My train began to move. I was to return to Menlo Park another day and pay my homage to the site of Edison's famous research lab. The guard was approaching down the aisle, clipping tickets with obsessive rapidity. I wanted to call down the years, to warn Adolphe of the dangers ahead. From where I stood I could see nothing but trouble down the track. The Le Prince tragedy was approaching its climax, and I could no more prevent it than I could stop my train as it picked up speed again for the last leg through Newark to Penn Station.

The first blow came with the refusal of Choate's firm to take up the Le Prince case. In February 1899 they wrote: 'We deem it advisable to decline your application for bond as administration . . . We are under the impression that there would be too much litigation . . . consequently involving a lot of our time in watching the case.' Adding insult to injury, they concluded, 'We never write an administration bond where there are no tangible assets, which we get for joint control.'*

So much for Choate's benevolent image. Lizzie was furious. Choate himself was unreachable, having just taken up the post of US ambassador in London. The whole business confirmed her opinion of him, which had been steadily worsening. He had still not returned Le Prince's patents. Recently Adolphe had been forced to apply for new copies, at the very moment when they needed them most.

It was a serious setback. Now they had to begin the process of finding a sympathetic lawyer all over again. This was not easy. The case required not only detailed technical knowledge of up-to-the-minute developments in photography, but also a lawyer who was prepared to take on the notorious Edison legal battalions on behalf of a client who could not afford even the costs of a victory, let alone a defeat.

The months went by. A series of initiatives taken by different lawyers came to nothing. Invariably, their searches turned up the US Patent Office's 1887 refusal of the claim which Adolphe regarded as covering the single-lens camera, the erasure of which he was convinced had

involved foul play. Each time this happened, the lawyers interpreted the erasure of the claim as a bar to Le Prince having any subsequent claim on a single-lens camera in the United States, in spite of the existence of the single-lens claim in Le Prince's British patent of 1888 which, to Adolphe, was a clear pointer to the fact that Le Prince had intended, but been prevented from making, a similar claim in his US patent application of 1886.

Adolphe reasoned in vain. 'They should never have cast out the claim,' he told Willis Fowler, one of the lawyers. 'It was a deliberate crime.' Fowler shook his head sympathetically. 'I'm not a criminal lawyer, Mr Le Prince.'

Lizzie was so incensed when told of this encounter that she stormed down to Fowler's office the next morning. 'Don't you see!' she fumed at him. 'My husband was going to contest their decision on his return to the United States. But they stopped him. Kidnapped him, Mr Fowler, precisely so that he could not come back here and insist on his rights to a one-lens machine!'

Fowler was out of his depth. As a patent lawyer, he considered it extremely unlikely that the Patent Office would allow the reinstatement of Le Prince's cancelled claim more than ten years after it had been erased, when the inventor was to all intents dead. Reissues of patents were notoriously hard to achieve.

A few days later the Le Princes received a familiar rejection. 'A contest would be long and expensive, and even then the issue somewhat doubtful,' the lawyers wrote. 'It would not be prudent, in our judgement, for you to embark on this litigation unless you had the money with which to prosecute it.'

While these depressing events were unfolding, Adolphe faced a series of setbacks in his attempts to get his article published. McClure's, *Cosmopolitan* and Scribner's all turned it down. To Lizzie, it began to look like deliberately orchestrated obstruction. Adolphe's piece questioned Edison's claims. Could it be, she wondered, that the various editors were reluctant to publish anything critical of the Wizard? Were they afraid that the business concerns which advertised in their pages might join ranks in defence of a man of Edison's stature and withdraw their accounts?

Then in May, a writer who had promised to develop Adolphe's article for a major story in the London *Daily Mail*, suddenly went off the idea.

I have carefully studied the case of your father as presented by you and I am sorry to say that I am very much disappointed. It is a technical discussion, of interest only to photographic trade papers

and patent lawyers. Le Prince certainly was the first, but his case is one of hundreds where great injustice has been done and clever men have overcome obstacles by bribing Patent Office employees etc. The only thing that would have interested the editors was the idea that Le Prince had been assassinated by Lumières people or else put away in a mad house. Le Prince's mode of life being upright in everything points to the idea that he was assassinated or put away. But you do not advance an idea of that kind, nor do you connect your father's disappearance with his invention. Until someone can come forward and make a serious charge the matter would not be of sufficient interest to publish . . .*

'That's precisely what I avoided doing!' Adolphe said, as he handed the letter to Lizzie. 'The courts wouldn't take father's claims seriously if we coupled them with his disappearance.'

'They're afraid to publish the truth,' said Lizzie, jabbing at the letter with her forefinger. 'We should've named names.'

Adolphe reasoned with her. 'Whose names, Mother? We know he was put away for his invention. But we can't risk a libel action at this stage.'

Lizzie was in no mood for this commonsense line. She smelt treachery. 'And why do you think this Sherman has suddenly changed his tune?'

'Because he didn't like my piece!'

Lizzie spluttered disagreement. 'Think, Adolphe, think! Who's just arrived in London? Who's the most likely person to have had a word in the editor's ear? Who's the man who won't pursue our case and has persistently refused to return your father's patents?' She nodded contemptuously as Adolphe resisted the inevitable conclusion.

'Choate's not that kind of person,' he said at last.

'Mr Choate?' Marie echoed. 'He's far too nice to do a thing like that.'

DISAPPEARANCE II

The main arcade of Bourges Cathedral is higher than that of its high Gothic sisters. The shafts that cluster round the main piers soar up from ground level, through the capitals, on upwards past the triforium to the gallery, where they burst like stone fireworks into the sexpartite vaults.

It was a most elegant solution, preferable to Nôtre Dame, Le Prince thought, though perhaps without quite the majesty of Chartres.

'It seems so light and airy,' said Mrs Wilson.

'Thanks to the flying buttresses,' Le Prince said.

'I wonder who paid for it all?' chipped in Wilson.

They strolled up the nave. A priest's voice intoned the mass in some distant chapel. An old woman in black rose from her knees. Her chair scraped the stone floor. Clustered pinpricks of candlelight created small oases of warmth in the grey ambulatory. The smell of burning wax intermingled with the mustiness of ancient masonry.

He should have felt exhilarated and inspired. He hoped that he had given that impression. For a week now he had been unofficial guide to Mr and Mrs Wilson on a brief tour of the cathedrals. It was a farewell vacation, their last time together before his supposed return to New York. The façade of optimism had been hard to sustain. His cheeks ached from the false smiles. His joints were stiff from the affectation of light-heartedness. They were under the impression that he had succeeded, that it was merely a matter of securing the French patents before sailing for New York and the triumphant American début.

'How do they work, Augustin?'

'The weight of the vault is carried outside, where it flies through the buttress, and is taken down to ground level. It takes the strain off the walls, otherwise they wouldn't have been able to have all these marvellous windows.'

'What became of the stained glass?'

He felt painfully remote from their questions. How he would have loved to confide in them. Wilson was aware of his financial difficulties, but he didn't know their extent. For months now, Le Prince had been telling him that success in his experiments was imminent, that within

261

weeks his machines would be a paying proposition enabling him to wipe out his considerable debts, that his mother's legacy was a guarantee against bankruptcy. Now, as far as Wilson knew, the long-awaited 'result' had been achieved; Le Prince was on his way to Dijon to make final arrangements about receiving the legacy; he had solved his last problems, as he'd promised.

'Lost through the centuries,' Le Prince answered. 'A great pity. Perhaps I should turn my talents to stained glass, instead of squandering my capital on useless experiments.' He emphasized the words with a grin, as if repeating Wilson's past doubts. The banker acknowledged the jibe with a warm clasp of Le Prince's hand, relieved that his friend was in such good spirits.

'It's awfully high,' said Mrs Wilson, staring upwards.

'Not as high as Reims or Amiens,' Le Prince answered.

'What about Beauvais? Isn't it even higher?' Wilson asked.

'Ah, Beauvais,' Le Prince reflected wryly. 'Their vision went beyond their technology. They built it too high and it fell down.'

A church bell tolled. It was noon. In two hours Le Prince was due to see the priest. Later on he would take the train to Dijon.

'We'll meet you in Paris on Tuesday,' Wilson said. 'At the Gare de Lyon. What time?'

'Late afternoon. I'll wire you from Dijon.'

Le Prince answered absentmindedly, wondering how he could manage to slip away without alerting the Wilsons' suspicions. He had met the priest several times in recent days. Their friendship went back to boyhood days in Cette, near Montpellier, where Le Prince had spent idyllic summers with his mother's family. This sense of continuity reassured Le Prince in these difficult days.

For the past weeks he had been possessed by a mounting sense of failure. The three-lens projector was not good enough. No matter how many modifications he made to the picture-belts and the various gearing devices that worked the shutter and three advance mechanisms, it would not come right. There had been identifiable movement on the screen. Recognizable figures flickered on the wall, but it was still not adequate for commercial exploitation.

It was the same old chicken-and-egg problem. The lack of suitable film material had dictated a projector design which, although much better than the earlier prototypes, was still limited by the lack of a suitable film material. None of the materials had so far proved satisfactory. Even gelatine, which showed so much promise, began to crack after one showing. Celluloid, which still seemed to him to be the key, was unavailable in the refined form in which he required it.

If there had been more time and money he would have felt confident of solving the problem. But both had run out. It was worse than that. He had exhausted his options on whom to borrow from. He was now utterly dependent on his mother's legacy and even that, if he managed to secure it from his brother, was unlikely to cover the debts he had already incurred. Wilson didn't know it, but this was the main reason for his visit to France. And he was, frankly, dubious about the outcome. The legacy had been so long in coming to him that he had ceased to believe it ever would. And if it didn't he would have to face the intolerable disgrace of bankruptcy.

Le Prince had spent most of his life cushioned by moderate family wealth. Even the recent hard times had been bearable with the prospect of a modest inheritance. However bad things got, he had always been able to look to this ultimate safety net. Things would come right in the end, he had always assumed, because they always had done in the past.

As long as he had continued to make progress with his experiments, this conviction had sustained him. But when, after two years of repeated failure to realize the quality of projection he sought, he looked up from his work one day to find himself over an abyss of debt; when, like the architects of Beauvais Cathedral, he was confronted by the unrealizable nature of his ambitions; when he looked downwards for the familiar foundations of his life to discover that they were no longer there; when it dawned on him that no matter which way he turned there was no longer anything or anybody up there to hold on to, then something verging on terror set in; then he was overcome by Carlyle's 'infinite dread', not just the fear but the awesome reality of not succeeding.

Did they meet in a confessional? Did they stroll deep in conversation through the medieval streets of Bourges? What did they talk about, this priest and this desperate inventor? Was Le Prince seeking validation of a life he now wished were over? Was it the priest who insisted on meeting him again and again, to dissuade him from even contemplating the unpardonable sin?

I am jumping to conclusions. Who's to say what passed between them? People confess to sins other than failure. And seek solutions other than suicide.

One day, in the course of my long search, I tracked down a Le Prince painting in Wakefield Art Gallery. It was a large gouache portrait of an elderly in-law. In the hope of discovering some overlooked clue, I asked the gallery curator if I could look at the painting's provenance.

Someone else had been there before me. In the margin, alongside a

typed 'Painted by Le Prince in 1881', I found a pencil-scrawled note which read: 'Le Prince was gay. He was having an affair with his father-in-law. He engineered his own disappearance to avoid a scandal.' The observation was signed.

Le Prince and old man Whitley? I had difficulty imagining a less likely scenario. But the suggestion took hold. That night I looked long and hard at my only photograph of Whitley and Le Prince together.

They were sitting on a cast-iron bench in the garden at Roundhay. It looked like the late 1880s. Le Prince sat impassively in a smoking cap, looking tired and impenetrable. Whitley, on the other hand, appeared angry. Perhaps he resented the intrusion of the camera? [Plate XXII]

But why would he have resented it? My mind raced. Had some act of intimacy between the two men been broken in on? If so, who took the picture? Absurd thought. Far more likely, they were discussing Le Prince's looming financial crisis and Whitley's inability to help out. Or the old man was past it, paddling in the pool of setbacks and disappoint-ments which now constituted his life.

Some time later I tracked down the author of the note. He was an elderly man who ran an antique shop in the West Country. It was clear from his shop window that he had an interest in the beginnings of cinema. Magic lanterns were displayed alongside various old optical toys. As soon as we spoke I realized why he had drawn this conclusion. He had no evidence, only a very strong feeling, a conviction even.

'It's obvious,' he said. 'You can tell.'

'I don't find it obvious,' I replied.

On the way home I found myself fantasizing the gay scenario. But a relationship of this nature with old Whitley seemed inconceivable. I giggled aloud at the thought of it. Then John came to mind. Had the elderly antique man meant John Whitley, who as a young man had befriended the handsome young Frenchman in the 1860s? Had he meant Lizzie's brother, who had, over the years, exerted such a strong influence on Le Prince's life? John had been responsible for his coming to Leeds in the first place and, latterly, his emigration to New York. Had there been something between these two men that I had overlooked? Something beyond the pale of sturdy brotherly friendship? Something beyond the pale of sturdy brotherly friendship? Something unspeak-able, a scandal that had come to light in the summer of 1890 when John Whitley was preparing the last of his great Earl's Court exhibitions, the French, and Le Prince was struggling with his unwieldy projection machines? And if not John, what about the mysterious suicide of the lodger in Le Prince's digs after his disappearance? Could this have had anything to do with Le Prince's engineering his own disappearance – at

a time when the Oscar Wilde trial was headlining homosexuality as an unpardonable sin?

We were on a long stretch of welded track. The wheels hummed on the rails, uninterrupted. I let my thoughts run. For some time I dwelt in the shadows of stifled desire, snatched pleasures, the teeming charge of the illicit, the corrosive power of old lies . . . male love. Then the buffeting shockwave of a train speeding in the opposite direction bumped me from my dreams.

I looked out and imagined the man in the brown coat flash by, framed in the window of the passing train. Was he peering after the diminishing evidence of his dirty work? We were crossing an embankment. I pictured the roll and tumble of Le Prince's body. But where was his black valise? Did the brown-coated man make off with it in the hope that it contained the vital moving-picture patents he was after?

I sauntered down the carriage corridor towards the buffet. A drunk businessman with a black attaché case was approaching me. I brushed his fat belly and caught the full blast of beery breath. When I reached the door I pulled down the window and stuck my head out into the rushing air. A sheet of white paper had caught in the slipstream of the train and was being tugged along in its wake. Was it Le Prince's French patent? Did his black valise leave the train with him, breaking open as it fell, scattering white documents which were sucked along by the train just like the one I was looking at?

The guard's voice came over the PA. 'This train is now approaching Leeds. Please will passengers please be sure not to leave any of their belongings behind please . . .' I left these fantasies and returned, once again, to Le Prince's final weekend with his brother.

On Friday 12th September, 1890, he left the Wilsons at Bourges, and took the train to Dijon. The three friends had arranged to meet up again in Paris, a few days later, and return to England together.

It was a hellish three days. Albert spent most of the time avoiding Le Prince, rushing off to spurious meetings which he said his job as city architect demanded. Le Prince passed the time with his nephews and nieces, playing the kind uncle, while inside he grew more and more distraught.

On the morning of Le Prince's last day, Albert finally sat down to talk. Le Prince was to have taken the noon train to Paris, but their discussion became an argument and he missed it. Over lunch they reached the heart of the matter. Le Prince demanded settlement of the will, claiming that he was owed at least £1000 and that Albert was deliberately obstructing the legal process. For his part, Albert was

convinced that his brother had had more than his fair share already.

They arrived at the station early to be on the safe side. Albert waited to see him off on the 2.39 p.m. The argument continued on the platform, attracting the attention of other waiting passengers. Le Prince was adamant that Albert was swindling him. Albert rounded on him fiercely. Why should he be expected to shoulder the burden of his brother's impending bankruptcy? Gus had had all the money there was coming to him. If he'd chosen to waste it on worthless experiments, then that was his lookout. He'd always warned that such extravagance would lead to disaster.

The train arrived on time. As the locomotive clanked past, the two brothers were momentarily enveloped in steam. When it cleared Le Prince was already boarding the train. He was carrying a single black valise. Albert had already left. They parted without a farewell.

FIN DE SIÈCLE

By the summer of 1899, what had begun as a year of promise for the Le Prince family had turned out to be the familiar round of reverses. With no one willing to shoulder legal responsibility for their case, their independent initiative faltered. Gloom and depression returned. As they were passed from one set of unhelpful lawyers to the next, their situation felt increasingly desperate.

In these grim circumstances one small ray of hope emerged. In spite of Adolphe's humiliating experience at the hearing, a new development in the AMC–Edison litigation seemed set to bring at least a degree of public recognition to Le Prince.

In their fight to disprove Edison's claim that he was the first and sole inventor of the moving-picture camera and projector, AMC had cited the prior patents of many pioneers, but in the absence of the hardware their arguments had been vulnerable to allegations that the machines did not work, and the subsequent assertion that only Edison had succeeded in producing commercially viable moving pictures.

To get round this problem and to step up the pressure on the Edison camp, Parker Page proposed to Herman Casler and Harry Marvin of AMC that they settle the validity of the most significant of these patents by constructing working models to the patent specifications.

First among these was the Le Prince patent. They chose to construct the three-lens camera, which had been proposed by Le Prince as a variant, and which their expert, Main, had contended could be worked out from Le Prince's sixteen-lens specifications. The three-lens configuration required three rolls of film and three intermittent mechanisms. It was a cunning move, with three aims. Firstly, it would prove the viability of Le Prince's multi-lens patent specifications. Secondly, it would prove Main's contention that Le Prince's single-lens camera could be arrived at by simply leaving out two of the lenses and their corresponding mechanisms, so heading off Edmonds's objection that such a deduction was improper. Lastly, if it came to AMC's losing the case, it would have a viable multi-lens system with which to continue in business without infringing Edison's patent on a single-lens camera.

The Le Princes watched these developments with mixed feelings. It

seemed such a convoluted route and the outcome was by no means certain. Wouldn't it have been so much simpler and more convincing to have shown the examiner the single-lens camera itself in the first place? But by this time they had no real choice in the matter.

The new century came in. The case unfolded relentlessly. Late in January, Page trundled out to West Orange to question the Wizard himself about his cinematic claims. For his part, Edison dreaded the prospect of testifying. He much preferred to leave the dirty realities of litigation to his lawyers, but on 29th January, 1900, he was forced to take the stand. His testimony was casual, almost arrogant.

'When did you begin your experiments on the kinetograph?' Page asked.

'I think in the latter end of 1888.' Edison could afford to be vague. He was on home ground.

'Did you see any machine of Marey's at the Paris Exposition of 1889?'

'Yes, sir. I saw a wheel with a horse jumping a hurdle, but it was the same as the old zootrope, except that it was photographs.'

He was lying. It was from Marey's camera that he had taken the idea of an intermittent mechanism advancing a long band of film.

'It was very, very jerky and the pictures were only a few per second.' More lies. They were upwards of twenty, and steady.

'Why did you omit to state what kind of material should be used in your patent?'

'I have not read the patents – lately, I mean to say. I cannot tell till I do.'

Edison's prevarications went on in this vein until Page raised the awkward issue of Armat's projector. Wasn't it true that Edison had passed the invention off as his own?

He struck a sensitive nerve. The Wizard squirmed visibly. 'We saw that it was our machine except that he had a different movement for feeding the film along.' He was referring to the small matter of Armat's quantum leap in projector design, which made film projection a reality.

> Raff & Gammon wanted us to build that machine and they wanted to use my name and as the movement seemed to be a good one . . . I gave them permission to use the name for the reason that all that there was in the machine belonging to Armat that we did not have was simply his movement . . . The whole thing was mine except that one movement of Mr Armat's.*

It wasn't. It was decidedly Armat's and Page proved it by quoting the

letter which Raff & Gammon had written to Armat, pressing him to agree to Edison's being credited with the machine: 'In order to secure the largest profit in the shortest time, it is necessary to attach Mr Edison's name in some prominent capacity to this new machine,' they had urged.

'Never heard of such a letter,' Edison lied, unconvincingly. Page was pleased with his day's work. On the Wizard's own territory he had exposed an exemplary sleight of hand by which Edison had both stolen another man's invention and claimed it as his own. No mention had been made of Le Prince, but it was clear, at least on the issue of projection, that Edison certainly was not the first inventor.

When, in February, the Edison camp's expert, Morton, took the stand, Page pushed this line of questioning further into the more critical terrain of celluloid and the camera itself.

It was accepted by both sides that suitable celluloid had not been available to any pioneer until late 1889 at the earliest. Morton regarded any other material as impractical. 'I consider that the absence of such a film,' he told Page, 'is very strong evidence against the claim of prior invention, because it shows that such an invention was certainly not put into practical operation or use.'

Page then passed Morton the paper strip of frames from Le Prince's 1888 garden sequence, and asked, 'If it should appear that the series of photographs which you are examining were taken in October 1888 and showed, among other things, an old lady who died in October 1888, would you still be of the opinion that there was no material suitable at that time for taking a series of photographs at twelve to twenty per second that are suitable for exhibition?'

Morton paused before replying. To say no would mean acknowledging that Le Prince had solved the 'taking' problem before Edison. Yet by focusing on the 'taking' Page was dodging the fact that both 'taking' and exhibiting were required for the reproduction of the moving image. And projection required celluloid, not paper.

'No. Provided that the rate was genuine,' he said cautiously.

Page pressed his advantage. 'Was the problem which Le Prince undertook to solve by the apparatus described in his patent, original with Le Prince?'

'No, it was not, as I understand. Several inventors had endeavoured to solve it before.'

'There was no new philosophical or optical principle involved in the production and exhibition of a series of photographs of an object in motion?'

'No, there was not, as I understand it.'

'It was perfectly well understood in 1889 that different degrees of movement required a greater or lesser number of pictures per second to secure a faithful and natural reproduction of such movements, was it not?'

'In a general sense, it was.'

Page hammered away at the Edison position in this fashion for several days. Marey, Ducos, Le Prince were all acknowledged by Morton as having had the idea of moving pictures before Edison. But Morton was consistently careful in distinguishing between the theoretical aspirations of Edison's predecessors, and the practical and commercially successful results of Edison himself.

When it came to Le Prince's specific achievements, Morton judged the results of the Le Prince three-lens camera, which Casler had constructed and tested, to be the kind of jerky images he would have expected from a multi-lens camera. More fundamentally, he objected to the apparatus as not warranted by Le Prince's patent, which in his view was inoperative. In order to produce results, the new three-lens camera had required invention on the part of Casler. It was not a Le Prince machine.

Morton also renewed the Edison attacks on Le Prince's sixteen-lens camera, and continued to pour scorn on Le Prince's single-lens clause, repeating the argument that the construction of the alleged single-lens camera could not be deduced either from the sixteen-lens patent or Casler's spurious three-lens afterthought. In the continued absence of the actual machines, these onslaughts were dangerously convincing.

Late in March 1900, AMC boss Harry Marvin took a totally unexpected initiative. With the testimonies now complete and Edison's lawyers pressing for a judgement, he wrote to Edison in person, proposing a truce.

> Of course, if you insist on forcing the suit to an issue, our attorneys must immediately proceed with the preparation of their brief for the defence . . . an expense which will be useless if we are to come to an amicable agreement. Would it not be to the interest of both of us to suspend hostilities in the suit until we can have time to negotiate this matter and come to a definite understanding?*

Edison's response was equally unexpected. Perhaps because of his recently renewed hopes for his doomed ore-separation project, which was to end finally in May, or due to optimism about his burgeoning ideas for storage batteries and cement, or perhaps because he was

thoroughly depressed by the prospect of any further litigation, he agreed to meet Marvin.

The outcome was even more surprising. Marvin secured an option to buy all of Edison's moving-picture interests for half a million dollars. The proposed merger had become a buyout. AMC would control the industry.

Such an outcome might have favoured the Le Prince claims, which could have gained some form of recognition from AMC. But it was not to be. When the time came for AMC to make their first payment, their bank failed. By this time, Edison's uncharacteristic detachment had waned. No new deal was acceptable. The war was set to continue.

The verdict finally came in July 1901. It was bad for AMC. And devastating for the Le Princes.

> ORDERED, ADJUDGED AND DECREED as follows, to wit: that United States Letters Patent #589,168 granted August 31st, 1897, to the complainant, Thomas A. Edison, for Kinematographic Camera, are good and valid Letters Patent; that the said Thomas A. Edison was the first and sole inventor of the invention described therein . . . and that the defendant American Mutoscope Company has infringed upon the said Letters Patent . . .*

This grim decree had dire consequences for AMC. It forbade them to engage in any form of business which infringed Edison's patent, and ordered them to pay substantial damages to Edison, backdated to August 1897, when Edison's camera patent was issued.

Harry Marvin immediately took steps to appeal, urging the court to allow AMC to continue in business until the result of that appeal were known, as even a few weeks of closure would ruin the business beyond repair. It was an outrageous verdict on many counts. Edison was clearly not the first and sole inventor of the moving-picture camera. What particularly incensed Marvin was that the verdict applied not simply to the Edison-related camera designs which they used, but also to their own biograph camera which had been designed by Dickson with the specific purpose of avoiding infringement of Edison's patent, should that ever become an issue.

Marvin argued that:

> The nature of our business is closely analogous to that of a great news bureau, collecting and imparting pictorial or illustrated news to thousands of subscribers and millions of their customers. A

single failure to 'take' – that is, photograph – an event of prime importance would deprive the public at large . . . and would injure us.

To emphasize AMC's determination not to be driven out of business, Marvin concluded by telling the court that AMC was constructing yet another camera which was:

> entirely outside of that contemplated in Mr Edison's patent; a construction in fact which includes a plurality of lenses, so that the photographs are taken from more than one point of view. The development of this camera will take some time . . . When it is perfect, we expect to abandon the cameras involved in this suit; but until then we have nothing to use save the films and cameras against which the recent decision was rendered.*

This multi-lens camera was no less than a development of Le Prince's multi-lens machine. Clearly Casler's three-lens Le Prince-rebuild had been sufficiently effective for AMC to consider seriously the option of using it in their business, should the outcome of Equity 6928 demand it.

This was small comfort to Adolphe. He had pinned his hopes on the vindication of his father's single-lens camera which was still in his possession. Yet as far as the law was concerned, it was as if it had never existed.

VANISHING TRICKS

I was sitting in the vast Egyptian foyer of the Peabody Hotel in Memphis, sipping a margarita with Chick and Billy. We were speculating about Le Prince's disappearance. 'I'll play the villain on the train,' Billy said, twisting an imaginary moustache with a 'Tee hee!'

'Who'll play the vamp?' Chick asked.

'What about her?' Billy said. Just then, a tight, Levi-clad butt swung past. Both men's eyes followed the young woman as she disappeared beyond a fountain in the centre of the hall where a dozen ducks idly paddled.

'Maybe he cheated on Lizzie?' Chick suggested.

Billy would have none of that. '"His home life with his family was ideal". Didn't I read that somewhere?'

'I think Adolphe wrote it,' I said.

'He would, wouldn't he?' There was a glint in Chick's eye.

Billy rounded on him. 'Why would he?'

'If the man had been playing around, they'd have hardly been likely to admit it. It's the same with the money business.'

'What d'you mean?' Billy asked.

Chick echoed my suspicions. 'I mean that, throughout the memoirs, Lizzie takes great care to rule out certain possibilities. She includes Adolphe's comment about his ideal home life, *ergo*, there was no other woman. She lays great stress on his mother's legacy, *ergo*, he was not short of money. It looks fishy to me.'

'What about the telegram?' Billy challenged.

'What telegram?' I asked. It was the first time I'd heard of one.

Chick ignored me. 'You can read it two ways,' he said to Billy.

'What telegram?' I repeated, alerted.

'Didn't we show you?' Billy asked, almost casually.

'It was lying at the bottom of the cardboard box,' added Chick. 'We'll show you later.'

Towards 5 p.m., the hum of afternoon tipplers was joined by the buzz of a camera-swinging crowd which had begun to mill expectantly round the fountain where a man in a topper and tails was unrolling a red carpet

towards the elevator. Then he blew a whistle. Zz-klik-zz-klik-zz-klik went the motorwind Nikons, taking as many frames a second as a pioneering movie camera. Ducks waddled from the fountain, across the carpet and into the elevator. The place erupted with applause.

Later on we watched the sunset from the hotel roof. Beneath us, downtown Memphis fronted the vast meanders of the Mississippi. Once it had been a busy inland port, at the hub of the cotton industry. Now it had a strange administrative emptiness. Across the river, the flat farmlands of Arkansas stretched westwards.

'How did Adolphe die?' I asked.

The two men looked at each other for an answer. The occasional drowsy quack broke the silence. The ducks were settling down for the night in a nearby enclosure.

'We were always told it was a hunting accident,' Billy said at last.

'Ask Julie,' said Chick. 'She knows.'

Lizzie smiled from the gilt frame with such intensity that I felt it was for me. But she was smiling at Le Prince who was painting her. The small, Impressionistic portrait, painted in 1880, overflowed with their love. It was painted in the golden Leeds days, long before tragedy overtook her life.

Today her image hung from the panelled wall of a Memphis living room, surrounded by the stuffed ducks of every imaginable variety which Julie's son, Lester, had bagged on his numerous hunting trips. Even the telephone was a duck. Lester's small armoury of rifles and shotguns was displayed in a glass cabinet.

'I think we've got ducks in the family,' Julie said. 'My father used to go duck-shooting a lot with his brothers at Point O' Woods. Lizzie got heartily sick of ducks in the end. In winter, the whole cellar would be hung with them, frozen stiff.'

I asked about Adolphe. 'He died before I was born,' Julie said. 'Lizzie never got over it.'

'How did he die?'

She seemed to withdraw from my question. Her manner was suddenly more formal.

'It's one of those things that's hard to tell. My grandmother thought that they had shot him. They didn't like how he'd spoken up for his father's camera at the trial. He knew too much.' She paused before qualifying the veiled allegation. 'Either that or a hunting accident. They found him one day with his gun at his side.'

In the late summer of 1901, Adolphe Le Prince's world fell apart. Nearly

half of his short life had been spent searching for his father and fighting to get recognition for his achievement. He was guided in this by an almost reverential sense of loyalty to Le Prince and fired by the conviction that he'd been 'put away' for his invention. Now, finally, every avenue had been explored and injustice had prevailed.

One afternoon, as so often before, Adolphe went out shooting on his own. He was usually very careful with firearms, ensuring that the safety catch was on except when he was actually shooting. For some reason, that day was an exception. Or else, when he tripped on the tufted grasses at the top of a dune and tumbled down into the hollow, his thumb somehow released the safety catch as he fell, and his gun twisted round and went off. Later that day he was found, crumpled, bloody, and dead.

Or, one afternoon, as so often before, Adolphe went out shooting on his own. He was a familiar sight and would have attracted no attention. But if anyone had been watching him carefully that day, they might have noticed a careless stumble in his walk, and overheard the strange mutterings of a young man stunned by the disintegration of his image of his father. 'Silly. Damned silly. Stubborn. Too damned perfectionist. Should've shown it as it was. Didn't betray him. He betrayed me. The coward. The coward.'

Once out of sight of the house, Adolphe put the gun to his head and blew his brains out. He fell into a hollow where blood flowed into dry sand. Above him, the wind whined in the dune grasses. The ocean thundered beyond.

Why did Adolphe die? Murder? Accident? His devastated reaction to the grossness of the verdict, to ten years of struggle come to nothing? Or perhaps what it took him to pull the trigger was the pain of acknowledging Le Prince's failure.

One night, about a year after Adolphe's death in the Point O' Woods sand dunes, Bart Hulso of the Point O' Woods life-saving station on the Great South Beach was doing his midnight patrol when he was startled to hear a voice from the top of one of the dunes. 'Hurry along!' it intoned. 'There are evil spirits abroad!' Then the silhouette of a figure of a man rose up. He was carrying a shotgun.

The terrified Hulso doubled back to the life-saving station and woke up his colleagues. Within twenty minutes a small group had returned to the spot. The man was still there, issuing the same strange warnings and threatening with the gun. It didn't take them long to overpower him. They recognized him immediately. He was Fernand Le Prince, Adolphe's younger brother, who had been supervising the building of a new wing to Lizzie's summer home.

A few days later Marie spoke to a *New York Times* reporter. 'My brother Fernand was brought back from Point O'Woods the other day. He was ill. Tonight he is seriously ill and in the charge of a doctor.'

The reporter lost no opportunity in exploiting the bizarre episode. 'About a year ago a member of the Le Prince family was found dead at Point O'Woods,' he wrote. 'He was said to have committed suicide. Mrs Le Prince is a painter of note. Years ago her husband disappeared mysteriously, it is said.'

Early in December 1930, Marie Le Prince bade her farewells to Frederick Mason, E. K. Scott and all the others who had contributed to the unveiling of the plaque in memory of Le Prince. She left Leeds feeling a great weight had lifted from her. It wasn't just that the city had honoured Le Prince's achievement, meaning that for the first time anywhere in the world one of the key pioneers of moving pictures, her father, had been recognized. The visit had been a kind of spiritual reckoning for her. She had stayed up at Roundhay, in her grandfather's house, where she had been born sixty years earlier. She had walked in the garden where nearly half a century earlier Le Prince had first tested his moving-picture camera on Adolphe, as he played the melodeon and danced with his grandpa and grandma. Now the house belonged to someone else, but sitting in the old summerhouse, looking through a cracked pane on to the wintry lawn, she felt a great release.

Somehow the tragedy had gone beyond her. It was as if the ghosts of those distant events, of her father and Adolphe, who had been ensnared in the family grief for decades, had suddenly been liberated. The simple act of unveiling the plaque had freed them all, living and dead, from the unresolved pain of their bereavement. Even Lizzie, who had died four years earlier, still unpublished and unheard, could now rest in peace. It was over. [Plate XXIII]

From Leeds Marie travelled to London, where she made arrangements for the Science Museum to receive her father's cameras and spoke to the Royal Society. Then she continued on to France, to pay final homage to the land of Le Prince's birth. News of the unveiling had travelled fast. In Paris she gave several newspaper interviews. In Metz, where Le Prince was born, she was guest of honour at another celebration.

Whilst in Paris, Marie met the French film historian, Georges Potonniée, who was preparing a talk on Le Prince for the French Photographic Society. She gave him a selection of documents and photographs on which to base his conclusions.

At the talk, which Marie attended, Potonniée came up with the

familiar disappearance story. 'In spite of exhaustive enquiries, the mystery has remained unsolved. An absolute silence hangs over Le Prince. He loved his wife and children dearly. He had succeeded. His inventions, which were so dear to him, necessitated his return to England. He had no reason to disappear.'

But being a thorough historian, Potonniée had cast his net wider than Marie's single viewpoint. While talking with the descendants of Le Prince's brother, Albert, about the inventor's fateful last days, an entirely different picture emerged. In the margin of his preparatory notes Potonniée scribbled the following bombshell:*

> *Confidential* opinion of a great nephew of Augustin Le Prince, grandson of his elder brother who was architect at Dijon and who last saw Le Prince on September 16th, 1890: 'In 1890, Augustin Le Prince was on the brink of ruin. His brother was convinced that the inventor committed suicide having taken all the necessary steps not to be found.'

Potonniée clearly thought better than to include this version of events in his talk. To have done so in front of Marie would have been deeply insensitive. Besides, the evening was about Le Prince's achievements, not his failings.

We shall never know whether somewhere deep inside Marie feared this possibility. Lizzie was certainly aware of her husband's financial straits, as indicated by her repeated references to money shortages in her memoirs. But, as Chick had implied, the energy with which she denied that money had anything to do with Le Prince's disappearance merely drew more attention to it as a possibility.

Adolphe is more likely to have glimpsed the spectre of Le Prince's ultimate failure. He bore witness to the extended period of experiments and the tightening financial reality. He was familiar with his father's infuriating perfectionism. It seems likely that when the verdict on Equity 6928 was given in favour of Edison, he was faced with the overwhelming probability that Le Prince had been defeated by the unrealizable standards that he had set himself for moving pictures. He had played Pygmalion and failed. In that scenario, the unbearable disgrace of not succeeding would have seemed to Adolphe to have been just as likely a motive for Le Prince's disappearance as an unsubstantiable kidnapping or murder.

Because the fact was that, in spite of the power of Lizzie's veiled allegations and Adolphe's conviction that foul play was involved, my enquiries never turned up a shred of evidence to suggest that Edison, or

anyone else, had anything to do with Le Prince's disappearance. There was no smoking gun.

But while Edison was not proved the agent of kidnapping or murder, the morality which underpinned both the myth of the Wizard and the long-perpetrated lie that he was the first and sole inventor of moving pictures had been revealed to me as ruthlessly corrupt. Not that Edison was alone in resorting to lying, intimidation and dubious business practice when it came to asserting his power. As much then as now it was the unwritten law of capitalism.

I was unable to broach the suicide theory with Julie. To avoid discussing it, she launched into a string of anecdotes. I heard how outraged Lizzie had been when she had once danced unwittingly with a grandson of Edison at a Point O' Woods yacht club ball. And how Lizzie had done her best to prevent the marriage of her father, Joseph Le Prince, to her Cuban mother, going so far as to pay the fare of a former society girlfriend of his to Havana to interrupt a courtship of which she strongly disapproved. And how she loved English fruitcake, home-made, and gardening and marmalade.

Later that evening Billy and Chick showed me the telegram, as they'd promised. It had been sent by John Whitley in London to Lizzie in New York, in November 1890, two months after the disappearance.

Billy read it out to me. ' "Albert says Gus knows one thousand pounds due him from Boulabert estate some day. Even if you came you could do no more than we are doing." You can't get much clearer than that,' he said, passing it to me. 'Money was no problem.'

I stared at the handwriting of the Western Union clerk, milking the brief words for meaning. John had used the phrase 'Gus knows', present tense, so they had assumed that Le Prince was still alive.

Chick took the telegram from me. 'Can't get much clearer?' he said to Billy quizzically. 'Listen to this.'

He reread the telegram to both of us with a different emphasis. ' "Albert says Gus knows one thousand pounds due him from Boulabert estate *some day*." '

'And?' Billy said.

'Can't you see it? The words "some day" mean that he didn't get hold of the money on that visit to Dijon.'

I took the telegram back. Chick was right. The tone of the message declared the question which had prompted it. Sick with anxiety, only too aware of Le Prince's mounting money crisis, Lizzie had wired her brother the true nature of her doubts. 'Could Augustin's disappearance have anything to do with his debts?' she would have asked. In this light,

John's answer would have meant, 'Why should he want to engineer his own disappearance if he knew that he would be getting his legacy some day?'

What Lizzie could never accept, and what destroyed Adolphe, was the knowledge that the elusive 'some day' was too late.

'We put notices in the French and English newspapers,' Lizzie wrote. ' "Urgent. Will Augustin Le Prince, last seen at Dijon boarding the train for Paris, please contact his family?" But no one ever answered.'

One afternoon, when I had tired of tracking Edison through the newspaper reports of the Paris Great Exhibition of 1889, I wound idly on through *Le Temps* microfilm to September 1890 to see if I could find her message in the *Correspondances Personnelles*.

The front page was full of the exploits of 'Jack *L'Eventreur*' in Whitechapel. I knew about Ripper paranoia from my years of living in Leeds, and it was uncanny to come across his namesake at the time of Le Prince's disappearance.

As I wondered whether Le Prince might have been the crazed killer, my eyes caught his name at the bottom of the page. I was disappointed immediately. The article began with *'Le prince et la princesse Waldemar de Danemark . . .'*

I never found Lizzie's message in the *Correspondances*. But as I hunted, it occurred to me that Le Prince himself might have left or been left a message by or for someone else.

For several hours I tripped through a baffling labyrinth of love and crisis. One impenetrable code read '35 Dpnnf kf wpvcabjs fusf qsft ev mju q.n'. Another, 'Wag I have myself sticked with so much gum.' A third begged a lover for a meeting. 'Maud. *Venez a 4h conv port Mareng j.v. suppl.'*

A fourth was more promising. 'L.A.,' it began, in letters that could have stood for Louis Augustin, *'partir de dim mat à t seul mes pens'*. But even if this was some secret assignation involving Le Prince, I was none the wiser.

So he vanished. Erased all traces of a life. Began anew, somewhere else, someone else. Headed south for Marseilles instead of north to Paris. Took a boat to North Africa. Satisfied his wanderlust. Finally embraced the life of prolonged absence from his family, leaving them to fester on memories.

So he vanished. Arrived late at night in Paris, checkmated, nowhere to turn, in the depths of depression, could not face the Wilsons, walked Pissarro's dark boulevards, found his way to the Seine where he hurled

himself from a bridge, fractured his skull on the stonework, floated bleeding in the water which twenty years earlier had been stained red with the blood of slaughtered communards, drowned in minutes, drifted unseen through the night down the Impressionist river, past Seurat's *Grande Jatte* towards Renoir's Argenteuil. All the while slowly sinking.

Or was grabbed from behind, robbed and murdered in some dark Parisian alley.

I have waited for him at Monet's Gare Saint Lazare. I was at the wrong station, but I hoped that somehow I might glimpse him in the brew of early morning mist, steam and coal smoke which held up the latticed steelwork of the shed. I hoped that somewhere among the fleeting fig-ures on the platform I would spot his familiar gait, but the closer I looked, the more they became broken brushstrokes. I returned several times, later in the day, as Monet had done, at noon, mid-afternoon and evening, but my man never showed up. So I left the mélange of slamming doors, clanking piston rods, shouting guards and took the night train to London.

Back in Leeds, Joseph Whitley awaited Le Prince's return. His condition had worsened since the summer. The frustrated and forgetful energies of his old age had been crippled by a stroke. He could now scarcely speak and his right side had become virtually useless.

They were booked to sail on the SS *Etruria*, leaving Liverpool for New York on 26th October, 1890. When by early October there was still no word from Le Prince, the old man began to worry. Who would accom-pany him if not Augustin?

'Don't worry,' Richard Wilson told him. 'He's probably been held up on business. He told us that he'd arranged to take moving pictures of the Paris Opéra. Perhaps it's that.'

'But I've my affairs to be seen to,' Whitley conveyed with great effort. He had hoped for Le Prince's support in planning the future of his foundry.

On 10th October, with still no sign of Le Prince, Whitley signed away his life's work. Power of attorney over the firm went not to John Whitley, whose disastrous handling of it fifteen years earlier still pre-cluded his having anything to do with it, but to Whitley's trusty mana-ger, Henry Horsman. Signing his name required supreme effort. The pen sputtered the semblance of his name.

A fortnight later Whitley sailed for New York in the care of a cousin. It was the end of an epoch.

A few months later, when Lizzie had little choice but to accept that Le

Prince had disappeared, she instructed Richard Wilson to wind up his affairs in Leeds.

The loyalty of a friend and fellow mason prevented Wilson from ever speculating too deeply about the precise nature of Le Prince's disappearance. The only indication of what he might have thought lies in a remark made much later by his wife who said that Le Prince 'may have suffered a disappointment'.

But the thoroughness he brought to disposing of Le Prince's property suggests that the banker was by this time privy to the full extent of his friend's debts.

What there was of Le Prince's property lay in the workshop on Woodhouse Lane. While Wilson knew what Le Prince was doing, he was ignorant of the technical details of his work and unaware of its true value. When he opened the door of the workshop his untrained eye saw merely the detritus of the *bricoleur* – the half-dismantled, many times modified, enigmatic bits and pieces which were the mechanical grammar of Le Prince's evolving dream.

With half an eye to posterity, Wilson kept the more complete-looking bits. One of these was the single-lens camera, packed and ready for shipping to New York. Other objects included the remnant of the sixteen-lens camera and what Mason later termed 'parts of the projector'. Conspicuously absent from what Wilson retained was a complete projector, which suggests that there was no projector crated up, ready for the début showing in New York. If Mason's inference is to be followed, it lay 'in parts', lending weight to the view that Le Prince had still not solved the problem of projection to his satisfaction, and was not prepared to go public with his invention.

'I took possession of all his effects,' Wilson said later. 'I disposed of some by sale including the unused and unspoilt materials connected with the working of his invention.'

What he disposed of, in ignorance, was the stuff of history, the half-completed jigsaw of Le Prince's achievement.

'I picked up a few relics,' Mason testified in 1931, 'and am sorry now that I did not secure some exposed films and the drawings, as unfortunately nothing was done to preserve them. That they might have had historical significance was not appreciated.'

In March 1902, the circuit judges reversed the verdict on Equity 6928, on appeal.

It is obvious that Mr Edison was not a pioneer, in the large sense of the term, or in the more limited sense in which he would have

been if he had also invented the film. He was not the first inventor of apparatus capable of producing suitable negatives, taken from practically a single point of view, in single line sequence, upon a film . . . neither was he the first inventor of apparatus capable of producing suitable negatives, and embodying means for passing a sensitised surface across a single lens camera at a high rate of speed, and with an intermittent motion, and for exposing successive portions of the surfaces during the periods of rest. His claim for such an apparatus was rejected by the patent office, and he acquiesced in its rejection.*

This judgement was of little comfort to Lizzie. The judge gave the credit for the single-lens camera to Marey. His summary of Le Prince's work was dismissive, and when it came to the single-lens camera, the weakness of Le Prince's patent again proved to be his Achilles' heel. In the absence of single-lens specifications the judge could only base his conclusions on Le Prince's sixteen-lens details.

> The suggestion that one lens be employed, implying, of course, the use of single film, is quite enigmatical, and would seem to be impracticable, without altering the principle of his apparatus. The problem of dispensing with the other lenses would also involve changing the mechanism so as to secure rapid movement of the film . . .*

Even AMC's victory was short-lived. For the next six years Thomas A. Edison and the Dyers continued their fight to put their chief rival, and numerous smaller rivals, out of business, with the aim of securing absolute control of the moving-picture industry. They failed ultimately, but not before bringing the industry to its knees. The outcome, which brings us once again to the steps of Edison's laboratory in December 1908, was a merging of interests in the Motion Picture Patents Company, Frank Dyer's brainchild, which, while sharing the business through the pooling of patents, in the eyes of the world gave the invention of moving pictures the virtually indelible stamp of Thomas A. Edison.

This was also the year that the daguerreotype of Le Prince survived the fog-bound collision in New York harbour, when, gazing at the stained image of her husband while recovering from her near-fatal accident, Lizzie reflected that 'law' and 'justice' were not synonymous and vowed that the world would one day know the truth through her memoirs.

ENDPIECE

Lizzie spent the last months of her life in Memphis, in the care of her son Joseph and his family. Joseph Le Prince was by this time a colonel in the US Army. A life-long affair with the mosquito had brought him to the cotton-belt, where he continued his fight against yellow fever.

Lizzie died in Memphis in 1926. Marie was there at the end. The body accompanied her back to New York on the train. They buried her in the family plot, next to Joseph Whitley and Adolphe.

A few years later, around the time that Marie visited Leeds to speak at the unveiling of the plaque honouring Le Prince, a newsreel crew paid one of many birthday visits to Thomas Edison at Glenmont, his West Orange mansion.

They filmed him in his garden. George Eastman was also present. The idea was to show the inventor of film alongside the inventor of the moving-picture camera. The set-up involved asking Edison to wind the crank of a movie camera while Eastman held up a strip of film. It was an early talkie.

When the director said 'Action', the white-haired old men beamed at the camera. When the director made a little circling movement with his hand, Edison started winding the crank for all he was worth. Then he paused and said solemnly, 'In the late 1880s I invented the motion-picture camera. Fire has destroyed the early models, but it was my work which made motion pictures a success.'

It's been ten years since I first went down to the Leeds Reference Library on the trail of a story which I thought might save my house. We start shooting next month, with a bit of luck – on film, of course, using two up-to-the-minute 16mm Aaton cameras. The character of Le Prince, by the way, is a non-speaking part. I wouldn't want to go putting words into his mouth.

May, 1989
London

CHRONOLOGY

1841	28th August. Louis Aimé Augustin Le Prince born in Metz.
1844	Whitley Partners, brassfounders, established in Leeds.
1845	4th January. Sarah Elizabeth Whitley born in Leeds.
1847	Thomas Alva Edison born.
1855–65	Le Prince attends various schools in Bruges and Paris, then studies chemistry, mathematics and German at the Universities of Bonn and Leipzig.
1866	Le Prince meets John Whitley in Paris, visits Leeds, meets Lizzie and becomes a partner at Whitley Partners, where he works as a translator and draughtsman.
1867	Le Prince represents Whitley Partners at the Exposition Universelle in Paris.
1869	Le Prince marries Lizzie Whitley.
1870	Le Prince returns to France, enlists in National Guard, endures the Siege of Paris during the Franco-Prussian War.
1871	Le Prince returns to Leeds and resumes work with Whitley Partners. Marie Le Prince born.
1872	Adolphe Le Prince born. Edison invents duplex and quadruplex telegraph. Muybridge makes first experiments with motion photography.
1875	Aimée Le Prince born. Lizzie and Le Prince exhibit paintings and ceramics at the Yorkshire Exhibition. Le Prince leaves Whitley Partners, which goes into liquidation.
1876	Joseph Le Prince born.
1876–7	Le Prince and Lizzie found the Leeds Technical School of Art.
1877	Muybridge photographs Stanford's trotter, Occident, in motion at Palo Alto, and publishes the results. Edison improves Bell's telephone and invents the phonograph.
1878	Fernand Le Prince born.
1879	Edison perfects incandescent lamp.
1877–81	Le Prince teaches art, teaches himself photography, perfects various ceramic processes, visits Paris frequently.

1881 Le Prince visits the United States with John Whitley to explore commercial potential of Lincrusta–Walton process, a form of decorative linoleum.

1882 The Le Prince family emigrates to New York. Le Prince enters Lincrusta partnership.

Marey invents photographic gun.

1882–3 Muybridge lectures across north-east America.

1883–4 Lincrusta-Walton business fails. Le Prince and Lizzie set up their own interior decoration firm, Le Prince & Pepper.

Lizzie begins art teaching at the Manhattan Institute for the Deaf.

Edison illuminates New York.

1885 Le Prince becomes manager of Poilpot's panorama company.

Eastman's paper roll-film becomes commercially available.

Le Prince begins his first moving-picture experiments.

1886 More panorama work. In November Le Prince applies for a US patent for the production of animated pictures.

1887 April. Le Prince returns to Leeds from New York.

Muybridge publishes *Animals in Motion*.

May/June. Le Prince goes to Paris to be with his sick mother and constructs the sixteen-lens camera.

Summer. Le Prince returns to Leeds and constructs the small sixteen-lens projector and a stereo viewing device.

Lizzie visits Leeds from New York, with the children. Adolphe remains in Leeds to assist Le Prince.

1888 January. US patent granted to Le Prince. He applies for French and British patents.

February. Le Prince applies for Belgian, Italian and Austro-Hungarian patents.

Le Prince begins work on large sixteen-lens projector – the big deliverer.

February. Muybridge and Edison discuss moving pictures.

March. Le Prince starts work on single-lens camera.

Summer. Lizzie spends the vacation in Leeds again, returning to New York in September.

10th October. Le Prince sends complete patent specification to British Patent Office. It includes the single-lens clause.

14th October. Trial of the single-lens camera in Joseph Whitley's garden.

24th October. Mrs Whitley dies.

Marey constructs a single-lens moving-picture camera.

Edison files his first moving-picture caveat.

7th November. John Carbutt announces his celluloid-based film in Philadelphia.

Le Prince becomes a United States citizen.

1889 Summer. Le Prince experiments with a single-lens projector.

Single-lens camera trial on Leeds Bridge.

July. Dickson begins work on Edison's moving-picture idea. Friese-Greene applies for a British patent for moving-picture apparatus.

August. Edison is fêted at Exposition Universelle in Paris and sees Marey's latest camera.

September. Adolphe returns to New York.

October. Le Prince acquires sensitized celluloid sheets which he makes up into rolls.

November. Muybridge shows his zoopraxiscope in Leeds.

Le Prince continues with projection experiments.

Lizzie moves into the Jumel Mansion in New York, which she begins renovating as a venue for the début of Le Prince's moving pictures.

1890 February. Friese-Greene publicizes his moving-picture apparatus.

March. Le Prince begins work on a three-lens projector. Le Prince's celluloid proves unsatisfactory so he reverts to using glass and gelatine as a film base.

April/May. Le Prince encounters problems with three-lens projector.

June. Le Prince successfully demonstrates one of his projectors to the Secretary of the Opéra National in Paris.

September. Le Prince takes a vacation in France with the Wilsons and visits his brother in Dijon.

16th September. Le Prince's brother sees him on to the Paris train at Dijon.

October/November. Lizzie realizes that Le Prince is missing. The search begins.

1891 January. Joseph Whitley dies in New York.

24th August. Edison applies for three patents for moving-picture apparatus.

1894 Raff & Gammon open the first kinetoscope parlour in New York.

1895 December. Lumières Brothers give world's first showing of projected moving pictures before paying audience in Paris.

1896 Bioscope and vitascope.

1897 The War of the Patents begins.

1898 December. Adolphe Le Prince testifies in Equity 6928.

1899 American Mutoscope Company constructs a three-lens camera based on Le Prince's patent.

1901 July. The verdict of Equity 6928 pronounces Edison to be the first and sole inventor of the moving-picture camera.

Adolphe is found shot dead on Fire Island.

1902 Equity 6928 verdict reversed on appeal. The judge declares that Edison is not the inventor of moving pictures.

1902–8 The War of the Patents rages on.

1908 The formation of the Motion Picture Patents Company brings the Patent War to an end. Edison is acknowledged to be the inventor of moving pictures.

Lizzie is shipwrecked in New York harbour.

1908–26 Lizzie writes her memoirs, which remain unfinished.

1926 Lizzie dies in Memphis, Tennessee.

1930 Marie unveils a plaque in Leeds commemorating Le Prince's achievement.

1931 Edison dies.

1988 William Le Prince Huettel unveils a plaque honouring Le Prince on Leeds Bridge.

FURTHER READING

MOVING PICTURES – GENERAL

Barnes, John. *The Beginnings of the Cinema in England* (London, David & Charles, 1976). The first of a detailed three-volume history, followed by *The Rise of the Cinema in Great Britain* (Newton Abbot, Bishopsgate Press, 1983) and *Pioneers of the British Film* (Newton Abbot, Bishopsgate Press, 1988). A Robert Paul and Birt Acres fan.

Chanan, Michael. *The Dream that Kicks* (London, Routledge & Kegan Paul, 1980). A braiding of all the strands, including patent history, music hall and theories of perception, which made up the prehistory and early years of cinema in Britain. A Friese-Greene fan.

Coe, Brian. *The History of Movie Photography* (Ash & Grant, 1981).

Fielding, Raymond (ed.). *A Technical History of Moving Pictures* (University of California Press, 1967). A useful collection of articles from the *Journal of the Society of Motion Picture and Television Engineers*.

Jenkins, C. Francis. *Animated Pictures* (Washington DC, 1898). A very early history, interesting because of its closeness to the events in question.

Liesegang, F. S. *Dates and Sources – A Chronology of Pre-Cinema History* (London, Magic Lantern Society of Great Britain, 1986). Full of images and information.

Ramsaye, Terry. *A Million and One Nights* (New York, Simon & Schuster, 1926). A dazzling voyage through the first forty years of cinema by an Edison fan. This is still the standard work on the period, but it is frequently unreliable.

Sadoul, Georges. *Histoire Générale du Cinéma* (6 Vols., Paris, Denoël, 1975). The definitive history, from a Marxist. No English translation yet.

Spehr, Paul. *The Movies Begin* (The Newark Museum/Morgan and Morgan, 1977). A history of the early movie days in New Jersey, focusing on the Edison Company.

Talbot, Frederick. *Moving Pictures* (Heinemann, 1923).

Wyver, John. *The Moving Image* (London and Oxford, BFI and Blackwell, 1989). Embraces the full sweep, so far, from panorama to film, through television and into the digital beyond. A useful contemporary overview.

MOVING PICTURES – PARTICULAR

Barnouw, Erik. *The Magician and the Cinema* (Oxford University Press, 1981). An account of the magical precursors of moving pictures.

Coe, Brian. 'William Friese-Greene and the Origins of Kinematography' (*Photographic Journal*, March/April 1962).

Hendricks, Gordon. *Eadweard Muybridge – The Father of the Motion Picture* (London, Secker & Warburg, 1975). Good narrative history.

Hendricks, Gordon. *The Edison Motion Picture Myth* (University of California Press, 1961). Ground-breaking, thorough detective work on much original material. Hendricks is a Dickson fan. Not a scintillating read, but a model of responsible method. This history of the first years of moving pictures in the USA continues with *The Kinetoscope* (1964) and *The Beginnings of the Biograph* (1966), under the generic title *The Beginnings of the American Film*.

Hyde, Ralph. *Panoramania! The Art and Entertainment of the 'All Embracing' View* (London, Trefoil Publications with Barbican Art Gallery, 1988). Richly illustrated exhibition catalogue, charting the evolution of the panorama.

Kerr, Page & Cooper. *Appellant's Brief* (US Circuit Court of Appeals. In Equity No. 6928, 1902). When in doubt, go to the lawyers. This is one of numerous briefs, from both sides, which made up the epic Equity 6928. It is a version of early cinema history, necessarily partisan, since it is, literally, arguing a case. But because fortunes ride on it, it is more thoroughly researched and dynamically written than most academic studies. For balance, read the Edison lawyers' briefs as well. These are all available in the Edison Archive at West Orange, New Jersey.

Robert-Houdin. *Robert-Houdin*. (1859). An autobiography of the great illusionist.

EDISON

Conot, Robert. *A Streak of Luck*. (Repr Da Capo, 1979). Complementary to Josephson's *Thomas Edison* (see below).

Dyer, F. L., and Martin, T. C. *Edison. His Life and Inventions* (2 Vols., New York, Harper & Row, 1910). The official version, overseen by Frank Dyer but written by others. Biased and boring.

Josephson, Matthew. *Thomas Edison* (New York, McGraw-Hill, 1959). Well-written, if occasionally unreliable, biography of Edison by the author of *The Robber Barons*. Also a useful background read.

Wachhost, Wyn. *Thomas Alva Edison, an American Myth* (Massachusetts, MIT Press, 1982). Thorough dissection of the evolution of the Edison myth, based on an analysis of all that was ever published and said about him.

The Edison Papers. Volume I. First of the ambitious Rutgers project on Edison which aims to publish ten per cent of the three and a half million Edison documents which have lain virtually uncatalogued at West Orange since his death in 1931. The project will eventually provide the basis for a complete reassessment of the man and his work.

LE PRINCE

Crawford, Merritt. 'A Mystery of the Motion Picture's Beginnings – Louis Aimé Augustin Le Prince.' (*Cinema*, December 1930)

Le Prince, Adolphe. 'Missing Pages in the History of Moving Pictures.' Unpublished article.

Le Prince, Sarah Elizabeth. *The Life Story of Augustin Le Prince, Inventor of Moving Pictures*. Unpublished manuscript.

Potonniée, Georges. 'La Vie et Les Travaux de Le Prince' (Paris, *Bulletin de Photographie*, 1931 No. 4).

Scott, E. K. 'The Career of L. A. A. Le Prince (*Journal of the SMPE*, Vol. 17, 1931). The fullest account of Le Prince's work, until now.

'Un Précurseur Oublié. L. A. Augustin Le Prince. Son Oeuvre et Son Destin' (Afitec, 1968). Unsigned article.

MISCELLANEOUS

Fraser, Derek (ed.). *A History of Modern Leeds* (Manchester University Press, 1980). Essays on nineteenth-century Leeds.

NOTES

I have not indicated the source of every fact asserted in this story. To have done so would have made for an impenetrable labyrinth of reference and cross reference. But below are my principle sources for given areas of the work. The notes to the text refer to further important sources and take up matters of particular interest. (Some of the principle source references will appear abbreviated in the notes as in the brackets below.)

My main sources on Le Prince were: Lizzie Le Prince's unpublished memoirs – *Missing Chapters in the History of Moving Pictures* – the original of which is in the possession of Julia Le Prince Graves in Memphis, Tennessee (*Memoirs*); the memoirs also included Adolphe Le Prince's 'Missing Pages in the History of Moving Pictures', a useful and again unpublished account of Le Prince's life and work written in 1899 ('Missing Pages'); also in Memphis, in addition to numerous photographs, is a box containing a large number of original Le Prince letters, patents, bills, drawings and so on, upon which Lizzie's *Memoirs* were based (Le Prince papers).

The Merritt Crawford Archive in the Museum of Modern Art Film Study Center contains notes and reminiscences from Marie Le Prince, written in 1930, for Crawford's subsequent article about Le Prince. There are also reminiscences from other witnesses of Le Prince's work, including the electrician, Walter Gee (Merritt Crawford Archive).

E. K. Scott's short pieces on Le Prince were the invaluable starting point for all my sleuthing. All are available in Leeds Reference Library (see Further Reading).

Where public events are described, they can be traced in the relevant newspapers on the appropriate dates.

For the broad sweep of Edison's life I have drawn on Matthew Josephson and Robert Conot's biographies (see Further Reading). For Edison's moving picture work I have taken the far more rigorous approach of Gordon Hendricks in *The Edison Motion Picture Myth* as my starting point (Hendricks, *Edison*).

The patent wars remain largely unresearched to this day. Terry Ramsaye was one of the first film historians to delve into the many reams of legal documents for his *A Million and One Nights*, written in 1926 (Ramsaye). Gordon Hendricks explored the terrain rather more thoroughly thirty years later (see above), as I did twenty years after that. Doubtless there have been others. The records are to be found in the Federal Archive at Bayonne, New Jersey and in the Edison Archive at West Orange, New Jersey (Edison Archive). They comprise letters, briefs and, above all, page after page of testimony. Equity 6928, the main but by no means the only lawsuit, runs to two thousand pages (Equity 6928). The patent wars also consisted of numerous other lawsuits.

The George Kleine Papers in the Library of Congress, Washington DC, are a useful complement to the official testimony of the patent wars. Kleine, a prominent film distributor in the early years of the century, often found himself embroiled in litigation against Edison. Numerous letters and other documents chart Kleine's part in the patent wars, his fight against Edison and the eventual consolidation of opposing interests in the Motion Picture Patents Company (Kleine).

The industry's journal, *Moving Picture News*, also charts these developments in

detail, but more from Edison's standpoint (*Moving Picture News*).

A recent and thorough exploration of this turbulent period of moving picture history has been made by Thomas R. Gunning in his 1986 doctoral thesis for the Department of Cinema Studies, New York University – 'D. W. Griffth and the narrator-system: narrative structure and industry organisation in biograph films, 1908–1909 (Gunning).

My principle sources for Joseph Whitley and his Leeds brass foundry were: two boxes of unsorted legal papers in Leeds City Archive, Sheepscar, one of which contained the writ served on Le Prince in 1888 (Whitley papers); a company letter book and a diary in Whitley's own hand, made available to me by Peter Kelly of Leeds Industrial Museum, which chart the ups and downs of the Whitley business in glorious detail from the late 1870s to the mid–1880s (Whitley letterbook and Whitley daybook); a sheaf of letters and company balance sheets belonging to the grand-daughter of Whitley's last manager, Henry Horsman (Horsman papers); various letters and documents among the Le Prince papers, Memphis.

The ambience of Leeds Philosophical and Literary Society can be found in the Leeds newspapers which reported the annual conversaziones with great relish. The Society's library and collection is now part of the Brotherton Library, University of Leeds.

For details of who was living where and when in Leeds, I went to the 1861/71/81 censuses and the annual town directories, available in Leeds Reference Library. I did the same for New York at the New York Historical Society.

For details of Le Prince's US patent application, I obtained a copy of the file wrapper from the US Patent Office. This contained all the correspondence that ensued between Le Prince, his agents and the patent office prior to the granting of his patent. The US Patent Office also supplied me with the detailed documentation of Interference 18,541, between Herman Casler (AMC) and Edison (US Patent Office).

NOTES TO THE TEXT

3 Le Prince's daughter, Marie, gave details of Le Prince's departure from Dijon to the film historian Merritt Crawford for an article he was writing on Le Prince (see Further Reading). Her sheet of notes survives in the Merritt Crawford Archive.

8 I am indebted to the initiative of Alexandra Ehrmann for making this call.

12 Among the Le Prince papers in Memphis is a document certifying that Ferdinand Mobisson, Secretary of the National Opera in Paris, had ordered a complete study of Le Prince's 'Methode d'appareil pour la projection des tableaux animés, en vue de son adaptation aux spectacles de l'Opéra'. It was signed on 20 March 1890 and approved by Le Prefet de la Seine on 16 June. This kind of examination was a requirement of the French patent application process. The opera connections are a clear indication of the applications Le Prince had in mind for his invention.

14 The unveiling ceremony was well covered by the *Leeds Times* and *Leeds Mercury*, 12 December 1930.

16 This was not a roll of celluloid film, but a roll of spliced 4″×12″ celluloid strips which Le Prince appears to have assembled for film processing purposes. The dimensions of the strips suggest that they were cut from 12″ square celluloid sheets. The existence of this roll, if authentic, is further confirmation that Le Prince used celluloid. It is in the Science Museum, London.

† Marie's recollection appears in several places, with slight variations: *Yorkshire Evening Post*, 12 December 1930 and in Merritt Crawford's article about Le Prince in *Cinema*, December 1930.

17 Frederick Mason signed a declaration of his recollections of Le Prince's work in the presence of the US Vice Consul in Bradford on 21 April 1931. It appeared in full in an article by E. K. Scott in the *Journal of the Society of Motion Picture Engineers*, July 1931 (see Further Reading).

19 Walter Gee gave his recollections of this day to Merritt Crawford in a letter dated 12 January 1931 (Merritt Crawford Archive).

20 See Mason's declaration, note to p. 17.

† See 'Queer Things' (pp. 163ff) for details of these Patent Office wrangles.

21 See 'The Peet Valve' (pp. 92ff) for details of Le Prince's relationship with Whitley Partners. Or dip into the Whitley Boxes in Leeds City Archive.

† Whitley to Lizzie, 10 October 1886 (Le Prince papers).

22 See 'Missing Pages'.

† See Richard Gregory, *Eye and Brain*, Chapter 7 (Weidenfeld and Nicolson, 1966), and Michael Chanan, *The Dream That Kicked*, Chapter 4 (RKP, 1980), for discussions of the persistence of vision.

24 Adolphe Le Prince described this projector in 'Missing Pages': 'He also constructed in 1889 a one lens deliverer. The picture belt was arranged in an endless spiral, the pictures appearing before the lens in rapid succession, and storing automatically as soon as projected and released.'

26 In a memo to Le Prince, 8 August 1889 (Le Prince papers), Longley described a single lens projector he was working on which appears to differ from the 'endless spiral' projector which Le Prince drew and Adolphe described in 'Missing Pages', pp. 24–5:

'Dear Sir, I tried the machine today and the best results that I got was 426 per minute. The chamber I had was 2 feet long and I had a 12 inches rise with 3 pounds weight at the back of the checks. But we shall get much better results by having the weight pulling by a cord as it gives so much friction being placed at the back of the checks. I also had one of my counters fixed to it and every time I tried it I also counted the checks and they was always right with the counter showing that the machine always worked right. But the test was not a fair one as I had to hold the machine and work it. Awaiting yours I remain yours truly J. W. Longley.'

This particular solution to the single lens projector design was probably Longley's conception rather than Le Prince's. That an assistant took this kind of initiative indicates the depth of Longley's involvement with the project. By 'checks' Longley meant individual framed positive images. His use of the word derives from his interest in ticket machines, of which he was an inventor (British patent no. 1623, 1885). Longley's ticket machine technology seems to inform this particular projector solution, in which a stack of individual positives was pushed towards the bottom of a sloping rack by a weight, where they were released ticket-like, one by one, for projection.

In a letter to Adolphe Le Prince, 15 January 1899, Longley described the shortcomings of either this, or more likely Le Prince's, 'endless spiral' single lens projector: 'In regards the one lens deliverer [projector], we made one but it gave *blurs* similar to Edison, Cinematograph, so your father would not have anything more to do with a one lens deliverer, and we got the best results from the three lens deliverer which he considered *perfect*.'

Longley's recollection of Le Prince's enthusiasm for the three lens projector is almost certainly wrong. Le Prince did not consider this machine 'perfect'. See pp. 252ff.

See also p. 218 for the relationship between Longley and Le Prince.

28 I have drawn fairly extensively on Josephson and Conot (see Further Reading)

for the broad sweep of Edison's life. The details of Edison's early moving picture work are intricately and incomparably charted in Gordon Hendricks's *The Edison Motion Picture Myth* and its companion volumes (see Further Reading).

32 See Hendricks, *Edison*, pp. 10–11.

34 The Daguerre dinner was held on 19 August 1889. See Hendricks, *Edison*, pp. 169–72 for discussion of Marey's work and this dinner.

Since Le Prince had met Daguerre when a boy, I had hoped that I might find evidence that he was present at the dinner. But he was not named in the guest lists announced in the newspapers. To have discovered Le Prince, Marey and Edison in one room was perhaps too much to hope for.

36 Tom Maguire was a poet and photographer, as well as a colourful political activist. These events are best described, often by Maguire himself, in the *Yorkshire Factory Times*.

37 Le Prince to Lizzie, 15 July 1889 (*Memoirs*).

38 See Mason's declaration, note to p. 17.

The source of Le Prince's sheet celluloid was possibly that referred to by Will Day in a letter to Merritt Crawford on 12 March 1931: 'You ask for records regarding sheet film [celluloid] available in England. My records show me that at the latter part of 1888, and the beginning of 1889, a Mr Fitch of Fulwood's Rents, Holborn, who died a pauper in Holborn Workhouse, was able to supply sheet film. Where he got this from I have never been able to fully substantiate . . . whether it was Carbutt's film or Blair's film sold by Fitch, I have not been able to get definite information of. I have a small reel of the original film supplied by Fitch which might elucidate the mystery' (Merritt Crawford Archive).

The availability of Carbutt's celluloid in Britain is substantiated in an article in *Photographic News*, 11 November 1888: 'From John Carbutt we have received a package . . . [of] . . . celluloid films coated with emulsion.' On 22 March 1889, the same journal reported that 'celluloid was going into pretty extensive use as a basis of gelatino-bromide emulsion.'

The other manufacturer of celluloid at this time was the Blair Company of St Mary Cray, Kent. Blair could well have been Le Prince's source. Talbot (*Moving Pictures* pp. 28–9) comments: 'Though this film was far from being perfect, showing considerable variation in thickness, it served to assist the experiments in animated photography to a marked degree.'

Eastman's tends to appear much later in connection with celluloid and is therefore unlikely to have been Le Prince's source. On 6 September 1889, *Photographic News* reported 'The Eastman New Transparent Film . . . [its] great flexibility makes it practical to wind as many as one hundred exposures on one spool to be carried in one roll holder.'

See also Hendricks, *Edison*, pp. 38–44, on Carbutt in the United States.

39 Eugene Lauste, a pioneer of sound on film, claimed that he was present in the photographic room at West Orange when Edison returned from Paris to view Dickson's progress on the moving picture idea. In a letter to Will Day, 30 May 1933, he wrote: 'I think the next day or so, after the return of Mr Edison, Mr D wanted to show the possibility of projecting these pictures on the screen, but the difficulty was no projector was made for this purpose, so Mr D decide to use his kinetograph as projector, I was at that time in the photographic room to install a screen for the show, when Mr Edison was near the door, Mr D notice him and then told me to hid myself behind the screen as he do not like that Mr Edison see me here, after a few words between them, Mr D start the machine. Unfortunately the pictures was blur and out of focus, also the film jump from the sprocket for the reason that the positive film could not fit the negative sprocket of the camera, consequently the show was a fail-

ure, and Mr Edison leave the room with dissatisfaction.' (Merritt Crawford Archive.)

Lauste's description of projection and sprockets at West Orange as early as 1889 is almost certainly predated. Hendricks's convincing research suggests 1891 as the earliest possible date for this technology at West Orange (*Edison*), and shows that Dickson was concentrating on the phonograph-derived moving picture technology at the time of Edison's return from Paris. But Lauste's description of Edison's dissatisfaction with what he saw at this time is more convincing.

40 For Muybridge in Leeds, see *Leeds Evening Express*, 28 November 1889. Also C. H. Bothamley, 'Reminiscences', reprinted in *A Technical History of Moving Pictures*, ed. Spottiswood.

41 For the Le Princes and the Jumel Mansion see *Memoirs* p. 41.

42 *Scientific American*, 16 November 1889.

† Le Prince to Lizzie, Christmas 1889 (*Memoirs*).

‡ Le Prince to Lizzie, 15 January 1890 (*Memoirs*).

43 Le Prince to Lizzie, 19 March 1890 (*Memoirs*).

† Le Prince to Lizzie, 11 April 1890 (*Memoirs*).

44 The intensity of this 'true inventor' controversy can be glimpsed in correspondence in the Merritt Crawford Archive. Addressing those who claimed that Marey was the inventor of moving pictures, Will Day wrote to Merritt Crawford on 12 March 1931: '. . . with regard to the radio speech of Mr Grimoin-Sanson, President of the Marey Committee, this is only the usual cackle of a Frenchman, giving honour to their nation to the exclusion of all others. It is a simple question to ask, if Marey produced successful commercial kinematography [Day's criterion], why did his invention not be generally adopted, and why did the world wait until others really invented this science, when it could have been done, according to this gentleman's report, so many years before? The same applies to Le Prince. . . .'

On 6 January 1931, E. K. Scott wrote to Crawford of Will Day's attitude to Le Prince: 'a sort of boycott is being made here against Le Prince by those who have been boosting Friese Greene.'

The controversy also raged on in the pages of *Le Cineopse*, January 1931. In *The History of the Cinematograph*, G. M. Coissac wrote, 'The letter of the upright and intellectual Jules Marey . . . declared Lumière as the inventor of the cinematograph and was the final blow in refutation of all contestations. However, ill-will cannot be stopped any more than thistles can be entirely exterminated. That is why we defend ourselves unrelentlessly in just cause: First, because it is the truth, and, second, because it is a French cause.'

45 Scott listed these Le Prince 'firsts' in *The Pioneer Work of Le Prince in Kinematography*, pp. 28–9, unpublished typescript, 1923; Leeds Reference Library.

47 See Marie Le Prince notes in Merritt Crawford Archive. Also, *A History of Fidelity Lodge*, Leeds, 1894.

48 Mrs Wilson to E. K. Scott, quoted in *Pioneer Work of Le Prince in Kinematography*, 1923.

† The weekend was described in a letter to Marie Le Prince from her cousin Marie, Albert's daughter, 10 November 1890, Le Prince papers. Lizzie refers to the legacy several times in the *Memoirs*.

50 These events are described fully by Lizzie in the *Memoirs*.

52 The landlady's daughter, Mrs Douglas, gave a version of these events to Adolphe in a letter of 6 May 1891 (Le Prince papers).

53 The passenger lists are available in the New York Public Library.

55 Le Prince applied for United States citizenship in 1886.

59 Marie wrote a useful sketch of Lizzie's life in an appreciation printed in the Art Center Bulletin, Vol. IV, No. 5, January 1926, shortly after Lizzie's death.

63 There is a sighting of Lizzie's involvement with Chautauqua in the Chautauquan, October 1891–May 1892, p. 120.

64 See *Memoirs* for this incident.

71 *Moving Picture World*, 21 December 1907.

The columns of *Moving Picture World* paint a vivid, if partisan, picture of the pioneering years of moving pictures in the United States. The George Kleine papers in the Library of Congress, Washington DC, also offer invaluable first hand insights into the rough and tumble of these early days. See also Gunning for detailed discussion of these pioneering years.

74 *Moving Picture World*, 28 March 1908.

75 These events are described, somewhat unreliably, in Ramsaye, chapter 46.

79 See *New York Times* and *New York Herald*, 28–29 November 1908, for detailed reports of the collision. See also *Memoirs*, where Lizzie erroneously gives the date as 1910.

93 See Whitley papers.

105 See Whitley papers.

107 Lizzie and Le Prince had intended to live in the affluent township of Roundhay, north Leeds, close to her parents. In the early 1870s Le Prince failed to secure one of several new plots in the area, the plans of which survive in the Whitley papers. Instead, they moved into a house in Brandon Villas, just off Chapeltown Road.

109 Several examples of Le Prince's miniatures and decorative ceramics are still in the possession of Le Prince's descendants, Francois Auzel in Paris, Billy Huettel and Julia Graves in Memphis, Tennessee.

113 Le Prince's land speculation involved the site of the house I once lived in in Leeds. In spite of the claims of Tom (see p. 4) Le Prince never lived at this house, 16 Sholebroke Avenue. But Le Prince had owned the land upon which it was built. On 18 March 1876, while living at Brandon Villas close by, he bought a large area of building land, including the present site of 16 Sholebroke Avenue. Within a year he had resold it as individual plots. This speculation doubtless helped towards the purchase of 33 Park Square late in 1876, where the Le Princes lived and ran their Technical School of Art until their departure for New York in 1882. (Whitley papers.)

† There is a large gouache portrait of Margaret Perkin by Le Prince, dated 1882, in Wakefield City Art Gallery. In Memphis, Julia Graves has a fine watercolour of Lizzie by Le Prince, dated 1880. She also has several Le Prince copies of 18th-century French painters and some of his ink and wash landscapes.

‡ For details of Leeds Fine Art Club, see *Leeds Graphic*, December 1974, Vol. 25, No. 199.

117 Beulah R. Foster, still visiting Point O' Woods at the age of 88, described these classes to me in a letter of 5 January 1988.

121 Leeds Phil. and Lit. conversaziones were reported fully in the Leeds newspapers every December. Le Prince was also active in the launch of Halifax Phil. and Lit. for which he received a certificate of thanks in 1880.

122 Le Prince's friend Richard Wilson was manager of Brown Brothers bank in Leeds, later Lloyds. Wilson was a collector of furniture and ceramics and bought several items from Le Prince, two of which are in the Leeds City Art Gallery collection.

123 Whitley's letterbooks of 1878 are full of the story of his involvement with the obelisk. Leeds Industrial Museum possesses one of Whitley's model obelisks.

129 Whitley's daybook 1882–85 details this relationship with Samson Fox. (See also 'The Leeds Forge Company Ltd' in *Leeds Sketches and Reviews*, 1905.)

132 See Whitley papers for this correspondence.

134 Among Julie Graves's Le Prince memorabilia in Memphis is an empty leather wallet inscribed Mrs A. Le Prince, New York given by two of her most affectionate admirers, 24 September 1882. Presumably the wallet contained money, a gift from wellwishers to help the Le Princes settle in New York. Its existence suggests that although the Le Princes were not poor at this time they were by no means affluent.

138 'Practical Instructions on Lincrusta-Walton' by Mme. S. E. Le Prince, Society of Decorative Art, New York, 1884.

† Jean was the youngest Le Prince child, who appears to have died in infancy, date unknown.

140 Two great battle panoramas, Gettysberg and Atlanta, survive in the United States at Gettysberg and at Atlanta. They are an impressive experience, particularly at Atlanta, recently restored, where the 'faux terrain' is still in place.

141 A brochure of Poilpot's Monitor-Merrimac Panorama survives among the Le Prince papers. Le Prince is named as Manager. See also 'Art that resembles Nature', *New York Times*, 10 January 1886.

142 In *The Career of L. A. A. Le Prince*, E. K. Scott quotes Jean Le Roy (New York) who later invented a moving picture projector: 'I met Le Prince in about 1884. I recall an order for lantern slides of military scenes, that he explained were to be made to scale so that he would be able to project them without any varying sizes or proportions. It was to help him make outline drawings on canvas to be used in the panorama of the war.'

148 John Whitley later became the driving force behind the French–English resort at Le Touquet, an idealistic internationalist venture designed to bring the two (middle class) peoples together (see Le Prince papers). A brief life of John Whitley was published in 1911, after his death.

150 This incident was recalled by John Whitley in a letter to Lizzie, 9 February 1899 (Le Prince papers).

151 Le Prince papers.

152 This anecdote was recalled by Aimée Le Prince in a letter to Merritt Crawford, 1 April 1931 (Merritt Crawford Archive).

154 These three testimonies were reproduced by Lizzie in the *Memoirs*.

159 See note to p. 129.

161 Joseph Whitley to Lizzie, 10 October 1886 (Le Prince papers).

162 Le Prince to Richard Wilson, 2 November 1866 (*Memoirs*).

163 US Patent to Le Prince, #376,247, and its accompanying file wrapper provide the basis for much of the following two chapters.

172 For more on Marey see note to p. 249.

178 See Hendricks, *Edison*, chapter 18.

183 Raff & Gammon to Armat, 5 March 1896. Quoted in Ramsaye, p. 224.

187 See record of Interference 18541, US Patent Office, for the details of this engagement.

189 See *Memoirs* for details of Lizzie's dealings with Choate.

193 Richard Wilson to Adolphe, 4 June 1898 (Le Prince papers). See also Testimony of Richard Wilson, 20 October 1898 (*Memoirs*).

197 See record of Equity 6928, South District New York, held in Federal Archive, Bayonne, New Jersey, for transcripts of this lengthy lawsuit.

204 The remnant of Le Prince's sixteen-lens camera at the Science Museum, London, is almost certainly the machine that Le Prince had constructed in Paris at this time. The maker stamped his name on the wood: 'D'appareil photographique. H. Mackenstein. SGDC. 23 Rue des Canues, Paris.'

† Le Prince to Lizzie, 18 August 1887 (Le Prince papers).

206 Lizzie quotes this entry in the *Memoirs*. I have never located Whitley's journal for these years. According to Lizzie (*Memoirs*) in 1923 it was in the possession of a Whitley relative, Arthur Oates. If found, it would be a rich seam for further work on Le Prince's life during these years.

207 Both quotes from a letter from Le Prince to Lizzie, 8 January 1888 (*Memoirs*).

† Le Prince's British patent agents were Thompson and Boult, 323 High Holborn, London.

208 Le Prince to Lizzie, 2 February 1888 (*Memoirs*).

209 Le Prince to Lizzie, 18 March 1888 (*Memoirs*).

212 For more on total Cinema, see Bazin, André, 'Total Cinema' in *What Is Cinema?*, Vol. 1, University of California Press, 1967.

213 See H. Mark Gosser, *A History of Stereoscopic Moving Pictures*, Arno, New York, 1977. This is a thorough history of stereoscopic ambitions through the nineteenth century and into the twentieth. On p. 171 Gosser observes that Le Prince's description of the gearing configuration of his sixteen lens camera in his patents would mean that the shutters were released in four vertical sequences of four, rather than in eight horizontal pairs. He concludes from this that Le Prince did not intend the apparatus as a stereoscopic moving picture camera.

 I think that Gosser is wrong here. Le Prince's US patent shows a binocular viewfinder in the drawing, suggesting stereoscopic intentions. Furthermore, the surviving remnant of Le Prince's sixteen lens camera has an electrical switching device wired to electromagnetic armatures for releasing the shutters in place of the purely mechanical solutions described in the patent. The precise sequence of shutter release would then have been a function of the wiring of the switching device and could have been changed at a moment's notice, unlike the mechanical version which would have been limited to a single order of shutter release.

 If any further evidence of Le Prince's stereoscopic ambitions is required, we have only to turn to Adolphe: 'From the beginning,' he wrote in 'Missing Pages' (*Memoirs*), 'Le Prince's mind was bent upon devising methods for projection in relief, and [he] constructed machines for this purpose with alternated projected pictures, as well as in a "peepshow" way... Le Prince intended to take out a patent on his "stereoscope" as he called it; but his elimination put an end to all his work and projects.'

214 See Frederick Jameson, 'The Cultural Logic of Capital', *New Left Review*, No. 146, July–August 198?, p. 66, for discussion of the simulacrum. See also Jean Baudrillard, 'The Precession of Simulacra, Simulations, Semiotext(e), Columbia University, New York, 1983.

217 See *Yorkshire Evening Post*, 16 December 1930.

218 Annie Hartley to Lizzie Le Prince, 18 November 1888 (*Memoirs*).

† Longley to Adolphe, 15 January 1899 (Le Prince papers). Longley also signed two declarations on his work for Le Prince at this time on 19 September 1898 and 25 March 1899 (*Memoirs*). For more on Longley, who died in 1907, see note to p. 26.

 Adolphe also obtained the sworn testimonies of several other witnesses to Le Prince's Leeds work during his visit to Leeds in 1898. These witnesses included Wil-

liam Mason (Frederick Mason's brother); Edgar Rhodes, who helped with the mechanical construction of the sixteen lens camera and projector and the smaller stereoscopic viewer during 1887 and the early part of 1888; and John Vine, who made limelight burners for one of the sixteen lens projectors. (*Memoirs*.)

220 'I blame thee not . . .' by Heinrich Heine, for Schumann's Dichterliebe 'Ich grolle nicht . . .'

221 Le Prince to Thomson and Boult, 4 October 1888 (*Memoirs*).

222 British patent to Le Prince #423, November 1888.

228 Adolphe to Page, 11 December 1898 (*Memoirs*).

† Wilson to Adolphe, 4 January 1899 (Le Prince papers).

234 Less so since the appearance of the first volume of the Rutgers project on the Edison papers (see Further Reading).

235 Morton to Edmonds, 28 June 1899, Equity 6928 correspondence (Edison Archive).

236 Equity 6928. Brief for Appellant (complainant). 28 October 1901 (Edison Archive).

238 Animation of the few surviving sequential images of Le Prince's garden sequence (20 frames) and melodean sequence (20 frames) for my film *The Missing Reel*, confirmed their origination in a single lens moving picture camera. In both sequences, backgrounds are rock steady in relationship to foreground action. Positive prints of these sequences, and the Leeds Bridge sequence, are in the Science Museum, London. The frames of the Leeds Bridge sequence are 'edge-numbered' in what appears to be Le Prince's handwriting. The last number is 129, suggesting an original sequence of at least that number of frames – six times as many as have survived.

239 Richard Wilson's testimony, 20 October 1898 (*Memoirs*).

† Longley's testimony, 19 September 1898.

240 J. P. Ward (Photography & Cinematography Collection, Science Museum, London) to author, 15 January 1981.

246 Mason's declaration, reproduced in E. K. Scott, 'Career of L. A. A. Le Prince', *SMPE Journal*, Vol. 17, 1931.

248 Le Prince to Lizzie, 19 March 1890 (Le Prince papers).

249 The French journal Comptes Rendus, Vol. 107, pp. 677–8, reproduced in a paper delivered by Marey to the French Academy of Sciences on 29 October 1888. 'I have the honour to present today a band of sensitized paper upon which a series of impressions has been obtained, at the rate of twenty per second,' Marey told his audience. 'The apparatus which I have constructed for this purpose winds off a band of sensitized paper.'

The French patent for this 'chronophotographic camera' was issued to Marey on 3 October 1890.

Marey and Le Prince's work on their respective single lens moving picture cameras evolved more or less in parallel in France and England through 1888. I have not been able to determine whether there were specific influences one way or the other. Le Prince is likely to have known of Marey's work with 'chronophotography' since the announcement of the French physiologist's Photographic Gun in 1882. Marey is far less likely to have known of Le Prince's work. The influences, if any, were more likely to have been from Marey to Le Prince. Of the two, Le Prince possibly achieved a result with his camera slightly before Marey, the earliest datable Le Prince footage being the garden sequence, taken on 14 October 1888. But it was a close thing. Marey

showed his result to the French Academy on 29 October 1888 (see above). Of the two cameras, Marey's was more technically sophisticated and probably capable of higher speeds than Le Prince's. But unlike Marey, Le Prince had a vision of cinema. He intended the reproduction as well as taking of animated pictures, whereas physiologist Marey settled, at this time, for 'the decomposition of the phases of a movement by means of successive photographic impressions . . .' – a sequence of stills.

† For Friese-Greene see *Photographic News*, 28 February 1890.

250 Several of these bills survive among the Le Prince papers.

253 Le Prince to Lizzie, 25 April 1890 (Le Prince papers).

254 Le Prince to Lizzie, 24 May 1890 (Le Prince papers).

257 See file wrapper to US #376,247 to Le Prince, US Patent Office.

258 Choate Evans and Beaman to Lizzie, February 1899 (*Memoirs*).

260 J. G. Sherman to Adolphe, 30 May 1899 (Le Prince papers).

268 'movement of Mr Armat's', Edison's testimony, Equity 6928, 29 January 1900.

270 Marvin to Edison, 27 March 1900 (Edison Archive).

271 Judge Wheeler's decree, 25 July 1901, Equity 6928, Circuit Court, Southern District of New York.

272 Marvin's deposition, Equity 6928, 23 July 1901, Circuit Court, Southern District of New York.

277 This incident is described in L. A. Augustin Le Prince, 'son Oeuvre et son Destin', an unsigned French article which appeared in the journal *Afitec* some time in 1969. I have been unable to locate the source more precisely since the photocopy of the article in my possession yields no more information.

282 Judgement, Equity 6928, 10 March 1902, Circuit Court of Appeals, Second Circuit.
cuit.

INDEX